ART HISTORY REVISITED

Art History Revisited

Sundry writings and occasional lectures

CALVIN G. SEERVELD

Edited by
John H. Kok

DORDT COLLEGE PRESS

Cover design by Willem Hart
Layout by Carla Goslinga

Dordt College Press www.dordt.edu/dordt_press
498 Fourth Avenue NE
Sioux Center, Iowa, 51250
United States of America

ISBN: 978-1-940567-03-7

Printed in the United States of America

The Library of Congress Cataloguing-in-Publication Data is on file with
the Library of Congress, Washington D.C.

Library of Congress Control Number: 2014934603

Cover: Henry Moore's large watchful woman of brown Horton stone
(*Reclining Figure,* 1929) portrays the rugged strength of mountainous
terrain that lasts for ages. A fertile mother not to be trifled with. Sprawling
art history too needs to be respected and well understood. *Reproduced by
permission of The Henry Moore Foundation.*

TABLE OF CONTENTS

Abbreviations used throughout this volume:

NA Calvin G. Seerveld, *Normative Aesthetics: Sundry writings and occasional lectures*, edited by John H. Kok. Sioux Center, IA: Dordt College Press, 2014.

RA Calvin G. Seerveld, *Redemptive Art in Society: Sundry writings and occasional lectures*, edited by John H. Kok. Sioux Center, IA: Dordt College Press, 2014.

CP Calvin G. Seerveld, *Cultural Problems in Western Society: Sundry writings and occasional lectures*, edited by John H. Kok. Sioux Center, IA: Dordt College Press, 2014.

CE Calvin G. Seerveld, *Cultural Education and History Writing: Sundry writings and occasional lectures*, edited by John H. Kok. Sioux Center, IA: Dordt College Press, 2014.

BSt Calvin G. Seerveld, *Biblical Studies and Wisdom for Living: Sundry writings and occasional lectures*, edited by John H. Kok. Sioux Center, IA: Dordt College Press, 2014.

INTRODUCTION TO PART ONE

Art History Revisited

Dirk van den Berg

Often the reader of Seerveld is first struck by the vibrancy and richness of his language and by concepts that border on shimmering allusiveness. On the surface this may well hide the remarkable consistency in category formation and the drive toward coherence that mark Seerveld's thinking over the wide range of areas of his special interests. This is certainly due to the single-minded directional power of its biblical roots, sustained by philosophy's intricate "transdisciplinary" reach in its systematic and "encyclopedic" response to the creational order—grasped in Seerveld's governing metaphor of the "cosmonomic theatre."[1] A cardinal feature of the "cosmonomic theatre" is its double scope. Beyond God's creational order and divine rule it also deals with the ontic status of cosmic genesis[2]—*proton* to *eschaton*—including the reality of historical periods or "time streams" as pancultural forces.

The selection of Seerveld writings in Part One of this volume appeared between 1973 and 2006. This book's title, *Art History Revisited*, suggests two ventures into art history. The first began with the exploratory extension of Vollenhoven's problem-historical method into the discipline of art historiography, while the second involved a more searching revisit to topics in this field.[3] The arrangement of the texts in Part One follows a general course from philosophy to art history,[4] from the historiography

1 Note in particular the section on critically Christian transcendental philosophical historiographic categories in the chapter "Biblical Wisdom underneath Vollenhoven's Categories" (12–22).

2 Rather than Dooyeweerd's modal conception of history, Seerveld joins Vollenhoven in a broad cosmic conception of the manifold manifestations of structured genesis, from the birth of stars and the formation of mountains and waterways to the culti-vation of human generations. Cf. Seerveld on "Dooyeweerd's Contribution to the Historiography of Philosophy" [1965], reprinted in *CE*: 199–209.

3 The two articles in this volume on Vollenhoven provide convenient if rough dates for the start of the two ventures—1973 and 1993.

4 The transposition from philosophy to history of art was neither direct nor simple.

of philosophy to the historiography of art and aesthetics[5]—quite distinct from the chronological order of their writing or their appearance in print. This sequence imparts some sense of a systematic unfolding of the problem-historical categories that Seerveld made his own on the basis of Vollenhoven's historiography of philosophy. Here they are articulated as cartographic[6] categories in the disciplinary field of art historiography, in its methodology, and in certain art historical topics of special significance to Seerveld—for instance, the revolutions, movements, and "style-wars" in the cultural dynamics in the wake of the Enlightenment at the inception of the modern, secularized, and industrialized world.[7]

The Enlightenment and especially the Rococo cultural dynamic drew Seerveld's attention during his initial cartographic explorations in the history of art and of aesthetic thought after his appointment as senior member at the Institute for Christian Studies in Toronto.[8] "Towards a Cartographic Methodology for Art Historiography" (61–78) offers a key example of how Seerveld exploited the tangle of many voices in unresolved debates among art historians concerning the Enlightenment and the Rococo to introduce the categories of the cartographic method

The study of literature played a key role in Seerveld's own training and several of the typiconic categories have literary origins (for instance, "mystic," "heroic," "pica-resque," and "idyllic") and are applied by the same token to literary, visual, musical, or dramatic arts. Since for Seerveld they involve worldview frames, these categories could also be applied in domains like aesthetics, ethics, and politics—hence the es-sential need for an appropriate hermeneutics for each of these domains.

5 For an excellent, intimate as well as extended, critical survey of Seerveld's art historical thinking consult Henry M. Luttikhuizen, "Serving Vintage Wisdom: Art historiogra-phy in the Neo-Calvinian tradition," in *Pledges of Jubilee: Essays on the arts and culture, in honor of Calvin G. Seerveld*, eds. Lambert Zuidervaart and Henry Luttikhuizen (Grand Rapids: Eerdmans, 1995), 78–104. Dirk van den Berg, "Coping with Art Historical Diversity in Methodological Terms," *Acta Academica* 22:1 (1990): 35–52, presents a brief introduction to the cartographic methodology, originally delivered to a secular, politically charged, and fractious audience.

6 Evolved from Vollenhoven's *Schematische Kaarten* (which were "tables" rather than "charts"), the impulse to map history that is implicit in the term "cartographic" war-rants brief critical reflection on the perils involved in spatialized views of history, found already in the early modern foundation of cartography and perspective design in projective geometry. Hence, mapping's drive to achieve total rationalized coverage of an infinite but static extension. Art historians today do not need a view of art his-tory through an Albertian *finestra aperta*.

7 Appropriately termed *Sattelzeit* by Reinhart Koselleck, this transitional era is concise-ly summarized in art historical terms in the schematic worksheet in "Vollenhoven's Legacy for Art Historiography" (46).

8 The Rococo became the focus of Seerveld's historical investigations in philosophical aesthetics with "Early Kant and a Rococo Spirit: Setting for the *Critique of Judgment*" [1978] {*CE*: 317–342} as well as in art history with "Telltale Statues in Watteau's Painting" (171–195).

to a secular audience. In a subsequent group of articles Seerveld expanded his forays into the art, aesthetic theory, and art policy of the Neoclassical and Romantic idealisms.[9] His nuanced treatment of leading artists and philosophers in this timeframe helped to get rid of the so-called Classicism-Romanticism dialectic—a distant relation of the Dooyeweerdian nature-freedom ground motive—that used to form the basis of many conventional histories of modern art.

Seerveld's has a unique style of wonder, scrutiny, and exposition. One special feature of his work concerns a chiasmic interlacement of philosophical systematics and historiography. The following terse statement from "Biblical Wisdom underneath..." (11) captures Seerveld's conviction regarding the common ground of ontology's encyclopedic topics and Vollenhoven's critical historiographic categories: "Basic ontic matters are perennial *historical challenges* ('problems'!) and have staying power through the ages *because* they are *creational structural affairs.*" He investigates the positional intricacies of any particular historical case (the work of an artist or the methodology of an art historian, for instance) by interrogating it in terms of basic systematic categories. In systematizing basic philosophical or "worldview" categories, on the other hand, he remains sensitively as well as ideologically alert regarding their historical plurality and relativity as well as their legacy of directional partialities.

It is clear from Seerveld's writings that a scholar has to be constantly aware of and forthright about the relativity and partiality of one's own historical position and legacy, about the tradition of one's systematic categories, and about one's ultimate commitments. Thus I find that my work as art historian has been primed and inspired equally by Seerveld's art historical writings and by his systematic accounts of basic categories that serve to focus such inquiry.[10] In my experience, this interconnection of systematic and historiographical components is one of this method's pedagogical fortes, extremely suitable for basic courses in art history. By raising awareness of the interconnectedness of everything in this field, it serves the nurturing of more advanced critical questioning.

Seerveld also addressed the chiasmic interlacement of philosophy and history in his inaugural address at the Institute for Christian Studies

9 This group includes the following articles in this volume: "Methodological Notes for Assessing What Happened 1764–1831 in the History of Aesthetics" [1988] (117–125), "The Moment of Truth and Evidence of Sterility within Neoclassical Art and Aesthetic Theory of the Later Enlightenment" [1983] (127–129), "Idealistic Philosophy in Checkmate: Neoclassical and Romantic artistic policy" [1989] (131–136), together with "Canonic Art: Pregnant dilemmas in the theory and practice of Anton Raphael Mengs" [1984] (223–240).

10 Such concepts typically include Seerveld's ideas concerning aestheticity, imaginativity, the hearted embodiedness of human existence, and the affective power of the image.

in 1972.[11] In particular when describing the task of the hermeneutic aesthetician, he illustrated this point with the metaphor of an academic flower, growing from the central core of philosophy and history to the inner petal of modal aesthetics, the petal of the theory and historiography of art to the outer petal of art criticism and hermeneutics. I consider the development of a special hermeneutics to be a mainstay pedagogical strength of his explorations in the history of art and of aesthetics. In fact, I believe that general hermeneutics should share with philosophy and history the key position at the academic flower's central core.[12]

This hermeneutics is aware of its key role in engaging historical works of art at the interface of aesthetic and art-theoretical systematics and, on the other hand, contextual junctures, societal frames, and historical positions to be identified and circumscribed in terms of art historiographical categories. It furthermore has the intersubjective focus of image hermeneutics, sensitive to the affective potency and imaginative cogency of the image.[13] The human dialogic exchange with the artwork as a positioned quasi-subject as well as the complexities of continuity/discontinuity between the historical junctures of the artwork's origin and that of the hermeneutic art historian are first of all imaginative human events, to be informed and enriched by image hermeneutics.

The first writings in this volume[14]—introductions for diverse audiences to the cartographic method's synchronic, perchronic, and diachronic categories—tend to treat separately the once-only *Zeitgeister* or cultural dynamics of periods, the recurrent typiconic traditions, and the footprint trails of historical development.[15] In the subsequent explorations,[16] the discourse ripens into intricately interwoven complexes of cartographic categories. Nonetheless, diachronic interests appear to have been underdeveloped already in Vollenhoven's historical attention

11 Cf. *A Turnabout in Aesthetics to Understanding* [1974] in *NA*: 233–258, in particular pp. 248–252.

12 Seerveld's work in philosophical hermeneutics, particularly on Hans-Georg Gadamer and Paul Ricoeur, provided an important platform for his explorations in art history. See his "A Review: *Truth and Method*" [1978] in *NA*: 289–295.

13 The image involves more than visual or graphic representation. The imaginative potential of its nuanced metaphorical qualities applies equally to poetic imagery, tonal and motivic structuring in music, tectonic spaces and shapes, etc.

14 For instance, "Biblical Wisdom underneath . . ." (1973) is directed to the immediate Vollenhoven cohort, "Vollenhoven's Legacy for Art Historiography" (1993) is addressing a wider Reformational circle, and "Towards a Cartographic Methodology. . ." (1980) addresses a mainly secular readership with a low key discourse.

15 Cf. also Seerveld's "Footprints in the Snow" [1991] in *CE*: 235–276.

16 For instance, "Antiquity Transumed and the Reformational Tradition . . ." (2006), "Methodological Notes for Assessing What Happened . . ." (1988), and "Badt and Dittmann . . ." (1994).

and, as the third leg or component in Seerveld's cartographic method, have always seemed to me to be somewhat of an add-on to the Vollenhoven methodology.

In "Vollenhoven's Legacy for Art Historiography," for instance, Seerveld writes that the "third coordinate of what actually takes footprinted place . . . is difficult to get precise when it comes to art, because much depends upon the history of what the art historian aims to tell" (47). For this reason I would rather consider the diachronic as the primary coordinate. Given the countless and incessant changes in any field, the historian from the outset has to limit and sharpen the focus of investigation. To my mind this begins with the posing of diachronic questions regarding significant change in institutional frames, kinds of art and media, and the functions of images; for instance: "What is it?" "How did it function?" "How was it (re-)used?" "What has it become?" "How is it to be appropriated today?" In the case of art history, the historian's primary material furthermore comprises the at times strange and eventful interactions with and imaginative participations in artworks or installations.[17]

Seerveld fully appreciates the playful initiative art objects have in such encounters—once-only events, frustrating or inspiring, requiring repeated mutually questioning concretizations. Hence, he appreciates that "Kurt Badt's drive . . . to let the art object in its defining artistry ask us questions is methodologically right, . . . bringing art-historians professionally face to face with artworks as nuanced embodiments of committed human vision and passion" (101).

Seerveld is here investigating the *spoliatio* attitude towards the wisdom and art of pagan antiquity—opposing Jacob Klapwijk's proposal of transformational philosophy.[18] He follows the lead of three extraordinarily different artists—opening himself imaginatively to questions silently posed in key paintings by Nicolas Poussin, Johannes Vermeer, and Anselm Kiefer, ruminating on diverse attitudes to antiquity in concert with opposing commentaries from other art historians. The concluding theses present humbled yet enriched comments on the cartographic project: ". . . we need to select choice flashpoints in the past to orient the next generation to understand our human task, lest the newcomers soon become lost in an amnesiac network of being fashionably current, and thus become all too soon outdated, obsolete prophets" (113).

17 Cf. Seerveld, "Human Responses to Art: Good, bad, and indifferent," *Human Responses to Art*, ed. Mike Vanden Bosch (Sioux Center: Dordt College Press, 1983), 1–18; reprinted in *In the Fields of the Lord: A Calvin Seerveld reader*, ed. Craig Bartholomew (Toronto: Piquant & Tuppence Press, 2000), 316–329.

18 Cf. Klapwijk, "Antithesis, Synthesis, and the Idea of Transformational Philosophy," *Philosophia Reformata* 51:1/2 (1986): 138–152.

The last piece in Part One contains the outlines of an unfinished project on two Continental art historians, hardly known in North America, namely, Kurt Badt and Lorenz Dittmann. It is devoted to their different ways of reworking or amending Martin Heidegger's art theory with an ontological focus open to transcendence and truth—the familiar "structure" and "direction" that in Seerveld's own tradition would hold for all art.[19] Seerveld's conclusion can be read autobiographically as a confessional statement on his own work (166):

> ... respect art and thinking that gives a sure place to things, bears a world with redemptive horizons, and dares stake out a position in matters of life and death, truth and lie, meaning and vanity. If one could engage such systemic analysis and historiographic narrative to elucidate the human meaning of making, receiving, and reflecting on art and literature, sharing one's insights in scholarly journals, this would become not so much a conflicting one-upmanship argument as making music for one another.

Dirk van den Berg
Professor Emeritus
Department of History of Art and Visual Culture Studies
University of the Free State
Bloemfontein, South Africa

19 This topic is explored extensively in Lambert Zuidervaart's *Artistic Truth: Aesthetics, discourse, and imaginative disclosure* (Cambridge: Cambridge University Press, 2004).

INTRODUCTION TO PART TWO

Art History and *Sterkte*

Henry Luttikhuizen

Cal Seerveld is not an art historian. He does not even play one on television. His field of study is philosophy. Yet, as this selection of essays attests, Cal is not only well versed in the history of art, he is able to make significant contributions to the field. Admittedly, this move is a bit courageous, even in an era when interdisciplinary scholarship seems to be all the rage. Many philosophers of art or aesthetics may be familiar with contemporary trends, but most are woefully naive about matters of historical development. To be fair, art historians have intellectual weaknesses of their own and many fail to see the philosophical framework underlying their interpretations. In fact, it is extremely rare to hear a philosopher speak at an art history conference or an art historian talk at a philosophy symposium or congress. Seerveld strives to promote dialogue between these disciplines. He does not believe the adage that good fences make good neighbors. On the contrary, Seerveld neighbors should cooperate in hopes of learning from each other. Undaunted by disciplinary limitations, Seerveld makes the academic leap into art history because he recognizes the promises this holds for philosophical aesthetics. He wants to learn from studying the history of art. At the same time, he hopes to show and tell art historians a thing or two about the significance of philosophical aesthetics. Philosophy, after all, not only plays a role in the historical development of art, it also helps shape the manner in which art history is written.

Nearly a quarter of a century ago, Seerveld supervised my master's thesis. For two years, he served as my mentor at the Institute for Christian Studies in Toronto. He taught me much about phenomenology and existentialism, but I never became a philosopher. In fact, after working with Seerveld, I continued my studies at the University of Virginia in the field of art history. As I write this introduction, I cannot help but reminisce about my life in Toronto. I was really blessed. Seerveld was a marvelous teacher and he prepared me well for studying art history. He

made me think more carefully about philosophical categories. Seerveld offers some good lessons in this selection of essays. First, communication need not be straightforward or blunt to be effective. Subtlety and nuance are not merely forms of linguistic decoration. As Jean-Antoine Watteau has shown, they can be playful vehicles of meaning. Second, Plato was wrong; there is no essential correlation between beauty and goodness. Seeking the beautiful in terms of mathematical harmony does not always provide the stronger sense of morality that it promises. In fact, beauty may, on occasion, hinder ethical behavior. To do the right thing, we may need to explore alternatives, as William Hogarth, Peter Smith, and Gerard Folkerts have done. Finally, art history is not the pursuit of trivia. Interpreting the visual arts is more than a parlor game of deciphering hidden symbols or iconographic clues. On the contrary, studying art history provides us meaningful opportunities to learn about the thoughts, actions, and beliefs of others as well as those of our own. Art history is not idle curiosity nor is it a matter of academic navel gazing. Images have real power. They help shape the ways humans live. Consequently, it is not only important to consider how they work, but also to convey this message to a broader audience, beyond the circle of professional academicians.

In his essay "Telltale Statues in Watteau's Paintings" Seerveld reexamines the eighteenth century artist's interpretation of love. Watteau is often described as a Rococo painter who imaginatively challenged the authority of the French Academy by producing *fête gallantes*, scenes of aristocrats at play, a subject that did not fit traditional categories of art. These pictures were neither history paintings nor portraits. Nor did Watteau depict vagrancies of peasant life. Instead, the artist introduced a new category of painting, one that called into question the implicit hierarchy of genres delineated by the Academy. Watteau subtly deflated the clout of classical mythology in art by fusing it with the *commedia dell'arte*, contemporary theatre.

As Seerveld notes, the aristocrats depicted in Watteau's *fête gallantes* perform various acts of romance within idyllic gardens of love. In these paintings, Watteau reinterprets the late work of Peter Paul Rubens. Like the seventeenth century Flemish Baroque painter, Watteau represents an imaginative garden, cloistered off from political and economic affairs. Often containing sculpture and fountains, these painted scenes subtly allude to the pleasure gardens of an ancient Roman villa, while updating them. Yet his gardens do not resemble those at Versailles. Geometric order and symmetry do not define his painted places. Rather than focus on the noble simplicity or quiet grandeur, Watteau, like Rubens before him, looks to the garden not as a site embodying dominion or control, but as the ideal place where love might grow. Unlike Rubens, however, Watteau makes no reference to the goals of marriage and parenthood.

The figures in his paintings delight in erotic play with little concern for morality or matrimony. Watteau softens the scene, emphasizing the delicacy of the setting and the stages of romance. He also introduces new iconography, such as the swing, indicating the to and fro of lovemaking. Consequently, most scholars have interpreted Watteau's *fête gallantes* as Rococo invitations to revel in hedonistic pleasures, liberated from the obligations of courtly life. Seerveld, however, disagrees.

To his understanding, Watteau's paintings offer a critique of fashionable society. The masquerades and theatrical games of love played by the aristocracy do not offer freedom. On the contrary, they suppress sensuality and the risks associated with being frisky. In Watteau's pictures, lovers are often oblivious to potential dangers associated with erotic play. They remain blind to emblematic clues available to the viewer. Beneath the veil of sweetness and courtly elegance, the art of seduction quietly goes about its business. According to Seerveld, Watteau recognizes that "every earthly paradise has its snake in the grass." The sculptures depicted in Watteau's imagery seem more aware of the power of love than his painted amorous figures. The wry smile of the Venus sculpture does not offer a moralizing admonition. The goddess of love does not advocate celibacy. On the contrary, she promotes passionate relationships. Venus approves of sensuality and the physicality of lovemaking. Her knowing gesture may reveal that lovers are easily fooled. She understands that in the pilgrimage of love, no sojourners are sexually innocent or in complete control of their movements. Lovers may ultimately get hurt, but it is a risk worth taking.

In a Festschrift essay celebrating the career of Dordt College professor John Vander Stelt, Seerveld investigates the witty imagery and writings of William Hogarth. His contribution, "God's Ordinance for Artistry and Hogarth's 'Wanton Chace,'" praises the good sense of modestly recognizing one's homespun accomplishments rather than foolishly seeking pompous accolades associated with the Academy.

According to Seerveld, Hogarth's engravings offer diaconal service for those imaginatively impaired. He pokes fun of the injustice, ignorance, and cruelty found underneath the politeness of high society. In his satirical reworking of Bunyan's *Pilgrim's Progress*, individuals proceed down the road to ruin. Hogarth's picaresque "morality plays" resist the heroic. With Socratic irony, the smartest thing to do is to admit one's stupidity.

Hogarth's *Analysis of Beauty* (1753) addresses time-honored design principles. However, he refuses to genuflect before Antiquity. To his understanding, the traditional concept of Beauty as fundamentally ennobling is false. Aesthetic norms of proper proportion and harmonious arrangements are not absolute. Calm and orderly imagery will not necessarily ennoble the beholder. The balanced compositions of Raphael and Nicolas Poussin need not, as suggested by Jean-Baptiste Colbert and

the French Academy, provide the norm. Sir Joshua Reynolds' promotion of grand manner portraiture, the fusion of history painting and portraiture, is too closely aligned to the French Academy for Hogarth's taste. More important, it wrongheadedly elevates sitters to the status of mythological figures. Hogarth has no patience for such haughtiness. Art should be down-to-earth. Hogarth makes images for his neighbors, the general public, rather than for a cultural elite. To his understanding, pictures should not merely lead the eye to "wanton chace" through the aesthetic contemplation of beauty. On the contrary, art should be produced in a playful manner that calls for greater justice rather than passive acceptance of the status quo.

In "Canonical Art: Pregnant dilemmas in the theory and practice of Anton Raphael Mengs," Seerveld analyzes the work of an eighteenth century theorist and painter. Mengs was a powerful figure in the art world of his day. In many ways, he helped shape the canon of art by defining the norms for beauty and taste. Mengs is often linked in art historical scholarship to Johan Joachim Winckelmann, author of *Geschichte der Kunst de Altertums* (1764). Winckelmann's neoclassical tome calls artists to follow Greco-Roman models in the imitation of nature.

Although Winckelmann's book is dedicated to Mengs, Seerveld encourages readers to consider the differences between Winckelmann and Mengs. For Winckelmann, the ancient Greeks offered the perfect paradigm for artistry. By contrast, Mengs praises the ancient Greeks for their desire to learn from nature, but he does not validate their work as the sole standard. Mengs also looks to Renaissance art, especially the paintings of Raphael, Correggio, and Titian, as models to imitate. Training the eye is not merely a matter of knowing a set of timeless rules. On the contrary, it is also the process of disciplining the eye in relationship to the best pictures that the Western tradition has to offer. The ancient Greeks may have introduced illusionistic painting, but contemporary artists, according to Mengs, are called to imitate nature in ways that supersede the work of the ancient Greeks. For Mengs, the canon is not predetermined. Instead, the canon is constantly under revision as artists continue to search for aesthetic standards.

Mengs practiced what he preached. His fresco painting of *Parnassus* on the ceiling of the Villa Albani in Rome fits its neoclassical setting. However, the image of Apollo and the Muses does not merely follow ancient Greek principles of art making. In fact, his picture has much in common with Raphael's lunette fresco in the Stanza degli Segnatura. Meng's painting is not a passive illustration of days gone by. On the contrary, it is an image designed to enliven the exhibition space of Cardinal Albani's collection of antiquities.

Seerveld's essay "No Endangered Species" examines the wood engravings of a contemporary English artist, Peter S. Smith. After

providing a biographical sketch of the artist, Seerveld offers a brief history of engraving. According to Seerveld, printmaking flourished during the Protestant Reformation. Even though Reformers were quick to challenge Catholic liturgical images as idolatrous, they never merely promoted verbal discourse. On the contrary, sixteenth century Protestants produced polemical prints, portraits of ecclesiastical leaders as examples of virtue, and devotional images in their battle for Christian bodies and souls. Printmaking helped spread the Reformation.

In the eighteenth century, the English artist and natural historian Thomas Bewick revolutionized printmaking by popularizing wood engraving. Traditionally, engravers carve grooves into a soft metal plate. Bewick used the same tools, but altered the ground—wood. His work should not be confused with the production of woodcuts. In wood engraving, the artist carves inkling grooves against the grain of a hardwood, such as boxwood. By contrast, woodcutters use soft woods and they carve away only the areas that they do not want to receive ink.

Wood engraving proved to be an excellent medium for printing newspaper illustrations. Despite their popularity, or perhaps because of it, Bewick and his colleagues were pejoratively called "woodpeckers." Wood engravers were not allowed membership into the Royal Academy of Arts. Their labor was considered to be a craft rather than a fine art.

In the late nineteenth century, William Morris and his colleagues in the Arts and Crafts movement promoted wood engraving as a means of bringing beautifully designed items to industrial workers. Of course, this idea was incredibly idealistic and never panned out. The production of wood engravings demands time and artistic skill, making the cost of such handiwork too expensive for common laborers to afford.

The Society of Wood Engravers was established in 1920. However, throughout the twentieth century the popularity of this unpretentious medium has waned. Nonetheless, Peter Smith and others have worked hard to revive it, ensuring that wood engraving will not become an endangered species of artistry. Trained as a painter, Smith discovered wood engraving later in his career. His preoccupation with the medium seems to have coincided with his growing interest in neo-Calvinism.

Smith was raised in a non-conformist Methodist household. His understanding of Christian piety was closely defined in terms of spreading the Gospel through missionary work and preaching. This changed, however, upon meeting Hans Rookmaaker, a Dutch art historian who took his neo-Calvinist convictions seriously. Rookmaaker revealed to Smith a new interpretation of devotion—that all of life was religious. One need not choose between living a life committed to art or one committed to faith. Rookmaaker encouraged Smith to see the presence of grace in the ordinary. He called the artist to make meaningful images for a broad audience rather than for a Christian elite. Smith, it

appears, has followed the art historian's advice. His intimate quiet images of figures walking, working, and waiting offer opportunities to reflect on simple moments of daily life. The dim luminosity of the scenes is not threatening or ominous. On the contrary, it elicits a sense of mystery and wonder.

In "Redemptive Grit" Seerveld addresses the work of another Christian artist, Gerard Folkerts. Like Smith, Folkerts sees grace in the ordinary. Although he seeks to reveal the presence of the divine, Folkerts does not promote mystical transcendence. There is no need to climb a contemplative mountaintop. To his understanding, the sacred is always already here. Yet Folkerts does not shy away from pain and suffering. The Winnipeg artist shows stories of hardships. In *Restless Slumber*, Folkerts conveys the longing for security. His image of Chernobyl reveals the monstrous nightmares that humans can produce. Folkerts shows how local disasters can have global ramifications. Yet even within the brokenness of the world, Folkerts sees hope for redemption.

Seerveld's short book review of *The New Art History* examines the paradigmatic shift within the discipline. The New Art Historians, a loose alliance of neo-Marxians, feminists, and post-structuralists, rightfully criticize the assumed neutrality of the Old Art History. These scholars strongly challenge the notion of a disembodied eye. Race, gender, and social class affect perception. The burden of Ideology cannot be lifted. There is no transcendental vantage point. Art historians, like all beholders, are guided by socio-economic convictions. Theory is a cultural practice.

For Seerveld, the New Art History poses serious questions. If all metanarratives are false, is it responsible to keep teaching survey courses? If we embrace a semiotic interpretation of art history, is there any place for the distinctively visual or is it really just a matter of intertextuality? Although the New Art History has encouraged the development of methodological pluralism, Seerveld seems to wonder if it will welcome more cross-disciplinary dialogue or if it forecloses the possibility of such a conversation. In this marketplace for ideas, methodological unity no longer appears feasible. Nonetheless, Seerveld hopes that art historians and philosophers will continue to learn from one another courageously.

In closing, Seerveld often ends his correspondences with the Dutch word, "sterkte." Literally, the term denotes strength or fortitude. However, such a simple interpretation would be a short-sighted translation. *Sterkte* is a word of encouragement. It is often spoken at tough times in places like hospitals and funeral homes, at moments when words seem woefully inadequate. To say "sterkte" is to exclaim that the speaker (or writer) has faith that the listener (or reader) will persevere. The term also reminds those who suffer and grieve that they are not alone. With grace, tragedies can be overcome. Seerveld is well aware of *sterkte*'s meaning. However, I think that it is fair to say that he playfully extends the context of its

significance. *Sterkte* can be used as a benediction for nearly every occasion. To his understanding, *sterkte* is like a rainbow. It reveals a redemptive promise to a broken and fallen world—that God will always be with us. *Sterkte* indeed.

Henry Luttikhuizen
Professor of Art History
Calvin College, Grand Rapids, Michigan

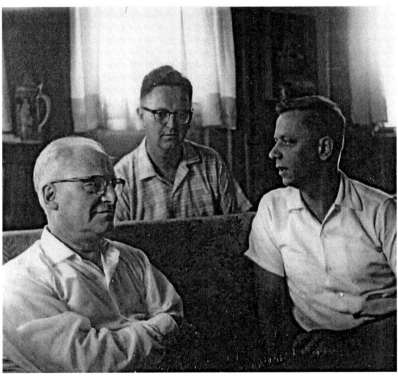

Discussing Aristotle's paradigm shift from IIC3 to IIC4: Dirk H. Th. Vollenhoven, H. Evan Runner, Calvin Seerveld, in Runner's Grand Rapids home, Michigan, 1959

BIBLICAL WISDOM
UNDERNEATH VOLLENHOVEN'S CATEGORIES
FOR PHILOSOPHICAL HISTORIOGRAPHY

The formidable methodology of philosophical historiography developed by Vollenhoven in the past forty years has occasionally received passing attention *inter nos*.[1] But too often it was thought to be a specialist shorthand by which the initiated *promovendi* discussed their latest "finds," or it was misunderstood to be a club long enough to hit and knock down prejudged thinkers with whom Christians really did not want contact. A careful and penetrating study by Albert Wolters, in English, has changed all that.[2] By using Vollenhoven's method on Vollenhoven's methodological position itself, Wolters has readied the philosophical community for a new phase: a critical rather than a scholastic use of what is living and normative in Vollenhoven's canon for philosophical historiography, and letting go what is dead wood.

On this occasion I should like to state concisely the crux of Vollenhoven's approach, as I see it, the historical complex in which it was born, and then indicate what seem to me to be the biblical insights that ground and permeate Vollenhoven's basic categories.

I mean this brief study as a background for showing in another chapter in these volumes (see *CE*: 277–315), from my experience in teaching the history of philosophy to undergraduate students in the United States, the pedagogical strength of Vollenhoven's methodology. Every teacher, like every historian of philosophy, goes to the text with apriori's, even if

1 Cf. listing in K.A. Bril, *Tien Jaar Probleemhistorische Methode: Bibliografie en overzichten over de jaren 1960–1970* (Amsterdam: Centrale Interfaculteit der Vrije Universiteit, 1970), 11–15.

2 A. M. Wolters, *An Essay on the Idea of Problemgeschichte* (Amsterdam: Centrale Interfaculteit der Vrije Universiteit, 1970), mimeograph 69 pages.

First published in *The Idea of a Christian Philosophy, Festschrift for D.H. Th. Vollenhoven* (Kampen: Kok, 1973), 127–43.

the apriori be a blank mind or the position of an eclectic monographer.[3] It is my conviction that the christian reform Vollenhoven has begun in the historiography of philosophy furnishes beginning students with a precise, methodical apriori for inductive analysis of texts in the history of philosophy that demands of them an open, detective kind of research activity within a truly christian, structural overview. To make that credible one needs to see illustrations of its classroom use—the proof is in the pudding, not in the recipe. Yet it is important first to understand that Vollenhoven's work is neither arbitrary nor esoteric, also not finished, but is truly a beginning in wise, professional philosophical historiography.

Systematic theses underlying Vollenhoven's methodology
There are three basic theses assumed by Vollenhoven's methodology, with which I agree.

(1) **Historiography of philosophy should be historiography of philosophy**. And not, as Maurice Mandelbaum has also pointed out, historiography of mere unit-ideas, in the manner of A. O. (*Great Chain of Being, History of Ideas*) Lovejoy.[4] Philosophy should not be phased into the general cultural woodwork either, so that one is left with a general intellectual history or simply Burckhardt's tracing the shift in "cultural ideals." Although philosophy shares a mutually influential bond with our human societal life matrix at large, there still are definite, if indeterminate, boundaries between philosophy and art, philosophy and political action, specific philosophical products and a man's love life.[5] So historiography of philosophy should zero in on philosophy.

What philosophy is, of course, is moot. A working definition of philosophy consonant with Vollenhoven's *Isagôgè Philosophiae*[6] is this: committed and critical, synoptic, systematic, scientific knowing, and results

3 ". . . there is something wrong with the common idea that the true historian approaches his facts entirely without preconceptions and surrenders himself completely to their spell. The true historian, on my account, makes judgments of intrinsic importance as well as judgments about what brought about what; the latter are, or ought to be, wholly determined by the evidence, but the former themselves determine, broadly, what evidence the historian shall take into account and what general sorts of questions he shall ask about it." W. H. Walsh, "Hegel on the History of Philosophy," *History and Theory*, Beiheft 5 (Hague: Mouton, 1965), 78.

4 Maurice Mandelbaum, "The History of Ideas, Intellectual History and the History of Philosophy," *History and Theory*, Beiheft 5.

5 Ibid. 55–66.

6 *Isagôgè Philosophiae: Introduction to Philosophy*, Dutch/English, translated by John H. Kok (Sioux Center: Dordt College Press, 2005), 1–18.

of that activity, that analyzes things and aspects of things humanly so knowable, in their interrelated meaning. Historiography of philosophy will then treat the systematic analyses made by human thinkers reflecting upon interrelational-meaning problems. The core of a philosophy conceived as such an encyclopedic, "totality" science consists in the conceptual position taken while theoretically explaining the diversified unity to creational reality (cosmology), the special makeup and task of man amid society in the cosmos (societal anthropology), and the final structure-of and universe wide law-for everything (ontology).

Early Vollenhoven considered anthropology to be a specially pregnant focus to the thematic structure of a philosophical conception.[7] But it is the whole network of these three matters—cosmic variety, societal man's cultural command of things, and the order holding for every thing's duration—the interrelational meaning nexus of these three matters that constitute the skeletal crux of bona fide philosophy. That means the complicated study called epistemology is secondary, partial, and less fundamental a study within philosophy than its prominence since 1600 in Western thought seems to indicate. Lingual analytic positivism too, in the twentieth century, latched onto crucial semeiotic problems, but has been ambivalent on whether its explorations are specialized, prolegomenal studies in the field of linguistics and philology or a pretension to swallow philosophy proper—which reduction could only yield loss of scope and distortion of meaning dimensions for both legitimate disciplines. Any confusing identification of epistemology or semantics with philosophy will only make a muddle of historiography of philosophy.[8]

Émile Bréhier has succinctly posed the next critical question about historiography of philosophy.

> . . . can we speak of a steady evolution or progress in philosophy? Or did human thought, from the beginning, have in its possession all possible solutions to the problems it raises, and does it afterward only repeat itself indefinitely? Or do systems supersede one another in an arbitrary and

7 "En wijl van alle schepselen de mens rechtstreeks in de meeste verbanden staat, komen de schema's van een wijsgerig systeem tot hun breedste ontwikkeling in dat deel der kosmologie dat zich speciaal met den mens bezig houdt, dus in de anthropologie." D. H. Th. Vollenhoven, *Het Calvinisme en de Reformatie van de Wijsbegeerte* (Amsterdam: H. J. Paris, 1933), 52–53. Cf. H. Hart, thesis 14 in "Historicale Problemen," *Correspondentiebladen van de Vereniging voor Calvinistische Wijsbegeerte* 28 (December 1964): 9.

8 One could say that primary concepts about the genetic unfolding of things (cosmogony) and significant change (history) have remained underdeveloped sections in Vollenhoven's idea of a philosophy. Cf. early elemental statements in *Isagôgè*, 77–106.

contingent way?[9]

That is, is there one, single line of development? Is there a certain connecting order to the multi-variety of philosophical conceptions that have appeared in chronological succession?

(2) The continuity in philosophies is typological rather than teleological or genetic; and the development of successive philosophies is not one of betterment to type of truth, but is a lurching crisscross of integrating simplifications and refined complications. There is type continuity in philosophies because there is a continuously God-held structural order to the creational states of affairs to which philosophically analyzing thinkers respond (obediently or not) in a limited number of various, coherent ways. And there is development within the discontinuous, successive philosophies because as a human cultural product within the temporal, durational base God blesses creation with, philosophy too is subject to the structuring law of unfolding: differentiate, integrate, individuate, or petrify, fragment, and peter out.

Most major historiographers of philosophy have mistakenly converted the terms involved, sundered the union, and then either pressed for a one-sided connection to all philosophies or virtually denied any history of philosophy at all and squared off for polemical *sic et non* classification. Augustine (providential teleology), Hegel (dialectical logicism), Comte (organic evolutionism), Dilthey (metaphysics-dissolving historicism)—each gave his own twist to the single, necessary, evolving progression posited toward the millennium philosophy. While Francis Bacon, Renouvier, Jaspers, and Soviet Marxists catalogued basic types of philosophical systems, denied any real, interwoven influences among them, and left you with the option to choose one. The former geneticistic thinkers recognized continuity but melted type-continuity into a necessary, *genetic* continuity so that different types of philosophies became basically phases of the one final type of philosophy. The latter structuralistic thinkers recognized discontinuity, different philosophical positions, but affirmed such types so statically that significant development was precluded. Either way, the significant changes and developing influences going on among the different, continuing types of philosophy in history is taken amiss.

The fact that there are similar philosophical responses made in time to the basic core of recurrent, creational meaning-problems, and

9 Émil Bréhier, *The Hellenic Age*, translated by Joseph Thomas (Chicago: University of Chicago Press), 1938, 2.

therefore definite, fairly closed types of philosophy, is very humbling: there is nothing radically new under the sun in the history of philosophy (unless, perchance, you should get truly *good news into* and opening up your philosophical systematics. [When Thomists dogmatically affirm their position, taken broadly, as the mainline *philosophia perennis,* they are only calling virtuous, somewhat imperialistically, what lacks the broken-spirited, seeking anew character that marks christian philosophy.[10]]). However that may be, the important point I understand Vollenhoven to have quietly found out here is this: within the dimensions of recurrent types there is genuine historical influence, either lateral interacting modification by contemporary philosophical systematics of different types or a systematic formation of schoolish successors in a following generation; but the permutations unfolding historically are not the clue to philosophical continuity, and the connection of the changes is neither (bio) genetic nor (teleo)logical. Rather, the significant changes and their linkage has a Spirit-led, trans-entity nature.

Because philosophy is also a responding-to-God execution of woman and man's religion task, philosophy too has a directed, Spirit-led dynamic. And because the Spirit-led allegiance of the key persons taking historical initiative together at a given time gradually permeates and by and large dominates all cultural manifestations of that day, in a homogenous way, disparate types of philosophy during a given period are also usually characterized and Spirit-ually driven by whatever ἀρχάιν or ἐξουσίαι reign. Therefore, (3) **integral to christian historiography of philosophy is careful depiction of the transcendental Zeitgeist that incorporates and overpowers the various types of philosophical analyses current, at whatever stage of unfolding complication they be.**

There is some difficulty in putting one's finger on exactly what *Zeitgeist* is, its apparent power to shape a whole era, inclusive of philosophy, and how come each communal ground swell of shaping, Spirited commitment changes; but there should be neither skepticism nor speculation about its reality. When definite, idolatrous principalities and powers, instead of the Holy Spirit, capture and bind together the hearts of a certain human generation, the driving vision that gets formative authority among men in that age is a palpably real influence. *Zeitgeist* is much more than a fictive generalization constructed by later historians trying

10 Cf. C. Seerveld, "Dooyeweerd's Contribution to the Historiography of Philosophy," *Philosophy and Christianity* (Kampen: Kok, 1965), 201–202 {see *CE:* 208–209}, and K. J. Popma, "Philosophia Perennis," *Philosophia Reformata* 20:2 (1955): 64–86.

to organize their material: a *Zeitgeist* is the major δύναμις at work whose Kingdom seems to be coming, whose Regime of whirlwind (or shalom) is being historically built up by willing human servants in . . . that "day of our Lord!"[11]

With respect to philosophy, early Vollenhoven (1933) had simply posited that the major periods of philosophical history should be determined by how philosophy relates itself to the Word-revelation[12]: pagan, ethnic period BC, followed by a synthetic-christian period AD, followed by an anti-synthetic-christian or secular period since the Renaissance in Western Europe. Later Vollenhoven (1956) began to designate certain *systematic,* subdividing decisions, like universalism, partial-universalism, and individualism, within pagan Greek Subjectivistic philosophical conceptions, for example, as "trends" (*richtingen*) and "currents" (*stromingen*), identifying such matters closely with "periods" and "years" of thought.[13] Around 1959 and after, it seems, while explicating the *kindred spirit* grouping quite different philosophical conceptions together because they gave similar answers to what is the final Law-word for reality, Vollenhoven introduced the term *tijdstroming* ("time-current," current [of thought] for a time).[14] For Vollenhoven it is important that the histori-

11 Dooyeweerd analyzes this dimension of reality as a "religious basic motive" in *In the Twilight of Western Thought* (Nutley, NJ: Craig, 1960), 30–34. Cf. my comment on Dooyeweerd's "*religieuze drijfkracht*" in *Philosophy and Christianity*, 194–195 {see *CE:* 201}. Henk Hart spells out the same matter in *The Challenge of our Age* (Toronto: Wedge, 1968), 7: ". . . when a communal spirit prevails for a long period of time and fundamentally directs the course of history, we speak of the spirit of the age. When the basic law or 'word' setting the context for such a direction is formulated we speak of a ground-motive."

12 *Het Calvinisme en de Reformatie van de Wijsbegeerte,* 71–72. Cf. also Vollenhoven, *Geschiedenis der Wijsbegeerte, Deel I* (Franeker: Wever, 1950), 16–21.

13 *Kort Overzicht van de Geschiedenis der Wijsbegeerte voor den Cursus Paedagogiek M.O.A.* (1956), in *De Probleem-historische Methode en de Geschiedenis van de Wijsbegeerte,* ed. K. A. Bril (Amstelveen: Haes, 2005), 31–32, 49, *et passim.* Translated by John de Lievit, "Short Survey of the History of Philosophy," in *The Problem-Historical Method and the History of Philosophy,* ed. K. A. Bril (Amstelveen: Haes, 2005), 31–32, 47–48.

14 "Nu bestaat er een bonte veelheid van dergelijke concepties. De geschiedenis der wijsbegeerte is echter meer dan deze verzameling. Want deze concepties houden alle verband met elkander. En wel op twee manieren. Bij de beantwoording van de vraag naar de plaats der wet kwam eerst de ene, daarna de andere oplossing naar voren, zodat een *opeenvolging* van tijdstromingen ontstond. Daarentegen staan verschillende beantwoordingen van de vragen naar de verticale structuur reeds vroeg binnen één tijdstroming *naast* elkander. Successie en simultaniteit gaan hier dus hand in hand." "Conservatisme en Progressiviteit in de Wijsbegeerte" (1959), in *De Probleem-historische Methode en de Geschiedenis van de Wijsbegeerte,* ed. Bril, 16–17. Translated

ographer of philosophy recognize that these identifiable "time-currents," which do not repeat themselves, "cross" the recurrent typological aspect of definite philosophical conceptions.[15] So Vollenhoven's *tijdstromingen* come close to a restricted sort of *Zeitgeist*, albeit with a troublesome, unresolved problem: his *tijdstroom* in effect tries to explain the *chronological* (and "spiritual"?) *contemporaneity* of thinkers (*tijdgenoten*) in terms of their common *structural* position (on the place of the Law).[16]

It has always been tempting for those who somehow recognize the cohering and shifting fact of *Zeitgeist* to determine some pattern in the succession of one *Zeitgeist* upon another. Bréhier says the general law is one of alternation of over-emphases.[17] Dooyeweerd reduces the major Spirited periods of history to three—somewhat like early Vollenhoven— sweeping, apostate motives (plus the minor, never-yet culturally dominant biblical dynamic), that follow a turbulent law, he says, of dialectically posing a counter idol to some absolutized aspect of reality.[18] And

by S. Franke, R. Sweetman, and J. de Lievit, "Conservatism and Progressiveness in Philosophy," in *The Problem-Historical Method and the History of Philosophy*, ed. Bril, 16–17.

15 ". . . terwijl de tijdstromingen, die primair met de quaestie van de plaats der wet te maken hebben, zich niet herhalen, maar . . . steeds weer een ander antwoord brengen. . . . In een conceptie kruisen dus steeds een bepaalde tijdstroming en een bepaald type. Vandaar dat een conceptie eerst goed doorzien is, wanneer beide—tijdstroming en type—zijn aangewezen." "De Consequent Probleemhistorische Methode" (1961) *Philosophia Reformata* 26:1/3 (1961): 15, 22. Translated by Robert Sweetman as "The Consequential Problem-Historical Method," in *The Problem-Historical Method and the History of Philosophy*, 110, 118.

16 Wolters has carefully signaled this latent antinomy of treating a non-structural, non-recurring affair as a structural and therefore recurrable matter (*Problemgeschichte*, 37–40). But say "When Vollenhoven speaks of a 'tijdstroming,' he means a specifically philosophical, i.e. logical kind of time" (54) may charitably oversimplify what is at stake. As a matter of fact, however, Vollenhoven treats Pythagoras *after* Socrates, Democritus and Hippocrates in *Deel I* and in *Kort Overzicht*, for principled reasons, and therefore can maintain only with difficulty that his historiographic methodology honors a genuine chronology—despite such keen observations on sequential happenings within a period of philosophy like, e.g., the general shift from universalism to partial-universalism to individualism in Greek philosophy before Plato (*Deel I*, 228). Vollenhoven himself, in a 1967 analysis of his emeritated work after 1964, seems to distinguish "stromingen" such as monadology and Neo-Platonism from "tijdstromingen" (cf. Bril, *Probleemhistorische Methode*, 2), but leaves unresolved the precise difference.

17 "For example the intellectualism of the eighteenth century, with its reliance on reason, is followed closely by the romantic orgy, a very instructive alternation and one which, perhaps, is a general law of the history of philosophy." Bréhier, *Hellenic Age*, 30–31.

18 *Twilight*, 35–38. In fact, though, Dooyeweerd's Form vs. Matter absorbed by Nature

there indeed seems to be a restless, short-term rule to each epoch before a new pseudo-holy Spirit lords it over men and women and drives them and their philosophies to another distraction; but such deeply significant changes, I believe, cannot be logically mastered, turned into a formula, or rid of their inscrutable character any more than the work of angels can be x-rayed and predicted. A christian historiography of philosophy must test the spirits of the day and show panoramically how their influential perspective permeates given philosophies, but not play god and speculate towards a "Masterplan." Vollenhoven's stark listing (1962) of sixty-one *tijdstromingen*[19] certainly avoids speculation but is obviously more an unfinished, mnemonic potpourri of various features peculiar to different ages than a thought-through refinement of major *Zeitgeister.* Vollenhoven's historical roots probably have inhibited him from giving this crucial point more attention sooner and is something his grateful students should pick up and develop.

Historical context of Vollenhoven needing reformation
Wolters has accurately detected and documented the Neo-Idealist setting in which Vollenhoven started to make the problem-historical method of philosophical historiography his own.

The whole conception of a *problem*-historical method rose out of a rebuff to Neo-Positivistic historicism rampant at the turn of the century, which was dissolving all cultural and epistemological norms, as human products, into an on-going, genetic flux. Thinkers like Windelband and Nicolai Hartmann agreed that such relativism applied to the realm of particular things and individual acts, but wanted to except the *allgemeingültige* categories of Reason itself. More specifically: there are objective problems given by *Vernunft,* they said, that are all-the-time there, above every variable, historical approximation of them, and that guarantee by their unchanging unity the very possibility of continuity in philosophical history.[20] This means that the crux to a *problem*-historical approach

transcended by Grace secularized to the polar tension of (personality) Freedom and (scientific) Necessity are somewhat more vague generalities or something different than idolized modal aspects.

19 Cf. "Overview of the Time-Currents," in *The Problem-Historical Method and the History of Philosophy*, ed. K. A. Bril (Amstelveen: Haes, 2005), 153–155.

20 Cf. e.g., Hartmann, "Zur Methode der Philosophiegeschichte" (1909) in *Kleinere Schriften:* "Das Problem selbst als solches steht fest; es hat nur seinen systematischen Grund zur eigenen Bestimmung, und alle historische Variabilität an ihm betrifft nicht es selbst, sondern nur die Grade oder Stufen seines Hindurchdringens zum Selbstbewusstsein" (3: 10) and "Die Einheit dieser Probleme ist die Einheit der hi-

to historiography is taking the old noumenal *Dinge an sich* stabilizers of phenomenal reality and cashing them in methodically for *Probleme an sich,* which are ungrounded but (dogmatically) affirmed and validated by human Reason.

It is not pertinent here to trace how after World War I Hartmann, Hönigswald, and others like Stenzel and Heinemann tried to "enliven," "existentialize," "concretize" Vernunft into *Welt* as the source of the continuing problems with which philosophies grapple.[21] The key point is this: the original Neo-Idealists turned creational structural affairs into Universal Rational Problem-patterns, and such Problematic-Idealizing of creatural reality accounts for (1) the estrangement of philosophical problems from lived history, and (2) a loss of interest in actual counter-influences between philosophical positions—difficulties that seem to hang onto the problem-historical method of philosophical historiography. Wolters claims that the separation of timeless *Problemgehalt* from any historical *Problemlage* is its chief tenet, although one still finds among them a melioristic trust in final arrival at Truth that belies a pure, unchanging structure.[22]

Vollenhoven, of course, has no sanguine expectations about what disobedient philosophies can produce in their varying grades of ignoring or blindly suppressing the truth. And Vollenhoven has also meant to honor the fact that philosophies have a definite, historical individuality and that "the typical" feature that types them is an abstraction of the given conception, its dimension of structural continuity, and not some real thing that makes occasional, docetic appearances.[23] But sometimes Vol-

storischen Kontinuität—jener Kontinuität, in der aller innere Zusammenhang des zeitlich Getrennten beruht. Denn hinter ihr steht die Einheit der Vernunft in aller Zeit, welche uns unsere Probleme wiedererkennen lässt in der historischen Ferne. Darin liegt die Bedingung der Möglichkeit aller Philosophiegeschichte" (3: 15).

21 Cf. Wolters, *Problemgeschichte*, 11–16, who points out the change in Hartmann's "Der Philosophische Gedanke und seine Geschichte" (19.36) in *Kleinere Schriften:* "Die generelle Überlegung ist diese: die Welt in ihrer Gesamtheit, die uns die großen Rätselfragen aufgibt, ist eine und dieselbe in aller Zeit; was also wahr ist in unseren Gedanken über sie, das muss sich von selbst ineinanderfügen und auf die Dauer einen Zusammenhang ergeben" (2:21).

22 Wolters, *Problemgeschichte*, 1. Cf. Hans Hess: "Aus einer verwandten systematischen Haltung heraus erwächst dann noch ein besonderer Typus der Philosophiegeschichte, wenn das Problem selbst—ohne Rücksicht auf die zeit-örtlichen und historisch-individuellen Besonderungen—zum substantiellen und ausschließlichen Träger der Fortschritte gemacht wird" from "Epochen und Typen der philosophischen Historiographie," *Kant Studien* 23 (1923): 355–356.

23 "Wat zichzelf bij het wisselen der tijden *gelijk blijft* zijn immers ook hier *niet de concepties maar slechts het typische daarin,*" Vollenhoven, "De Consequent Probleemhistori-

lenhoven's fascination with seeking out possible representatives of typical conceptions[24] raises the specter of having almost hypostatized types (comparable to the mistake of someone's supposing "the modalities" exist, like so many colored balloons), and then you invite doing historiography of philosophy merely as an exercise in systematic classification.

It is so, I agree, that history of philosophy must be studied from a certain (skeletal) systematic position and the results of the analysis should be chronicled in such a way as to deepen our *systematic* philosophical insight into what was posited in that period so we can give more fruitful philosophical leadership *today,* aware of what has happened. Both an academic, archivistic penchant and a would-be, existentialistic disregard of the past except for illustrational material hurt sound historiography. The reform Vollenhoven began of the Neo-Idealist problem-historical method has steered fairly clear of both those distortions; but Vollenhoven's methodology, still bothered by certain Rationalistic *an sich* shadows, itself needs and perhaps already points to further reform that can forge a more impassioned historiographic method that will push back to creational problems as historical givens and will highlight the Spirited drive intrinsic to every philosophical architectonic response.[25]

Vollenhoven's particular tack forces every historiographer of phi-

sche Methode," *Philosophia Reformata* 26 (1961): 22 [my italics]. Cf. S. U. Zuidema, "Vollenhoven en de Reformatie der Wijsbegeerte": "De consequent probleemhistorische methode . . . zal gaarne gewonnen geven, dat geen wijsgerige conceptie van een denker van betekenis samenvalt met die van een tweede denker van enig formaat. Zij zal zelfs een open oog hebben voor het feit, dat elke conceptie van enige importantie iets unieks biedt, dat in zijn enigheid onanalyseerbaar is, en als totaliteit meer is dan de delen, waaruit het is samengesteld, daar ook de samenstellende delen meer zijn dan losse fragmenten, en slechts door hun functie in het geheel en dank zij het geheel waarin zij een plaats hebben, tot hun recht komen" *Philosophia Reformata* 28 (1963): 142. Hönigswald too aimed for the historically enmeshed character of philosophical problems: "Man kennt ein philosophisches Problem nur, wenn man es in der Mannigfaltigkeit seiner historisch bedingten Erscheinungsformen wiedererkennt" (1917), "Einleitung," *Die Philosophie des Altertums, Problemgeschichtliche und Systematische Untersuchungen* (Leipzig, 1924), 18.

24 E.g., ". . . zal men er goed aan doen, het zoeken naar een eventuele vertegenwoordiger van een dergelijke conceptie niet al te spoedig op te geven: het blijft altijd mogelijk dat men hem alsnog vindt." Vollenhoven, "Consequent Probleemhistorische Methode," 32.

25 I am not certain the search for an elusive "universal history" and "panchronic" solvent that "must both unite and keep apart the periods and levels [sic] of human history' (cf. Wolters, *Problemgeschichte*, 51–55) is what we need to save Vollenhoven's methodology from a structuralistic schematism. The unreformed trouble is not, I think, so much a large structural failing as it is the underdeveloped meaning of *Zeitgeist* and a certain naiveté toward pedagogy.

losophy to take seriously, on pain of being undeep or anachronistic, the large measure in which Greek patterns of thought seem to have shaped all that has followed in Western reflection.[26] A living awareness of the fact that God deals covenantingly with generations, I sense, has led to this sobering awareness of the hold tradition has upon thinkers and Vollenhoven's recognition that every philosopher works *from* his historically given school-milieu.

But what needs better articulation is this: the web of four fundamental problems shaping, for example, pre-Platonic investigator Parmenides, and therefore the terms in which he should be understood by twentieth century historiographers of philosophy,[27] is not a topical Greek problematics whose categories (*denkvorm*) have wrongheadedly come to dominate subsequent philosophy. Rather: when philosophy became differentiated from mythology circa 700 BC in Asia Minor and Italy, its basic issues of final law-Word, status of the human, cohering cosmos, and the nature of historical process[28] got formulated in decisions for or against Fire (πῦρ) and the Quality-of-being-Is (τὸ ἐόν), man as microcosmos (ἡ ψυχή . . . ἡ ἡμετέρα ἀὴρ οὖσα συγκρατεῖ ἡμᾶς, καὶ ὅλον τὸν κόσμον πνεῦμα καὶ ἀὴρ περιέχει), whether all things are One (ἕν πάντα εἶναι), no be-coming (ἀγενητόν) or utter flux (. . . τὴν ὕλην ῥευστὴν εἶναι), which were circumstantially *Greek responses,* to be sure, and conceived in a thoroughly pagan Spirit, but neither essentially Greek *problems,* that then persisted for centuries, nor quasi timeless fixations, incumbent upon every systematic thinker to adopt. Those basic ontic matters are perennial *historical challenges* ("problems"!) and have staying power through the ages *because* they are *creational structural affairs.*

So it might remove some of the shadows of inflexibility from Vollenhoven's method if we can maintain its focus upon ontic issues, account for the persisting, existential press of the basic problems upon philosophy, but relativize "the Greek pattern." Not every philosophy is a modification of pre-Socratic problematics or must make its peace with the influence of Plato and Aristotle, and to force a tie-in historiographically could be pedanticism. It is true, no Western philosophy can make-believe it begins *de novo,* but our philosophical historiographic method will be a more supple instrument if we recognize that the structural philosophical

26 ". . . de simpele overweging, dat in een historisch proces het vroegere wel niet geheel, maar toch in sterke mate het latere bepaalt." Vollenhoven, "Consequent Probleemhistorische Methode," 10.

27 Cf. Vollenhoven, "Methode-perikelen bij de Parmenides-interpretatie," *Philosophia Reformata* 30 (1965): 68, 110–112.

28 Cf. supra p. 3 and infra p. 13ff.

problems have a continuing historical (creational) contemporaneity, and it is not so that the historical Greek problems have given us the "inherited" structure.

Critically christian
transcendental philosophical historiographic categories

The most genial reform Vollenhoven has begun for philosophical historiography—and in my judgment it has been insufficiently noticed and sorely unstressed—is that he has fashioned technically precise categories that make possible a truly transcendental christian critique of other philosophies. Vollenhoven points beyond the usual combination of immanent critique (which examines lingual consistency and clarity and tries to straighten out analytic contradictions detected in a thinker) and transcendent criticism (which simply judges the other's error seen from the critic's standpoint). Vollenhoven gets beyond the trial and error temporizing of sifting through a given philosophy, pretending to adopt its assumptions, till you have found things out of joint, exposing that lack and then, either stop with a hypocritical modesty that encourages the cowardice of skepticism, or dogmatically present your own articulate alternative. Such intrinsically monographic critique can produce scholarly insights, toughen and sharpen up the critic's knowledge of philosophies, but I doubt there can be much more than a juxtaposition of one's christian philosophical systematics next to the godless theoretic reflection.

However, transcendental critique (which asks christian questions within the other thinker's assumed framework) does allow for in-depth confrontation,[29] that is, opportunity for listening intently to the (checkmated) contribution of non-christian philosophies to our (faulty) christian understanding of reality. There is no temporary "suspension" of the christian ποῦ στῶ, methodologically, and as a result there is a sureness and directedness to one's probing, hunching, and evaluation. Vollenhoven's historiographic terms have this kind of sensitivity built in. Vollenhoven's five fundamental categories, as I see them, also have an intrinsically rela-

29 "In-depth confrontation" does not entail "agreement." Cf. *Twilight*, 52–61, although Dooyeweerd does hold out hope for "really critical discussion" between fundamentally disagreeing philosophies. P. A. Schouls subjects "Communication, Argumentation, and Presupposition in Philosophy" to a rigorous analysis in *Philosophy and Rhetoric* 2:4 (1969): 183–199, and because his conception of "communication" includes some kind of fundamental understanding, he arrives at conclusions that "will dim the hope of those striving for communication and hence reunion in philosophy." Cf. also Schouls' "Reason, Semantics, and Argumentation in Philosophy," *Philosophy and Rhetoric* 4:2 (1971): 124–131.

tional, demographic bite, so that the potential for fine analysis *and* sweep is very great.

(1) What is so christianly critical about Vollenhoven's precise category of DUALISM and MONISM is this, that those philosophies that are not enlightened by the biblical perspective inevitably miss the modal coherence of creation and yet inescapably treat how the world (and humans) cohere as cosmos, doing it distortedly, as Monists or Dualists.

For example: lacking insight into the integrating and referential heart-depth, transcendental, self-hooded focus to the whole man, pagan thinkers ascribed special transcendent character to some part of him and thereby fractured man into deified and disqualified separate pieces of activity (Dualism), or believed the human to be a tension of higher and lower, antagonistic or cooperating, contrasting sorts of functionings (Monism). Similarly on the world: without knowledge of the single, cosmos-ordering gracious Word of the Lord, thinkers not touched by God's biblical revelation testifying to the Christ and God self idolized certain aspects of reality into a transcendent realm above and independent of a different disqualified area of creation (Dualism), or explained the diversity of the Universe in terms of struggling pairs of higher and lower patterns of functioning (Monism). Exactly where a philosophy chooses to split or tense up man and world, and what kind of functioning is made the Law-for the rest, the focal point, or the dominant feature in the cosmology, determines the variety of Dualism or Monism at hand.

The transcendental bent to the categorical designation of Monism and Dualism lies in the fact that these are unchristian answers to the christian question of "How does the goodly order of our created world disclose itself?" And whether it be the tired Monism of late Plato in the *Laws,* trying to pull his republic together, or the blatant, pugnacious Monism of rhapsodic Lucretius and his Nature of atomic particles, Monists and Dualists are struggling to make meaning out of a fallen humpty-dump cosmos, and their misplaced zeal thwarts every relative insight gained. "Monism" and "Dualism" are not just transcendently conceived curse words nor surgical labels of an immanent diagnostic, but are vivid, compassionate, and damning categories pinpointing (cosmological) philosophical positions that are frustrated and distracted from the Way of shalom.[30]

30 "Wie buigt voor Gods woord behoeft in dezen strijd geen partij te kiezen: beide groepen, zoowel deze dualisten als de monisten, begaan dezelfde fout: ze zoeken de vastheid daar waar deze niet is te vinden, nl. in het schepsel" Vollenhoven, *Het Calvinisme*, 57.

(2) Vollenhoven's major partitions of mythologizing philosophy, purely cosmological philosophy, and cosmogono-cosmological philosophy have never struck me as particularly rigorous descriptions of clear-cut matters whose definite structural character was well substantiated. Perhaps the relation of pre-Platonic philosophy proper to mythology was a touchy matter then, but why should "mythologizing" or not (myth = "*het product van pisteutische fantasie*"[31]) be a category applicable to (only some of) twentieth century philosophy?

Yet with these categories Vollenhoven has latched onto the main trilemmic ways philosophy can misconceive the God-ordered, to-the-eschaton, durational fabric of created reality, the very ongoing mesh of structured genesis within which we humans are called to respond historically to the Lord God. Because this is a most elemental, unavoidable feature of reality, the category of STRUCTURALISM, GENETICISM, and MYTHOLOGIZING PHILOSOPHY is a very large and somewhat diffuse matter.[32] But one finds a large group of thinkers throughout the ages who notice order to reality that persists, and then idolize it to the detriment of genetic concerns; in fact, genesis is explained in terms of compositional order. Such structuralistic philosophy casts analysis of reality all in terms of structure-only and tends toward having a cut-and-dried world, putting the damper on initiative in a fundamental sense (Cosmology only is the concern). Certain other thinkers see development as a given but worship it into a restless, relativizing, "progressive," ongoing flow forever and ever; that is, structure gets dissolved into developmental flow. Such geneticistic philosophy casts analysis of structural reality into terms of genesis-only (Cosmology gets swallowed up in cosmogony). Some thinkers hold the structurally ordered durational matrix of reality underdevelopedly undistinguished, with the result that the order is given genetic finality and genesis is given everlasting, repetitive order. Whenever philosophy has this character it shows a not-so-theoretically differentiated, a more world-and-life-viewy character, usually attended by a cultic atmosphere—mythologizing philosophy (Cosmogony and theosophy predominate).

Again, these categories have a critically christian openness to them

31 Vollenhoven, "Consequent Probleemhistorische Methode," 15.

32 These are my tightened-up terms comparable to Vollenhoven's "louter kosmologische," "kosmogono-kosmologische," and "mythologiserende" philosophy. One innovation of mine is this, that while "merely cosmological" philosophy depreciates genesis and "cosmogono-cosmological" philosophy presumably gives cosmogenetic affairs a far more legitimate place along with cosmological investigation, I sense that Structuralistic philosophy treats genesis *as* a structural matter and Geneticistic philosophical theory *would* dissolve structure into actual process.

because they show how distorting analysis can yet genuinely grapple with the rudiments of our existence and how, despite the pushing and shoving into line, philosophies unformed by the Good News of creation warp the glory of our becoming a new heaven and a new earth.

(3) Vollenhoven uses the SUBJECTIVISM, OBJECTIVISM, and REALISM category in a special, careful sense to show how lamentably puny the no-god stuff is unchristian philosophies posit as the ultimate Source of reality. Whether it be Kant's *Vernunft* activity or Anaximander's τὸ ἄπειρον quality or the *lex aeterna* of Thomas Aquinas—whatever thinkers sometimes agonizingly select as Arché and trust as the final guarantee for every thing's being there—that surrogate for the Lord God of heaven and earth constricts all the analysis that goes on under its aegis.

Without an understanding that the Creator Lord God providently sustains every ordered thing's functioning as subject and as object, many thinkers have satisfied themselves that only "Subjects" exist and that subjective properties or functionings are what determine what goes on (Subjectivism). Other philosophers have recognized that there are perceptibles (like colors and sounds) or measurables (like proportions and velocities), which are not reducible to specific subject-functioning of things correlative to such qualities; because their vision of reality reaches no further, such philosophers believe that these sensible or mathematical object-functionings of things—which are bounds to every subject and compel subjective obedience—are indeed the most permanent states of affairs, and therefore they have called for allegiance to such purely "Objective" matters (Objectivism).[33]

Still other important thinkers whose philosophic reflection has not been biblically enlightened, have pursued the cause for the lawful regularity of human subject-functioning and the persistence of object-functioning qualities, pursued the cause in something else beyond them both. Plato was the first to posit thingless, geometric ordering and timeless,

33 "Object-functioning" must not be confused with the so-called "primary qualities" in vogue after Galileo, for "primary qualities" refer to the subject-functionings or properties [my term] of things independent of an other perceiving subject. The "object-functioning" dimension of creatural things is that characteristic of latent qualities [my word] belonging to things that await a developed subject-functioning to activate their praising glory—even hues of red and giant proportions get turned into cursing or blessing, they are never simply givens. The "secondary qualities" doctrine of early modern, secular epistemologies, which reduces colors, for example, to an activity within the perceiving subject or to UFO sense qualia, shows how remote the recognition of "object-functionings" became to the Scientialistic (Copernican revolution) mind.

noetic form as the true "Real" of reality, a certain substantial patterning that somehow conditioned our begoing world but was not contaminated by it (Realism). In effect, Plato was giving modal norm-law order and the retrocipatory mathematical moment to creation, as it were, god-status, confusing it with individuality-structure (an εἶδος for every thing), while robbing this structuring Word-for things of its binding law character— ἰδέαι were paradigmatic models and not the grip of a Covenanting God which when followed yields blessing.

Right here the confrontationally critical and redemptive pleading within a Vollenhoven category shows up clearly: Roman catholic scholastic and Protestant scholastic "Realist" thinkers inexorably tend to end up with an abstract concept of Providence and a demiurgic God masterminding that timeless blueprint into history, because they mistake the sureness of his creational Word holding us creatures for God self. That is, according to Vollenhoven, a "Realistic" conception of reality, trying to honor God's overruling hand in our creatureliness, goes wrong by idolizing its sureness into a noetic fixity and consequently both depreciates our cosmic life time as an interim between timeless eternities and loses the biblical God, the faithful Almighty One who is gracious and angry and truly moved by the prayers and bloodshed of God's people and even by the dumb cows on the hills around Nineveh—there is no room for such a God in their "Realistic" (notice the irony!) philosophical or theological scheme.

It is obvious that the usual Windelband, textbookish sense of "realism" as an academic debate on whether *universalia* exist *ante rem*, *in re*, or *post rem*, lacks the biblically penetrating, religion-deep insight and dimension of Vollenhoven's analysis. Vollenhoven meets "Realist" thinkers on their own deepest grounds, with christian demands, and discloses— indeed, only for those who have eyes to see—the pathos of their grand distortion. It may also be so that what Vollenhoven's category of Subjectivism, Objectivism, and Realism focuses upon—the nature of that to which a thinker gives final allegiance—is more influential in determining a man's whole perspective than whether, for example, he be a Monist or a Dualist. But I am not convinced that the structural choice philosophers make on "the place of the law" is so singular, exclusive, and decisive for binding them together as kindred spirits of a particular period.[34] Heraclitus, Parmenides, and Plato differ significantly on that very point, but each one is fundamentally driven by the same unifying Spirit of other-worldly polis-idolatry and race-conscious, elitist purism we call the (classical)

34 Cf. supra pp. 6–7 and footnotes 14–16.

Greek way of doing things. Further, refinements within this "place-of-the-law" category are not adequate, it seems to me, to probe the shifting difference between the earliest, cosmologically curious philosophy called Greek, for example, and the later eclectic, syncretistic philosophy of Hellenism, with its dominant epistemological apriorism—both periods are overwhelmingly Subjectivistic, but their differing, cohering dynamics depend basically on other factors than what the leading contemporaries in each period take to be the Arché.

(4) The fact that creatures only exist as members of a kind (humankind, the order of angels, animal kingdom, plant world, realm of physical entities) and that cultural artifacts and the multiple relationships of people always are of some sort or other (art objects, mathematical concepts; family, business, church, state, and neighborhood, for example) has faced everyone who has tried to examine encyclopedically the meaning of things. Even philosophical analysis that has purposely restricted its parameters to, say, epistemological affairs or wished to temporize on *whether* things have any meaning, such philosophical reflection still has had to face the basic fact that whatever they investigate inextricably belongs to a universe-wide kind (because of creational modal structuration) and has definite, identifiable particularity (because of creational individuality-structuring)—why? What is the point to similarities and identities? How real is the reality of societal and typifying, cosmic bonds creatures show? What's the sense to this apparently intrinsic "family"-clustering peculiarity of things?

It so happens, unfortunately, that most philosophies have not been basically informed by the biblically revealed truth that all things cohere in Jesus Christ. Most philosophies miss the pivotal insight that the creational fact of being-there after its kind depends literally on the cohering Word of God and that God incarnate is the actual Archimedean point to every creation's existence, its very meaningfulness or not. Further, the body of Christ is not some *corpus mysticum* of transubstantiated saints, but is the living, corporate union of men and women sealed together by the Holy Spirit-worked Amen in their hearts, at work as the conduit for a rising chorus of praise from heavenly bodies, lions chasing their prey, the rolling leviathan, bird song, garden flowers, and the ministry of angels. That is, the real, lasting community of the people of God, ἐν χριστῷ, is an earnest of the veritable Kingdom! coherence and meaning the Almighty Lord was pleased to lay down in God's creation of heaven and earth and *everything* in them. When philosophy intent upon relating

data denies, ignores, or has lost this truly mediating, Archimedean key to interpreting the meaning of our creatural generic specificity, philosophy falls into the distortions Vollenhoven designates exactly as UNIVERSALISM, INDIVIDUALISM, and the MACRO-MICROCOSMOI motif.

Without a transcendental mediating focus, thinkers have gone wrong by giving either the universe-wide "kind" bond to things subsistence or the individuality-structured "thisness" of a thing subsistence, and then disposed of the other feature in terms of the one. Certain philosophies make the universe feature a substantial "concrete Universal" of which "the individual" is considered merely an expendable offshoot, like leaves falling off a tree (Universalism). If they believe the individual offshoot returns in-to the Universal, you get a form of mysticism. Other philosophies affirm that only "Individuals" exist and that kinds, societal bonds like family, or any "universe" be merely vague concepts or names for a motley collected group of "Individuals" (Individualism). Still other investigators who persist more evenhandedly in accounting for the creational reality at stake maintain that the universe as Macrocosmos is an analogous, determining counterpart for a myriad number of microcosmoi surrounding it—to which is sometimes added also a Mesocosmos of Society (Macro-microcosmoi motif). Human entities and Society and World are all given separate, substantial, next-to-the-other existence. And even still more sophisticated, penetrating but mistaken philosophies hold that every thing has an Individual part and a Universal part; while some declare that the Individual part is the most critical factor, giving integrality to general elements (Partial Individualism), some believe that the Universal part links up and integrates the Individual matters like the mold to Jell-O particles or purpose to instruments (Partial Universalism). . . .

Vollenhoven has most helpfully delineated other specialized varieties of this category, but right now my concern is simply to exposit the transcendental christian insight Vollenhoven's categories afford the historiography of philosophy. Universalistic and Individualistic philosophies, along with their modifications, are struggling, unwittingly it seems, to answer the religion question of the meaning of things—which shall find a restful locus of reference only in the kingdom-reconciling reality of the Lord Jesus Christ—by juggling haecceity and universality into a simple, abstract equation neutralized from the multifarious richness of our creatural bonds and voided of any transcendental reach; therefore échec necessarily follows! And no matter whether Church councils presume to settle the affair once and for all with anathema, or the "problem of universals" is relegated to peripheral, syncategoremata status for

polite debate at the high tables of Oxford: like an implacable ghost this same creational reality, which has been immanentistically misconceived, will keep on returning, restlessly. And the falsifying alternatives of the Universalistic-Individualistic philosophical construction placed on it insure distortion of the human cultural task, twisting all kinds of limited, human-authority relationships out of kilter.[35]

(5) The Spirit that drives a given philosophical conception and unites that thinker with the generation of his day, often with the artistic élan of a nearby period, getting the philosophy to breathe along with the fashion, etiquette, architecture, mode of doing politics, and the whole pace and style and pulse of the daily life current: that permeating Spirit, often called *Zeitgeist,* is as serious and as powerful, *and limited,* as an evil spirit, abetting a man's willful course of action. *Zeitgeist,* the SPIRIT OF AN AGE, must be neither underestimated nor overfeared, because its prophetic power, its promises of establishing the cultural work, the philosophical thought, of our human hands, must stand the winnowing test of being fruitful, compassionate and just in the eyes of the Lord, or not.

All I am prepared to add now to what was stated earlier is this, that in my judgment *Zeitgeist* is not identical to the Arché question, to what you finally trust (Vollenhoven's unfinished stage of thought on the matter: the place-of-the-law), and *Zeitgeist* is also distinct from the Archimedean point question, one's structural stance on the meaning of things (the locus of what I hear Dooyeweerd getting at with "religious motive," combined with modal absolutization). *Zeitgeist* must also not be hypostatized into a supra-individual universal "Mind," just because this uncanny Spirit does command a populace, a whole generation or two and sometimes more. Perhaps the Spirit of an Age will continue to elude our scientific scrutiny as much as the precise nature of Σάρξ, which Scripture reveals, remains mysterious; but *Zeitgeist* is real and it is the calling of a christian historiography of philosophy, christian historiography of any cultural performance or institution, to test its dynamic, trace its rise and fall—not to moralize upon!—but for exorcizing its influence out of our work so that we may build up, by contrast, what has an abiding, holy spirited breath to it.

35 Cf. Harry Antonides' analysis of the false dilemma between (Individualistic) private enterprise Capitalism and (Universalistic) collectivistic Socialism in publications of the Christian Labour Association of Canada. Cf. Harvey A. Smit on the inadequacy of frequent Western analysis of Japanese "values" in terms of "individual" and "group," in "The Center of Value in Japanese Society," *The Japan Christian Quarterly* (Winter 1973): 15–22.

Taking off from early Vollenhoven's lead, a first thing christian historiography of philosophy must straighten out is the standard partitioning of Western philosophy's progression into "ancient," "medieval," "modern," and "contemporary" periods. Everybody knows to what these would-be noncommittal and somewhat makeshift terms refer, but the Humanistic prejudice they mask is as staggering as "the Big Lie," and therefore the misguidance they give thinkers today is almost incredible.

Shortly after 1600 a "modernistic" mentality began to write off human philosophical reflection from c. 600–1500 AD as an interim ("medieval"); later on the eighteenth century European *Aufklärung*, epitomized by Winckelmannia, proclaimed that finally the true Renaissance was arriving;[36] Windelband's 1892 *History of Philosophy* more or less canonized this optimistic arrangement for philosophical historiography, so that latter-day Science-worshipper Bertrand Russell, for example, can dismiss indiscriminately, with an air of iconoclastic authority, the crucial Spirit-deep changes for Western civilization called "Renaissance" and "Reformation" as similar subjectivistic confusions really unimportant to the history of philosophy.[37]

What needs showing, however, is that after the Greek-Hellenistic **pagan spirited** philosophy c. 600 BC–180 . . . 529 AD), a **synthetic-christian Spirit** of fitting together christian dogmas into or onto the fabric of the great past cultural achievements of Greco-Roman humanity in order to forge a grand catholic system of complete knowledge drove a whole thousand year span of philosophical reflection (c. 135 AD–1450 AD). The complex, unraveling skein of that long synthesis followed, as Vollenhoven's careful probing has helped disentangle: for about a century there was a surge of *Humanistic* synthetic-christianly spirited philosophy (c. 1350–1450 AD), while the old scholastic eon waned;[38] and within the 1450–1600 AD period dominated largely by an **anti synthetic-christian**

36 Cracks in the self-assured dawn of civilized Reason were not long in coming, of course. Cf. Schiller's laconic remark: "Das Zeitalter ist aufgeklärt, das heißt, die Kenntnisse sind gefunden und öffentlich preisgegeben, welche hinreichen würden, wenigstens unsere praktischen Grundsätze zu berichtigen. Der Geist der freien Untersuchung hat die Wahnbegriffe zerstreut. . . . Die Vernunft hat sich von den Täuschungen der Sinne und von einer betrüglichen Sophistik gereinigt, und die Philosophie selbst, welche uns zuerst von ihr abtrünnig machte, ruft uns laut und dringend in den Schoß der Natur zurück—woran liegt es, dass wir noch immer Barbaren sind?" *Über die ästhetischen Erziehung des Menschen, in einer Reihe von Briefen,* Achter Brief.

37 Bertrand Russell, "Introduction" to *History of Western Philosophy and its connection with political and social circumstances from the earliest times to the present day* (London: George Allen & Unwin, 1955), 15–20.

38 Cf. Vollenhoven, *Het Calvinisme,* 200–301, and *Kort Overzicht,* 23–33.

secular Spirit—the hard core Renaissance days of excitement driven by a Faustian ambition to discover secret Nature power, so that by man's own godless *virtù* he might achieve *humaniora*—within that age there were two generations of men gripped by a radical Reformational dynamic, an **anti synthetic christian biblical Spirit** that wanted communal, *coram Deo* obedience into the world at large. Though that significantly different, holy spirited thrust of a cosmic, reconciling *diakonia* took cultural hold too briefly and too weakly in Western Europe to humble philosophy of the day, that Reformation has become a signpost for the philosophical reform needed to please God.[39]

But since 1600 most philosophy has been shaped by an **anti synthetic-christian, secular Rationalistic Spirit** of enormous power. A concomitant, positivistically Operationalistic movement in philosophy since around 1850 has been as thoroughly anti-christian and secular in temper. And within a decade after the so-called first World War, one could say, a definitely **post-christian Spirit** had greatly infected both academic, phenomenological philosophy and the fits and starts of revolutionary, neo-pragmatistic philosophy with a hardening, virtually nihilistic technicism.

That is, rightly conceived, I dare say, from a biblically christian vantage point, the millennium in philosophy foretold by Hegel, Comte, Engels, or Moritz Schlick and his ilk[40] has not and shall not come into sight. Instead, armed with a biblically Reformational sensitivity developed so tentatively and firmly by Vollenhoven and Dooyeweerd, one can smell the stench of death, a dead-ending Spirit! in the language game analysis and eccentric erudition afoot in so many different neighborhoods of philosophy today.[41]

39 While Dooyeweerd has come to reject the term "Calvinistic philosophy" for the systematic reflection Vollenhoven and he have pioneered, and rejects formation of "school-philosophy" à la Thomism out of hand, after twenty years he remains unchanged in his judgment "that a real reformation of philosophic thought cannot historically proceed from Luther but only from Calvin's point of departure" *A New Critique of Theoretical Thought* (Amsterdam: H. J. Paris, 1953), 1:522. That thought deserves more scrutiny by Christ-believers from all evangelical traditions, I think, and extension of its insight. The difference between "spiritual revival" occasioned by Spirit-led, individual men and the sustained vision of a newly directed, biblical "reformation" that may come to shape generations still unborn is a difference critical for understanding how the christian faith breaks in principle with synthetic-christian life tendencies and can lead Christ-believing men and women in a secular age to humiliated but expectant cultural work.

40 Cf. Moritz Schlick, "The Turning Point in Philosophy," and Rudolf Carnap, "The Elimination of Metaphysics through Logical Analysis of Language," with others in *Logical Positivism*, ed. A. J. Ayer (Glencoe: Free Press, 1959).

41 Cf. S. U. Zuidema, *Communication and Confrontation: A philosophical appraisal and*

It remains now to be shown how the insightful grasp of Vollen-hoven's philosophical historiographic categories brought to bear upon study in a classroom situation is conducive to a pedagogy that is both professionally careful and deeply christian. I hope to present such a study at a later date.

First conference on Vollenhoven's methodology in North America, in Seerveld's home near Trinity Christian College, Worth, Illinois, 1971 Left to right: Cal Seerveld, Bob Hassert, Pete Steen, John van Dyk, Bob Elliott, John van der Stelt, Jim Olthuis (photo by Inès Naudin ten Cate-Seerveld)

critique of modern society and contemporary thought (Toronto: Wedge, 1971); Johan van der Hoeven, "Filosofie op het spel," Philosophia Reformata 30 (1965): 137–158; N. Th. van der Merwe, "Grepe uit die kontemporêre Wijsbegeerte," in Die atomeeu— "in U lig" (Potchefstroom, 1969), 76–112.

VOLLENHOVEN'S LEGACY FOR ART HISTORIOGRAPHY

In the cacophony of highly trained art historical voices today one can hear the painful wages of our Western Rationalistic sin in theoretical endeavors: eclectic confusion, learned skepticism, nihilistic provocation, begging for attention. The professional standard of "objective" scholarship set by Alois Riegl (1858-1905) and Heinrich Wölfflin (1864-1945) for a differentiated discipline of art historiography has become largely discredited in the last decades, because the covert Positivist ideology of logocentric, factistic scientism[1] has been found wanting in weighing out the peculiar qualities and worth of graphic art in and for society.[2]

More serious still is the forthright calling into question today of any unified history of art:[3] art has no self-evident nature; art objects are not

1 Wölfflin has been known in English-speaking lands more than Riegl because Riegl remained mostly untranslated into English until recently. It is interesting to note how the positivistic science note sounded by Wölfflin was softened in the English translation. Wölfflin wrote: ". . . wenn man auch jederzeit so sieht, wie man sehen will, so schließt das doch die Möglichkeit nicht aus, dass in allem Wandel ein Gesetz wirksam bleibe. Dies Gesetz zu erkennen, wäre ein Hauptproblem, das Grundproblem einer wissenschaftlichen Kunstgeschichte" ("Einleitung" [1915], to *Kunstgeschichtliche Grundbegriffe* [Stuttgart: Schwabe, 1984], 31). The English version, translated by M. D. Hottinger, omits the important word "wissenschaftlich": "To determine this law would be a central problem, the central problem of a history of art" (*Principles of Art History* [New York: Dover, 1950], 17).

2 Christine McCorkel, "Sense and Sensibility: An epistemological approach to the philosophy of art history," *Journal of Aesthetics and Art Criticism* 34:1 (1975): 41, 48; Michael Baldwin, Charles Harrison. Mel Ramsden, "Art History, Art Criticism and Explanation," *Art History* 4:4 (1981): 433; A.L. Rees and F. Borzello, *The NEW Art History* (London: Camden Press, 1986), 7–10.

3 "Meine zweite These lautet deswegen: Je komplexer unser Begriff vom Kunstwerk und seinen Determinanten wird, desto schwieriger wird eine synthetische Darstellung, die noch die Vielzahl der Zusammenhänge, in denen wir Kunst sehen lernen in die einheitliche Sicht einer 'Geschichte der Kunst' einbringen kann. Die traditionelle

First published in *Philosophia Reformata* 58:1 (1993): 49–79.

unique monuments to be housed and admired intact in niches of a mu-sée imaginaire, but are intertextual puzzles whose "norms" are constantly changing; and historical continuity of succession is a myth.[4] Warburg authority figure E.H. Gombrich,[5] who sees Hegel's totalizing ghost haunting every historiographic attempt, idealist or materialist, to bring closure of judgment to the art historical process,[6] continues to feed the uneasy dissemination of suspicion that no "history articulated within a discursive framework based upon centrality, homogeneity, or the conti-nuity of self-identity can be other than oppressive."[7]

The breakup of a dominating positivism in art historical scholar-ship bodes opportunity for the committed theorist who self-critically knows what he or she stands for. But you do not have to be Hercules to realize that after one of the hydra's heads has been cut off, you have only scotched the snake, not killed it. Power politic struggles between deconstructive critics of art history and would-be semiotic colonialists of the art historical discipline, along with the seductive moves of historio-graphic bricolage face one at every step. Brilliant, scattered fragments of critique are so much easier to fashion than positing a fruit bearing thesis. All the current noise in the excitement of our post-Positivist age (or as my colleague Graham Birtwistle aptly put it recently, our presumed post-guilt age,[8] where theorists wash their hands of any complicity or rootage

Geschichts-schreibung von Kunst als Kunst, die eben dieses leistete, kann heute nur mehr als Folie dienen, vor der sich neue Aufgaben empirischer Forschung abzeich-nen." Hans Belting, *Das Ende der Kunstgeschichte?* (München: Deutscher Kunstverlag, 1983), 34.

4 See Belting, "Vasari und die Folgen: die Geschichte der Kunst als Prozess?" in *Das Ende der Kunstgeschichte?* 86; Donald Kuspit, "Conflicting Logics: Twentieth-century studies at the crossroads," *Art Bulletin* 69:1 (1987): 119.

5 But see Carlo Ginzburg's incisive analysis of how Gombrich has subverted the con-ception of Warburg's program, in "Da A. Warburg a E. H. Gombrich (Note su un problema di metodo)," *Studi Medievali*, serie terza (Spoleto: Centro Italiano di Studi sull'alto Medioevo) 7 (1966): 1061.

6 E. H. Gombrich, *The Ideas of Progress and their Impact on Art* (New York: Cooper Union School of Art and Architecture, 1976), 2, and David Summers, "'Form': Nine-teenth-century metaphysics, and the problem of art historical description," *Critical Inquiry* 15 (Winter 1989): 383.

7 "There is no history that is not uninvested ideologically: At issue is the question as to whether any history articulated within a discursive framework based upon centrality, homogeneity, or the continuity of self-identity can be other than oppressive." Donald Preziosi, *Rethinking Art History: Meditations on a coy science* (New Haven: Yale Uni-versity Press, 1989), 44.

8 At a workshop on "Creation Order and the 'wanton chance' of Artistic Disorder," during a 1992 conference celebrating the twenty-fifth anniversary of the Institute for

in the past): all the turmoil does not help a Christian say, like *Qoheleth*, that there is nothing new under the sun in scholarship . . . except scripturally directed theory that shows a Way to go that honors the Rule of the Lord. Such a single-minded project occasions embarrassment more than opposition, because old, worn-out "christian" slogans have made redemptive cups of cold water suspect.

I happen to believe, however, that there is a certain sanity to Vollenhoven's conception of historiography that bodes wisdom and healing service to the stymied ingenuities at large today in the field of writing art history. Let me mention certain features of Vollenhoven's legacy that prompt the programmatic contours of my proposed cartographic methodology for keeping art history.

Methodical insight is only born out of painstaking, long-term research, said Vollenhoven.

(1) Good method is not a quick fix for incidental problems, but sets limits to sources, field of investigation, and the nature of what gets processed in a multifarious world.[9] So a sound art historical method would focus upon significant changes in artistic matters, and protect the historian from slipknot wandering into psychological and societological pronouncements. Because artworks and artistic events are human-made entities, the art whose history one tracks naturally embodies circumstantially myriad non-artistic features, not the least of which is the wile and guile of us human makers. But art history, following Vollenhoven's lead, will properly be an art history, and not convert art into documents for psychoanalytic or socio-economic history. As Norman Bryson puts it, the art historical point of Gericaults portraits of the mad, and Manet's *Olympia* at the Salon of 1865, is that they "overturned" categories of *painterly* discourse; that the artworks did not reform insane asylums or prostitution in France is not material to their art historical significance.[10]

(2) Already early on Vollenhoven stated clearly that Scripturally directed thinking would help history-keeping see that the fundamental struggle on the face of the earth from the fall of Adam and Eve to the final judgment day return of Jesus Christ is the knock-down battle between the Spirit of God and what the Bible calls *Sarx* and its legions to rule

Christian Studies, Toronto.

9 D. H. Th. Vollenhoven, *Geschiedenis der Wijsbegeerte* (Franeker: Wever, 1950), 114–15. Also Susanne K. Langer, *Philosophy in a New Key* (New York: Mentor, 1942), 1–2; and Preziosi, *Rethinking Art History*, 34f.

10 "Introduction" to *Calligram: Essays in the new French art history* (Cambridge University Press, 1988), xxvi–xxviii.

the cultivating work of human hands, including artistry.[11] For millennia of humankind, from Babylonian ziggurat, Egyptian temples of the pharaohs, and African tribal dances in circumcision rites of passage: brilliant vanity and imaginative perversity largely carried the day. Then there arose a millennium of sacred icons, courtly love poems, soaring cathedrals, and madrigals, where a holy spirit and strange gods, as it were, vied and allied in empowering exquisitely crafted artistic labors, until such artificial synthesis of allegiances lost its attraction, and a pure bred secularist dynamic weaned itself on *humaniora*.

That is, Vollenhoven claims as biblically informed the thesis that the history of the world is one and once-only, and Jesus Christ's birth-death-resurrection-ascension and prospective triumphant return to earth is a central historical reality that in principle blocks out the major periods of happenings on earth BC and AD.[12] And within that BC/AD period framework, our "last days" of history,[13] since the actual happening of Pentecost, are marked principally by the body of Christ's wrestling, as K.J. Popma brings to the fore, with demonic principalities,[14] whether it be domination under the so-called *pax romana* Roman Empire, the chiliastic Dritte Reich, or the Utopian angel-of-light culture "made in USA." According to Vollenhoven, as I understand his Augustinian thought, Christ's communion of followers being buffeted by a succession of incognito, violent ἐξουσίαι and pervasive δυνάμεις is the primal scream of suffering that historians need to hear, or their historiographic vision will be biblically off-center.

Thanks to God's grace our creaturely theatre of operation is more complicated than a stark Armageddon.

(3) Not only is there misleading sin within the generations of the people of God, but the peoples of the world and their cultural leaders live and move and have their meaning in the reliable matrix of creational ordinances like seedtime and harvest, summer and winter, a chromosomal DNA genetic code, the order of irreducible difference between feelings

11 D. H. Th Vollenhoven, *Het Calvinisme en de Reformatie van de Wijsbegeerte* (Amsterdam: H. J. Paris, 1933), 306.

12 On BC and AD, see *Isagôgè Philosophiae / Introduction to Philosophy* [1945], translated by John Kok (Sioux Center: Dordt College Press, 2005), 77–102; *Geschiedenis der Wijsbegeerte* (1950), 18; see also Jaap Klapwijk in "Geloof en Geschiedenis," in *Het Leven Beschouwd: Facetten van het werk van prof. dr. K. J. Popma* (Amsterdam: Buijten en Schipperheijn, 1974), 56–59.

13 Hebrews 1:1–2, Acts 2:14–21.

14 See Jaap Klapwijk. "Over Mogelijkheden van Christelijk Filosoferen," in *Mededelingen van de Vereniging voor Calvinistische Wijsbegeerte* (no. 3, September 1971): 7–8.

and thoughts, the comeuppance of bankruptcy for profligate commerce, the limits to ethical infidelity: creational bounds to which creatures are willy-nilly subject testify to the provident presence of God mitigating evil.

It was the genius of Vollenhoven to identify various typical philosophical categorial framework constructions that seem to show up over the ages, apparently because the abiding cosmonomic universe has regular dimensions, which admit of recurrent, different cosmogono-cosmological assessments. The historian of philosophy must beware, said Vollenhoven, of reducing the given texts read to too few schematic formats, if one wants to honor the richness of the many contributions to human knowledge;[15] and it is so that how philosophies systematically conceive of the structural fabric of reality is secondary in importance to their innovative "historical" place.[16] But it belongs to the redemptive work of historiography, if I follow Vollenhoven correctly, as the historian tracks any specific trail, always to diagnose the intersecting axes impinging upon a given human artifact like philosophy or art: the systematic, repeatable purview the human conception adopts, and the non-repeatable period dynamic that stirs the particular piece or oeuvre under review. Otherwise the historian does not honor the concretely connected—contemporary cultural kinship *and* persuaded human tradition—does not honor the cosmically and humanly connected singularity of what one is investigating.[17]

There is one other basic Vollenhoven thesis that I think is crucial to note before I try to articulate an art historiographic method swimming in Vollenhoven's wake.

15 Vollenhoven, *Geschiedenis*, 594.

16 Ibid., 591; also, "Derhalve is het geoorloofd te zeggen, dat in de geschiedenis der wijsbegeerte het opkomen van een tijdstroming aan een wijziging van opvatting inzake het probleem van de plaats der wet valt toe te schrijven, daarentegen de visies op de verticale structuur, eenmaal ontstaan, mede door de vorming van scholen, de simultaneïteit in de geschiedenis veroorzaken. Daarom is het opkomen van een nieuwe tijdstroming belangrijker dan dat van een nieuw type." From "Conservatisme en Progressiviteit in de Wijsbegeerte" (1958), in *Vollenhoven als Wijsgeer*, eds. A. Tol and K. A. Bril (Amsterdam: Buijten en Schipperheijn, 1992), 313. Translated: "Conservatism and Progressiveness in Philosophy," in *The Problem-Historical Method and the History of Philosophy*, ed. Bril, 17.

17 "Want wie een auteur belicht, heeft, of dit nu in een kort overzicht of in een brede monographie geschiedt, hem toch te zien en anderen te tonen in het licht van het geheel. . . . tot een behandelen van de enkeling in het licht van het geheel behoort het aangeven van tijdstroming en type." D. H. Th. Vollenhoven, "De Consequent Problem-historische Methode," *Philosophia Reformata* 26 (1961): 34.

(4) Given the eschatonic continuity of creation's course that holy Scripture posits, and the seamless cloth of cosmic creatural ordinances that Scripture reveals as God's calling us creatures to task: because Vollenhoven takes the surd reality of sin seriously, he believes it belongs to the responsibility of an historian to judge, in keeping history, whether whatever is made of an inheritance is historically good or evil, wasteful or redemptive.

That's a scandal, I realize; but Vollenhoven does not propose or practice historiography as an anonymous, panoptic divinity gazing pitilessly down upon all that transpires.[18] For an historian to make a judgment call on the definite historical fecundity or impoverishment transacted in a given setting once upon a time is simply doing justice in the account to what took place. An historian should indeed not play God or cull self-righteous, moral lessons while describing past incidents. But it makes deep human sense in God's world to recognize, with the pain of scrupulous integrity, whether the historical appél present was rightly, wrongly, mistakenly, weakly, or enrichingly responded to . . . by William Hogarth in the Enlightenment British artworld, or by Zeno of Kition for philosophy in the commercialized heyday of Macedonian Alexandrian Hellenism.[19] To pretend good and evil do not inhere human deeds because as historian one feels more comfortable with a noncommittal hermeneutic of deferral or echo[20] is to commit a scandal of an other, abdicatory kind, one that Vollenhoven lamented as lamentable ignorance.[21]

Primed by Vollenhoven's theses that historiographic method rightly takes a specific focus, that history is fundamentally the story of God's creation enduring human cultivation during the promised coming final triumph of the Truth over the Lies of false powers, that human art like human philosophy inescapably embodies a committed world-and-life vi-

18 Preziosi, *Rethinking Art History*, 59–72, 76–77.

19 Vollenhoven situates Zeno snugly in the world-business societal complex of Zeno's day, in "Het Nominalisme van Zeno den Stoïcijn," *Wetenschappelijke Bijdragen* [celebrating fifty years existence of the Vrije Universiteit] (Amsterdam: De Standaard, 1930). "In dezen tijd nu treden de eerste Stoici op. . . . Dáárom, wijl hun leven andere vragen stelde werd hun wijsbegeerte een andere dan die hunner voorgangers" (183). After a careful exploration of the Zeno texts and their antinomies, Vollenhoven says: "De betekenis van Zeno voor de geschiedenis der wijsbegeerte komt vooral dáárin uit, dat zoowel die aanvullingen als die veranderingen hun grond vinden in de leemten, inconsequenties en contradicties van den meester" (201).

20 See Johan van der Hoeven's careful critical remark in "Gadamer over 'Vermittlung,'" *Philosophia Reformata* 56:1 (1991): 93.

21 Vollenhoven, *Het Calvinisme*, 309–310.

sion of some sort, and that historians assume criteria for judging what is historically normative in a field of human endeavor or forfeit their authority to be listened to: let me now try to translate such thetical insights into the basic categories of an art historiographic method.

I

A history of anything implies there be a connected story. It is impossible to write a history of anything without simplifying its story. But every historical account that *over*simplifies what one is recounting distorts the record.

Historians normally recognize endings and beginnings in the becomings they treat. Chapters in historical writing, like pericopes (paragraphs) in a text, signal the rounding off ending and beginning of a different phase within the succession of something; but this "break" in the story is not the absolute ceasing of entitary existence, and also not the mere mark of astrophysical change in date, like a new year number, 1717 AD. The *selah* or chapter caesurae in the tale historians tell bespeak subtle, crucial interpretive decisions on significant changes in the course of an identity being traced. A fundamental question is: are there good ontical grounds for such historiographic pauses? Given the overriding temporal continuity of creational reality, what affords the conjunctive possibility of temporal creatural discontinuities?

I can do no more than adumbrate here the bitterly contested reality of historical period.[22] The old schema of Augustine that read the progressive revelation of God's Rule on earth in history to be a step by step dispensational supersession of earlier ages—*ante legem* superseded by *sub lege* replaced by *sub gratia Christi* (to which others following Montanus added the new age of the Spirit)—gradually gave way in European Humanist reflection to the position that **we humans** set the Spirit of the times in play. A consuming rationalist faith in human progress, later relativized by a pervasive historicism among leaders,[23] which highlighted the incredible

22 For a sharp-eyed, insightful overview see Götz Pochat, "Der Epochenbegriff und die Kunstgeschichte," in *Kategorien und Methoden der Deutschen Kunstgeschichte 1900–1930*, ed. Lorenz Dittmann (Stuttgart: Franz Steiner Verlag Wiesbaden, 1985), 129–67.

23 Hans Robert Jauss, *Toward an Aesthetic of Reception* (1967), translated by T. Bahti (Minneapolis: University of Minnesota Press, 1982), 78. The diverse referents of the term "historicism" betray the quite different horses any given thinker is flogging. See Barbara Jo Douglas, "Musicology or Musikwissenschaft? A study of the work of Carl Dahlhaus" (Toronto: Institute for Christian Studies M.Phil. thesis, typescript), 12–16.

complexity of any given cultural period of time, further served to undermine "epoch" as too global a category for delineating trenchant features of composite human deeds at some one time or other. A nominalist climate and a pervasive individualistic temper in the academic world today have, like acid, by and large corroded historical periods into conceptual heuristic devices, disposable "metaphors," which may be utilized for the nonce, but have little referential meaning.[24]

Hegel's *Zeitgeist* indeed encumbered the idea of "period" with the onus of being an expendable phase of a monolithic universal rational process, but Riegl's *Kunstwollen*, a positivist stab at affirming a non-transcendent, atemporal force that regulates periodic changes in style, persisted in maintaining the idea of some fundamental pancultural unity obtaining at a given time.[25] Old-fashioned Panofsky tends to anchor analysis of the style period of artworks in a supratemporal Weltanschauung of *humanitas* that has unchanging universal permanence.[26] Even Foucault, dealing in non-scientific knowledges and institutions, who would shun any pancultural solidity, uses "episteme" early on, and later "archive," to point to the hologramic interpositivities of quite different **eras**, which despite undefined boundaries still somehow deeply configure the welter of constant transformational goings-on at the many levels of human artifactuality.[27]

That is, unless one is prepared to return to atomistic recitation of

24 See Jost Hermand, "Über Nutzen und Nachteil Literarischer Epochenbegriffe, Ein Vortrag," *Monatshefte* 58:1 (1966): 298. Preziosi's rhetoric views the homogeneous period more sinisterly as an Idealist plot for mind control (*Rethinking Art History*, 23,33), correlative with totalitarian art history (*Critical Inquiry* 18 [Winter 1992]: 383). Also, Fredric Jameson, *The Political Unconscious: Narrative as a socially symbolic act* (Ithaca: Cornell University Press, 1981), 27–28.

25 Alois Riegl, "Kunstgeschichte und Universalgeschichte" (1898), in *Gesammelte Aufsätze* (Wien: Berno Filser Verlag, 1929), 5–9. Cf. Otto Pächt, "Art Historians and Art Critics: Alois Riegl," *Burlington Magazine* 105 (1963); Henry Zerner, "Alois Riegl: 'Art, Value, and Historicism," *Daedalus* 105:1 (1976): 179; Hans-Bertold Busse, *Kunst und Wissenschaft: Untersuchungen zu Ästhetik und Methodik der Kunstgeschichtswissenschaft* (Mittenwald: Mäander Kunstverlag, 1981), 50.

26 Erwin Panofsky, *Aufsätze zu Grundfragen der Kunstwissenschaft* (Berlin: Bruno Hessling, 1974): "Der Begriff des Kunstwollens" (1920), 35; Über das Verhältnis der Kunstgeschichte zur Kunsttheorie" (1925), 49. Also in *Meaning in the Visual Arts* (Garden City: Doubleday Anchor, 1955): "Iconography and Iconology: An introduction to the study of Renaissance art" (1939), 28, 30, 41; "The History of Art as a Humanistic Discipline" (1940), 23–25. Cf. Michael Ann Holly, *Panofsky and the Foundations of Art History* (Ithaca: Cornell University Press, 1984), 160–62.

27 Michel Foucault, *Les mots et les choses* (Paris: Gallimard, 1966), 11–15; and 1971 "Foreword to the English Edition," in *The Order of Things: An archeology of the human sciences* (New York: Vintage, 1973), xiii–xiv. Also *L'Archéologie du Savoir* (Paris: Gallimard, 1969), 166–173.

disparate artistic facts and be satisfied with the cohesion of a monograph for studies in artworks or an artist's oeuvre, some kind of unifying, relating, communifying, over-all matrix is apparently needed for locating and dating the definite cultural presence and power of the art whose changes one as historian is describing. It is so that a cultural period like the European Renaissance is not a solid state of being or values, a hypostatized ideal type that prescribes apriori all that takes place within its confines.[28] A cultural period like the Enlightenment is also not a passing stage of a grand process of **poiesis** dialectically enroute to a millennium of well-being.[29] But a cultural period like ancient Near Eastern Hellenism or the cultural drive of modem world-wide Pragmatism is not merely a ghostly appearance either, an egregious over-simplifying label projected by anxious, armchair cataloguers to spook the uninitiated into a classificatory textbook history.[30]

A cultural period I take to be a dated, non-recurring dynamic communion of leadership that manifests in its span of time a certain spirit whose élan sets the dominant pace and pattern of human activity and institutional life at large somewhere. A cultural period is a lived reality. The cultural dynamic for a few generations south of the Alps in the 1400-1500s AD called "Renaissance" certainly admits of countervailing cultural tensions (like Pomponazzi's Scholasticism and Valla's Humanism), important locale variations (Venice, Florence, Rome); and various sectors of cultural life (music, painterly art, politics, commerce, church, transportation) vary in picking up the Renaissance beat. But the Renaissance cultural dynamic is discernibly quite different from the cultural drive of the Reformation in those days, and not just because Luther's songs take place north of the Alps. Savonarola is not a "Renaissance man," but Francois I at Fontainbleau certainly does breathe, like the Roman church under the Borgia popes, an infectious, this-worldly *sacra ambitio*.[31]

28 René Wellek, "Periods and Movements in Literary History," *English Institute Annual 1940* (New York: Columbia University Press, 1941), 92.

29 Cf. Arnold Hauser on "the rococo" in *The Social History of Art*, translated with S. Godman (New York: Vintage, 1951), 3:33.

30 See articles in *New Literary History* 1 (1969–70), especially Meyer Schapiro, "Criteria of Periodization in the History of European Art," 113–25; and Lawrence Lipking, "Periods in the Arts: Sketches and speculations," 181–200. Also Alastair Fowler, "Periodization and Interart Analogies," in *New Literary History* 3 (1971–72): 487–509.

31 One could say that young John Calvin, for example, in his dissertation commentary on Seneca's *De clementia* (1532) was working his thought loose from what Vollenhoven carefully calls the late ("derde") synthesis of "Christian Humanism," distinct from both a Renaissance and Reformation orientation (Vollenhoven, "Short Survey of the History of Philosophy," in *The Problem-Historical Method and the History of*

To give a concrete idea of cultural period, an example of a cohering cultural dynamic, let me try to build up an *Erwartungshorizont* (Jauss) that would parlay what in art history has often been called "rococo" period style into an emblem of what I think characterizes the ludic rationalism of Enlightenment Europe.

Gainsborough (Mary Countess Howe [#1]) shows the favorite color of rose along with a touch of the delicate chinoiserie fashion of the day. A defining shape in favor was the concave shell, for ladling soup or as pattern for your bedstead. Expensive, fragile porcelain fit the salon and its art of polite conversation on the respective merits of French and

[#1] Thomas Gainsborough, *Mary Countess Howe*, c. 1760

Italian music, on what is beautiful and what sublime, where repartee is normative, wit essential, and sallies of *l'esprit* crucial for your social existence. Idle high society in Venice confessed a world

[#2] Fake bridge to view from Kenwood House, United Kingdom

as make-believe as possible, with carnivals and masked balls lasting for months. A fake bridge [#2] on an artificial lake would be constructed for the view, to be admired from the distant picture window at Kenwood house in England during dessert where the soirée was being held. In Paris Madame Pompadour [#3] was virtual minister of culture for French society: lifestyle *des lumières* was defined by dalliance tête-à-tête in the park, coquetry,[32] gallantry, flirtation paired with decorum, epitomized in the

Philosophy (Amstelveen: Haes, 2005), 124–131). The tribute to Plato in Calvin's *Institutiones Christianae religionis* (1533, I, xv, 6–8) is also evidence of the ongoing struggle and weaning of deep-going allegiances that takes place within any given time, although the whole *Institutes* treatise breathes devotion to the Lord's Rule on earth, and Calvin's intent is instill piety in God's needy people.

32 John Gay's poem, "The Fan" (1714) describes the role of fans for flirting in church:

minuet danced[33] on gleaming parquet floors near Chippendale furniture, where evil seems to be an impropriety![34] The culture of Queen Anne and Louis XV and Frederich der Grosse breathed the spirit of refinement, *le coeur sensible*, *sentiment*, the *Empfindsamkeit* of Scarlatti chamber music, Couperin, Goldoni—

One could go on indefinitely, committing what Gombrich calls the "physiognomic fallacy,"[35] noting that philosophy of the Enlightenment period was conceived and performed differently than philosophy constructed during a somewhat earlier Scientialistic "episteme" where Galileo, Descartes, Newton, Leibniz, Spinoza, Baumgarten, exuded an air of universal calculus of analysis.[36] Voltaire does philosophy by story, *le conte* of *Candide*; Diderot writes

[#3] Francois Boucher, *Madame Pompadour*, 1756

> The peeping fan in modern times shall rise
> through which unseen the female ogle flies;
> this shall in temples the sly maid conceal
> and shelter love beneath devotion's veil. . . .

33 Cf. Philippe Minguet's analysis of the minuet: ". . . tout est révérence, rencontre, départ feint, pirouette" (*L'esthétique du Rococo* [Paris: Vrin, 1966], 246), so different in feel from the Romantic *Schwung* of the waltz, which appeared around 1760.

34 How mores and morals merge in such minds Roman catholic Alexander Pope puts delicately into "heroic couplets" in his mock-epic 'Rape of the Lock":

> . . . Whether the nymph shall break Diana's law,
> or some frail china jar receive a flaw;
> or stain her honour, or her new brocade;
> forget her prayers, or miss a masquerade;
> or lose her heart, or necklace, at a ball

35 E. H. Gombrich, "On Physiognomic Perception" (1960) in *Meditations on a Hobby Horse and Other Essays on the Theory of Art* (London: Phaidon, 1978), 45–55.

36 See Michel Foucault, *Les mots et les choses*, 64–72; Vollenhoven, "Short Survey of the History of Philosophy," in *The Problem-Historical Method and the History of Philosophy* (Amstelveen: Haes, 2005), 76–79.

philosophical articles in an *Encyclopédie* organized alphabetically rather than systematically; theater-poet Schiller puts philosophy into short letters for a duke;[37] Hume's philosophy comes in **essays**[38] called "Enquiries": the spirit infusing the philosophes and contouring Enlightenment philosophy is as different in temper from the classical grandeur of science written in Latin as Rigaud's pretty portrait [#4] of Louis XIV ("Louis XIV en habits de sacre") differs in spirit from Philippe de Champaigne's presentation of cardinal Richelieu [#5]. Richelieu has the formal bearing, *la grande manière* of Versailles, Le Brun, and Dryden, while Rigaud's rococo bedroom version of the Great Louis, flashing a turned leg! bears the imprint, to my eye, of the cultural dynamic to seek the flirtational life, a sunny-side-up liberty, and pursuit of elegant happiness. Even Immanuel Kant in his light-hearted 1764 *Beobachtungen*—which Kant took very seriously[39]—has all the verve and play of the Aufklärung. Enlightenment culture has a ludic spirit also worlds apart, one might say, from the somewhat later Romantic Idealist cultural dynamic

[#4] Hyacinthe Rigaud, *Louis XIV*, 1701

37 *Über die Ästhetische Erziehung des Menschen in einer Reihe von Briefen*, for Schiller's patron the Duke of Augustenburg.

38 "Die Funktion des Essays, gelehrtes Wissen in ein Ganzes einzuordnen, das Einzelne gegen den Hintergrund des Universalen auszuleuchten und, wenn nicht jedem Menschen, so doch einer geistig aktiven Schicht der Gesellschaft fasslich zu vermitteln, hätte den Intentionen der Aufklärung in besonderer Weise entsprechen müssen." So Gerhard Haas, *Essay* (Stuttgart: J. B. Metzlersche, 1969), 21f. See also Heinrich Knützel, *Essay und Aufklärung: Zur Ursprung einer originellen Deutschen Prosa im 18. Jahrhundert* (München: Wilhelm Fink, 1969).

39 There are at most 200 printed pages of marginalia to the 1764 *Beobachtungen über das Gefühl des Schönen und Erhabenen*, in Kant's *Gesammelte Schriften* (volume 20), waiting for a revised version; see my article on "Early Kant and a Rococo Spirit, Setting for the *Critique of Judgment*," *Philosophia Reformata* 43:2 (1978): 145–67 {see *CE*: 317–342}.

[#5] Philippe de Champaigne,
Cardinal de Richelieu, c. 1640

of adventuresome cruelty and crusade for *la gloire de la France* stirring much of the artistry, for example, of Delacroix.

The way I should like to redeem the category of *cultural period as cultural dynamic* is first of all to recognize that one is **not** tracking an historical trail when you detect the reigning thrust of a certain cultural dominance. You do not get an art history by using art as documents for examining cultural periods. But Gombrich and others go wrong, in my judgment, to think artworks are intrinsically incommensurable,[40] because dated/located human artwork has an aura, a definite bearing, a discernible marked empowering in its allusive meaning that it shares with other layered cultural phenomena of the day. True, a cultural period dynamic does not drop out of heaven full blown and unchallenged, but materializes out of trends, currents, homogenous movements in varied arenas of culture, which may not last generations-long enough or reach a broad enough hegemonic strength somewhere to set and qualify a cultural period. Different generations of leaders at home in the same cultural dynamic also seriate and complicate its waxing and waning hold on certain zones of human life. But the jealous aegis of each cultural period constitutes a compelling horizon for human position taking and human generation and completion of deed.

A second thesis of mine would be that there is *no predictable interperiod connection*, no rise and fall *between* cultural periods. I do think that *within* a cultural period dynamic there are usually discernible stages of a generation's responsibility toward initiation, consolidation, or ramification of a cultural period's regime. There are also normally within a period

40 Cf. Gombrich, *Ideals and Idols: Essays on values in history and in art* (Oxford: Phaidon, 1979): "Art History and the Social Sciences" (1973), 148–49, 155; and "The Logic of Vanity Fair: Alternatives to historicism in the study of fashions, style, and taste" (1974), 61.

dynamic telltale marks of suicide with which idolatry is fraught. But each cultural period dynamic is intrinsically at odds with any other cultural dynamic in force at the same time. Cultural periods like Renaissance, Enlightenment, Positivism, Pragmatism—which are *not* a class of chronology[41]—occur disjunctively, and are uncanny historical forces apriori conditioning, almost environmentally, empowering and ruining, abetting, directing, thwarting what happens as the work of human hands—art, philosophy, war, church doctrine, whatever. To my knowledge Vollenhoven never worked out any clear connection between his major periodization of history for philosophy—before and after synthetic-christian philosophy[42]—and what Vollenhoven came to call "tijdstromingen."[43] But that is the crux I am after: recognition that the cultural milieu embedding art is not inert but lethal, fertile, an impelling and often imploding drive for the art to be reborn (Renaissance), "enlightened," "positive" ("Impressionism"), thoroughly "pragmatic." Yet a cultural period dynamic is *not in any historical sequence.*[44]

41 Cf. Claudio Guillén, "Second Thoughts on Currents and Periods," in *The Disciplines of Criticism: Essays in literary theory, interpretation, and history*, eds. P. Demetz, Theodore Greene, Lowry Nelson. Jr. (Yale University Press, 1968), 489, 492.

42 Vollenhoven, *Geschiedenis der Wijsbegeerte*, 18

43 Vollenhoven, "Conservatisme en Progressiviteit in de Wijsbegeerte" (1958), in *Vollenhoven als wijsgeer*, eds. A. Tol and K.A. Bril, p. 313. See my "Biblical Wisdom underneath Vollenhoven's Categories for Philosophical Historiography," *Philosophia Reformata* 38 (1973): 131–32, especially note 16 {supra p. 7}.

44 Vollenhoven's description has always seemed to me too neat how, because of the combat between the exaggerations of Scientialism and Practicalism, ". . . wordt het nodig, op een verzoening bedacht te zijn. Daarmee is dan de tijd aangebroken voor het Oude Idealisme, dat Scientialisme en Practicalisme met elkander verbindt (*Kort Overzicht*, 34). The same pattern is found by Vollenhoven to be evident in the series of Positivism, NeoPositivism, and NeoIdealism, in late Rationalism (*Kort Overzicht*, 37). It is true, as Vollenhoven says "Een periode in de philosophie wordt altijd mede beheerst door de voorgaande" (*Kort Overzicht*, 30); but he adds immediately: "De wijze, waarop dit geschiedt, is niet steeds dezelfde. Soms constateert men vooral afhankelijkheid, omdat de latere periode in sterke mate aan de traditie trouw blijft. Dan weer valt een krachtige reactie waar te nemen. Maar ook reactie is een soort van afhankelijkheid. Want gegeven is dan datgene waartegen men vecht." J. H. J. Pot's caution remains "De invloed van de wereldbeschouwing op de periodisering mag zich echter alleen uitstrekken tot het gezichtspunt, van waaruit men de geschiedenis indeelt, en niet leiden tot een apriorische constructie van het verloop van de geschiedenis zelf" (*De Periodisering der Geschiedenis: Een overzicht der theorieën* [Hague: Van Stockum, 1951], 34). In my judgment the "succession" of cultural period dynamics blows where they list, because periods are *dynameis* and not blocks-of-time or cross-sections of the underlying processional bed of eschatonic duration integral to creatural reality. Hans Robert Jauss' early program of *Receptionsgeschichte* wrestles with this very problem by encouraging focus upon the contemporary reader's retrieval of the *event* character of earlier literary works,

Finally, although it makes me a bit uneasy, I understand the anonymous neutronic power of such a cultural period dynamic to be the presence of those inscrutable *dynameis, exousiae, archai*, with which the Bible says we humans contend (Ephesians 6:10–18, Colossians 1:15–20). Their contagious presence as a third dimension to human artworks is precisely why an historical account cannot be rationally boxed in and gift-wrapped; there is much more to the history of art, Horatio, than is dreamt of in any would-be scientific causal-chain methodology. But an historian then is called upon to penetrate through to, name, and expose whatever the cultural dynamic in force be in the artwork scrutinized—christian scholarship always has a quiet facet of critical exorcism[45]—to show the fascinating entrapment in how Positivism, Pragmatism, Nihilism, or how Enlightenment art, for example, sweetly beckons its patrons to accept delight that is too good to be true. Taking cultural period dynamic to heart can also meet a concern Vollenhoven had, to avoid anachronistic judgments, like reading our current circumstances back into earlier times or seeing our present state "anticipated" by former ages.[46] Only when an historian recognizes and lets the power of an other earlier cultural period dynamic speak its own piece can one come to know the limits of our own times, and avoid parochiality.[47]

plumbing the older text's "original negativity," that is, its upset of the first readerly expectations (Literaturgeschichte als Provokation der Literatur-Wissenschaft [Konstanz: Universitätsverlag, 1967], 20–22). (This note was developed as a partial response to Sander Griffioen's excellent question at the presentation of this article as a lecture on 6 November 1992. See also note 61 below.

45 See Hans Sedlmayr, "Kunstgeschichte als Geistesgeschichte" (1949), in *Kunst und Wahrheit: Zur Theorie und Methode der Kunstgeschichte* (Mittenwald: Mäander Kunstverlag, 1978), 90–91. But in "discerning the spirits" (1 John 4:1) one must scrupulously beware of speaking, as it were, *ex cathedra*. Lorenz Dittmann writes: "Wir halten uns an das wissenschaftlich Prüfbare und bestreiten auf das entschiedenste, dass ein gläubiger Christ dem Urteil Sedlmayrs folgen muss" (*Stil / Symbol / Struktur* [München: Fink, 1967], 191).

46 Vollenhoven, "De Consequent Problemhistorische Methode," *Philosophia Reformata* 26 (1961): 33–34.

47 "Wohl die größte Gefahr dieser Art von Existentialisierung ist der Verlust an Vergleichsmöglichkeiten, der zu einem unleugbaren Sieg der Literaturkritik über die eigentliche Literaturgeschichte geführt hat. Denn durch diese Verheutigung oder Vergegenwärtigung tritt häufig eine Beschränkung auf die 'Moderne' ein, die ihre Vorteile hat, jedoch allzu oft in ein modisches Manöver entartet." Jost Herman, "Über Nutzen und Nachteil Literarischer Epochenbegriffe," *Monatshefte* 58:1 (1966): 300.

II

A second major coordinate for mapping out the complexity of horizons impinging upon artworks that an art historian needs to expect is the reality of what I shall call *typiconic formats*. Just as there are a number of categorial frameworks exercised by philosophers throughout the ages such that Heidegger, for example, latches onto Anaximander as a kind of fine philosophical source,[48] and Gadamer's systematic approach to hermeneutics is especially appreciative of a Heraclitean thought pattern (in spite of Hegel's also being partial to *coincidentia oppositorum*), so too there is a plurality of definite world-and-life-visions whose contours are firm enough to be distinct from one another, and that seem to give shape to the artistic and literary endeavors of humans throughout the generations. I do not mean to suggest there be a warehouse of Platonic *noéta* where artists shop for frameworks to give their work a certain profile. Apprentices in Rubens' workshop picked up their Rubenesque configuring practice existentially; students at Hogarth's alternative Academy in St. Matins Lane practiced a different line of beauty than that prescribed by Sir Joshua Reynolds at the Royal Academy: a beginning artist's training carries the knowhow in differently molded vessels. It is normal for an artist to belong initially to a "school" of art, with a cachet as pronounced as handwriting; little telltale features make visible whether you were taught in Ingres' or David's atelier, or belong to the stable at Warhol's New York Factory.

Working with the fact that artists enter their profession informally **formatted** by a certain earlier generational construct in artistry, and spired by the Vollenhovian legacy of various enduring **typical** philosophical conceptions, I have identified several basic ways artists (including music composers, novelists, architects, choreographers, cinematic auteurs) prefabricate, as it were, their symbolific presentations of meaning. By "typiconic format" I do not mean an apriori structure as analytically precise as a philosophical categorial framework, and I am not dealing in psychological or mythopoeic archetypes. *Typiconic format* refers to how the artist frames his or her artistic production to be imaginatively received. The framing may not be self- conscious, may or may not be self-critical, and certainly has shadowy borders appropriate to a subliminal, preconceptual weighting of cosmic emphases and societal priorities; but the framing typiconic format gives artwork focus, like specially filtered eyeglasses, to configure the playing field on which and in which things

48 Martin Heidegger, "Der Spruch des Anaximander" (1946), in *Holzwege* (Frankfurt am Main: Vittorio Klostermann, 1957). Cf. S. U. Zuidema, "Heidegger," in *Denkers van deze Tijd* (Franeker: Wever, 1955), 19–20.

happen, are depicted, heard, habituated, followed, and then presented by the artist. Again, typiconic format is not conceptual, not semantic in nature, but is an imaginative apriori that gives a specific cast, a typical cast, to an artist's work. The framing is not pronounced as exclusive, but in its very unobtrusive decisions on certain relational questions of what is life-important, what is subsidiary, what connects, what portents are possible, a typiconic format claims to be relatively all-embracing.

Vanbergen's sustained, insightful analysis of *typus* may phrase the matter more semiotically than I care to, but if I understand his writing correctly, his acute probe of *typus* as an encoded artistic tradition,[49] related to but distinct from genres,[50] gets close to my Vollenhovian category of "typiconic format," the types of esemplastic (Coleridge term) hold operant in artworks. *Types*, states Vanbergen, like "the rape of Europa," "une tempête sur terre," "figure at the window,"[51] are more than iconographic motifs with lexical identifications; types are really process-geared, perceptual formations of the content being, in Vanbergen's terms, "predicated" by the artist, determining the way a representation means.[52] A *genre* like still life, "history painting," *vedute*, or portrait, is a class of painterly art with features common to its members; but "types" for Vanbergen are a configuration of features functional within the whole of an artwork, a sort of internal context of the representation itself, which is nevertheless not the same for all the pieces in its type.[53]

To give provocative body to my theoretical proposal let me sketch and give names to a few typiconic formats I have inductively found to be orientations recurrently adopted by artists great and small for a long time.[54]

49 ". . . de typus als een vorm van artistieke codering door een traditie." J.F.H.H. Vanbergen, *Voorstelling en Betekenis: Theorie van de kunsthistorische interpretatie* (Universitaire Pers Leuven, 1986), 134.

50 Ibid., 58, 69.

51 Ibid., 45–49.

52 "De figuur is dus niet slechts een *énoncé* of uitspraak, onder de vorm van een geïdentificeerde figuur, maar zij is vooral een *énonciation*, d.w.z. een wijze waarop de voorstelling niet de betekenis van een figuur, maar haar eigen betekenis door de figuur tot uitdrukking brengt." Ibid., 47; see 54–55, 67–68, 123–24.

53 "Genres zijn natuurlijk ook een vorm van meer algemene typen, maar zij hebben niet een gelijkwaardige verklarende, hermeneutische functie. Waar het genre bestaat uit een aantal die aan alle werken die ertoe behoren gemeenschappelijk zijn, bestaat een typus uit een configuratie van kenmerken die functioneel zijn binnen een geheel. Deze configuratie is uiteraard niet dezelfde in alle werken die tot dat type behoren. Het bepalen van de typus van een werk is dus niet hetzelfde als het onderbrengen van dit werk in een duidelijke klasse." Ibid., p. 75.

54 N.B. In the text here I list *typical examples across different* cultural period dynamics.

- a "*mystical*" typiconic format [#6] whose preoccupied slant moves to transcend the visible, tending to hover tremulously beyond our ken, prone to theosophic and anthroposophic eurythmic incandescence [El Greco, Fuseli, Brancusi, Kandinsky, Chagal, *De Branding*];
- an "*heroic*" type [#7] focuses on titanic struggle against attractive evil, a daemonic superhumanity monumentally in tension with the ravishing erotic, where excess is respected [Michelangelo, Rubens, Delacroix, Beckmann, Pollock];
- a "*picaresque*" format [#8]—Vollenhoven would have said, "in de lijn van Brueghel en Jan Steen," Bakhtin would refer to the "carnival' vantage point of Dostoevsky—where the vitality of what is naturally lusty and rough-hewn is celebrated, where the wry, the incongruous, the bawdy comic, is real and appreciated [Hogarth, Daumier, Miro, Lichtenstein];
- a "*scenic*" type [#9] quietly spreads out the horizontal world with meticulous wonder and simplicity, and joys in the panoramic stretch of land [Canaletto, Guardi, Diebenkorn];
- an "*idyllic*" typiconic format [#10] values some unspoiled perfection next to or within a carefully observed natural landscape, foil to the innocence [Leonardo, Giorgione, Claude Lorrain, Watteau, Gainsborough, Reynolds, Constable, Thomas Cole, a format practically canonized in the happy-ending twist by the Hollywood studios for films from 1933–1945);
- a "*paradigmatic*" *typus* [#11] holds out for compositional restraint, a world of utterly still completion, unchanging paradigms of order [Raphael, Vermeer, Chardin, Cézanne, Braque, Chirico, Senggih];
- the "*hedonic*" type [#12] revels in sensuous richness, lush curves of pleasure; the glorious erotic overpowers human task [Correggio, Titian, Boucher, Ingres, Bougereau, Renoir, Klimt];
- a typiconic format called "*troubled cosmic*" [#13], where awareness of unresolved evil needing reconciliation sets the parameters; an unidealized normality is disturbingly deep, and misery as a surd is touched by glimpses of joy [Rembrandt, late Goya, Manet, Van Gogh, Barlach, Rouault].

Let it be said immediately that these typiconic formats I presume to have discerned as loading the artistic dice of many gifted persons over the years are not *universalia*, are not logical pigeonholes for classificatory

For the Vollenhoven-kenners I include mention in small print on the accompanying "footprints" chart (pages 46–47) the somewhat comparable types of philosophical conceptions Vollenhoven worked with.

[#7] Michelangelo, *Day*, 15261–1531

[#6] El Greco, *The Virgin with Saint Inés and Saint Tecla*, 1597–1599

[#8] Pieter Bruegel the Elder, *Bauerntanz*, c. 1568

[#9] Canaletto, *Venice: The Basin of San Marco on Ascension Day*, 1754

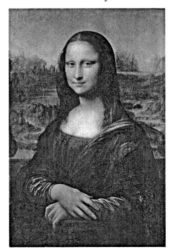

[#10] Leonardo da Vinci,
Mona Lisa, 1503–1505

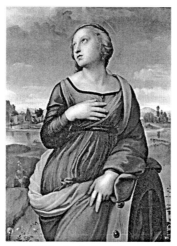

[#11] Raphael, *St. Catharine of
Alexandria*, c. 1507

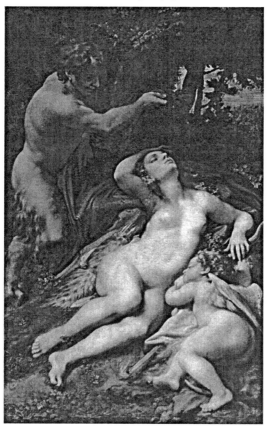

[#12] Correggio, *Jupiter and Antiope*, c. 1528

[#13] Rembrandt, *Self-portrait*, 1659

purposes—the taxonomy is also probably incomplete—and the fact that various artists' oeuvres lean into the same typiconic format does not necessarily entail actual *historical* connection.

Typiconic formats arc indeed historical realities, namely, artistic traditions, wonts (time-worn practices of artistry with certain contours) passed on by seasoned practitioners to inexperienced hands, enabling injunctions to do art from and with a certain orientation.[55] But one can be born into a given artistic tradition, like into one's mother tongue, and never question it; or one might discover a certain typiconic format as if you invented it yourself only to find out later that there is a long line of artists who also independently of you and others found such a picaresque or hedonic way of stamping artworks congenial to one's outlook and praxis. Assuredly there is an unmistakable personal signature to artworks, which is more than the sum of intertextual references and borrowings,[56] which signature sets a given artwork off as some one person's final re-

55 See my "Footprints in the Snow," *Philosophia Reformata* 56 (1991): 5–9 {see *CE*: 239–245}.

56 See Vanbergen, *Voorstelling en Betekenis*, 60–61.

sponsibility. But no artist is an island without a pedigree, without an artistic inheritance, without some kind of typiconic stance in doing art that shows contours typically similar to other artist's artwork in God's world.

A genial, pedagogical strength of Vollenhoven's approach, emphasizing types of human thought alignments, which I am translating into imaginative constructs embodied apriori in artistic traditions, is that an historian, whose stock in trade is hindsight, is then prompted continually to keep an eye open for similarities, to hear echoes, find parallels, that is, be on the lookout across the arts comparatively thinking encyclopedically, tentatively, searchingly.

Typiconic formats within dated/located artworks, like the categorial frameworks Vollenhoven delineated in patterns of actual philosophical analysis, may find some resonance in Dilthey's unleavened roster of *Weltanschauungen*, but are not at all like the rigid, cyclical code of Northrop Frye's basic narrative categories, or Hayden White's fourfold *tropoi* claimed to be the range of possible historical consciousnesses.[57] Typiconic formats are not abstractions for me: they are as real as a person's committed vision of what life and death mean, and how one wills or is compelled to order praxis. Typiconic formats are not in a hierarchy, do not follow a fixed succession, do not determine the quality of the artwork;[58] but they are relatively **comportable**, and can be a good index to the noticeable shift that takes place, for example, between early (heroic) and late (idyllic) Poussin's art, or for positioning the differing natures of the clashes between Hogarth and Reynolds, Reynolds and Gainsborough artistry (cf. schematic overview).

A pedagogical danger of the cartographic methodology, which holds

57 The basic types of philosophical worldviews for Wilhelm Dilthey are Materialismus-Positivismus, objektive Idealismus and Idealismus der Freiheit (in "Das Wesen der Philosophie" [1907], translated by S. and W. Emery [Chapel Hill: University of North Carolina, 1961], 62–66). Northrop Frye's five distinguished fictional modes— mythic, romance, tragic, comic, ironic—"evidently go around in a circle" (42) (*Anatomy of Criticism* [Princeton University Press, 1957], 33–67). Hayden White uses "the tropes of Metaphor, Metonymy, Synecdoche, and Irony as the basic types of linguistic "prefiguration" for historiography (Baltimore: John Hopkins University Press, 1973, 426ff.). Kornelis A. Bril relates in detail and carefully distinguishes Vollenhoven's basic categories from those of J. H. van den Berg, Thomas Kuhn, J. J. Poortman, and others, in *Vollenhoven's Problem-Historical Method: Introduction and explorations* (Sioux Center: Dordt College Press, 2005).

58 While both Boucher (1703–70) and Ingres (1780–1867) have a hedonic cast to their mature artwork, Boucher is a stilted, second-rate painter of figures, while Ingres is a first-class draughtsman.

Schema		*only valid for people with a sense of humor*				
		Showing coordinates of a cartographic methodology for art history				
		Christian	Learned Classical	Rococo	Neoclassical	Romantic
	cultural period	Humanist	Grandeur	Enlightenment	Idealism	Sturm und Drang
	dynamics:	Baroque –1674	(Louis XIV)	(Louis XV)	c. 1755–1815	c. 1770–1830
mystical (mythologizing philosophy)				Maulbertzsch		Füseli
heroic (daemonic Empedocles or Heracleitan wrestle)		Rubens	early Poussin	Tiepolo	Jacques Louis David	Byron Delacroix Beethoven
picaresque (interactionary monism)			Louis Le Nain	Hogarth & Fielding Pater, Longhi, Greuze		
scenic (parallelism)			Canaletto	Guardi		
idyllic (schematist dualism with dichotomy in anthropology)			Claude Lorrain late Poussin	Watteau Lancref	Reynolds	Constable J.J. Rousseau Wordsworth
Paradigmatic (dualism without dichotomy: Monarchian)				Chardin		
hedonic (materialistic monism)				Boucher	Ingres	
troubled cosmic			J.S. Bach			

(Left margin, vertical:) *typiconic formats – artistic traditions*

also for using Vollenhoven's charts, is to mistake the shorthand sketched overview to be the master plan printout. This schematic worksheet is not like a table of chemical elements out of whose archive experiments can be planned, and is also not a strategy chart for military generals to mastermind battles, but is, if we need a guiding metaphor (and do not press it too far), the tentative positionings of movements in a three-dimensional chess game, or real-life pageant, where knights and bishops, castle, pawns, and queens play out their parts, have their exits and their entrances; and as historian you are trying to track the traces, the footprints, of the many trails they make.

It may be helpful to say here that the cross of these two x and y axes, the cultural period dynamic and the typiconic format (art tradition), gives one a good bead on the composite character of style—the way humans posit aesthetic imperatives, in all cultural activities as well as in art—so that style is conceived as idyllic-rococo or picaresque-rococo and not left globally "rococo," or individuated, as if it be handwriting, to the "style" of Watteau.[59] It should be said too that the culturally spirited, typiconically formatted matrix of an artist may not be the most important matter on occasion for an historian to record, although such milieu always enters somehow into history-keeping.[60] For example, the episodic

59 See my "Towards a Cartographic Methodology for Art Historiography," *Journal of Aesthetics and Art Criticism* 39:2 (1980): 148 {infra p. 75}.

60 "The relation between social change and that many-layered form of expression we call a literary text (which can exaggerate, distort, complicate, or embody reality and also create a new world from the materials the outside world provides) will perhaps always remain elusive. . . . There is . . . an ecological chain in culture, a network of mutual dependency and influence between art and history that cannot be unraveled but that must nevertheless be respected." Jean Hagstrum, *Sex and Sensibility: Ideal and erotic*

run and melodramatic crises of Dickens' early novels may be a response to their serialized production and delivery by horse-drawn postal carriages to his avid readers, without discounting in the least the picaresque Victorian, hurly-burly carnival turmoil slanting *Oliver Twist*. I am just saying, cartographic coordinates as **échafaudage** (scaffolding) foster a steadying, comprehensive historical consciousness in the back of one's mind, but when as historian you tell the tale of the novel or depict the trail of the painterly artwork, you don't treat types or periods but relate the exploits of flesh and bloody humans who leave footprints.[61]

III

That third coordinate of what actually takes footprinted place—the specific historical thread of something—happening amid continuous traditions and discontinuous cultural periods—is difficult to get precise when it comes to art, because much depends upon the history of what art the historian aims to tell: painterly art? Dutch art and literature? Amer-

love from Milton to Mozart (University of Chicago Press, 1980), 10–11.

61 In the 1980 *Journal of Aesthetics and Art Criticism* article I called the pancultural reality of a period *synchronic* (happening together at roughly the same time), the perduring types of worldview *perchronic* (lasting relatively intact through time), and the third dimensional reality of historical development (where change is ongoing) *diachronic*. Although I have avoided using these technical terms here I should like to make my careful usage clear, because Saussure and others have only two dimensions. As I understand Saussure, for him "synchronic" study of language deals with its systematic state as *langue*, without reference to time, and "diachronic" study of language respects the factual evolution of speech (*parole*) in time. Al Wolters read Vollenhoven's method of *Problemgeschichte* with Saussurean terminology, to be saying that "synchronic" continuity is the relative unity of a particular cultural period, and "diachronic" continuity is the relatively unchanging constancy of certain structural features throughout successive periods of time ("An Essay on the Idea of *Problemgeschichte*," Systematic Philosophy at Vrije Universiteit mimeograph, April 1970, 51–52). K. A. Bril indeed identifies the synchronic with Vollenhoven's "tijdstromingen" (periods) and the "diachronic" with Vollenhoven's meta-paradigmatic (types), as Bril himself argues for a "pluralistic diasynchrony" (*Vollenhoven's Problem-Historical Method*, 36; see also K. A. Bril, "Gnostiese en Esoteriese Motiewe in die Westerse Kultuur en Kuns" [Potchefstroomse Universiteit vir Christelike Hoër Onderwys: Studiestuk, 13 Mei 1987], 1). What Wolters and Bril call "diachronic" I call *perchronic*—the perduring imaginative apriori's, the typiconic formats, art traditions. This precision is important to me since I think Vollenhoven's theory of historiographic method tends to slight the actual *historical* changes that take place, what Saussure would call the factual diachronic processes in the history of language, philosophy, or art: in my terms Vollenhoven seems to conceive diachronic non-contemporaneity as perchronic! By distinguishing three coordinates I think my cartographic method gets more exactly and fully at the depth dimension of history Bril/Vollenhoven's "diasynchrony" wishes to formulate.

ican art—popular art—since the so-called World War II? a history of Rembrandt's full-orbed artistry? Is there an "art in general" that changes with a simplified connected story line? If art has a differentiated nature, as we know it, is an account of "decoration" in predifferentiated, tribal societal contexts a "pre-history" of art?

Rather than stir up myriad quandaries at this point, let me focus down on three matters and then, rather than argue for the points, try to demonstrate briefly how a cartographic methodology following such imperatives might recount an art historical trail, remembering Vollenhoven's erudite investigation—more genealogy than historiography?—of *ahoristos duas* in the folds of prePlatonic philosophical fragments.[62]

(1) It is a mistake to look for causal influences in affairs artistic to ascertain art history: the historical is to be found in what a new generation makes of its inheritance. The crux to be noted by an historian of art is not so much what is given as what is taken. The **historical connection** is the unpredictable innovative modification made across the break in continuity. On certain occasions artwork of poorer quality may be historically more important than artwork of superior quality.[63]

(2) Significant historical changes can be good or evil or both toward what was in the balance. The historical ordinance that art is to follow for good is this: discover surprising ways to hone and enhance the special (disciplined) calling of artistry, integrated within society, so that artwork's contribution to human life be enriching, refining, celebrative toward praise of God, evoke wisdom, and care of one's fellow neighbors. An art historian needs to decide, to make a nuanced judgment that is minutely informed and just, on whether the change brought what good or ill. The history to art history is not like a continuation of the same plant, but is more like a report on how the ground has been prepared, nutrients add-

62 D. H. Th. Vollenhoven, "Ennoëtisme en 'ahoristos dyas' in het Praeplatonische Denken," *Philosophia Reformata* 19:2, 4 (1954): 58–86,145–68.

63 William Hogarth's artwork is an example of art that by its accessible popularity (multiple engravings) and quirky twist (offending the Bath portrait trade) integrated professional artistry of quality—but not great art—into British societal life as importantly as the work of his rival, Sir Joshua Reynolds, founding The Royal Academy. Hogarth also lobbied hard to win extension of the literary copyright law to cover design, his series "The Rake's Progress" (enacted by Parliament, 1735), in order better to secure his and other artists' livelihood. Further, Hogarth's *Analysis of Beauty* (1745–53) is a pivotal text of rococo aesthetic theory, as important, in my judgment, in its analysis of the comic and "grace" in daily life and artistic style as Burke's exploration into experience of the sublime, both of which thoughts Kant incorporated into a focused, critical exploration of aesthetic taste in *Kritik der Urteilskraft* (1791), liberating aesthetic norms from a constrictive "beauty."

ed, polluted, wasted, out of which new seedling plants (artworks) grow.

(3) Art historiography is different from art critical analysis, but the tasks are in tandem. The historian's work is not finished until the artistic knowledge worth remembering, which has been described in its earlier setting, comes to speak to us today, augments, challenges, somehow modifies our current understanding of reality. It is so, as Kurt Badt says, that earlier artworks are seldom seen in full daylight, but are presented by historians more often with moonlight on a cloudy night.[64]

Example of cartographic methodology at work in examining artwork

Once upon a time just before 1702 when the young displaced Walloon Jean-Antoine Watteau (1684–1721) came to Paris, he fell in with the painter Claude Gillot, who was also managing a marionette theatre at the time. To put bread and wine on his table Watteau painted, drew, and designed what was wanted and commissioned by fashionable society: arabesques to fill the panels of salons in hôtels and chateaux, chinoiseries, and gallant figures or scenes from *commedia dell'arte* in demand by engravers. Around 1707 Watteau was outperforming his master Gillot, and moved up from hackwork to collaborate with Claude III Audran, curator of the Medici Gallery in Palais de Luxembourg. A folding screen, used to set off private space in a room, with a series of six leaves Watteau designed at this time (c.1709) is worth considering.

The title panel [#14] presents a pastoral scene of courtship in a glade where sheep graze peacefully near quiet waters. A shepherd boy plays flute for a reclining shepherdess; their faithful dog back from fetching slicks looks quizzically. Subterranean to the peaceful fountain is a smiling faun's head. Plants of growing grain anchor down the bottom corners, and up above cavort dolphins, time-honored messengers of love. A crown of roses in the upper middle-center hangs suspended over nothing in particular; two of cupid's torches are alight warming the air so that the phoenix also rises.

In the second panel [#15] Watteau's shepherd has assumed a smiling, gallant dance posture while a companion pipes at his side. The maiden stands spectrally behind the tree; she's not really in the picture yet—a fantasy. A medallion with her portrait in profile hangs over the lover's head with pipes that two winged cupids like wind blow to set in motion. The lower fountain has become rectangular stone draped with a cloak, and the subterranean faun's head has become a bold set of bagpipes, a

64 Kurt Badt, "Der Kunstgeschichtliche Zusammenhang" (1966–67), in *Kunsttheoretische Versuche*, ed. Lorenz Dittmann (Köln: DuMont Schauberg, 1968), 161.

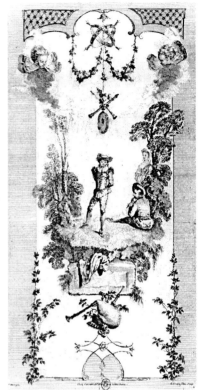

[#14] Antoine Watteau,
panel 1, 1709

[#15] Antoine Watteau,
panel 2, 1709

folk emblem for male genitalia.

Panels 3, 4, and 5, have identical frames of blossoms and cartouches, and very similar intent: highlighting heroes of the popular situation-love comedy—Colombine, Pierrot and Harlequin. One can notice how the inset down below and the busts dubbed in behind the stage-center figure are finely tuned to reveal and reinforce each stock character. Colombine [#16] serenades softly amid bouquets of flowers and potted plants under a trellis with the pleasant lad in lace collar on her mind; the female busts above her each have one breast covered and hold silence, one frowning slightly and one almost smiling. Pierrot [#17] takes his awkward bow before partly shrouded, puppet-like statuettes; the woman's face seems sadly averted, and even the partially visible face of Pan(?) has an unusually subdued reticence. The simple girl in country bonnet down below is the most Pierrot could ever hope to attract, temporarily, while the maid beneath Harlequin's feet [#18] has bells on her neck and bows on her cap.

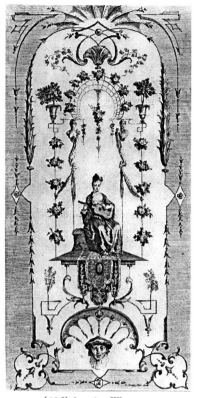

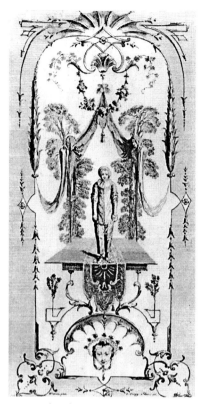

[#16] Antoine Watteau,
panel 3, 1709

[#17] Antoine Watteau,
panel 4, 1709

And a statue of Bacchus, topped comically by a basket of vines and de-
bris, chatting with a youngish bacchante forms a lively backdrop for this
wily confidence man talking you into something not wholly trustworthy.

In the final leaf of the series—after the *commedia dell'arte* figures—
Watteau circles back on the first pastoral scene; but now [#19] the court-
ship of amour—which has perhaps run the gauntlet of the possible comic
hindrances?—has ended. We see the maid crowned with the wreath of
flowers, which has always meant womanly victory, seated directly under
the symbolic circle of roses suspended in the heavens, as a pastoral queen.
Her adoring shepherd lover holds his staff as a ready scepter. Above
near the dolphins, cupid's shooting bow is hung up and his arrows are
sheathed, and the torch burns hard; the phoenix goes up in smoke. The
original placid pool of unwaked love has become a narrow rivulet from a
tumbling cataract of water that overflows the bottom fountain; and the
subterranean satyr has lost his free-wheeling grin.

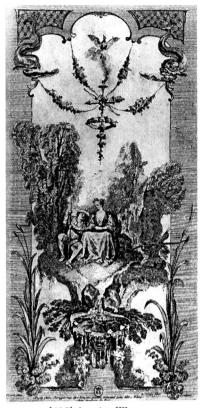

[#18] Antoine Watteau,
panel 5, 1709

[#19] Antoine Watteau,
panel 6, 1709

This piece shows what of art historical worth Watteau was doing in his day: forging an amalgam of domesticated mythology, *commedia dell'arte* types, and pastoral Arcadian motifs, all in a light delicate style of arabesques reminiscent of Fontainbleau's Primaticcio at the fashionable court of Francois I, whose troubadour courtly love ethic was codified, you could say, by Louis XIII (reigned 1610–1643), into an atmosphere of silken color tones, archaic clothes, and a fairy-tale dress-up world. But notice what has happened: when idealized shepherds and shepherdesses *and* vernacular comic types easily move within the same universe of discourse, *among* faint notes of mythical allusion, you have an art format able to talk high-flown courtly love with brief dashes of the jester's bagpipe impudence. Watteau's winsome "decorations" are unobtrusive, but they could stand up as conversation pieces if his patrons were to look at how the emblematic details, the satyr's faces, for example, or the busts in panels 3, 4, and 5, serve as mental echoes and invisible commentary

upon the main visible figure or scene.

Watteau made iconographic history at this same time with *l'Escarpolette* (c. 1709), introducing the swing, a folk pastime, into the gallant world of *fêtes champêtres*. And it is that mix of promenades in the park, rendezvous in fine clothes near a fountain, resting to picnic during the hunt—which were societal realities already in the days of Louis XIV: it is Watteau's mix of that genteel world with what is coarse that gave him a subtle, critical edge and mute counter-thesis in his artwork already before 1710. In a different study I have shown at length how Watteau's paintings are critical of the society he presented artistically.[65]

To conclude this sample art historical point one could look at *Les Bergers*, done in 1717 AD, the same year Watteau's *Cythara* served as *morceau de réception* at the French Academy. Compared to a garden scene painted by Watteau's student Lancret of the famed *Camargo Dancing* (c. 1730), to the admiration of primly seated women and other gentle folk in a lovely glade where trees act like parasols to bend with benedictions over the graceful scene of sweetness and light, Watteau's shepherds in *Les Bergers* [#20] look more bumptious, the scene less protected, the colors more robust, the hemline askew, the activities rather diverse, the trees more bow-legged than benedictional—the whole picture seems more

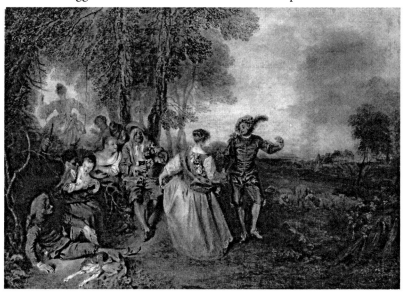

[#20] Antoine Watteau, *Les Bergers*, 1717

65 "Telltale Statues in Watteau's Paintings," *Eighteenth-Century Studies* 14:2 (1980–81): 151–180 {infra pp. 171–195}.

coarse than the dainty Lancret's commemorating the darling opera prima donna of the day. Watteau's *Les Bergers* lacks any fixed cultural referent, although it was very popular for aristocrats to hold masquerade parties in those days and also invite in a few real shepherds to liven up the amorous proceedings with a little real, coarse rambunctiousness.

The couple stage-center in *Les Bergers* is a happy couple. Whether their gallant gestures of her holding the dress ladylikely and his jaunty curved hand is totally nonchalant and carefree, part of the jig, or mimicking gallantry ever so slightly, is not sure; but the bright colors, silken textures, festive blue shawl and flowers, plume in hat, bespeak frolic and decorous contact, with her pale flesh-colored hand in his reddish one. In the alcove to the back left is a get-acquainted stage for a couple, playing with swinging; the painting seems to leave it off to the side, in the background, as if it be a memory of what has preceded the central activity where the light swinging contact between man and woman has become public and more vigorous.

The bagpiper seated with crossed legs near a tree stump has a third couple nestling in close to him together; she leans in and tucks the fellow's arm around her waist most cozily.

The lower couple is tussling: she defends her breast from being touched by this shepherd wielding his club, pouting with his mouth, acting overly aggressive—the ruffian!

While on the ground you have a fair-haired fellow taking it all in, especially the dancing couple, amid the successive stages of gently swinging, dancing frolic, cozying up to bagpipe music, and forward advances. On the lower left is this relaxing, half-lying-down fellow next to a dog, a half-quote from the Rubens' dog in the Marie de Medici series, but here the bitch has its genitals exposed—rather indelicately hinting at what all this frivolity is about?

And almost unnoticed, hidden off to the right, is a black-caped shepherd of sheep, a good? shepherd with a crook looking back over his shoulder, critical? wistful? both? while feeling left out? at least not partaking in the gaiety of *des plaisirs d'amour*. The black-caped shepherd betrays the painter's melancholic presence, I think, and is a wry comment within the painting about the delights of love, a kind of Jacques' penetration (in *As You Like It*) on the fleshly let-down that goes with courting amusements.[66]

66 This shepherd figure is not even mentioned in the interpretive description of *Les Bergers* given in the authoritative catalogue put out at the time of the major loan exhibitions prepared jointly by Paris, Berlin, Washington D.C. Cf. Margaret M. Grasselli

But Watteau's students like Lancret, as well as Frederick the Great who bought more of Lancret's paintings than he did of Watteau, dropped the bittersweet critical, questioning outsider's note in their versions of what came to be catalogued as *fêtes galantes* paintings. Therefore, Watteau's historically important integration of mixed artistic *topoi*, which laicized and "demythologized" art, not only made painterly art popularly accessible to the leisure society driven by a rococo pursuit of delicate happiness, but also deepened painterly art by excising the **literary** pictorial referents common to Cesare Ripa and fashioned, if you will, paintings whose graphic reference was exercised more by **painterly elements**, a *visual* world of *discourse*. The historical follow-up, however, to Watteau's deepening but secularizing artistic innovation was for artists to relax, miss the bittersweet note and rest in surface delights.

A cartographic art historian will also notice how the unreal *Le conert champêtre* [#21] by Renaissance painter Giorgione (including Titian?), a utopia where music, idyllic beauty, and reverie reign with perfect figures graced by lovely landscape decor, where an impeccably chaste distance rules the male fascination with erotic love, is a format that embraces Watteau's rococo-spirited art.[67] Watteau's world is a park in late after-

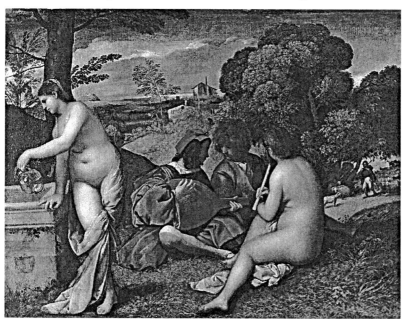

[#21] Giorgione Barbatelli da Castelfranco, *Le conert champêtre*, c. 1509

and Pierre Rosenberg, *Watteau 1684–1721* (Washington National Gallery of Art, 1984), 375–78.

67 See René Huyghe, *Watteau* [1950], translated by Barbara Bray (New York: George Braziller, 1970), 40, 48.

noon where amorous pilgrimages are made. There is never an occasion for marriage-bonds; Watteau's perception remains largely confined to a day-dreaming, adolescent longing tenderness, and the polite intrigues of opera comique. If one can come to see Watteau's painterly artworks historically, however, next to our brash exposure of *Niagara Honeymoon No. 4* (1968) by the Canadian Dennis Burton [#22], or the ubiquitous Madonna and *Sex*, where, in concert with Foucault, "sexuality" is construed/constructed to be a repressive imposition:[68] if one can read Watteau's contribution, one might be able to grasp art historically a sense of something largely lost today, that a human caress needs not a commercialized but an imaginary dimension, even when its beguilement deserves to be unmasked by black or blue-caped strangers.[69]

[#22] Dennis Burton, *Niagara Honeymoon No. 4–AUM–The Sound of the Falls*, 1968

68 Michel Foucault, "Scientia sexualis" in *La Volonté de savoir* [1967], translated by Robert Hurley, *The History of Sexuality* (New York: Vintage, 1990), 1:53–73 and 92–97. Also an interview with Foucault, "Truth and Power" [1977], in *Power/Knowledge: Selected interviews and other writings 1972–1977*, ed. C. Gordon (New York: Pantheon, 1980), 118–121.

69 See [#57], "Fêtes Vénitiennes," and analysis in my article on "Telltale Statues in Watteau's Paintings," 172–177 {infra pp. 188–191}.

* * *

I have tried to present a glimpse of cartographic art historiography in action,[70] against the expository backdrop of three basic categories: cultural period dynamic, typiconic format, and the once-only upon a time footprint trail.[71] No art historiographic method is a guarantee of a correct reading. Every method must also fade into the background as you meet the concrete artworking reality alive, begin a get-acquainted looking listening experiencing, and interpret. But art historiographic categories either prime, block, mislead, or enable receivers to taste artworks, which are indeed food for human imaginativity.[72] The thrust of this paper is to honor the Vollenhoven legacy for art history, and to show

70 David Summers is right when he says: "Art history . . . is an ongoing discussion about works of art by people who continually indicate and try to explain to others what they see either in works of art or series of them and what is significant about what they see. Such description, seriation, and explanation are by nature consensual and open to the works themselves" (in *Critical Inquiry* 15 [Winter 1989]: 395). For significant examples of an art historian looking at artworks working with cartographic methodological categories, see the important dissertation by Dirk van den Berg, *'N Ondersoek na die Estetiese en Kunshistoriese Probleme Verbonde aan die sogenaamde Moderne Religieuse Skilderkuns* (Bloemfontein: Universiteit van die Oranje-Vrystaat, 1984), and, for example, Dirk van den Berg, "Coping with Art Historical Diversity in Methodological Terms," *Acta Academica* 22:1 (March 1990): 35–52. Also, fine professional explorative and interpretive work has been done in this modified Vollenhovian way by Gudrun F. T. Kuschke, *The Representation of the Christian Ethos in the Poetry of Werner Bergengruen during the Third Reich Period*, diss. (Johannesburg: University of Witwatersrand, 1981); and Suzanne de Villiers Human, "Hogarth's Vitality," in *Suid-Afrikaans Tydskrif Kuns-Argitektuur-geskiedenis* 2:2 (1991): 42–49; and James Leach, "Instructive Ambiguities: Brecht and Müller's experiments with Lehrstücke" (Toronto: Institute for Christian Studies, M.Phil. thesis, November 1992).

71 If one wanted to track the history of painterly art, I find Lorenz Dittmann's focus upon *Farbgestaltung* promising, because Dittmann takes this nub of painterly art—color—as the relevant footprint trail to describe. See his *Farbgestaltung und Farbtheorie in der Abendländischen Malerei: Eine Einführung* (Darmstadt: Wissenschaftliche Buchgesellschaft, 1987).

72 The question, raised by Henk Geertsema in response to this paper, whether cartographic categories, and a Vollenhovian method in general, are not overly "determinative"—do they really allow an interpreter to engage "the other" historically, to listen to and understand what is "foreign" to the historian—is a fair question to ask of any historiographic method, of one that self-consciously knows its mind and of ones that are less self-aware. (See my comment on pedagogical strength and danger, above page 45, and "The Pedagogical Strength of Christian Methodology in Philosophical Historiography," *Koers* 40:4–6 (1975): 269–313 {see *CE*: 277–315}. Openness to what is strange, care for what is human, and the timing of one's judgment are probably crucial in the matter of whether one's diagnosis of the neighbor's face identifies its lineaments well or disfigures the profile.

that Vollenhoven gives wholesome bread rather than stones. This Vollenhoven centennial has also been a good occasion to put into practice Walter Benjamin's principle that the historian is redemptive in redressing past injustices by memorializing them.[73]

I picture the solitary Vollenhoven working late at 56 Koninginneweg under a glaring light bulb in a cold house kitchen during the winter war years of Nazi occupation, sifting through the debris of preSocratic philosophical fragments and testimonia, patiently trying to bring historical philosophical order out of Diels-Kranz' exhaustive labors. I know that when Vollenhoven's researched results were published in 1950, the hostility of the Dutch professional philosophical establishment's reception[74] was a factor in holding Vollenhoven's booked work in Greek philosophy to "Deel 1." I should like my contribution today, along with the others, to remember with gratefulness the faithful historiographic theoretical struggles that led Vollenhoven to enunciate the Scripturally directed principles he learned and practiced in those solitary labors with his *Inleiding en Geschiedenis der Griekse Wijsbegeerte vóór Platoon en Aristoteles.* One commemorates best, perhaps, by carrying on reformingly the earlier service rendered.

If there be any skeptics on the christian community's need to know what one's historiographic methodology is, a few lines from Bertolt Brecht's poem "An die Nachgeborenen" might be appropriate:

> . . . Ihr, die ihr auftauchen werdet aus der Flut
> In der wir untergegangen sind,
> Gedenkt
> Wenn ihr von unsern Schwächen sprecht
> Auch der finsteren Zeit
> Der ihr entronnen seid.

> . . . Dabei wissen wir ja:
> Auch der Hass gegen die Niedrigkeit
> Verzerrt die Züge.

> Auch der Zorn über das Unrecht
> Macht die Stimme heiser. Ach, wir
> Die wir den Boden bereiten wollten für Freundlichkeit
> Konnten selber nicht freundlich sein.

73 Walter Benjamin, *Thesen über den Begriff der Geschichte,* II, III, VI, XV, A, B.

74 Johan Stellingwerff's careful report on the controversy in *D. H. Th. Vollenhoven (1892–1978): Reformator der wijsbegeerte* (Ten Have: Passage, 1992), 195–203. K. J. Popma's strong apologetic remains a vital testimony to the tempest: "Historicale methode en historische continuïteit," *Philosophia Reformata* 17 (1952): 97–142.

Ihr aber, wenn es so weit sein wird
Dass der Mensch dem Mensch ein Helfer ist,
Gedenkt unsrer
Mit Nachsicht. . . .

And for all the faithful who mean to persist in doing justice by keeping history with integrity, the final word of shalom is this: to be a reliable historian, with a thickened,[75] charitable, fine-tuned remembrance, is possibly one of the highest reflective callings today, showing love to one's disoriented neighbors,[76] if you indeed do justice to your faith forebears by bringing their labors to life again, keeping your promise to those who gave us life, also in philosophy, and so walk humbly with our covenant God (Micah 6:8).

75 See chapter 11, "The Thick Autonomy of Memory," in Edward Casey, *Remembering: A phenomenological study* (Indianapolis: Indiana University Press, 1987), 262–287.

76 John Calvin's judgment, in an age of unruly partisan wars, that to be a civil magistrate (circuit judge) to administer God's merciful justice without respect of persons is "*vocatio . . . non modo coram Deo sancta et legitma, sed sacerrima etiam, et in tola mortalium vita longe omnium bonestissima*" (*Institutes of the Christian Religion* IV, 20, iv) deserves, in our day of overpowering media and hyper-reality, dominated by a pragmatistic mentalité turned only to future success, the complement of recognizing that historians who selflessly bear true witness in these "last days" to the deeds of others are at the crux of providing leadership.

With Dirk van den Berg, Professor of Art History at the University of the
Free State, in Bloemfontein, South Africa, 2004 (photo by Julia van den Berg)

TOWARDS A CARTOGRAPHIC
METHODOLOGY FOR ART HISTORIOGRAPHY

To designate certain affairs as a period in history is to assume or posit some kind of unified process or whole to what has been happening that can be overseen. When an historian judges a certain sequence of various occurrences to constitute a complex with the identity of a period, he or she is making the crucial and most conclusive historiographic decision of present knowledge about those events in times past.[1] Whether the historian's judgment be in fact insightful or superficial, tentative or certain, right or wrong, without attempting the ordering of knowledge which the category of "period" provides, the historian has abdicated his office. It is simply philosophically naive to think and write as if "periods" are a matter of chronology.[2] Historical beginnings and endings are of a different sort than those determined by which side of the earth faces the sun. Historiography is not a series of almanacs.

The kind of reality historical periods have is still a mooted problem. For millennia Western thinkers believed world development fell into definite epochs ordained to correspond to the six days of creation or the six stages of microcosmic man's lifetime. In their view periods existed as substantively different ages, marked by significant events outside of human control, which nevertheless succeeded each other in one continuous movement.[3] Italian Humanists of the fifteenth century devised the

1 J. H. J. van der Pot, *De Periodisering der Geschiedenis: Een overzicht der theorieën* (The Hague, 1951), 17–18, 22. This dissertation is accompanied by a very brief summary in English.

2 Claudio Guillén, "Second Thoughts on Currents and Periods," in *The Disciplines of Criticism: Essays in literary theory, interpretation, and history*, eds. P. Demetz, Th. Greene, Lowry Nelson, Jr. (Yale University Press, 1968), 489–90.

3 This framework developed by Augustine in *De Civitate Dei contra paganos* remained popular well into the 1500s, Cf. Denys Hay, *Annalists & Historians: Western historiography from the VIIth to the XVIIIth century* (London, 1977), 17–23, 27–32, 89–90, 118–19. Also, Van der Pot, *Periodisering*, 40–43.

First published in *Journal of Aesthetics and Art Criticism* 39:2 (1980): 143–54.

schema of "ancient," "medieval," and "modern" times. Although in common use today this periodization is uncommonly useless for scientifically precise historiography because of the bland content of each period, the uncertain criteria adopted for differentiating them, and the fruitless arguments engendered as to whether modernity began with the Renaissance or the Enlightenment.[4] Important for my topic is the twist Hegel, Herder, and Fichte gave to the "modern" period when they, in collaboration, if you will, converted the wisdom or spirit of ages past into the genius or spirit of their own post-French Revolutionary day. *Zeitgeist,* conceived as a cagey, almighty Daemon brooding with destiny over all cultural phenomena,[5] gave historiography a powerful, secular principle for periodization: detect the ruling Spirit of a time and you can characterize the historical homogeneity present; dated boundaries and lacunae in its regime can be discovered more exactly later.

Current historiography, however, by and large is leery of accepting the German Idealist mythology of a daemonic Spirit. The most that academicians are usually prepared to grant is that periods are heuristic devices, conceptual instruments to detect connections; "periods" can perhaps serve as hypothetical "regulative ideas" or disposable models for analysis, but not many thinkers today would accept responsibility for much more.[6] And a few intrepid souls walk in where more careful scholars fear

4 For sources and a critical review of the matter cf. Van der Pot, *Periodisering,* 113–23, 126–50. Jacob Burckhardt saw the modern era begin with the Italian Renaissance "individual." Ernst Troeltsch argued that only with the *Aufklärung* did culture break out of its restrictive, ecclesiastical imperium and begin a new age.

5 Herder's 1798 text sets the tone: "'Was ist der Geist der Zeiten?' Allerdings ein mächtiger Genius, ein gewaltiger Dämon" (II, 14). *"Geist der Zeiten* heiße also die Summe der Gedanken, Gesinnungen, Anstrebungen, Triebe und lebendigen Kräfte, die in einem bestimmten Fortlauf der Dinge mit gegebenen Ursachen und Wirkungen sich äußern. . . . Diesen Gemeingeist des aufgeklärten oder sich aufklärenden Europa auszurotten ist unmöglich. . . . Irre ich nicht, so sind *drei Hauptbegebenheiten* oder *Epochen Europas,* an denen dieser europäische Weltgeist haftet. Eine ist längst vorüber, sie dauerte fünf- bis achthundert Jahre und kommt hoffentlich nie wieder. Die zweite ist geschehen und geht in ihren Wirkungen fort; ihr Wert ist anerkannt, und muss, der Natur der Sache nach, immer mehr anerkannt werden. Über der dritten brütet der Weltgeist, und wir wollen ihm wünschen, dass er in sanfter Stille ein glückliches Ei ausbrüten möge" (II, 16). *Briefe zur Beförderung der Humanität* (Berlin, 1971), 1:77, 80–81. Cf. Karl Löwith, *Von Hegel zu Nietzsche* (Stuttgart [1941], 1958), 220–251.

6 B. von Wiese, "Zur Kritik des geistesgeschichtlichen Epochebegriffes," *Deutsche Vierteljahrschrift für Literaturwissenschaft und Geistesgeschichte* 11 (1933): 130–144; René Wellek, "Periods and Movements in Literary History," *English Institute Annual 1940* (Columbia University Press, 1941): 88–93; Wallace K. Ferguson, *The Renaissance in Historical Thought: Five centuries of interpretation* (Cambridge, 1948), 393; H. P. H. Teesing, *Das Problem der Perioden in der Literaturgeschichte* (Groningen, 1949), 8–11,

to tread and virtually reject periods as fictions. They tend to revert to re-sensing and "presentifying" great, old artifactual forms, so not to segment the worm of history, or skillfully catalogue discrete items found within parts of centuries.[7] Such a method is indeed without daemonic madness, but it also leaves historiography without ontic grounding, blowing where it lists, since "centuries" have nothing to do with historical knowledge and have no base in human experience other than their being a multiple of our normally having ten toes.

To elucidate the general problem I shall focus in this essay specifi-cally on what is called "the Enlightenment" in the eighteenth century, or the cultural span when "rococo art" was dominant in Europe. Did the Enlightenment actually exist as an historical period once upon a time, or is it only in a few scholarly minds?

I should like to pass in critical review several major positions taken on the question before I present my own alternative. The answer to the question on the reality and character of the Enlightenment period not only shows one's particular historiographic method but also deeply af-fects one's resultant understanding of art and literature produced by two generations of gifted people, let's say, from around 1712 to the 1770s in Europe and England.[8]

Historical sense comes, in my judgment, when one can relate our day to other times and interpret the difference in culture meaningfully for a next generation. If the Enlightenment period and any phases within it be nothing more than momentary shapes conjectured to be seen in the flames of history, many eighteenth-century scholars today will only have red faces for their trouble, from having been too near the fire. The same will hold true for historians of art and literature of whatever "period."

The late Arnold Hauser (1893–1978), perceptive and undoctrinaire, exposits French *fêtes galantes* painting, *hôtels,* and the decorative salon art of society during the years of the Régence and Louis XV as the dialectical

40–48 [Teesing corrects Von Wiese's misuse of Kant, pp. 46–47]; Alastair Fowler, "Periodization and Interart Analogies," *New Literary History* 3 (1971–72): 489–91.

7 Cf. Teesing, *Das Problem der Perioden,* 12–17; Jost Hermand, "Über Nutzen und Nachteil literarischer Epochenbegriffe, ein Vortrag," *Monatshefte* 58:1 (1966): 296–300; Lawrence Lipking, "Periods in the Arts: Sketches and speculations." *New Liter-ary History* 1 (1969–70): 189–200; David Rosand, "Art History and Criticism: The past as present," *New Literary History* 5 (Spring 1974): 437–38; lectures given by Ralph Cohen at the University of Toronto, spring 1979.

8 "Patterns of emphasis in research are not completely determined by assumed or ac-cepted schemes of periodization, of course, but it would be difficult to deny their focusing influence." Clifton Cherpack, "The Literary Periodization of Eighteenth-century France," *PMLA* 84 (March 1969): 323 n. 12.

turning point of elitist Renaissance culture and our more democratic way of pursuing happiness.[9] So-called rococo art, which was "the last universal style of Western Europe" and "the final phase in a culture of taste . . . the last style in which 'beautiful' and 'artistic' are synonymous," rococo art expresses *in its form* the worldview at work among the artistocracy and middle-class of those days seesawing back and forth for societal cultural power.[10]

Independently, in connection with his analysis of French literature of the same time, Roger Laufer posits practically an identical thesis. Rococo style, *style des "lumières,"*[11] says Laufer, in all its astonishingly backtracking, unifying sinuosity expresses perfectly in *un compromis souriant* the underlying socioeconomic contradiction of a bumbling *l'ancien régime* opening its doors to artisan and *philosophe* and the social-climbing middle-class picking up blue-blood culchah.[12] The very structure of rococo elegance mediates, manifestly blends with titillating technique, the constant opposition of *raison* and *sensibilité* which were held in tense

9 Arnold Hauser, *The Social History of Art,* translated by S. Godman (New York, 1951), 3:33. "The rococo itself prepares the way for the new alternative, by undermining the classicism of late baroque and by creating with its pictorial style, its sensitiveness to picturesque detail and impressionistic technique an instrument which is much better suited to express the emotional contents of middle-class art than the formal idiom of the Renaissance and the baroque. The very expressiveness of this instrument leads to the dissolution of rococo, which is bent, however, by its own way of thinking on offering the strongest resistance to irrationalism and sentimentalism. Without this dialectic between more or less automatically developing means and original intentions it is impossible to understand the significance of the rococo; not until one comes to see it as the result of a polarity which corresponds to the antagonism of the society of the same period, and which makes it the connecting link between the courtly baroque and middle-class pre-romanticism, can one do justice to its complex nature."

10 Ibid., 3:35. Also Arnold Hauser, *The Philosophy of Art History* (Cleveland, [1958], 1969), 241, and *The Sociology of Art,* translated by K. Northcott [1974], from a section published in *Critical Inquiry* 5:3 (1979): 429–30, 436–38.

11 Laufer has been criticized for his unusual and expansive use of the term "rococo." "Entre le classicisme de 1660 et le romantisme de 1830, la France n'a élaboré qu'un seul style, auquel je propose de donner un seul nom, celui de rococo." *Style Rococo, Style des "Lumières"* (Paris, 1963), 13. But he carefully notes nuances of change ("On peut distinguer dans le rococo trois moments. . ."), affixing more conventional limits (cf., 39). Dates are among the lesser worries for Marxist historiography. It is true, however, that various traits he ascribes to rococo literature may arguably be features of general artistic normativity rather than dated ones peculiar to a rococo style. And his repeated "la mise en question, caractéristique du rococo" (30) may overload, I think, the historical fact with eisegeted connotations borne by a twentieth-century existentialistic sensitivity. Cf. also 25, 28, 46, 48.

12 Laufer, *Style Rococo,* 13–14, 39.

dialectical equilibrium by the society in ferment until the critical '60s and only reached a resolution of sorts in the revolution.[13]

So both Hauser and Laufer see Enlightenment culture as a period to be a pivotal, passing stage in an ongoing dialectical struggle for a brave new world. Hauser's and Laufer's keen analyses of the restive preciosity of rococo art and literature remind one of the fascinating love-hate evaluation of the Enlightenment's blessed curse upon our life-patterns today made by Horkheimer and Adorno and various Neo-Marxists, as if "the Enlightened ones" halted between two opinions of privilege and revolution and therefore left a legacy of societal and cultural disarray.[14]

When Hans Sedlmayr treats the *Hôtel de Soubise* as an exemplary rococo *Gesamtkunstwerk* against the backdrop of world epochs in art history and, on a more restricted scale, in the setting of the four major eras of Western art since the Roman empire, one receives a much more settled picture of French art 1725–1750 AD than appears under Hauser and Laufer's scrutiny.[15] Régence and rococo architecture and painting may have been bitten by the bug of a velvet-gloved (*"taubenfüssige"*) revolution, but it is still a late species of the Renaissance-baroque age of Western art, 1470–1760, says Sedlmayr. The efflorescence of ornamentality and the obeisance to erotic passion stamp the rococo as secular, blind to regions of supersensible reality to which its images could be analogues; but the easy grace of the encircling rococo line saves it from the godless anarchy and subsequent disrespect for natural materials which begins in earnest sometime after 1770, leading to our present technocratized planet.[16]

13 "Le style rococo exprime la réalité la plus profonde du dix-huitième siècle: il découvre sans les dépasser les insolubles contradictions économiques dont les répercussions idéologiques amenèrent dans les années soixante la crise de la philosophie des Lumières" (Ibid., 42). Cf. also 32–34, 38, 43.

14 Max Horkheimer and Theodor W. Adorno, *Dialectic of Enlightenment*, translated by J. Cumming [1944] (New York, 1972). Analyzing fundamentally from the same position Pierre Francastel reaches a similar bittersweet judgment on "L'Esthétique des lumières" in *Utopie et Institutions au XVIIIe Siècle* (Paris, 1963), 336–37, 343, 348–52, 356.

15 Hans Sedlmayr, "Die Vier Zeitalter" (1948), "Weltepochen der Kunst" (1956), and "Das Gesamtkunstwerk der Régence und des Rokoko" (1958), in *Epochen und Werke: Gesammelte Schriften zur Kunstgeschichte* (München, 1960), 2:342–60, 188–93.

16 "Die innerste Triebfeder dieser sanften Revolution in beiden Hauptphasen—Régence und Rokoko—ist die Verkündigung einer neuen obersten Lebensmacht, der stärksten unter allen: der sinnlichen Liebe. Göttlich verklärte, verfeinerte Sinnlichkeit—das Geistreiche der Sinne—wird das Ideal" (Ibid., 2:190). Cf. also 2:191, 193, 350–52, 358–60. Also, "Analogie, Kunstgeschichte und Kunst," *Studium Generale* 8: 11 (1955): 697–703.

Helmut Hatzfeld follows the same line of attack, albeit more with literary flair than with philosophical precision.[17] It appears to be more important for the kind of historiography Sedlmayr and Hatzfeld practice to detect the general *Weltanschauung* incarnate in given art and literary works than to document their interacting crises, becomings and begoings. So Periods for them tend to become types or solid states of value-configurations in which the art and literary historian's task is to detect the spirit of a piece, deduce its measure of typicality, for example, as "rococo man," and further, using co-temporal cultural evidence from other fields, gauge its *geistesgeschichtliche* step on the world history scale of wholeness, beauty, holiness, or evil.[18]

Wylie Sypher's tack is not to debate the fact that bona fide styles are striking indices to cultural life and a prevailing, contemporary world outlook; but he takes pains to state that styles, which may double up in a period (= time-span) or in an artist's oeuvre, have a life of their own in art and literature, so that a history of style transformation does not need to become "culture history."[19] In fact Sypher originally held forthrightly that

17 "Der Versuch eines destruktiv-kritischen Bruches mit einer säkularen Vergangenheit, der von einer leichtfertigen Oberschicht durch geschickte Vulgarisation verbreitet wird, gibt dem Rokoko seine innere Anarchie. So darf man wohl Rokoko definieren als: *Seelische Anarchie unter der Maske des heiteren Spiels*." Helmut Hatzfeld, "Rokoko als Literarischer Epochenstil in Frankreich," *Studies in Philology* 35 (1938): 535.

18 Ibid., 35:534. Also, "The Rococo of the Eighteenth Century 1715–1789," in *A New Approach to French Literature* (Oxford University Press, 1952), 102–19; "A New Periodization of Literary History: A review article," *Romance Notes* 2:1 (1960): 73–75; and *The Rococo: Eroticism, wit, and elegance in European literature* (New York, 1972). The breath-taking seriousness of what is at stake for Sedlmayr becomes clear when Sedlmayr ups the ante on Max Dvoraks' methodology and talks about the metahistoriography of art: "Auf dieser höchsten denkbaren Ebene [where one judges the truth or lie of the art work] wandelt sich Kunstgeschichte als Geistesgeschichte in *Kunstgeschichte als Pneumatologie und Dämonologie*." From his piece "Kunstgeschichte als Geistesgeschichte" [1949], in *Kunst und Wahrheit: Zur Theorie und Methode der Kunstgeschichte* (Hamburg, 1958), 81–82. Lorenz Dittmann signals dangers in Sedlmayr's position in *Stil Symbol Struktur: Studien zu Kategorien der Kunstgeschichte* (München, 1967), 186–92, 204–208, 212–13.

19 Wylie Sypher, *Four Stages of Renaissance Style* (Garden City, 1955), 9–10, 13–18, 39. ". . . I have assumed that a genuine style is an expression of a prevailing, dominant, or authentically contemporary view of the world by those artists who have most successfully intuited the quality of human experience peculiar to their day and who are able to phrase this experience in forms deeply congenial to the thought, science, and technology which are part of that experience. . . . A style is more than the techniques that go into the making of the style, for a style expresses in adequate and, perhaps, classic form the whole consciousness of an age." *Rococo to Cubism in Art and Literature* (New York, 1960), xix–xx.

styles recur and probably follow a set cycle of integration, disintegration, and reintegration, although not in any strictly determined number of years.[20] His later reflection hedges a bit by saying that stylistic *techniques* recur, and he honors the cumulative debt of any newly occurring style to the total of past styles.[21] Yet Sypher is still willing to maintain that the rococo as a major modern style recurs; it returns in the late nineteenth-century stylization of Art Nouveau.[22]

With that the proverbial bag or muddle of worms is opened: how can "the rococo period, covering roughly the first half of the eighteenth century,"[23] born of honest Newtonian deism and breathing arabesque heroic couplets,[24] ever be said to "recur"? Is the idea of a "period style" emptied of calendar dates serviceable to an authentic writing of *history?* Are neo-styles ("neo-rococo," "neo-classical") historically possible as genuine atavisms?

The case argued by Philippe Minguet is more restrained. With admirable care he explores the equation that artistic culture is not wholly other from current societal affairs but as functions of one another, in tandem, art and other meaningful life practices show congruence and

20 Sypher, *Four Stages*, 6–9. ". . . we shall be less concerned with historical sequence or geographic latitude than with defining the alternations in style occurring everywhere in the renaissance arts. . . . Like the burning phoenix, a style can resurrect and transform itself in a miraculous way. It has its own fate, but not always the fatality of the history that is written in time" (Ibid., 32–33).

21 Sypher, *Rococo to Cubism*, xx–xxi, xxvi.

22 "Yet rococo is a legitimate—indeed, a recurring—style, and trifling as it may be, is singularly important because it is the last coherent style before the later eighteenth century, and the nineteenth, lost a style and had, instead, only stylizations. In fact, the return to a style at the close of the nineteenth century came in part through the neo-rococo methods of Art Nouveau. This is why we must deal with rococo as a modern style." Sypher, *Rococo to Cubism*, 4. Cf. also "the decorative Art Nouveau, the new rococo of the later nineteenth century" (24, 47, 229–231, 238–40). Between 1955 and 1960 Sypher's grand programmatic cycles of style ("The cycle of renaissance styles is closed," *Four Stages*, 34) broke down, I think, perhaps under the influence of Hauser and Francastel's more developmental, genetic approach (explicitly acknowledged in *Rococo to Cubism*, v, xviii–xix, xxi–xxiii, 152). In 1955 Watteau and rococo seem to be the last stage of a cycle (*Four Stages*, 9, 32); in 1960 rococo is called "the first modern style" (*Rococo to Cubism*, 20), and is followed only by "tendencies" until the "neo-archaic" (*Four Stages*, 32) or "archetypal" (*Rococo to Cubism*, xxiii) modern style of cubism takes command. If styles have the order of "systems" for Sypher (cf. Emil Kaufmann quote in *Rococo to Cubism*, xvii), then now rococo and cubism will not recur (?). In 1960 the brevity and danger of a full-fledged style is emphasized (*Rococo to Cubism*, xxiv, 153–55).

23 Sypher, *Rococo to Cubism*, 25.

24 Ibid., 12–15, 41–43.

convergence; and when historiographers recognize such a concordance for a time somewhere as a common style, a cohering *esprit du temps,* for example, from around 1720–1760 in Europe, and call it "rococo," nobody should nitpick the term to mean every fact alive and dead then has to exemplify every one of its family characteristics.[25] Minguet shows by painstaking analysis of peculiarly architectural features in buildings designed by Neumann, the Zimmermanns, and Cuvilliés in southern Germany, that one cannot do justice to their forms, purpose, aura, or structure in terms of "late baroque" or "classical" style architecture. Their architectural originality is thoroughly and irreducibly rococo, a third way *(une troisième voie)* aesthetic normativity shows up historically between the Renaissance and Impressionism, naturally always colored by particular artistic visions and locale.[26] He uses the close bond between architecture and life-style to draw a convincing portrait of the public mentality that lived and moved and had its being within bemirrored apartment, miniaturized salon, and atectonic church, under an "epiphany of graciousness":[27] so he documents the independent identity of a rococo art and life-style, however limited and short-lived.[28] Nevertheless the question still rises because of how he explains both the sublime baroque and the gracious rococo as being "deviations" from the most normal, perennial, more equal ideal of the three—classical beauty: does a rococo period style slip then somewhat for Minguet too into a possible categorical type?[29]

1. We do well to recognize the turbulence of historical genesis Hauser and Laufer highlight. In my judgment they force a disruptive, dialectical scheme upon the reality of cultural development and reduce

25 Philippe Minguet, *Esthétique du Rococo* (Paris, 1966), 181, 190–91, 254, 261–62, 272–73.

26 Ibid., 62, 123–24, 143–75, 277–79.

27 Ibid., 181–82, 200–06, 238–40, 277 *et passim.*

28 Ibid., 175, 277.

29 "On voit l'avantage considérable de la primauté *de droit* que nous reconnaissons au classique, en nous fondant, croyons-nous, sur la nature des choses. Repensé légitimement, non comme un pôle, mais comme le centre, il est susceptible d'être modalisé dans un autre sens que le baroque. A l'équilibre de *déficience* correspond cet équilibre de *surcroit:* la grâce. Double recherche de l'équilibre: l'une d'une harmonie qui se fait et se défait; l'autre d'une harmonie *parabolique,* corrigeant sa *mollesse* par la *virtuosité,* sa tension par la rémission" (Ibid., 276). Minguet's preference for classical style (au sent large) as *unité dans la variété* shows up repeatedly: 63, 116, 145, 158, 275. Fowler noticed a comparable bias in Ernst Robert Curtius and E. H. Gombrich's breakdown of styles, although they credit only one departure from the norm—mannerism. Cf. Fowler, "Interart Analogies," 494–95.

art and literature into pawns of a fated class struggle; but they honor the fact that periods are a war of currents and counter-currents and eddies of forces busy interacting, transacting, and confronting one another, and that the rise and fall of period styles is bloody because human allegiances are at stake. So no art or literary historiography worth its salt will describe rococo style in the Enlightenment setting as a checker game of artistic forms.[30] Periodization is not a chess problem.

2. Sedlmayr and Hatzfeld point to the unpopular truth that cultural leaders in history serve different idols. In my judgment they tie up the hegemonic stance on ultimate concerns at a given time into too neat a package; they tend to look at art and literature mostly as faces for world-views; and because they adjudge secularization to plague our civilization with an enormous loss of value they fail to see the past historical need for desacralization of culture if it would mature, and simply are suspicious of innovative changes in art and literature as probably destructive. But they rightly appeal to the fact that periods are dated, irreversible, discontinuous configurations of norms posited in time, and that the historiographic point is how a new generation trades on the tradition inherited in its field, evaluated against some final standard.[31] Art and literary historians who would believe that the Enlightenment is only a generalization and not a deep-going environment of spirited commitment surrounding the works of man's hands forfeit their historiographic birthright to assess the meaning and place in world history of the artifacts they examine. That leaves the field open for spot checks on individual pieces by new critics for anything curious to our attention.

3. The sanity with which Sypher and especially Minguet assemble comparative art detail and societal phenomena to describe a rococo style can teach us what an historical homogeneity is and is not. They exhibit the fact that periods are historical events: not sums of happenstantial entities in succession and not logical constructs. It would save untold debate over secondary matters if it could be commonly accepted that

30 Arnold Hauser, "Art History Without Names," in *The Philosophy of Art History*, 156, 161–65, 208–210. "Style is neither a genetic nor a teleological concept; it is neither set before the artist nor accepted by him as a goal. It is neither a special-concept under which particular phenomena are subsumed nor yet a logical category from which other concepts could be derived. It is rather a dynamic relational concept with continually varying content, so that it might almost be said to take on a new sense with each new work" (Ibid., 209). Cf. Laufer, *Style Rococo*, 42–43; Francastel, "L'Esthétique des lumières," 349–50.

31 Wellek, "Periods and Movements," 89–91; Dittmann, *Stil Symbol Struktur*, 163; John Passmore, "History of Art and History of Literature: a commentary," *New Literary History* 3 (1971–72): 575, 584–86.

it is unscientific to treat periods, i.e., *historical events,* as a *logical class* of items that need to have necessary and sufficient reasons to be included or whose members must instantiate a precise definition.[32] The community of traits Minguet and Ronald Paulson, for example, establish by deft, relevant characterization which honors peculiar national idiosyncrasies and the particularity of architecture, interior decoration, manners and mores, landscape art, engravings, painting and novel, while showing a significant, over-all, cultural pattern,[33] proves that historical realities caught and delineated by historiographic categories like period, style, tradition and trend, are of a different order than what a logical dart can hit. Just so little as the differences in ultimate philosophical convictions which bedevil theories of history can be adjudicated and settled by an umpire in logic, just so little can tightening up one's definition of terms provide genial historiographic insight or correct historiographic astigmatism.[34]

32 Historical reality may drive logicians berserk, but the solution would be to develop a logical analysis supple with imagination, not try to square the parabola of historical unity into a Venn diagram. Cf. Meyer Schapiro, "Criteria of Periodization in the History of European Art," *New Literary History* 1 (1969–70): 113–14; Fowler, "Interart Analogies," 492–93. Note Karl Aschenbrenner's nod to Kant's "reflective" judgment and his own careful thought on "historical universals" and "similation," in *The Concepts of Criticism* (Dordrecht-Holland, 1974), 295–319.

33 Cf. Ronald Paulson, *Emblem and Expression: Meaning in English art of the eighteenth century* (Harvard University Press, 1975), for example, "The Poetic Garden," 19–34, and "The Conversation Piece in Painting and Literature," 121–36.

34 Logical precision in making distinctions naturally has an important, limited service within all narrative. One must beware, however, of over-precisioning terms, as if univocality and equivocality are the only possibilities for sound discourse. In correcting Paul Hazard's extreme definition of "season," Roland Mortier opens the door for an ampler sense to do justice to Diderot's "raison-sentiment" ("Unité ou scission du siècle des lumières?" in *Studies on Voltaire and the Eighteenth Century* 26 [1963]: 1207, 1211, 1215–16), what one might call a ludic rationalism. Also, whether "rococo" deserves the dignity of synonymity with "Enlightenment," in Anger's terms, whether "rococo" is a *Zeitstil* or *Epochenstil,* and whether such cultural movements be truly cosmopolitan in Europe or staggered, parallel national developments: such problems are not questions demanding *logical* decisions. Cf. Alfred Anger, *Literarisches Rokoko* (Stuttgart, 1967), 11–14; Werner Krauss, "Zur Periodisierung Aufklärung, Sturm und Drang, Weimarer Klassik" within the section on "Zur Konstellation der deutschen Aufklärung," in *Perspektiven und Probleme, Zur französischen und deutschen Aufklärung und andere Aufsätze* (Berlin-West, 1965), 234–38; Carl J. Friedrich, "Style as the Principle of Historical Interpretation," *Journal of Aesthetics and Art Criticism* 14:2 (1955): 144–45. Also cf. Teesing, *Das Problem der Perioden:* "Was wir als primär and was wir als sekundär betrachten wollen, ist also lediglich eine Frage des Standpunktes. Mit wissenschaftlichen Mitteln lässt sich das kaum entscheiden. Nur dann ist eine Entscheidung möglich, wenn man auf Grund einer bestimmten Weltanschauung (oder doch einer bestimmten geschichtsphilosophischen Lehrmeinung) seinen

Before I conclude with a modest proposal on a way to overcome the most persistent bugaboo of art historiography into which Sypher and many less critical historians slip—the metamorphosis of unique periods into recurrent types of human cultural dispositions—I should note the important work of two masters of caveat in our search for a more fruitful historiographic method dealing with the Enlightenment as a period.

Herbert Dieckmann cautions against *le grand tableau* as an abstraction but admits that there is a general cultural current one may call "rococo" and "a movement of Enlightenment, which undoubtedly constitutes an essential part of the eighteenth century. . . ."[35] His worry is that a basic trait or specific ideology of the *Aufklärung,* such as its religious iconoclasm, be hypostatized, essentialized, and prevent historians from remembering, for example, Pascal's living presence then, including Pascal's contextual import for Voltaire's polemics.[36]

While no one will argue with the rejection of oversimplified generalizations and blanket preconceptions, nor doubt that the corroborating translation of criteria from one cultural field to another is fraught with pitfalls, still Dieckmann's confession to a nominalistic skepsis is sad.[37] His tired wisdom to forego "defining the oneness" of the period and to hold

Standpunkt verabsolutiert" (79).

35 Herbert Dieckmann, "Themes and Structure of the Enlightenment," in *Essays in Comparative Literature* (St. Louis, 1961), 56–59; "Reflections on the Use of Rococo as a Period Concept," in *The Disciplines of Criticism,* ed. P. Demetz, et al. (Yale University Press, 1968), 429–31, 434.

36 Dieckmann, "Religiöse und Metaphysische Elemente im Denken der Aufklärung" [1963], in *Studien zur europäischen Aufklärung* (München: Wilhelm Fink, 1974), 259–60, 266, 271–73.

37 Dieckmann, "Rococo as a Period Concept," 431–35. "Den Beiträgen zur Erforschung des 18. Jh., die in dieser Sammlung erscheinen, liegt keine allgemeine Theorie der Geschichte oder Deutung und keine allgemeine These des Wesens der Aufklärung zugrunde. Obwohl der Verfasser nicht abstreiten will, dass die Aufklärung als eine Epoche bezeichnet werden kann, ist er sich zu sehr ihrer Vielgestaltigkeit bewusst, um zu versuchen, ihre Einheit zu definieren; er vermeidet sowohl Antithesen aufzustellen, wie Synthesen zu konstruieren und glaubt, der Geschichte gerecht zu werden, wenn auf Grund von spezifischen Fragestellungen Beziehungen zwischen verschiedenen Autoren erkennbar und in einem problemgeschichtlichen sowie formgeschichtlichen Zusammenhang deutbar werden. Ob die Begriffe, die er verwendet, gültig sind, muss nicht das vorhergehende Reflektieren auf sie, sondern das Erkenntnisergebnis zeigen. Mit diesem Verfahren, in dem man ein Bekenntnis zu nominalistischer Skepsis sehen kann, hofft er angesichts einer modischen Aktualisierung der Aufklärung bewusst zu machen, dass uns diese Epoche nahe und doch fern steht. . . . Historische Anschauung oder sehende Erkenntnis ist immer schon Vermittlung zwischen Vergangenem und Gegenwärtigem, mithin eine Weise der Überwindung des Historismus." From the 1974 "Nachwort" in *Studien zur europäischen Aufklärung,* 491.

his "historical prehension" at making specific interconnections between different figures intelligible remains fixed by the very logicistic project of definition he rejects and belies the accumulating promise of his own methodical notation of themes and characteristics that are "representative."[38]

Concept specialist, and gadfly extraordinaire, Patrick Brady has faulted so many analysts of rococo style one may sometimes think he believes that any consistent method will falsify the cultural whole if it identifies a pattern that is more than an artistic tendency.[39] Other times Brady himself uses "Zeitgeist," "rococo society" and even "rococo culture" as if they were established terms.[40] Perhaps his strictly individualist-empiricist bark is worse than his more recently acquired Structuralist bite?

Yet despite the enormous, important knowledge helpfully gathered, as it were, on the head of a pin, and the intense rigor of statement exacted by his expert analytic precision, there are a few dubious tenets that need questioning.

(1) On what grounds should one believe that a strictly *definitional* thread will lead us out of an *historical* labyrinth?[41] Does not such a logical class conception of "period," ultimately based on dates, named by majority vote of artifacts of the time,[42] miss the very nub of "defining" a period

38 Cf. Dieckmann, "Rococo as a Period Concept," 421, 431, 435.

39 "A style label is useful only in so far as it defines primarily an aesthetic attitude or tendency rather than a period." Patrick Brady, "Rococo Style in French Literature," *Studi Francesi* 30 (1966): 428, repeated in "From Traditional Fallacies to Structural Hypotheses: Old and New Conceptions in Period Style Research," *Neophilologus* 56 (1972): 3–4, and again in "The Present State of Studies on the Rococo," *Comparative Literature* 27:1 (1975): 30. Also, cf. review of Hatzfeld in *Comparative Literature* 25: 4 (1973): 265, and "Present State of Studies," 22, 33.

40 "A un certo momento, una delle varie tendenze coesistenti può avere il sopravvento, o perché esprime una specie di *Zeitgeist* che meglio appaga, o perché s' armonizza col temperamento dei massimi artisti dell'epoca, o perché esprime il gusto del ceto che ordina le opere a questi artisti: ed è un fatto che i suddetti motivi sono raramente indipendenti fra loro." Patrick Brady in *Dizionario critico della letteratura francese* (Torino, 1972), 1011, repeated in "Present State of Studies," 30–31. Also, cf. "From Fallacies to Hypotheses," 6. "The term rococo refers to a relatively unified culture existing in a relatively short span of time. . . ." "Period Style Terms and Concepts: the Wittgensteinian Perspective," *The Journal of Critical Analysis* 4:2 (July 1972): 67.

41 "Period style is inevitably concerned with necessary and sufficient criteria, i.e., with definitions: the history of the relationships between terms and concepts is absolutely crucial to period style research. . . . We can wander about in this delicate labyrinth without a definition, but if we wish to go anywhere in particular, or even ever to emerge from the labyrinth, only a definition will provide the thread to draw the phenomena involved together into a coherent pattern." "Period Style Terms," 67–68.

42 "La validità della tendenza a denominare il primo Settecento 'la période du rococo'. dipende dal presupposto che l'estetica del R. è quella che, nell'epoca in questione, è

by what *sets* the prime cultural norm and pace of *historical* initiative in motion?

(2) Why should one follow the method of taking a term defined by its use in its original sphere of interior decorative art, elaborate it by finding formal stylistic correspondences in other arts (characteristic of the other arts and literature), and then expect such careful, detailed comparisons to deliver "the essential" of the *period* style?[43] If one works from art and literature first, before going to their common cultural stock, will it not leave one with an "essentially contested concept" of period style, since historical periods are not primarily artistic matters but fully cultural events?

(3) Why is the denomination of (capitalized!) Nature and Woman as the "spirits" of rococo and the binary opposition of "feminine" and "masculine" (elaborated as *esprit de finesse* and *esprit de géométrie)* any less simplistic historiography for contrasting rococo and neoclassical period styles than other "traditional fallacies"?[44] Does not such categorical judgment cast into (eternal) *types* what should instead be both conceived and perceived as an *historical* progression or regression?[45]

stata illustrata dal maggior numero di capolavori." *Dizionario*, 1011.

43 Patrick Brady, "Rococo and Neo-classicism," *Studi Francesi* 8 (1964): 34; "From Fallacies to Hypotheses," 4–5. Or has the earlier (1960s) empiricistic method of obtaining "convincing analogies" by having interior decoration "colonialize" other arts reached a bind, and Brady now (1970s) settles for a Structuralistic "myth" that is not verifiable but permanently hypothetical? Cf. Lipking, "Periods in the Arts," 196–97.

44 Brady, "Rococo and Neo-classicism," 42–43, 46–47; "Rococo Painting: Some Points of Contention," *Studi Francesi* 47–48 (1972): 271, 280.

45 Teesing exposes the inadequacy of bipolar schemes for catching the nuanced relation between two different periods and shows how such a reduced perspective avoids asking questions about the meaning of a given period for subsequent times; cf. *Das Problem der Perioden*, 117. Cf. also Guillén, "Second Thoughts," 484–86, 503. Do both Brady and Dieckmann themselves slip into the fault they warned others against, viz., conceiving "rococo" and "Aufklärung" as "recurrent" affairs? "The principles of enlightenment reflect or express a certain form of thinking, a definite bent of the mind, perhaps even a recurrent stage which by an inner determinism follows stages of predominantly metaphysical, religious, mythical, or simply speculative thought, periods of dominant structures, and solid, stable systems of the mind" (Dieckmann, "Themes and Structure," 71). "A style is static and permanent insofar as it represents an ever-recurring tendency of artistic expression (e.g. the tendency towards lightness, subtlety, grace, and finesse, as distinct from those of simplicity, symmetry, and cold sobriety or of dynamic power and drama). But it is not immutable or unvarying: while it never totally ceases to exist but merely becomes subservient, latent, or dormant at various times and in various places, it reappears in forms that are modified by historical and geographical circumstance. Thus, in the case of any given period style (e.g., the rococo) transformation is concerned with emergence from and return to a

The gist of my position could be postulated somewhat as follows: *Periods* are homogeneous, cultural historical events which do not recur. Periods are never periodic. But *Weltanschauungen* (of a certain indefinite number) do persist through different periods and "recur," that is, become articulated culturally again and again. *Styles* are aesthetic imperatives posited by a human community responding to the call for style in the world. Style is epitomized in art and literature but is not an artistic invention. Style is always the structurally embedded conjunct of a period and a *Weltanschauung*, and every style inescapably occurs in an idiom manifesting the particular variables (personal, national, special field, and the like) of its concrete circumstances. What counts historiographically most among the welter of style changes is this: does the intra-period and inter-period significant change represent *historical development,* regression, or what?

Let me hint at what these postulates mean for art and literary historiography of the Enlightenment by describing succinctly a few key features of three basic coordinates that are categorical factors constantly in force for art and literature and of special concern to historians.

1. The synchronic reality of a period is pancultural and takes its definition from the most dynamic cultural leadership, whether it prevails over all fields or less than all. The communal unity of a period, which sets it off from other periods, is most like that of a regime whose power and rule depend upon subjects willing to live and move and do their art, for example, under its sway. Because there normally are contending cultural leaders and because various arts and different cultural areas have differing pace and often perform at various levels of submission to the dominant cultural spirit, the homogeneity of a period is not some one prime characteristic. The structural macro-unity of a period is more like the snake of European currency values.[46] But periods can be roughly dated somewhere; periods can run simultaneously, although they do not recur;[47] and the more-than-individual hold on people, the principality

dormant or latent status" (Brady, "From Fallacies to Hypotheses," 8).

46 Van der Pot, *Periodisering,* 27–29; Francastel, "L'Esthétique des lumières," 334; C. van de Kieft, "De periodisering van de geschiedenis der middeleeuwen," *Tijdschrift voor Geschiedenis* 81 (1968): 433, 438, 44–41, 444; Lipking, "Periods in the Arts," 196.

47 The phasing in and out of different periods during an overlapping sequence of years is normal. Many have noted, however, that since the 1750s in Western civilization, when no one principality seems to have reached unrivaled rule, there tend to be a plethora of historical "movements" or "trends" or "currents" instead of settled "periods." Cf. Hermand, "Über Epochenbegriffe," 302; Guillén, "Second Thoughts," 482–83, 486–88.

of a period, is historically real, as real a compelling force as Nazism, for example, or Hellenism.

2. Complicating the synchronic cultural reality of period, which serves as a powerful, enveloping milieu for all kinds of individual acts, is the constant presence of different, distinct types of worldviews. Every discontinuous, synchronic historical homogeneity has a typological variety of perchronic (= enduring through time) stances on what counts in life and how the world is constituted. A person picks up a given worldvision as surely as one is born into a given mother tongue; it is much like the fact that every artist, by virtue of his or her early training, is outfitted with the a priori of a certain art tradition.[48] The point is that recognition of this living perchronic reality of multiple, coexistent *Weltanschauungen* (and art traditions) stops one from treating periods as one-dimensional phenomena. A period needs to be read not as a one-line Gregorian chant melody but as a symphonic score—not just because of the snake of cultural strata, the species of arts, and many other shifting, complicating features, but especially because of the culturally highly determinative, structural presence of worldviews that fundamentally affect artistic performance too.[49]

For example: Watteau's exquisite coloring shares the *spirit* and therefore period of Hogarth's serpentine line of beauty, but the *Weltanschauung* shaping Watteau and then Hogarth's art is as different as a pastoral idyll is from a picaresque tale. Watteau's *worldview* that shows obliquely through his paintings is similar to one embodied in Giorgione's art, and there may even be iconographic features true to that type of idyllic perspective, but Watteau and Giorgione belong to different periods. Analysis of art style will always do well to honor both the synchronic and perchronic factors informing its dated occurrence. There is no "typical" rococo painter or writer. There are always basic varieties of the rococo "period style"—idyllic-rococo (Lancret), picaresque-rococo (Longhi), heroic-rococo (Tiepolo), and others.

3. A third dimension is the diachronic reality of historical development. Historical passage is not predictable like ordinary genesis since sequential connections between human deeds may occasion surprises, and there is always something uncanny about the becoming of a period itself. What the relative contribution various acts within a period will make toward the enrichment or wastage of a heritage in a certain cultural area

48 Cf. Kurt Badt, *Kunsttheoretische Versuche, Ausgewählte Aufsatze,* ed. L. Dittmann (Köln, 1968), 148–150; Fowler, "Interart Analogies," 500.

49 Teesing, *Das Problem der Perioden,* 94–98.

awaits the imperfect, formative actions of those who, independently, follow such preparation or execution. There are two things of special note, however, for the historian who is intent upon detecting what actually happened:

(a) Within a period different *cultural* generations are called upon to perform different tasks if the various worldview coefficients are to be promissory notes rather than dead weights, and if the period itself is to foster maturation in the different cultural realms. Innovation in artistic style, for example, needs to be followed by practitioners who consolidate specific artistic gains; a following stage demands renewed diversification and modification, or the artistic élan of the period tends to sag at that point with "formula" art and undo itself.[50] Without culturally instigative or integrative initiative in a given field, the historical import of that specific field dwindles.

(b) The struggle between cultural adherents of different period constellations must not obscure the fact that each contending regime is judged not only on its evolvement of culture from where it begins but also on its long-range service in opening up each given area to a more normative performance.[51] The *historical* importance of many rococo art works, for example, lies more surely in their demythologizing action, wittingly or not, and coinage of a new artistic idiom bent solely on pursuit of life, liberty and happiness, than in any specific, marvelous rendition of form or theme.[52]

The forte of the alternative historiographic method I have only sketched here is that an historical period is conceived concretely in three-dimensional structure, so that relative simplicity, complexity, and flex-

50 The role of "generations" in cultural leadership and their "logic" of succession has been often noted since Wilhelm Pinder, *Das Problem der Generation* (1926); cf. Teesing, *Das Problem der Perioden*, 66–67, 73–76; George Kubler, *The Shape of Time: Remarks on the history of things* (Yale University Press, 1962), 101–03; Francastel, "L'Esthétique des Lumières," 353–55; Hermand, "Über Epochenbegriffe," 305, 308; Guillén, "Second Thoughts," 483, 499, 503. The critical moment in this pattern—will the style become formulized or regenerated—has led some to call the "formula art" "mannerist," and then see it as recurrent, viz., any style in crisis. Cf. Fowler, "Interart Analogies," 503–05.

51 Cf. M. C. Smit, "De Tijd der Geschiedenis" [1966], in *Bulletin van die Suid-Afrikaanse Vereniging vir die Bevordering van Christelike Wetenskap* 12 (January 1968), 5–19, and "Encyclopedie van de Geschiedeniswetenschap, nader over de dynamiek van de geschiedenis" (Amsterdam, 1975), 21. The former is translated: "The Time of History," in M.C. Smit, *Toward a Christian Conception of History* (Lanham: University Press of America, 2002), 347–357.

52 Paulson, *Emblem and Expression*, 50–51; also, my "Telltale Statues in Watteau's Paintings" in *Eighteenth Century Studies* {infra pp. 171–195}.

ibility are structurally assured. Every art or literary artifact considered historically will be immediately scrutinized comparatively as to current milieu, traditional matrix, and eventful import. One would not be afraid using this methodological approach, on the basis of firsthand examination, to associate Gainsborough with Watteau,[53] and to exegete Hogarth, Fielding, and Sterne as pace-setters in rococo-picaresque style.[54] One would need to test the spirit and cultural contribution of each specific item, and one can be kept from making easy generalizations if one always takes into account the three-dimensional mesh which is present and relevant for understanding what is going on.

But I shall not wager any more corrective judgments against traditional shibboleths at this time. My concern has been with general historiographic methodology. As far as "the Enlightenment" goes, which I have taken for illustrative purposes, once the fact of an Enlightenment period is granted, it could be called rococo in style, practicalist in philosophy, physiocratic in business and so on, depending upon usage best for a specific cultural area, but all meaning "the Enlightenment period."[55] That might solve a few terminological problems. But a question harder than terminology is, for example, whether the cultural direction whose style was spearheaded by the likes of Winckelmann and Mengs. David and Ledoux, or Reynolds, is Enlightenment in spirit. Such figures were not kindred to the Idealistic period which is called "Romantic," were they? Or was their movement simply an abortive, old-fashioned regression replete with authoritarian tendencies? A decision on such a matter generates polemic heat because one's committed view of history is involved, not just a certain judgment.

If Rémy Saisselin's muddlesome article[56] is only asking for more and more clarity about less and less meaning, it won't do as critique. But it can be read as a plea for an imaginative theory of historiography that will do justice to the rich complexity of the Enlightenment period. My three-dimensional cartographic methodology tries to do that, and would be

53 Paulson, *Emblem and Expression*, 98.

54 It seems to me to be a singular oversight that so few specialists in "rococo" have given serious attention to William Hogarth's treatise *Analysis of Beauty* (1745–1753), which, although it doesn't use the "term," is an essay describing the *fact* of rococo aesthetics, how "the lively feeling of wantoness and play . . . the joy of persute" pertains to painterly lines, architecture, decoration, dance forms, and ordinary life activities.

55 Dieckmann rejects this desirability because of how the equivalents have been loaded; cf. "Rococo as a Period Concept," 26–27.

56 Rémy G. Saisselizi, "The Rococo Muddle," *Studies on Voltaire and Eighteenth Century Studies* 47 (1966): 233–55.

serviceable for historiography in other cultural times too, "Renaissance art," "Victorian literature," or whatever. The theory of period underlying the methodology I propose also tries to have academics face the question in our world, the scholarly world too, of hunger, the lie, and hope for the truth, of whether and when the historiographic grand tour is worth taking.

Intermezzo with Bob Sweetman at the "Antiquity and the Reformed Tradition" conference hosted by the Institute for Christian Studies at Knox College, University of Toronto, Toronto, 1995

ANTIQUITY TRANSUMED
AND THE REFORMATIONAL TRADITION:
WHICH ANTIQUITY IS TRANSUMED—
HOW AND WHY?

It seems normal to me for artists and younger thinkers to pick up and/or cast off somehow articles of their inherited professional clothing. Such tailoring of one's outfit when you come of age is given with the dated and located, limited (dis)continuity of being a human with forebears, neighbors, and prospects. Trouble comes when one either tries to make past heritage the norm, as Anton Raphael Mengs and Johann Winckelmann may be said to have done in relation to Greco-Roman artistic antiquity[1] or if, because of whatever ideological utopian project, one presumes to begin in history *de novo*, as figures like John Locke and David Hume thought they were doing, empiricistically clear-cutting forests of apriori ideas, or as certain Western avant garde art attempted,[2] it can be argued, with its "rhetoric of purity."

The goodly number of those present who represent a third generation within the reformational thought-tradition as articulated by Groen van Prinsterer and Abraham Kuyper (first generation, 1880–1920), that is, persons from H. Evan Runner through to John Kok (third generation, 1948–), who studied under the living mentorship of Vollenhoven, Dooyeweerd, Zuidema, K. J. Popma, Smit, Mekkes, or van Riessen (second generation, 1920–70): we have a peculiar problem with our mainline cultural inheritance or "antiquity" today. Despite our European training, steeped in the Greek and Roman classics, medieval Christian Fathers and women mystics, along with the bright lights of Humanism, we Augustinian-Calvinian thinkers self-consciously remain both critical

1 Cf. Seerveld 1984, 113–130.
2 Cf. Cheetharn 1991; Van den Berg 1993, 77.

First published in *In the Phrygian Mode: Neo-Calvinism, antiquity and the lamentations of reformational philosophy*, eds. Wendy Helleman and Robert Sweetman (Lanham: University Press of America, 2006), 197–222.

and appreciative of our Western ancestors, almost as if double-mindedly halting between two opinions, because we will neither settle for a scholastic, hermetically sealed, reformed (past tense), canonic position nor for a revolutionary stance that prompts one to be a chameleon constantly transforming one's basic habit, world without end.[3]

Reformational philosophers, as I gather, deny that the millennium of Christian scholarship has already come.[4] So they largely accept, from Albert Wolters (*Creation Regained*) to Jacob Klapwijk ("transformational philosophy"), the *spoliatio* motif and the Niebuhrian grace-restores-nature formulation as the most biblically directed way for us to go in selecting God's gifts to the pagans and secularists we should humbly smelt down, God willing, into less adulterated service of our Lord Jesus Christ.[5]

I want to question the wisdom of recommending Augustine's *spoliatio Aegyptorum* as the most excellent policy. I dare question the *spoliatio* gambit both because of a Scriptural directive I hear, and because I am coming to wonder whether our secularized Western civilization in its splendid imperialistic vanity has misled us in restricting Christian attention to refining only Greco-Roman "Egyptian" antiquity. Thus, the subtitle to this contribution: "Which Antiquity is Transumed: How and Why?"[6]

The concrete embodiments of transumed antiquities I take for examination in my field are the artworks of contemporaries Nicolas Poussin (1594–1665) and Jan Vermeer (1632–1675). I shall use the important, neglected art-history theorist Kurt Badt (1890–1973) to prime my analysis, since the locus for my systematic examination of the problem of how have Reformed Christian artists and theorists dealt with antiquity and how should reformational leaders deal with our mixed synthetic and secularized inheritance: my entry into that problem is the matter of formulating and practicing a redemptive method of art-historiography. To face us with the increasing complexity of current cultural affairs I shall end my remarks by introducing the artwork of contemporary Anselm Kiefer, before I briefly pose for discussion an alternative to the time-honored *spoliatio* dictum.

3 See Helleman 1990, 25–29.

4 "'Christian philosophy' is not so much a reality as it is a resolution; it is more of a mandate than an achievement." See, for example, Abraham Bos's statement in Klapwijk et al., 1991, 26.

5 See Helleman and Wolters in Helleman 1990, 25, 202 and Klapwijk in Klapwijk et al., 1991, 186–188, 248–250.

6 "Transumed," as I am using the term, means "exhumed and transformed."

Nicolas Poussin and Greco-Roman-Egyptian antiquity

It probably takes the detective acumen of an Aby Warburg crossed with the sweeping vision of Leopold Ranke honed by the mind of Werner Jaeger or Oscar Kristeller to plumb the oeuvre of Nicholas Poussin, because Poussin's artwork is a 1600s epitome of European culture. By "European" I mean that Christian humanist mentalité that believes ancient Near Eastern, Greek, and Roman wisdom was good, true, and beautiful, but incomplete until Christian learning synthesized and climaxed the amalgam of *recta ratio* knowledge about world, humanity, history, and God. "European" is a hybrid, let's say, of Foucault's Renaissance and "Classical" epistemes.

At least this is the orientation Kurt Badt takes to sharpen up his thesis that "Poussin's art is visibly determined by antiquity as to its content, figuration, and formal composition. . . ."[7] because Poussin takes

[#23] Nicolas Poussin, *The Triumph of Pan*, 1636

7 ". . . dass Poussins Kunsi sichtlich von der *Antike* bestimmt worden ist: inhaltlich, figural und formal, und dass jede Epoch abendländischer Malerei, bis zum 17. Jahrhundert, bei der das der Fall war, mit einer Stellungsnahme zu den Gegensätzen von antiker und christlicher Göttlichkeit konfrontiert worden ist" (Badt 1969, 383).

gods to be real and open to our experience.[8] Poussin's *Triumph of Pan* (c. 1636) [#23] presents a frieze of live groups of figures: beginning on the left with a blue-clad woman riding goat with kneeling figure, trumpeter, and embracing shepherd. A second group is constituted by a red-clad woman in ecstasy bearing a deer like old-time maenads (but without bloody body parts). A third and fourth group are made up of wrestling pairs where a woman and two youths each subdue a satyr. Finally, a second blue-clad woman with red-cloaked tambourine exultant consort joyously reaching out to crown Pan with garlands from her attendant flower child. The priapic upright arm of Pan intersects the diagonal line from upper left background of cliff over Pan's head, the women's shoulders, heads and outstretched leg of youth to the lower right corner to be a resting point right of center mid-height, amid all the love-happy movement and drinking revel. By this means Poussin weds the band of figures into a whole within this secluded grove's protection. The paraphernalia of Bacchus in the foreground—panpipes, grapevine staffs, masks, discarded clothes, overturned cups, and amphora—footnote the godly power of Pan over animals, fauns, and humans who then celebrate such pleasure with decorous abandonment.[9] The blue and red colors are distributed evenly through the whole; the individual movements are gracious, unhurried, as if choreographed.

Poussin is not *like* the ancients, argues Badt. The various borrowings you can document from Roman sarcophagi and antiquaria in Poussin's friend Cassiano del Pazzo's fabulous library, which Poussin studied,[10] are also not to the point:[11] Poussin painted in a Greek and Roman spirit. Not that of Pericles, the Apollo Belvedere or imperial Rome, but Poussin had the originality to take Nature as an all-enveloping theophantic reality—*Physis*—where amid teeming natural life powers, which are also divine, immortals like Aphrodite, Bacchus, Flora, Pan with nymphs, satyrs, and heroes like Cephalus, Narcissus, and a legendary Midas, actually inhabit our fated human world. These splendid beings are busy on earth with heroic, erotic, transgressive deeds, not to be worshipped, but as normal

8 Cf. Ibid., 24–25, 421, 426, 452, 463, 478. ". . .wie die Künstler der alten Zeiten malte er [Poussin] Götter und Menschen in der Gegenwart von Göttern, deren Zusammen-Sein als etwas Natürliches, der Erfahrung Widersprechendes, durch keinen Akt des Bewusstseins zu Ergreifendes, er nur durch das ihm gewährte Erlebnis der Anwesenheit der *Götter* erfahren haben kann" (Ibid., 420).
9 Cf. Ibid., 534–36.
10 Cf. Haskell 1963, 104–106.
11 Dempsey documents the very free way Poussin appropriated designs and motifs from the Roman Palestrina mosaic and the Cornubarium. Cf. Dempsey 1963, 110–17.

cohorts who set the world agenda under the final Olympian horizon of felicity—there is no baroque yearning for a transcendent realm.[12] The *Triumph of Pan* and *Bacchanalian Revel* (c. 1634)—including the series of four Bacchanals commissioned from Poussin by Cardinal Richelieu for his apartments in the mid-1630s—are not sordid orgies but have a ritual character, like rites of passage, and portray mysteries that maybe never were but always are somehow mythically true.[13]

It is this same rigorously pre-Christian, pagan antiquity of a numinous world in which any biblical sense of sin is simply inapplicable, says Badt,[14] peopled by Romans of the ancient Republican era in all their *pietas naturalis* and public *nobilitas spiritualis*, which inspire, for example, Poussin's *Abduction of the Sabine Women* (c. 1632, Louvre, c. 1634, Metropolitan of New York). Poussin's decorum never allows his artistry to splurge, no matter the topic. He was *ein gläubige Heide,* says Badt (*KNP,* 419), and perfectly in tune, I would add, with the humanists and Jesuit intelligentsia of the day who were among Poussin's patrons. Indeed under the Society of Jesus' motto *ad maiorem Dei gloriam* Poussin's patrons affirmed the continuity of pagan and Christian access to the knowledge of God with their common source in Egyptian religion.[15] The precipitate of "antiquity" for Poussin was the syncretistic mix of supernal delight—"la fin est la délectation"—and edifying saga of *viri graves et sancti,* like the commanding figure of Romulus in both versions of the Abduction event.

Dance around the Golden Calf [#24] casts the amazing Older Testament story of Exodus 32–34 into the same mold as *Triumph of Pan* and *Abduction of the Sabine Women.* There are two token blasted trees, and a lowering dark cloud of godly displeasure, and a footnote in the upper left shadows of Moses' breaking the tablets of the law, but the main event is a festive symphony of yellow, blue, and red clothed dancers with lovely

12 Cf. Badt 1969, 328, 432–438, 444, 446–447, 471. "Dieses Wesentliche ist eine Wiederkehr des antiken Geistes, im Gegensatz zu einer Rückkehr zum Altertum verstanden, eine nicht von aussen, sondern von einem Innern her bestimmte geistige Haltung, die, von aussen bloss angeregt, dann sich in entgegengesetzter Richtung, die Anregung aus Eigenem wieder hervorbringend, nicht von Werk zum Wesen, sondern vom Ursprung zu den Werken hin bewegt" (Ibid., 422).

13 Cf. Ibid., 448–449, 466. "Seine [Poussin's] Synthese trägt folgende Kennzeichen: sic ist, welchen Darstellungsstoff sie immer behandelt, grundsätzlich *mythisch,* das heißt immer göttlich bestimmt. Poussin hat keine profanen Bilder gemalt" (Ibid., 445).

14 Cf. Ibid., 45, 387, 400, 477. "Diese mythische Welt war notwendigerweise schöner und ungestörter als die *sündige* Welt des Christentums, die im Aufschwung der Seele und des Geistes überwunden werden soll, wie das 17. Jahrhundert sie verstand. Poussin hat das Diesseits in jeder Phase 'verklärt'" (449).

15 Cf. Santucci 1985, 26–27, 47–48, 55.

[#24] Nicolas Poussin, *The Adoration of the Golden Calf,* 1633–1634

statuary bodies, and a right-hand phalanx of adoring suppliants backed up by charismatic hand-raising exultants. Aaron is clothed in a white Roman toga, and the golden calf has become a garlanded, godly Egyptian bull! These wandering Jews in the wilderness are conceived too generically beautiful to be taken as cursed malcontents; and the equanimity of their dramatic action—strong individuals belonging to a worthy group—wrap the proceedings in a mantle of virtue, for how could such wonderful happiness and grateful devotion be misguided? Not grace, but *ars perficit naturam* is Poussin's credo. [To interject a wry Calvinian remark: according to the biblical story here is *spoliatio Aegyptorum in concreto* (Exodus 32:1–6)—that is, Klapwijk's "inverted transformation".]

Poussin's transumed Archaic-Greek-Hellenistic syncretistic mix, with all its learned attention to detail, settles into a *maniera magnifica* (friend Bellori's term) when Poussin returned to Rome after the bad stint in Paris (October 1640 to spring 1642) at the behest of Richelieu and Louis XIII. The cultural winds changed after the death of power-broker Richelieu (1642), Louis XIII (1643), and pope Urban VIII (1644), thanks to the dispersal of the Barberini entourage and cutbacks for artistic *panem et circenses* made by Hispanophile, anti-French pope Innocent X (1644–55). Poussin was always on the margins of papal cultural politics, ill at ease inside the fawning French court circle; and Poussin avoided commissions

for public ecclesiastical paintings and frescoes.[16] So the clientele for Poussin's large easel paintings remained firm during the changing of the guards, but Poussin's patrons after his return from Paris were mostly extremely wealthy French intellectuals, connoisseur collectors like Roland de Chambray, busy translating Palladio and books like *Parallèle de l'Architecture Antique avec la Moderne,* and Paul Fréart de Chantelou, who were nevertheless sobered by the Fronde revolt (July 1648–September 1649) around Mazzarin in Paris at the end of the so-called Thirty Years War (1618–48).

There is a discernible shift, I think, in Poussin's artistic idiom before and after the Paris trip. The early *Et in Arcadia Ego* (c. 1630) [#25] has shepherds startled by the tilting tomb near a diagonal tree with a brawny river god in the foreground spilling water from an urn, while the late version [#26] (1650–55, according to A. Blunt) is a model of subdued, even-tempered, idyllic pensiveness.[17] An early *Lamentation of Christ* (c. 1628) has the Christ sprawled indelicately under the dramatic arm ges-

[#25] Nicolas Poussin, *Et in Arcadia Ego,* c. 1639

16 Cf. Badt 1969, 116–20.
17 Cf. Panofsky 1963, 222–54. Panofsky notes the significant difference between Poussin's early and late versions of the theme, but does so mainly to exegete the inscription. "Even in Arcadia, I, Death, am present" (early dramatic); "I, former loved one, lived in Arcadia too" (late elegiac).

[#26] Nicolas Poussin, *Et in Arcadia Ego*, c. 1650–1655

ture amid angled bent backs, cross diagonals of tomb lid and left-center tree, with bright red and white cloths animating the empty tomb to the right; while a later *Lamentation over the dead Christ* (c. 1650) shows the finished resolution of horizontal rigor-mortis and controlled despair, somber, mourners stilled to effigies.[18]

That is, the change of format in Poussin's artistic oeuvre can be characterized this way: Poussin earlier highlighted heroic struggle and the ebullience of vigorous human action; later Poussin settled on sobriety, serenity, a more ascetic perspective bringing norms and whatever may endure in the vicissitudes of life to the fore. But the same spirit of a this-worldly pagan spiritual humanity breathes through all the earlier and later artwork Poussin has done.[19] In my judgment Badt overstates, in Heideggerian fashion, Poussin's actual pagan spirituality because Badt over-reads Poussin's originality and art-historical importance to make Poussin's unique genius unlike anyone else's of Poussin's day, making mythic truth palpable in painting.[20] But Badt is correct in seeing that Poussin's transumed antiquity lies not in academic quotations of spot images or hack use of Vincenzo Cartari's *Le Imagini de I Dei Degli Antichi*,

18 Cf. Friedlander 1964, 102.
19 See note 13 above.
20 Cf. Badt 1969, 465–467.

or Natales Comes' *Mythologiae* source book,[21] but was veritably the deepest cultural dynamic out of which Poussin fashioned art. Just as one can become fluent in a language other than one's mother tongue, although it still remains acquired, so Poussin became so fluent in this syncretistic mix of pagan Archaic-Greek, ancient Republican Rome, Egyptian-Hellenism, it embodied what captivated him and his artistry: Poussin painted in the grip of this definite antiquity because it is what he stood for, what bespoke his bearing, longing, and integrity.

It is this composite aplomb that, like a sepia tone darkening old photographs, artistically colors especially late Poussin's transumed antiquity, whether he handles as painter a Bible story or the tale of a Greek myth. The famed *Madonna della Sedia* (1648) spotlights the Christ child, Maria enthroned as it were, and baby John—no halos—as the top of a broadly based triangular pyramid of figures seen from below. Yellow clad Elizabeth on the left is balanced by the in-profile Joseph's yellow trousered foot sticking out to the right. There are seven extremely foreshortened steps, a conglomeration of Roman temple architecture with Corinthian capitals, stone vase, orange tree, overflowing fountain, and then a basket-of-apples still life on the bottom step next to treasures, gifts of the magi. The unseeing stare of the Madonna into the distance leads Badt to expound on sacred Greek masks,[22] and Carrier to discuss the distancing of viewers by the gaze.[23] The crux, I think, is that Maria as *scala coelestis,* i.e., as the stairs to heaven,[24] is artistically presented to be read as an overlay of the traditional theme, but reversed. Now Elizabeth is visiting Mary, after the births, a possible ordinary life-occurrence, when Joseph is busy drawing with his compass. Nevertheless, the theme is staged with unusual seriousness (Matthew Arnold would use the word *spoudaios*), an architecture impossible for the real life of Bethlehem or Nazareth and therefore the whole is strangely hieratic and didactic, whose layers of meaning are primed for reflection but are not allegorical and not quite accessible iconographically. The apple offered the Christ child would be an odd hint of his being the second Adam! Poussin's artworks each seem to be a capsule retrospective of something intangibly important—that is the breath of his transumed antiquity.

Unlike Claude Lorraine's airy, full-dress land-and-seascapes of stunning light with anecdotal notes, late Poussin's depicted field settings re-

21 Cf. Friedlander 1964, 22.
22 Cf. Ibid., 499–501.
23 Cf. Carrier 1993, 215–17.
24 Cf. Hibbard 1974, 81–91.

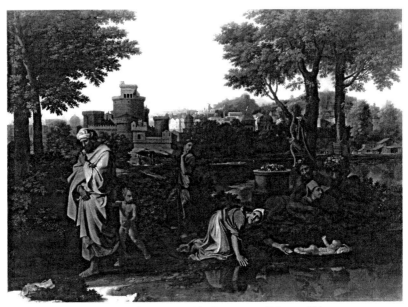

[#27] Nicolas Poussin, *The Exposition of Moses*, 1654

verberate as a frame for whatever is really at stake, and clothe the myth of Polyphemus or the story of Moses [#27] abandoned to God and the bulrushes with an aura of being a special theatre for portentous or fortuitous happenings. The meticulously-painted-over large leaves and panoramic layout of waterways and distant mountains are not so much vistas in Poussin's artwork as cosmos, cosmic horizons for the sheltered glade where something poignant is about to take place. The architectural amalgam in *Exposing Moses,* the usual Roman fort complex with Egyptian pyramids and Greek temples, has its cosmopolitan commentary curiously heightened by a river god holding a sphinx creature, behind which hang an assortment of Pan pipes, Bacchus cymbals, and Diana's bow and quiver of arrows—an unusual decor indeed to accompany Moses' mother and family leaving him adrift while sister Miriam cautions silence and points to the middle-ground shadows where Pharaoh's daughter and retinue approach.

Understanding Poussin's finely tuned, artistic homogenization of mythical, historical, and ordinary events, which are indiscriminately Roman, Greek, Egyptian, or Biblical in origin, gets at the heart of Poussin's transumption of antiquity, because what the paintings show is not real, yet is staged as if real to life. This moot defining feature of distanced (un) reality to Poussin's art is Badt's opening to argue that Poussin's figures

disclose a higher level of self-reliant being at rest and completion than the transient world of existence and becoming,[25] that Poussin's settings of luxuriant vegetation are conceived to admit the epiphany of gods and heroes as genuine, as actual as the divinities the Greeks knew,[26] and that viewers of Poussin's paintings, including the hybrid architectural decor and ubiquitous subtle proportionalities, are faced with the steady, serious realm of omnitemporal mythic truth, quite different from the Renaissance dynamic to rise like a phoenix from the ruins of a great past civilization, and utterly unlike baroque pseudo-antiquity[27] or Mannerist quotation of gods and personifications for beatic effect.[28] For Badt, Poussin's unusual reality is essentially reliving as *vates* the truth of Greco-Roman-Egyptian hermetic, non-transcendent religion.[29]

In my judgment the artistry of Poussin does not reveal a mystagogue, as Badt intimates, although the consequent syncretistic spirit of alloyed Greco-Roman Hellenism that Poussin's artwork emanates is indeed not secularist and neither biblically-Christian nor antiquarian-nostalgic, but is a definite spiritual-Humanist dynamic that buoyed other cultural leaders at the time too, and became canonized in painting and sculpture by Colbert and LeBrun in a century of *la grande manière* of *l'Académie française*. Both Badt and Carrier recognize the greatness and singularity of Poussin's artwork among his contemporaries that, as I see it, consolidates in a heroic format earlier and in a more elegiac idiom later, if you will, the wealth of what I would call the catch-all of Westward European learning, which Poussin calmly and persistently was affirming as the way to live! And this impression of "elevated" reserve, which Poussin's artwork car-

25 "Diese Figuren besitzen in ganz ungewöhnlicher Weise das Kriterium des Vollendeten. Es besteht darin, dass Wesen nicht nur als so seiende sind, sondern auch noch im vollen und stetigen Bewusstsein dieses Seins, also daseiend, so dass sie in der Lage sind, ihr eigenes Sein ständig kundzutun und zu verkünden" (Badt 1969, 500).

26 Badt cites Ulrich von Wilamowitz-Moellendorff, Karl Kerényi, and the classical philologians of the 1800s as the authorities who taught us, in the words of Karl Reinhardt, that "Bei den Griechen fällt die Frage nach dem Sinn zusammen mit der Frage nach den Göttern" (Ibid., 427).

27 Cf. Ibid., 424 n.13.

28 Ibid., 419–22. "Das Phänomen tritt nur im Hinblick auf sein Wesentliches—ontologisch—in die Erscheinung, da es Form des Seins selbst ist. Dieses Wesentliche ist eine Wiederkehr des antiken Geistes, im Gegensatz zu einer Rückkehr zum Altertum verstanden, eine nicht von außen, sondern von einem Innern her bestimmte geistige Haltung, die, von außen bloß angeregt, dann sich in entgegengesetzter Richtung, die Anregung aus Eigenen wieder hervorbringend, nicht vom Werk zum Wesen, sondern vom Ursprung zu den Werken hin bewegt" (Ibid., 422).

29 With Dempsey and Santucci I make the Egyptian features explicit. Badt leaves that element less noticed.

ries, Badt reads as the Heideggerian grasp of *being* and Carrier speculates results from the pictorial device of "internal tableaux," which wards off viewers.[30] This "elevated" reserve seems like formal artifice to those for whom such a committed, informed vision of this-worldly human tasks, replete with myths and history, a worldview where even catastrophes are fated and thus somehow rational, is foreign.

If one does not read or speak Latin, is not literate in Greco-Roman and Biblical-storied learning, or is at odds with this privileged European cumulative transumption of antiquity, Poussin's art will appear "distant" and be difficult to parse. But Poussin's art products are similar in temper to Dryden's poetry, the intricacies of Leibniz's mode of philosophizing, or the measured alexandrine cadences and layered compactness of Corneille's drama, all of which share nuanced reality in a retrospective mode. Poussin's art is "artificial" today because its inner dynamic is out-dated. Poussin was among the last signatories to the promissory note of "European" art that the Enlightenment cashed. Since the Enlightenment happened, Western culture has been using the cash capital as income, until today we are living on credit, it seems to me, looking for a new cultural world-bank.

Johannes Vermeer and the antiquity of ordinary creatural affairs
Vermeer, however, proffers art still promising today, I think, because Vermeer's transumption of antiquity was radically different from that of Poussin. Let me take the difficult, hotly debated piece *De Schilderconst* [#28] to initiate my point.

A heavy rich curtain is theatrically pulled aside on the left to invite us viewers in, as it were, to behold a painter intent upon sketching laurel leaves atop his model's head, set up with trumpet and book to pass as Clio, the Muse of History. The painter is dressed *op z'n antieks,* the Dutch would say, in a festive Burgundian costume of a hundred years ago, at least before 1581 when the seventeen provinces of the Niederlanden were still together under Spanish rule—which is precisely what the exquisitely detailed, decorative map on the rear wall depicts, bordered with vignettes of renowned cityscapes. The light that bathes the wall in the back, the

30 Carrier forces his idiosyncratic Bryson-Fried cliché (the painting's appeal to the external viewer is psychologically determinative of the artistic meaning [Carrier 1993, 129]) upon Poussin's paintings to misread the canvasses to be treating "the beholder as if he were not there." If I understand Carrier's contorted presentation, to belabor the idea that artist Poussin kills desire and undermines the unity of the images depicted by absenting the viewer (Carrier 1993, 132–43) seems to me a rather foolish analysis of the paintings.

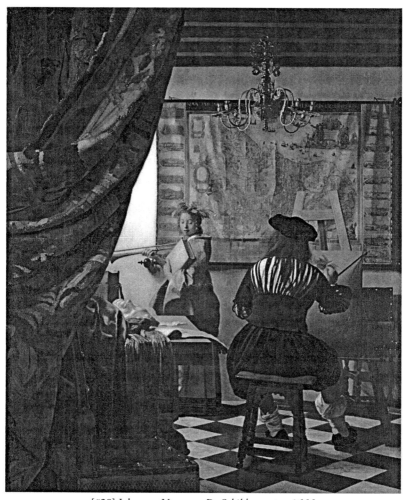

[#28] Johannes Vermeer, *De Schilderconst*, c. 1666

staged Clio, the creased velum map, the mask, piece of paper, and open score (?) on the table, the white shirt of the painter and white tiles of the floor—all this reinforces with a soft golden, quiet luminosity that ye olde scene, described by Leonardo championing painting in his *Paragone*,[31] is in praise of *ars pictoria* in the days of yore when painterly artistry inspired by Muses gave a kind of enduring memorial to whatever great deeds it

31 ". . . il pittore con grande agio siede dinanzi alla sua opera, ben vestito, e muove il lievissimo pennello con li vaghi suoi colori, e ornato di vestimenti come a lui piace, ed é l'abitazione sua piena di vaghe pitture e pulita, ed accompagnato spesse volte di musiche, o lettori di varie e belle opere, le quali, senza strepito di martelli o altro rumore misto, sono con gran piacere udite" (Da Vinci 1935, 145–46).

graphically fixed. There is incredible, subtle compositional unity to the painting. The rising line of the curtain connects by crossing the empty foreground chair, the folded material and book standing on the table, the bell of the trumpet, corner of the map, and horizontal ceiling rafters. The map overlaps and visually relates the two separated figures. Red is sprinkled like salt all over the cartouches of the map, the ball of the painter's maulstick, his leggings, highlights on the chair ready to seat a viewer, and subdued and inlaid with orange and blue on the gorgeously woven curtain. The unnoticed artifice of interlocked pieces set the possible ordinary activities back like a tableau in a niche, both distant and at middle-depth nearness to be taken in slowly, steadily, and whole.

Hans Sedlmayr (who probably helped set Hans Rookmaaker's perspective on modern art) continues the ancient medieval rubric of a three/fourfold reading of texts and images (literal, moral-allegorical, anagogic), which Dante practiced in *Divina commedia,* and sees Vermeer's art here at the ultimate level—which in Panofsky's parallel scheme would be the iconological dimension. Sedlmayr says that the uncanny, transparent light of *De Schilderconst* takes a secularized version of St. Luke's painting of the Virgin Mary (for example, by Roger van der Weyden, c. 1435), an old *exemplum* for certifying art academies, and transfigures, transfixes the whole into "a spiritual epiphany of Light," "a primordial mystical experience" that penetrates through to "the spiritual essence of painterly art,"[32] precisely what Jacques Maritain called "poetic."[33]

By contrast, Svetlana Alpers shaves with Occam's razor and takes a dim view of such time-honored over-reading: Sedlmayr's trying to turn up the three-way lamp of an image to full wattage. She would have Vermeer stripped bare even of all the iconographic slosh contemporary Dutch art-historians traffic in to exposit seventeenth-century paintings. Alpers' brief is that in the paradigm set by Kepler and Francis Bacon's trust in the mechanics of sight, coupled with Van Leeuwenhoek's experiments with microscopic lenses for the human eye, there arose in this nation of seafar-

32 "So wie das Thema des Bildes selbst unbestreitbar die Säkularisation eines Thema der geistlichen Ikonographie ist . . . so ist auch das innere Thema, das Lichterlebnis, zweifellos die weltliche Fassung einer ursprünglich lichtmystischen Erfahrung. . . . so ist im Bild Vermeers das natürliche Licht so schön, so licht, so geheimnisvoll klar, weil es gleichsam transparent ist auf ein spirituelles Lichterlebnis hin" (Sedlmayr 1978, 140–42). "So wie thematisch das Bild die Säkularisierung eines Lukas-Bildes ist, so ist es atmosphärisch die Säkularisierung einer ursprünglich mystischen Erfahrung" (Sedlmayr 1962, 57).

33 Sedlmayr 1978, 142; and cf. Jacques Maritain on the affective connaturality and "supernatural mystical experience" of "creative intuition and poetic knowledge," chapter 4 of Maritain 1966.

ers what she calls "a mapping impulse" (Alpers 1983, 119–68), a kind of enigmatic *Kunstwollen*, which divides descriptive surface-mapping art-making among the Dutch from Italian narrative artistic representational painting.[34] Vermeer's *Art of Painting,* according to Alpers, praises "descriptive painting"; "Vermeer withdraws to celebrate the world seen" (ibid. 166–68); "Vermeer presents the image as all we have" (ibid. 188). The truth Vermeer artistically maps and spellbinds us with, says Alpers, "is the appearance of the world as ungraspable," which Vermeer repeatedly thematizes "as the ungraspable presence a woman offers a man."[35]

Badt vigorously rejects Sedlmayr's methodology and theologized interpretation of *De Schilderconst,* although Badt would also find that Alpers overly restricts herself to the historical limiting-conditions (*negative Determinanten*)[36] of Vermeer' s art, pressing an apparent empiricist measure of visibility-to-the-eyeball as test of truth, thereby missing the genial, more-than-historical (*überhistorische*) human meaning of Vermeer's unique artistic contribution facing us today.[37]

Badt's main thesis is that *De Schilderconst* is an *encomium picturae* that itself makes history, deftly calling into question "history painting" while seriously honoring the painterly craft. Vermeer's *De Schilderconst* is smiling good-humoredly at the practice of dressing up ordinary Dutch women to be Greek goddesses to justify your painterly task. The model's nonchalant holding of the trumpet, her affected downcast eyes and half-smiling mouth with a torque to the neck, clasping the large book to her body, all before the seated painter's rapt attention, is having fun with such "antiquity." The emblematic accoutrements of painting prescribed by Ripa—mask, book, drawing paper—lie like clutter with the discarded cloth materials on the table behind the back of the busy artist, out of sight except to the actual painting Vermeer, and to us viewers.

And I would add to the ironic comment made by Edward Snow regarding the artist's drooping socks:[38] you may dress up with outlandish

34 Alpers' caveats (xix–xxi) that "This distinction is not an absolute one" do not stop her from thinking about other matters too in terms of "polar opposites" (Alpers 1983, 229–31). In my judgment binary oppositions usually oversimplify matters under investigation.

35 Ibid., 188, 224. "In isolating a woman observed as his subject, Vermeer thematizes something essential about the nature of such a descriptive art" Ibid., 223.

36 Cf. Badt 1961, 88–89.

37 Cf. Ibid., 10–12.

38 "His drooping stockings defy comment, yet they are touchstones for the painting as a whole" (Snow 1979, 113). Snow omits this insightful comment in his "revised and enlarged edition" of the book (1994, 138–39).

"antique" clothes and be totally engrossed in the high calling of grandly painting "History," but such mock reality takes place amid enormous debts and bills your mother-in-law is paying off for you—your socks are falling down. Artist Vermeer, however, never trivializes anything. The silent ennobling spectator of the scene is the large wall map; and the antiquity Vermeer celebrates is Dutch history—the major central crease of the map goes precisely through the town of Breda, which spot was critical in the eighty years war for the independence of the seven northern provinces.[39]

It makes good sense to notice the absence of Greco-Roman literary emblems in Vermeer's art, but not then flatten Vermeer's artistry into *camera obscura* depictions of *visibilia*. Vermeer's eye paints intimacy with exquisite finesse, a miraculous human reality that is never an appearance and is always more than a cumulation of sensa. For example, in *Girl Reading Letter by an Open Window* (c. 1657) the girl's reading of her letter receives its unmistakable privacy from having the drawn curtain painted as a covering onto the painting—Dutch homes often had curtains over their paintings in Vermeer's day—along with a sturdy table, dish of fruit, and frumpled rug tablecloth blocking us from the solitary figure we view. The girl's reflection in the glass of the window gives a further tête-à-tête interiority to the scene of absorption, like a conscience looking on, while the lion's-head finials of the chair wait impassively. There is not a speck of mythology or a jot of Ripa to be seen.

When Vermeer's maid in the *Milkmaid* [#29] pours milk slow-motion from a pitcher in a bare-walled kitchen to the audience of fresh bread glistening in its just-baked crunchy glory, the strong gentle arms of the woman bespeak care and pride in one's work, so that "domestic" is not a term of belittlement, and ordinary "menial" work has dignity, without any show of bravura. The hauntingly still *View of Delft* (c. 1661) [#30] has the same spirit of understated, loving respect for what is normal. Vermeer altered exact topography just a touch, darkening the fronts of the buildings facing us across the Shie river, and has painted a barely visible white line in the sky just above many of the roofs in order to emphasize a uniform horizontality to the skyline of Delft. (There is a similar white line painted around the *Milkmaid,* silhouetting her with a soft-spoken frontality, reliability.) The minutest attention to texture of brick, tile, wood, and water reflections in shadow (which are not picked up by *camera obscura* technique[40]) intensify the brief perfection of what is presented: not a postcard *vedute,* but Vermeer captures the ancient gates

39 Welu 1975, 541 n.62.
40 Cf. Wheelock 1988, 37.

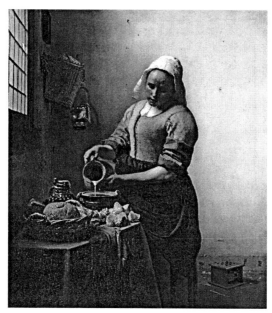

[#29] Johannes Vermeer, *Melkmeisje*, c. 1658–1661

[#30] Johannes Vermeer, *Delft*, c. 1661–1663

of the city, its church towers and houses scarred by battles since medieval times, basking in the ephemeral sunlight, as if permanent, on a summer Sunday afternoon before the dark clouds interrupt. The antiquity is local and a *memento mori* poignance is not emblematically added onto the scene but is through the painter's arc impregnated in the miracle of such calm loveliness, which cannot last but where time does momentarily seem to stand still.

It is the precise, gentle, blue-yellow-and-ochre spare appeal to ordinary-life givens and a paradigmatic order in *Woman in Blue Reading a Letter* [#31], undisturbed by Baroque fervor or Mannerist exaggeration, that makes it seem as if the Renaissance and its reach back to Greco-Roman antiquity is not around artistically. The Blaeu-van Berckenrode map of the 1620s on the wall signals historical context, but it is not a foreign history. The map stands concretely for what Johan Huizinga called the "municipal liberty" of the Lowlands, their "medieval (non-hierarchical)

[#31] Johannes Vermeer, *Women in Blue Reading a Letter*, c. 1662–1663

freedom" of having a decentered chain of limited privileges that mutated during Vermeer's lifetime into a Dutch *patria* where one did not stand on pomp and circumstance as in papal Italy, Cavalier England, or dynastic France,[41] but cherished other virtues. Vermeer's mature paintings are singular, low-key witnesses to a sort of Dutch Reformation of the European inheritance in which he was trained. Vermeer traded in *Diana and her Companions* (c. 1656), with its standard unlikely never-neverland context, for his standing single women in familiar home environs.

The *Woman in Blue Reading a Letter* (after 1660) is great with child, pictured by Vermeer as reading a letter so that our attention takes in her stature, wellbeing, and condition of bearing inner life as if it be in peripheral soft-focus because we are involuntarily focused on her preoccupation. Vermeer artistically fends off viewers as voyeurs, letting the woman be there, without encouraging anecdotal supplements, in her private concentration, merged with the simple everyday love-act of receiving and reading a letter. *Woman with a Pearl Necklace* (c. 1664) [#32] also gives

[#32] Johannes Vermeer, *Woman with a Pearl Necklace*, c. 1664

41 Cf. Huizinga 1948, 2: 414–37.

evidence of a deep-going, informed rejection of the age-old European topos of *vanitas* (jewelry, woman, mirror): the upraised arms suspended in tying the pink ribbon and the intrigued look on her face are held affirmatively in place by the halation of the soft light that radiates from the window, subduing the mirror activity. Vermeer's deflecting artistry overturns the moral didactic code of "antiquity," which stoically condemns mirrors and self-enjoyment, and reveals someone undergoing wonder at discovering herself something beautiful. The woman's pleasure, as Ed-

[#33] Johannes Vermeer, *Allegory of the Catholic Faith*, c. 1671–1674

ward Snow puts it, "is centripetal rather than centrifugal" (Snow 1979, 130). Without emblematic warfare, artist Vermeer has depicted the joy of a woman's unselfconscious delight in a world where you can trust what normally goes on to bring surprises.

If we follow the tack I am taking, one dares say that the late painting *Allegory of the Catholic Faith* (c. 1671–74) [#33] is not the mistake of a failing master but is a superb, chaste ironic critique of artistic "antiquity." Everything is nicely overdone: the uncertain hanging curtain holds back light to frame the melodramatically posed figure on a dais with her foot on a globe of the world covering Asia, not considered part of Christendom at the time; there is a pious surplus of objects to fill Ripa's prescription to represent "the Catholic faith"—chalice, open Bible, cross with raised *corpus Christi*, glass sphere with highlights to portray how the human mind can take in the vastness of God, Jacob Jordaen's early Rubenesque "Crucifixion" as somber backdrop enveloping the white-and-blue-with-gold vestments of the woman fixed by a heavenward seraphic gaze; in the front is a large rock (*petra*) crushing the life blood out of the snake of Protestant heresy on an immaculate white-and-black tiled Dutch floor. The jarring overkill and chilling explicitness—which would satisfy the most rigorous Jesuit commission for a Mannerist canvas—is everything Vermeer has exorcized (!) from his oeuvre. Next to the bemused and wistful, sunny *De Schilderconst, Allegory of the Catholic Faith* can be seen as a measured, veiled macaronic critique of current-day lifeless religiosity.

Woman Holding a Balance [#34], epitomizes Vermeer's Reformation stance toward antiquity. The light in the darkened room falls softly on her stately (pregnant) bearing, clothed in a blue housecoat with ermine cuffs and bodice, and bathes her tilted face and bare arms and fingers, the right arm holding the scale with sure poise and the left hand touching the solid-wood table top just to assure her balanced sense of reality. The indistinct back-wall baroquish painting of "The Final Judgment," where Christ is blessing the saints rising in the air to be with him, while the naked sinners below fearfully shriek for the mountains to cover them, is naturally in counterpoint to the woman's serene testing the truth of the balance. But one misses Vermeer's artistic reform if one draws a simple equation that subordinates the mainline activity in the painting to the picture-in-the-picture commentary.[42] As I read it, Vermeer shucks the

42 The involved problematic of how subtle use of intra-pictoral commentary can be a clue to the meaning of painterly art during the time period when the received world of allegorical meaning and emblems was gradually being secularized and dispersed, has been demonstrated by various studies: Chastel 1967, 16, 28–29; Paulson 1975, 35–47, 138–58; and Seerveld 1980/81, 151–80.

[#34] Johannes Vermeer, *Woman Holding a Balance*, c. 1665

hoary apparatus of multilayered otherworldly moralism and with refined ambiguity pulls the import of the apocalypse, without nervousness, into the faithful performance of one's present daily tasks. Vermeer bypasses, as it were, the Greco-Roman mythological stock of certified values, side-lines even the emotionally-updated reinvestment in medieval theology by the Counter-Reformation artists, and returns to the sheer glory of good creatural life championed by the Older-Testamented Biblical psalms and wisdom literature. The light in the painting blesses the woman's steady hand; the implications of unhurried equanimity and judicious judgment featured in her whole demeanor assure anyone that life-time and human decisions, as well as pearls, are precious.

The fact that Vermeer breaks with the then-dominant European

epistemes in force—Baroque and Mannerist—allows Alpers to contend that Vermeer's art, nested in 1600s culture, is purely descriptive in a Scientialist sense. Alpers' empiricist metaphysics, however, misleads her into working with false binary, exclusionary dilemmas—Albertian window perspective and narrative, or Ptolemaic grid and surface panorama, "art as emblem" or "art as mapping" (Alpers 1983, 138–39, 166)—and apparently blinds her to the reach of biblical-Christian faith commitment at work in the Dutch culture following up Erasmus, Grotius, "Vader" Cats, and Vondel, with Constantijn Huygens, Jan van Goyen, Jacob Ruisdael, and Rembrandt, for example. Alpers misses, I think, the singular historical breakthrough to an unusual depth of meaning that Vermeer and contemporary Dutch artists were finding and showing in the humble commonplaces of daily life.[43]

On the other hand, Kurt Badt was correct to dispute Sedlmayr's rather pat allegorical-anagogic reading of *De Schilderconst,* because Sedlmayr's hermeneutic disallows the possibility that artistic presentation of creatural glory and God's grace touching ordinary things with halos of benediction can fuse such "invisible" realities with visible nuances of painterly composition, color, rhythms, and texture, and need not be imported as literary coefficients. Badt's drive (comparable to that of Buber) to let the art object in its defining artistry ask us questions[44] is methodologically right, it seems to me, bringing art-historians professionally face to face with artworks as nuanced embodiments of committed human vision and passion.

Vermeer displaces the Renaissance inheritance in his artwork, as well as the Greco-Roman-Egyptian christianized mythological world Poussin was at pains to renew. There is no Latin and less Greek in Vermeer's paintings like *Woman at a Window with Pitcher* (c. 1665). But Vermeer's con-

43 Because Alpers dogmatically presumes with respect to Dutch artistry that "Pictures document or represent behavior. They are descriptive rather than prescriptive" (Alpers 1983, xxvi–xxvii), she also thinks, because emblems are not arcane, therefore they are surface illustrations in Dutch art (Ibid. 230–31). No wonder Alpers has trouble fitting Rembrandt into her reductive prescription for Dutch art: "Rembrandt resolutely refuses to produce the transparent mirror of the world of the Dutch *fijnschilderkunst*" (Ibid. 225). As Simon Schama says: "Even if one were to accept the thesis that 'the art of describing' really gets to the heart of Dutch art, it begs the enormous question of just what it is that we think is being described. For the notion of a natural universe that could be classified or investigated without reference to the Creator—a kind of amoral cosmos explored through a dispassionate lens—is about as far as one can imagine from the mentality of seventeenth-century Christian culture (let alone one compounded of Calvinism and humanism in about equal parts)," in Schama 1983, 30.
44 Cf. Badt 1961, 17, 60.

summate artistry sidelined European antiquity not by *creatio ex nihilo,* but by taking root in a different "antiquity," one that surfaces in Vermeer's art, breathing an open-eyed compassionate wonderment and unconditional praise. That the world is not a brute nature but a miracle of a provident Creator to be received gratefully, and that humanity is not an achievement but is a given as a diaconate calling, is the ancient Biblical vision and Reformation spirit I find priming and buoying Vermeer's artwork.

To situate Dutch Vermeer's artistic contribution of the mid-1600s AD for today, when "High Art" derived from the educated Renaissance mold is in mortal exchange with the perennial "Popular Art" now multiplied exponentially in quantity and power by technocratic means, arthistorians might consider, for example, whether the defining locus for understanding the extraordinary, noble, candid, commanding women in Vermeer's art is not as an echo of *isha chajil,* "the resourceful woman" of the acrostic poem in Proverbs 31:10–31,[45] and test whether such art does not receive its animation from Vermeer's following the spirit of the Newer-Testamented gospel where, it is said, the simple act of pouring a cup of cold water can be redemptive and satisfying to God and neighbor (cf. Matthew 10:40–42).

Poussin's spirit of reviving the cumulative European antiquity and renewing its grandeur, and Vermeer's taking a "road-less-traveled-by" under the dynamic of Reformation, putting the European inheritance in brackets, as it were, to explore the world as *theatrum Dei,* a good creation for human vocations: these diverse strategies were what Poussin and Vermeer stood for in those post-Renaissance, pre-Enlightenment times.

The plot thickens when you examine a post-Enlightenment, post-Positivist, pre-Apocalypse artistic figure in our heyday of Pragmatistic culture. I shall touch with embarrassing brevity on the thrust of Anselm Kiefer's artworks to clinch my final provocative point, since Kiefer's art sounds a large strong voice relating to "antiquity."

Anselm Kiefer and Nordic antiquity
The antiquity to which Kiefer orients his art is ostensibly an overpowering amalgam of Nordic mythology, Jewish Kabala, and German (Romantic) cultural history, in *Midgard* (1980–85) [#35], for example. The snake of evil slithers up from the underworld to Middle Earth, to penetrate the cracked artist's palette lying on the battle-scarred terrain, while breakers

45 Edward Snow's book on Vermeer is brilliant, but because of his adopting a Bachelardian metaphysics of male/female power struggle, Snow misreads Vermeer with antichristian overtones (Snow 1979, 132–36; 1994 edition, 156–66).

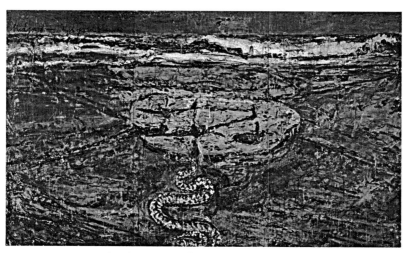

[#35] Anselm Kiefer, *Midgard*, 1980–1985

of an unruly sea toss under the high, bleak horizon line of a leaden sky. And Kiefer's *Alexandria* (1987–88) is in its initial underlayer a large but indistinct photograph of a silhouetted library building or piles of books, mixed with sheet-lead overlaid by grey paint and emulsions, blowtorched so that the heavy material looks as if it be burning to a crisp, permanently, by an unearthly, seraphic refining fire.

That is, Kiefer's antiquity is not only vastly different from that of Poussin—veritably another universe of imageic discourse—but Kiefer also does not try, as Poussin does, to resume an ancient civilization and cultivate its patina further. Kiefer's heavy-hearted artistry replays his antiquity as a primordial struggle of evil versus good, and human aspiration versus recurrent destruction. Unlike Vermeer's history-honed-down joy in the gift of ordinary creatural good, Kiefer's transumption of the significant past finds the present to be an illusory veil over the reality of crisis. *Lot's Wife* (1989) [*RA* #138] hovers like the white specter of a skin burn over a wasteland destroyed by fire and brimstone. The railroad tracks stretch through sand, thick oil paint, shellac, pieces of lead, going nowhere specific: those who turn around, like Lot's wife, better, like Walter Benjamin's angel of history (recapitulating Paul Klee's *Angelus Novus*),[46] see life, history—"antiquity"—ancient (and modern) urban civilization, truly as one monumental pile of randomly-collected rubble.

History merges into myth for artist Kiefer; antiquity like "nature" dissolves into elemental *stoicheia*:[47] straw, dead grasses, dried flowers,

46 Cf. Benjamin 1996, Thesis ix.
47 Cf. Galatians 4:1–11.

seeds! strewn as if wind-blown against a lead base, *materia prima*. Kiefer's *Multatuli* piece testifies that in the end and in the beginning there is spermatophytic sedimentation. Such unprepossessing yet mysterious transient material is the true Ur-antiquity for Kiefer, an everlasting primeval reality to which everything returns—dust and ashes.

What of "human" antiquity, epitomized by "the Book," generated originally in Zweiströmland (1985–89) near the Tigris and Euphrates rivers, long before Alexandria's library? Kiefer's enormous structure, also named *The High Priestess* [*CP* #1]—shelves stacked with soldered lead-foil sheeted folio-sized tomes—which towers over mere human mortals, seems like a misplaced section of Luis Borges' surreal *Library of Babel*. This research library, say, of the Great Books of Western Civilization, composed from the interminable compilation of twenty-two letters (holy to the Jews), contains (forbidden) images of cloud formations, desert regions of Israel, actual tufts of human hair, pictures of cauldrons and nuclear reactors, rusting aerial photographs—a wealth of earthy, weather-beaten knowledge. But the artistic point is that the impressive tedium of the ancient book-civilization is practically closed to us today—it would take a fork lift to check out just one of these lead volumes weighing 50 to 100 kilos apiece; they look crumpled, disordered, often charred, and the language inside is probably foreign, unintelligible, because there is an overwhelming aura of heaviness, tiredness, a sacral foreboding of entombed knowledge, a too-lateness haunting this huge construction. Even if, as in *Das Buch* (1980s), you give the sacred book fifteen feet of wings, the Icarus attempt to break free of earth results more in a prehistoric type-animal that cannot fly—despite the blacksmith Wayland's feat in the older Edda—because the wings are made of lead.

Anselm Kiefer's transumption of antiquity is not like Poussin's way of reliving and outdoing past legendary events, nor like Vermeer's sheer facing age-old daily life anew: Kiefer prods us to remember what we ultramodern people would rather forget—the scholarly trivia, the scorched earth and destruction of Wayland's Flight with wing [#36] we with all our winged fancy create (!)—and bids us reenter the hidden, non-transcendent tohuwabohu of Nordic myth, and silently face again the archaic underbelly of evil within us.[48] In *Shulamith* (1983) Kiefer would alchemically transmute the empty brick hall (earthen bricks are made of fired straw) planned as a Valhalla for Nazi war heroes into a blackened memorial for the Jews burned to ashes in the German Hitler holocaust. The

48 Cf. Hans-Jürgen Syberberg's *Hitler, ein Film aus Deutschland* (1977). Its title for North American release was significantly: *Our Hitler*.

[#36] Anselm Kiefer, *Wayland's Song (with Wing)*, 1982

tiny flames from the distanced seven stick candelabra are a feeble, not hopeful, but undying grim witness to an *ewige Wiederkehr* of "antiquity."

Although I do not share Kiefer's existentialistically-driven mytho-poeic mystical vision, his powerful art products prompt for me a sobering thought: Eurocentric culture, especially in North America, is becoming eccentric, given the clamor of world atrocities not only in politics and telecommunications but also in the world of art, both art-gallery salon and popular art, along with a dissolute trend to practicalize philosophy or give it a special-interest cachet with academic tenure. Art-historians and philosophers of the stripe who seriously examine transumptions of antiquity are an endangered species. Maybe we even deserve to become extinct, unless we conceive art and philosophy history-keeping as a trust to do justice to the committed spirited vision within artworks and phi-losophies as we compassionately judge their insightful or misleading contributions of imaginative and categorial knowledge for correcting or skewing our present-day ahistorical parochial mentality.

It would be a good step, I dare say, for reformational philosophers relating to Greco-Roman antiquity to realize that Western civilization is on the skids, whether despite or because of the monolithic blanket of its Americanized pragmatistic version spread across the face of God's earth. So we third generation of reformational philosophers need, I believe, to continue to make earnest with Scripturally-directed architectonics, com-

parable to what the artist Vermeer did in painterly art, and pick out carefully our historical sites for building specific cultural shelters, preparing to take in refugees.

Exorcism and giveaway goods rather than *spoliatio Aegyptorum*
This predicament of deep cultural shift and drift at large in civilizations worldwide is partly why I think the *spoliatio* guideline is wrong-headed.

Reformational philosopher Jacob Klapwijk supports the *spoliatio* approach to such an extent that he would transpose reformational Christian philosophy into a "transformational philosophy," which lives more dangerously, authentically in confrontation, he thinks, with nonChristian thought, because "transformational philosophy," in situational "solidarity with the surrounding world of (unChristian) learning" may adopt certain of its key concepts and then, "loyal to the Lord Jesus Christ," Christianize them, despoiling the Egyptian worldly wisdom.[49]

I hear Klapwijk maintain his intention to honor an underlying religious antithesis in the starting points of philosophy, and the admission that his project of "critical appropriation through transformation" has enormous risks—"loss of identity, polarization, apostasy"—because attempts at piecemeal eclecticist synthesis will undermine the rule of the gospel over current patterns of thought.[50] And I respect Klapwijk's benevolent, patient washing out the historical linen of those who gave life time to fashioning *Philosophia Christiana*. But I think he is wrong on at least two counts; so I use his adoption of the *spoliatio* hermeneutic to order my critique.

(1) The *spoliatio* metaphor is not sound exegesis of 2 Corinthians 10:5. It is misleading to interpret Scripture's revelation that Holy-Spirited adopted children of the Lord wield "God-all-powerful weapons for taking every contrived thought captive and leading them away into obedience of the Christ" as if that passage meant Christians are to be confiscating plunder from Egyptian overlords. Godless reasonings, vain artworks, and proud thoughts are not like inanimate gold amulets you can smelt down and recast as holy crucifixes; human philosophies are not ceremonial vats of water waiting to be turned into wine.[51] Klapwijk oversimplifies his preferred tactic, I think, when he writes:

> Critical assimilation implies, in other words, that the valuable insights of those of other persuasions must be shelled from the pods of their

49 Cf. Klapwijk 1986, 146–47; Klapwijk et al., 1991, 255, 263–64.
50 Klapwijk et al., 1991, 187, 252, 263–64.
51 Bos and Klapwijk in Klapwijk et al., 1991, 49, 249–50.

worldviews, that they must be pulled up out of the religious ideological soil in which they have thus far been accustomed to flourish. (Klapwijk 1986, 146)

In my judgment the fruits of Poussin's artistry are not able to be shelled like peas; and Kiefer's overpowering constructions lose their significance once they are cut flowers. Besides, 2 Corinthians 10:3–5 is not talking "appropriation," not even "conversion."[52] Scripture in 2 Corinthians 10 talks subjugation, destruction—not the "fleshly" iconoclastic sort of smashing persons and property—but God-all-powerful . . . exorcism! of what affronts the Lord and holds humans enslaved (cf. context of Ephesians 4:7–16, 6:12).

Poussin's artistry needs to have its offer of cultured Humanist delectation exorcized by naming and exposing its stultifying scholarliness. The tremendous centralizing, visionary power of Kiefer's mythologizing artwork needs to be exorcized by one's identifying its deadly, anguished futility. Exorcism rather than *spoliatio,* I propose, best catches the critical task of Christian philosophical analysis.

(2) The second mistake it seems to me that Jacob Klapwijk's writings so far encourage is that our age-long Christian and Reformed Christian practice of botched syntheses with "antiquity," despite disclaimers, are practically raised to normative status for policy, so long as our heart motivation is antithetically-pure and the resultant, ongoing dialectical tension of our mixed products is free from self-satisfaction and isolation.

Maybe this second correction of mine is too sharply formulated, but what I miss in Klapwijk's (reciprocal) "transformational philosophy," pendent from the *spoliatio* conception of "interaction" with non-Christian thought, is the scandal of the possibility of and the call to enact "Scripturally directed philosophy."[53] As H. Evan Runner said long ago: "synthesis"—the hybridization of incompatible strains of wheat and tares, which especially the Patristics fiercely struggled with and against—is what we all practice; but we will "reject the *desirability* of synthesis when we have seen the nature of the Word of God" (Runner 1960, 141; my emphasis).

Coming to the tradition of Kuyperian culture as an American "outsider," I have never understood "Reformational" Christian philosophy to mean you lead with an antithetical uppercut to your neighbor's theoreti-

52 Augustine uses the term "conversion, as Wolters points out, in promoting the "great project of Christianization" (Wolters 1990, 198–99).

53 Geertsema also hints of this problem in "transformational philosophy" when he asks whether Klapwijk's solidarity-with and openness-to nonchristian thought would problematize Dooyeweerd's transcendental critique of godless philosophy in God's world. Cf. Geertsema 1987, 155-58, 160–64.

cal chin, and issue God's final judgments at the drop of an antinomy.[54] Christian thinkers do not have a monopoly on knowledge and insight. But I believe that Scripturally led, self-critical saints in community reflecting humbly together on creatural matters and human accomplishment and misdeeds do have, in spite of the track record, a head start historically in being oriented to the truth. A redemptive tradition of (flea-ridden) Scripturally-directed philosophizing does not mean nothing. Each generation does not have to begin again without a birthright in exile, jostling like Sisyphus with the current slippage and apostasy to find an *orientation*.[55] Kuyper's old metaphor still comforts me with its thetical wholesomeness:

> What we really need is a seedling of scientific theory thriving on Christian roots. For us to be content with the act of shuffling around in the garden of somebody else, scissors in hand [to cut the other's flowers], is to throw away the honor and worth of our Christian faith. (Kuyper 1931–32, 3:527)

Indeed, I do not want to make it my *priority* to "Christianize Egyptian philosophy," as if I am still a refugee in Egyptland without my own home territory in which to grow grain, figs, and grapes for wine. I will listen intently to every new trend for diagnostic knowledge (Griffioen 1985, 35), and gladly fertilize my own humble fallible systematic philosophical position with scrutinized "antiquities," spending prime communal artistic and philosophical time trying to figure out what in God's world Poussin, Rubens, Cezanne, Kiefer, Kant, Nietzsche, Brecht, Heidegger, Foucault, and others have been ingeniously, astigmatically getting at. But my primary concern within a community of Christian theorists in God's world of history is to follow the sage advice the fiery S.U. Zuidema

54 "The re-forming christian approach to unchristian culture is not one of highway robbery and synthetic adoption but is one of serious, anti-sympathetic vibration, if you can take a metaphor; in forming, in building a re-formational christian culture we scrutinize unchristian genius (to know what is going on!) to see what they are mistakenly getting at in God's world and to use them for a good thing in fashioning our own wineskins" (Seerveld 1995, 20).

55 I am unable to accept what Klapwijk asks us to take for granted, that "the concepts forged in Christian philosophy cannot be expressed other than by way of critical examination and transformation of the historical materials at hand" (Klapwijk et al., 253–54), because Klapwijk's "transformational" cliché assumes that "both the concepts-to-be-transformed and the models-in-terms-of-which they are to be transformed [come initially] from the history of philosophy in *general*" (Ibid., 259; my emphasis). His position seems to preclude that followers of Jesus Christ can ever significantly start historically within a particular biblically reclaimed thought-tradition bearing categories fallibly spired by God's gracious creational revelation under Holy Spirited direction from Scripture.

once gave me: *stel maar de thesis; dan zul je wel de antithesis thuis krijgen* (Just posit the [redemptive] thesis; then you will get anti-Christian theses back in your face).[56] Or, as the gentle Vollenhoven taught us: be first of all thetical; then be critical, and don't conflate the two.[57]

You do not solve an ingrown, obscurantic, defensive "Christian" mentality by adopting a *spoliatio* methodology. An updated *spoliatio* policy today, without an infallible supervising authority to keep the orthodox lid on thinking, may be prone to mutate into a decentered Rortyan dialogue or an endless Derridean ironizing commentary on other persons' stockpiles of gold. I too eagerly await the Lord's consummation of the adulterated historical offerings of humankind, when the world's ethnic cultural treasures and glories shall be finally delivered as purified, sweet-smelling offerings to Jesus Christ (Revelation 21:22–27). The revelation of just what those treasures be will probably come as much a surprise to us as reward and judgment were to the people in the parable of the sheep and goats (Matthew 25:31–46).

"Reformation" that is radical (that is, rooted in the living word of God) with respect to art and philosophy and cultural service (rather than "reformist") lives out of the wellsprings of gratitude to the Lord for a biblically directed—God helping you—fresh position in history, and is not driven by the "motive" to be collecting booty from unbelievers.[58] The diaconal service of (reformational) God-obedient historical and historiographic knowledge, I believe, is to refine and deepen one's Scriptural systematic-philosophical-or-artistic wisdom abuilding in a community of Christ's followers, so you can giveaway to the neighbors every good thing you are finding and receiving from God's hand, world without end. The pertinent biblical directive for us philosophers and historians who would be found faithful to our Lord with respect to coming to terms with "antiquity" (and current godless cultural endeavors) is: become as wary (*phronimoi*) as snakes and as without guile (*akeraioi*) as doves (Mat-

56 See Seerveld 1995, 143.

57 Vollenhoven 2005, 6–8, 13–18; Kok 1988, 101–105, 136–38. "Christian philosophy must *presuppose* a more or less articulated basic philosophical conception or framework which not only incorporates a biblical sense of the dynamic of history, past and present, but which, more generally, accepts *in some way* what Bible-believers know to be the case in the light of Scripture" (Kok 1988, 104).

58 Robert Knudsen carefully notes that "On Kuyper's view the Dutch word for principle, *beginsel,* has a richer meaning than its English equivalent. . . . For Kuyper a principle is something that impels and molds. Christian principles are major forces that direct and form the life of the Christian community" (Knudsen 1986, 225). My concern is that *a spoliatio* policy not become a "principle" of operation or our guiding "motive."

thew 10:16). As thetical doves and critical snakes in God's world under the biblical injunction to not be conformed to this present age but to be thoroughly changed by the renewal of (our) consciousness in order to discern what be God's will (Romans 12:1–2) for theory, artistry, political leadership, all cultural endeavors—Jacob Klapwijk would affirm this guideline too—we do well, I think, to recount the blessings of our Augustinian legacy as well as its failings.

Calvin's pastoral wisdom and scope of reflective piety owes much to Augustine's incomplete battle against Platonism. Abraham Kuyper' s Neo-Idealist confidence still resonated and concretely extended Calvin's genial concern for advanced education and limited spheres of societal authority under the tutelage of Christ's Rule. Vollenhoven and Dooyeweerd expanded Kuyper's germinal ideas on societal spheres into a rigorous philosophical systematics that breathes encyclopedic and historiographic conceptual shalom.

We third generation theorists of the Reformed thought-tradition are busy correcting Dooyeweerd and Vollenhoven's weaknesses, inflexibilities, and missteps, we think, as we try to hand on its contoured redemptive promise; and we ought to be prospecting more vigorously for allies among the likes of Irenaeus, St. Francis, Chaucer, Luther, Shakespeare, Rembrandt, Bach, Dostoevski, Georges Rouault, Robert Bresson, Flannery O'Connor, and countless others who have not bowed the knee to Vanity or Mammon—that's why I reclaimed Vermeer for *the Reformational Tradition* (who, to join with the woman he wanted to marry, converted to Roman Catholicism and had to live in what was called "Pope's corner" in Delft at the time).

And the coming fourth generation, God willing, shall continue, if they are faithful, winnowing and making our spotty philosophical offerings more pleasing to the Lord. One does not have to start over from scratch every generation; one is not dependent upon the reigning secular philosophical environment for orientation, I believe. Our task is simply to be faithful in baking good Scripturally-directed systematic and historiographic bread to give away generously to our neighbors and the younger generation (cf. Ecclesiastes 11:1–6). Even if it be only cracked wheat bread and a couple of very small fishes, God knows how to multiply the blessing of a little faithfulness copiously.

Appendix for the saints who have everything: a few debatable theses

(1) History-keeping is an anagram of how Scripturally-directed philosophers are to treat antiquity: conserve and present anew what is

worth keeping.

Art history-keeping and art-historical writing both follow upon art-making and serve as its propadeutic. Art-historical critique is meant to bring art products (and artistic events) to fruition, mediating art objects for other and later responsive human subjects.

Historians of philosophy are called upon to deal with earlier (and current) philosophical products and theoretical activity in a similar Janus-faced way, which attests to the common human connection and difference later generations of theoreticians inescapably have with earlier conceptual contributions.

(2) Historians must give voice to earlier knowledgeable art and philosophy in their faith-impassioned pregnancy, or fall into anachronistic distortion.

A graphic or painterly dated/located art object is a quasi-subject (Mikel Dufrenne) to which viewers are accountable. Therefore, art-historians who view art objects may not judge artworks as if they be lifeless puzzles to solve or games from the distant past to play, but art-historians are responsible for letting the mute primary artwork (or performance) speak its knowledge with the full cultural-dynamic period-force and a-dopted committed vision. Interventionist art-historical studies, which use the artwork for one's own non-artistic purposes, are unprofessional activities.

Historians of philosophy are responsible historians of philosophy when they context the written product so its ancient voice and contribution can be heard today. Dismissive critique is unworthy of a Christian consciousness that knows all too well the sweetly coated wormwood of misguided ideas, yet how evil philosophical analysis normally does finger and crookedly know realities in God's world.

(3) Historians are called to do justice to past artistic and philosophical contributions; that is, become compassionate but firm judges.

Discovering art-historical sources (not to be confused as causes) and precisioning art-historical conditions (not to be taken as norms) is as necessary as establishing a *catalogue raisonné* for art-historiography, but knowledge of sources and (societal) conditions is not sufficient for acquitting the art-historian of doing justice to past artistic contributions. The crux to art-historical writing is fallibly detecting how, and possibly why, the artist made what significant changes he or she did in the current artform that enhanced or wasted aesthetic meaning for human neighbors

from then until now.

A clear précis of what earlier philosophy actually thought to be so must come first in practicing philosophical historiography. However, good philosophical historians also do need to judge what a given philosophical analysis, whatever its given ambience of spirited communion and definite perspective, has done for good or for ill with its inheritance of theory once upon a time, in order to trace the import, quality, and specific direction of its recorded footstep in tracking the pilgrimage philosophy is taking throughout the ages.

(4)　Historians need to treat art and philosophy within an overview whose horizons are set but open because not a *telos* but an *eschaton* is the certain prospect: good and evil lie within the possible realities of repentance, forgiveness, and hope.

Because it is the nature of historical reality to have beginnings and endings, if an art-historian has no horizon of eschaton and decides against any "master narrative," for fear of inflicting oppressive shortsighted closure, the resulting art "historical" investigation forfeits a connecting story to graphic and painterly art, for example, and the erstwhile historian is left an ontological nomad sifting with busy ingenuity through artistic bits and pieces in a no-name pawn shop. It is true that art-historians too see only in part, but human vision deals in the mystery of wholes; without vision art-history as a field of human endeavor is ripe for colonization or self-serving moralizing.

The contours of Vollenhoven's historiographic categories do serve as a Scripturally-directed categorial framework for chewing the produce of philosophical endeavor. It is important to keep in mind that philosophies are fleshy-and-bloodied embodiment of far-reaching fallible human decisions, and the eschatonic fulfillment, coming (which will refine all analytic dross), is not the telos of an achieved continuum but a gracious blessing not in human hands: so the Christian historiographic dove-and-snake policy must not rest content with monographic studies, but also develop the eyes and ears to discern a connecting, knotted thread through the ages of relative redemptive tracks in out-of-the-way places.

(5)　Historians are rightfully scavengers of art and philosophy, sorting through rubble, redemptively busy with leftovers, sketching the trail of human responses that count. It is fair to ask those who work with an art-historiographic method to see to its philosophical grounding and also to double-check whether the knowledge it delivers is worthwhile for human life today.

It is also fair to ask reformational thinkers who deal with antiquity (or shun such labors as obscurantic) not to covertly presume they have either escaped or succumbed to the error of one's predecessors. But we need to select choice flashpoints in the past to orient the next generation to understand our human task, lest the newcomers soon become lost in an amnesiac network of being fashionably current, and thus become all too soon outdated, obsolete prophets.

Bibliography of sources cited and used

Alpers, Svletlana. *The Art of Describing: Dutch art in the seventeenth century* (University of Chicago Press, 1983).

Badt, Kurt. *Modell und Maler von Jan Vermeer, Probleme tier Interpretation. Eine Streitschrift gegen Hans Sedlmayr* (Köln: DuMont Schauberg, 1961).

———. *Die Kunst des Nicolas Poussin.* 2 vols. (Köln: DuMont Schauberg, 1969).

Benjamin, Walter. "Über den Begriff der Geschichte" [1940], in *Walter Benjamin: Ein Lesebuch*, ed. Michael Opitz (Frankfurt/M: Suhrkamp, 1996).

Bialostocki, Jan. "Einfache Nachahmung der Natur oder symbolische Weltschau." *Zeitschrift für Kunstgeschichte* 47 (1984): 421–38.

Carrier, David. *Poussin's Paintings: A study in art-historical methodology.* (Pennsylvania State University Press, 1993).

Chastel, André. "Le Tableau dans le Tableau." In *Stil und Überlieferung in der Kunst des Abendlandes, Akten des 21. Internationalen Kongresses für Kunstgeschichte in Bonn 1964*, I. (Berlin: Gebr. Mann, 1967).

Cheetham, Mark. *The Rhetoric of Purity: Essentialist theory and the advent of abstract painting* (Cambridge: Cambridge University Press, 1991).

Da Vinci, Leonardo. *Pagine Scelte*, ed. by Arturo Pettorelli (Orinto: Paravia, 1935).

Dempsey, Charles G. "Poussin and Egypt." *Art Bulletin* 45 (1963): 109–19.

Friedländer, Walter. *Nicolas Poussin: A new approach* (New York: Harry N. Abrams, 1964).

Geertsema, Henk. "Christian Philosophy: Transformation or inner reformation." *Philosophia Reformata* 52 (1987): 139–165.

Gilmour, John C. *Fire on the Earth: Anselm Kiefer and the postmodern world* (Philadelphia: Temple University Press, 1990).

———. "Original Representation and Anselm Kiefer's Postmodernism." *Journal of Aesthetics and Art Criticism* 46 (1988): 341–50.

Griffioen, Sander. *The Problem of Progress* (Sioux Center: Dordt College Press, 1985).

Haskell, Francis. *Patrons and Painters: A study in the relations between Italian art and society in the Age of the Baroque* (New York: Knopf, 1963).

Haxthausen, Charles W. "The World, the Book, and Anselm Kiefer," *Burlington Magazine* 133 (1991): 846–51.

Helleman, Wendy E., ed. *Christianity and the Classics: The acceptance of a heritage*

(Lanham: University Press of America, 1990).

Hibbard, Howard. *Poussin: The Holy Family on the steps* (New York: Viking, 1974).

Huizinga, Johan. "Nederland's Beschaving in de Zeventiende Eeuw," in *Verzamelde Werken* 2 (Haarlem: Willink & Zoon, 1948): 414–73. Translated by Arnold J. Pomermans as "Dutch Civilization in the Seventeenth Century," in *Dutch Civilization in the Seventeenth Century and Other Essays,* ed. Pieter Geyl et al. (London: Collins, 1968.), 10–33.

Hulten, Karl Gunnar. "Zu Vermeers Atelierbild." *Konsthistorisk Tidskrift* 18 (1949): 90–98.

Huyssen, Andreas. "Anselm Kiefer: The terror of history, the temptation of myth." *October* 48 (Spring 1989): 25–45.

Jasnuszczak, Waldemar. "Is Anselm Kiefer the New Genius of Painting? Not Quite!" *Connoisseur* 218 (May 1988): 130–35.

Klapwijk, Jacob. "Antithesis, Synthesis, and the Idea of Transformational Philosophy." *Philosophia Reformata* 51 (1986): 138–52.

———. "Reformational Philosophy on the Boundary between the Past and the Future." *Philosophia Reformata* 52:2 (1987): 101–34.

Klapwijk Jacob, Sander Griffioen, and Gerben Groenewoud, eds. *Bringing into Captivity Every Thought: Capita selecta in the history of Christian evaluations of non-Christian philosophy* (Lanham: University Press of America, 1991).

Knudsen, Robert. "The Transcendental Perspective of Westminster's Apologetic." *Westminster Theological Journal* 48 (1986): 223–239.

Kok, John H. "Vollenhoven and 'Scriptural Philosophy.'" *Philosophia Reformata* 53:2 (1988): 101–42.

Kuyper, Abraham. *De Gemeene Gratie,* 3rd ed., 3 vols. (Kampen: Kok, 1931–32).

Madoff, Steven Henry. "Anselm Kiefer: A call to memory." *Art News* 86 (October 1987): 125–30.

Maritain, Jacques. *Creative Intuition in Art and Poetry* (Cleveland: Meridian, 1966).

Miedema, Hessel. "Johannes Vermeers 'Schilderkunst.'" *Proef* (September 1972): 67–76.

———. "Realism and Comic Mode: The peasant." *Simiolus* 9 (1977): 205–19.

Montias, J.M. *Vermeer and his Milieu: A web of social history* (Princeton University Press, 1989).

———. "Vermeer and his Milieu: Conclusion of an archival study." *Oud Holland* 94:1 (1980): 44–62.

Panofsky, Erwin. "Reality and Symbol in Early Flemish Painting: 'Spiritualia sub metaphoris corporalium,'" in *Early Netherlandish Painting: Its origins and character* (Cambridge MA: Harvard University Press, 1953), 131–148.

———. "*Et in Arcadia Ego*: On the conception of transience in Poussin and Watteau," in *Philosophy and History,* eds. R. Klibansky and H. J. Paton (New York: Harper Torchbooks, 1963): 222–54.

Paulson, Ronald. *Emblem and Expression: Meaning in English art of the eighteenth*

century (Cambridge MA: Harvard University Press, 1975).

Piguet, Philippe. "Anselm Kiefer. Histoire, mythe et memoire." *L'oeil* 435 (October 1991): 72–73.

Rosenthal, Mark. *Anselm Kiefer* (Chicago: Presiel-Verlag, 1987) (Exhibition in Art Institute of Chicago and Philadelphia Museum of Art, 1988–89).

Runner, H. Evan. *The Relation of the Bible to Learning: Christian perspectives* (Pella, IA: Pella Publishing, 1960).

Santucci, Paola. *Poussin: Tradizione Ermetica e Classicismo Jesuita* (Salerno: Cooperativa Editrici, 1985).

Schama, Simon. "The Dutch Masters' Revenge," *New Republic* 190:20 (1984): 25–31.

Sedlmayr, Hans. "Jan Vermeer: 'De Schilderkunst,' Nach Badt, zugleich Replik." *Hefte des kunsthistorischen Seminars des Universität München* 7–8 (1962): 34–65.

————. "Jan Vermeer: Der Ruhm der Malkunst." [1951] In *Festschrift für Hans Jantzen; now in Kunst und Wahrheit, Zur Theorie und Methode der Kunstgeschichte* (Mittenwald: Mäander Kunstverlag, 1978): 134–42.

Seerveld, Calvin G. "Telltale Statues in Watteau's Painting." *Eighteenth Century Studies* 14:2 (1980/81): 151–180 {infra pp. 171–195}.

————. "Canonic Art: Pregnant dilemmas in the theory and practice of Anton Raphael Mengs," in Vol. III of *Man and Nature/L'Homme et la Nature: Proceedings of the Canadian Society for Eighteenth-Century Studies,* ed. by Robert J. Merrett, (Edmonton: Academic Printing and Publishing, 1984): 113–130 {infra pp. 223–240}.

————. *A Christian Critique of Art and Literature* (1962–64) (Toronto/Sioux Center: Toronto Tuppence Press/Dordt College Press, 1995).

Slive, Seymour. "Notes on the Relationship of Protestantism to Seventeenth Century Dutch Painting." *Art Quarterly* 19 (1956): 3–15.

Snow, Edward. *A Study of Vermeer* [1979] (Los Angeles: University of California Press; rev, enlarged ed., 1994).

Syberberg, Hans-Jürgen. *Hitler, ein Film aus Deutschland* (Munich: TMS Films, 1977): 445 mins.

Tolnay, Charles. "L'Atelier de Vermeer." *Gazette des Beaux Arts* 41 (1953): 265–72.

Van den Berg, Dirk J. "Rhetorical Theory and the Abiding Actuality of Pictorial Rhetoric" *Acta Academica* 25:1 (1993): 49–82.

Van Gelder, Jan G. "De Schilderkunst van Jan Vermeer," a lecture with commentary by J.A. Emmens (Utrecht, 1958), 27 pp. and 26 illustrations.

————. "Two Aspects of Dutch Baroque." *De Artibus Opuscula* 40 (1961): 445—53.

Vollenhoven, D. H. Th. *Isagôgè Philosophiae/Introduction to Philosophy* [1930–1945]. Dutch/English. Translated by John H. Kok (Sioux Center: Dordt College Press, 2005).

Welu, James A. "Vermeer: His cartographic sources." *Art Bulletin* 57 (1975):

529–47.

West, Thomas and Peter Winter. "Evaluating Anselm Kiefer"; "Interview at Diesel Strasse"; "Whipping Boy with Clipped Wings"; "Energy of Broken Images," *Art International* 2 (Spring 1988): 61–83.

Wheelock, Jr., Arthur K. and C. J. Kaldenbach. "Vermeer's View of Delft and his Vision of Reality," *Artibus et Historiae* 3:6 (1982): 9–35.

Wheelock, Jr., Arthur K. *Jan Vermeer* [1981] (New York: Harry N. Abrams, 1988).

Wolters, Albert. "Christianity and the Classics: A typology of attitudes," in Helleman 1990.

Zweite, Armin, "Anselm Kiefer: Zweiströmland / The High Priestess," translated by David Britt, in *The High Priestess: Anselm Kiefer* (London: Anthony d'Offay Gallery, 1989).

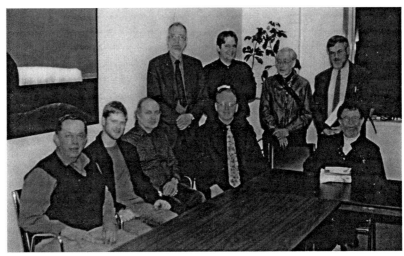

Second Vollenhoven conference in North America convened around a presentation by John Kok at the Institute for Christian Studies, Toronto, 2002
Standing left to right: Al Wolters, Bob Sweetman, Jan de Koning, Harry van Dyke
Seated left to right: Cal Seerveld, Eric Kamphof, Jim Olthuis, John Kok, Henk Hart

Methodological Notes for Assessing What Happened 1764–1831 in the History of Aesthetics

In the light of Peter McCormick's forceful, programmatic brief for rereading the history of aesthetics before we rewrite it today, I should like to stake out a few postulates and basic categories for a working historiographic method that would try to care for some of his major concerns. Then I should like to illustrate, in adumbrative form, how one might begin to plot a narrative on what happened in aesthetic theory from around 1764 to 1831 thereabouts. I'll end with a controversial proposal for writing a history of aesthetics.

I realize that whatever I put forward as relevant texts or give priority in a storied account of changes in aesthetic theory reveals my own tentative stance on the nature of aesthetics and is prejudiced by a resident idea of history. That is true for everyone, I take it. To keep one's inescapable point of orientation from becoming a foregone conclusion, one needs to reconsider the boringly obvious in the dominating received wisdom on aesthetics and simultaneously test one's critical innovations against other current reading options. Whose historical hindsight tracks the beast of philosophical aesthetics most insightfully to its lair today and points us in a direction that would be good for us to lumber on? Or, is there more than one labyrinth, and are we several beasts?

The least one should admit, in the interest of non-parochial objectivity and self-critical openness, is that the status-quo of aesthetics today may not be normative.

Orienting postulates
(1) A history of anything implies there is a connected story. It is impossible to write the history of anything without simplifying its story. But every historical account that oversimplifies what one is recounting dis-

Paper presented to the American Society of Aesthetics, Canadian Society for Aesthetics/Société canadienne d'esthétique, Vancouver, 26 October 1988.

torts the record. So, a basic problem in conceiving a history of aesthetics is the need to honor the complexity and multiple horizons of human embeddedness natural to aesthetics while keeping a story line focused on aesthetics as a theoretical discipline, if that is indeed what you are writing a history of.

(2) The contours of anybody's aesthetic theory are largely determined by one of several specific traditions of categorical frameworks that the given professional thinker favors. Whether it be an empiricist or a dialectical conceptual tradition, the conservationist perspective of *philisophia perennis*, the "mystic line,"[1] or whatever: thinking through the nature of aesthetic reality happens in a tradition of schemata that has earlier been a resource for other thinkers. Even what we might call "informal aesthetic theories," the cohering reflections of Diderot's salon correspondence, Reynold's presidential discourses, Delacroix's *Journal*, or Trotsky's 1922–23 writings on literature and revolution: each is framed by a discernable cast that has a heritage and disposes the kind of investigation made.[2] There are no immaculate conceptions of aesthetics, I believe, no theoretical aesthetics that spring like Athena straight from Zeus' immortal head. Everybody's aesthetic theory has a pedigree.

(3) An aesthetic theory is always dated and located, to be sure; it is conditioned by personal and societal straits, but the most important limiting factor is the powerful cultural dynamic that strives to permeate and direct human activity at large at any given time. There may be cultural dynamics for allegiance in the same overlapping years, like the Romantic spirit and Neoclassical idealisms, both struggling to move philosophy to respond to the engaging thought of Enlightenment philosophes and essayists. One does not need a metaphysical Zeitgeist to recognize the reality of these pan-cultural forces that make historical periods like Renaissance and Enlightenment and a Positivist climate more than names (and explain what Arthur Danto calls the "deep changes" occurring in between styles).[3] If one grants that aesthetic theories have a "period," that is, unrepeatable, dated "cultural movement" character, one is protected as a historian from reducing them to ideological epiphenomena[4] or from

1 Francis Sparshott delineates four such "traditions," in *The Theory of Arts* (Princeton University Press, 1982).

2 Cf. Susanne K. Langer, *Philosophy in a New Key* [1942] (New York: Mentor, 1948), 1–2.

3 Arthur Danto, *The Philosophical Disenfranchisement of Art* (New York: Columbia University Press, 1956), 202.

4 Cf. Jean Hagstrum, *Sex and Sensibility, Ideal and Erotic Love from Milton to Mozart* (University of Chicago Press, 1980), 10–11.

treating the aesthetics theories anachronistically, in currently approved terms.[5]

(4) The fact that there is a history to the formation of aesthetics as a theoretical discipline should not tempt us to assume its development follows a single evolutionary, teleological principle or has been a priori ruled by a dialectical pattern.[6] The historical connections that a historian tries to discover between contemporary and subsequent aesthetic theories is not found by thinking one deals in a series of logical solutions to a common nest of aesthetic problems, any more than one is doing historical analysis by taking friendly note of original "aesthetic" ideas being freely disseminated. Historical connections between aesthetic theories are the significant changes wrought by a new generation of innovators or consolidators in a received inheritance.

(5) Sound historical narrative on aesthetic theory comes by judging whether a certain contribution brings about more inclusive justice for conceiving a family of aesthetic realities; or, if it waffles conceptually on the specificity of a functional aesthetic task or promotes it with an anti-societal exclusivity.

A few strands in the plait of theoretical aesthetics history
If one picks up the story of aesthetic theory with Kant's 1764 text, *Beobachtungen über das Gefühl des Schönen und Erhabenen*, one can show how Kant was integrating there, in a deftly rococo and philosophical way, the Shaftesburyan point of disinterested discernment of "the fair and shapely" with Burke's accreditation of experiencing the sublime in Nature as a veritable propaedeutic for moral humanity. Kant joined these planks of an aesthetic theory with a view of a fundamentally benevolent human nature whose felt but unargued disposition could claim a subjective, universal communicability.[7] This basic, finer feeling for the beautiful and the sublime is what Kant made from the reading of Hutcheson and Hume's "internal sense" and "just sentiment."

Kant's *Observations* are self-consciously not cast in an empiricist, stimulus-response format,[8] but the *Observations* do dance with a gallant

5 Jerome McGann, *The Romantic Ideology: A critical investigation* (University of Chicago Press, 1983), 11.

6 These alternatives correspond to McCormick's characterizations of the millenarian analytical tradition and the archaeological hermeneutic way of doing the history of aesthetics, in his paper for this session, ms. 18.

7 Cf. my analysis on "Early Kant and a Rococo Spirit: Setting for the *Critique of Judgment*," in *Philosophia Reformata* 43 (1978): 165 {see *CE*: 339}.

8 Kant, *Beobachtungen*, in *Kant's Gesammelte Schriften* [KGS] (Berline: Preußischen

spirit of politesse by referring to Hogarth's engravings, quoting the *Spectator*, and becoming an epitome of the Enlightenment's lighthearted essay way of doing philosophy.[9] Rousseau's books impressed Kant at this very time with the educability of basic human feeling;[10] so the *Observations* clearly voice a societal concern with taste, picking up now in a practicalist vein Gracian's earlier courtly context so foreign to the Scientialistic exactness of Baumgartner's key epistemological analysis of "thinking beautifully" (*pulchre cogitandi*). The *Beobachtungen* are the text of lectures Professor Kant presented to the Prussian military officers after dinner at General Meyer's residence along with their cognacs; they are as close as Königsberg could replicate Paris, and as such are a brilliant summing-up of Enlightenment "occasional" philosophical aesthetic theory.

A figure like Sturm und Drang Herder in the 1770s at Bückeburg took aesthetics beyond the confines of both *Schulästhetik* and delightful, essayist theories of taste and belles lettres. In the spirit of Goethe's *Die Leiden des jungen Werthers* (1774) and scandalizing theatre piece *Stella* (1776), Herder was so caught up at the time in the Ossianic fervor, translating Shakespeare and Percy's *Reliques of Ancient Poetry*, partial to Edward Young's thoughts on the wonderful strangeness of originality, that Herder converted Hamann's conviction that *"Poesie ist die Muttersprache des menchlichen Geschlechts"* and *"Das Heil kommt von den Juden"*[11] into a cluster of revolutionary aesthetic theses: humans are poetic subjects who create rather than discover what is there; human speech is the most telling way to give Gestalt to the kaleidoscope sea of images, perceptions, and contradicting forces that we humans and the world are; the Semitic *maschal*, a spoken hieroglyph, is the prototype for true poetry; aboriginal folksong of Celt or German has a native, evocative power that make the papery test of learned verses following the rules of Batteaux show up as pettifoggery; and since every age of cultural activity has its own epicenter of sanity and criteria in itself, abstracting analytic commentary does violence to poetry—the only proper hermeneutic is to let the author's spirit speak by your preforming the text.[12]

Akademie der Wissenschaften, 1900–55), 2: 207.

9 Cf. Robert Ginsberg, ed., *The Philosopher as Writer: The eighteenth century* (Selinsgrove: Susquehanna University Press, 1987), especially 7–11.

10 Kant, KGS 2:217, and "Bemerkungen zu den Beobachtungen," KGS 20:58–59. Also cf. Paul Arthur Schlipp, *Kant's Pre-critical Ethics* [1938] (Evanston: Northwestern University Press, 1960), 49–51.

11 Johann Georg Hamann, "Aesthetica in nuce" [1762], in *Sämtliche Werken*, ed. Joseph Nadler (Wien: Herder, 1950), 2:197, 210

12 Cf. my essay, "Herder's Revolutionary Hermeneutic and Aesthetic Theory," in a col-

Sturm und Drang Herder was opening up aesthetic theory to focus on gnomic images voiced and heard, as an ordering principle for highly intelligent, intuitive knowledge neither rationally defined nor subject to analytic tests. The literary artists as cultural leaders turned reflective and were radically rejecting the encrusted inheritance of "poetic diction" and codes of rhetoric that constricted the other arts as well as poetry to be topically loaded. Herder in the 1770s led the way in repudiating in theory as well as in praxis such intellectualistic subordination of the aesthetic, and reinstated poetry to its age-old office of *vates*, where the bard leads the people. Unfortunately Herder and later Romantic theorists promoted the primitive gem of lyric, Lied, and genius with a passion that short-circuited the recognition and place of bona fide imaginative human knowledge they had pushed to the foreground. The artistic genius as dae-monic spirits removes artistry from functioning within civilized society, and "genius" blacks out the possibility of precision for aesthetic theory to determine the nature of art or to delimit aesthetic specificity.

Meanwhile, Winckelmann mania had been building a formidable cultural force throughout Europe since 1755. The doctrines of Anton Raphael Mengs, who was lionized in the artistic Mecca of Rome and served as chief painter at the Madrid court of Charles III in Spain, came to dominate art academies from Turin to Vienna to Copenhagen, fortify-ing late neoclassical Goethe's ideas and the Weimar Kunstfreunde.[13] Sir Joshua Reynolds inaugurated the Royal Academy of Art establishment in England in 1769, encouraging commissions for portrait painters on the fashionable circuit of Bath and instilled canons of antiqued Greco-Roman decorum. The arts policy dictated by key leaders of the French Revolutions (1789–1799) maintained that the sole purpose of art is to teach civic virtue in public places and to extol heroic traits that will in-still patriotic fervor among the *sans-culottes* in this new age of France, year II.[14] The aesthetic theory of Quatremère de Quincy, authoritative

lection resulting from the proceedings of "Herder Today, an Interdisciplinary Confer-ence," held at Stanford University, November 1987. {See *BSt*: 133–148.}

13 Mengs' *Gedanken über die Schönheit und über den Geschmack in der Malerei* was pu-blished in Zürich by the father of Henry Füssli in 1762. Mengs' complete works were published in Italian, 1780, Spanish, 1780, French, 1781, and in English, 1796. On Mengs' importance for Goethe, see note 3 in my "Canonic Art: Pregnant dilemmas in the theory and practice of Anton Raphael Mengs," in *Man and Nature/L'Homme et la Nature*, ed. Robert J. Merrett (Edmonton: Academic Printing and Publishing Company, for The Canadian Society for Eighteenth-Century Studies/La Société ca-nadienne d'étude du dix-huitième siècle, 1984), 3:126 {infra p. 224}.

14 Cf. a speech by Hassensfradz at *le Club Révolutionnaire des Arts*, session 14 Germinal, l'an II. Also, "Report, Comité d'Instruction de la Société Populaire et Républicaine

cultural *secrétaire* not only during the revolutionary years but also for Napoleon's reign, insisted on a theory of art that posited simple, generic imitation of ideal beauty as the aesthetic norm.[15]

Keeping faith with this conserving Idealist dynamic that gave pulse to his thought, Kant now pulled Baumgarten's old epistemological concerns for aesthetic perception into an encyclopedic, philosophical framework that seemed able to host a number of prior theoretical insights (*Kritik der Urteilskraft,* 1790). Kant argued for the pre-conceptual, non-practical nature of human aesthetic functioning (*Gunst*), yet emphasized—a new concept since the *Observations*—its possible reflexive playfulness in mediating various cognitive faculties in our unified complex of consciousness (*Gemüt*). Such productive and imaginative ability engenders "aesthetic ideas," which are so creatively laden with thoughtful images that no word or concept could possibly pin one down. And Kant was critically concerned to keep the autonomous aesthetic functioning a constitutive factor within human knowing, to ground the free-floating empirical "judgment" of "tasting" what is beautiful and sublime with its own a priori ontological structure and to keep the autonomous aesthetic in principle bound to the larger societal dimensions of fostering a moral and cultural humanism (*Symbol der Sittlichkeit*).[16] Kant's philosophical lynchpin, *Technik der Natur,* a necessary postulate of reflective judgment, did allow, however, the aesthetic activity of "disinterested delight" to float between a species of feeling and an ennobling refinement suspiciously close to moralistic propriety.

Second generation Romantic theorists like Schelling, Schopenhauer, and Coleridge appropriated Kant's aesthetic theory through the loophole of "aesthetic ideas" and renewed a gnostic valuation of artistic activity that Kant in no way approved. Whether it be *intellecktuelle Anschauung*, secondary esemplastic (coadunative) imagination, or the belief that artworks transcend the mist of ordinary experience to show us the truth about things,[17] such tenets undid Kant's systematic balancing act

des Arts," 16 Germinal, l'an II.

15 Cf. e.g., Quatremère de Quincy, *Considérations sur les arts du dessin en France* (Paris: Devaux, 1791), 28–31, 55–60, 124–125.

16 Gilles Deleuze is very clear in expositing this complex matter, in *La Philosophie Critique de Kant* [1963], translated by Hugh Tomlinson and Barbara Habberjam (London: Athlone, 1984), 55–58.

17 Cf. Schelling, "System des transzendentalen Idealismus," in *Sämtliche Werke*, ed. K.F.A. Schelling (Stuttgart/Augsburg, 1856–61), 3:612–34. Cf. Schopenhauer: "Jedes Kunstwerk ist demgemäß eigentlich bemüht, uns das Leben und die Dinge so zu zeigen, wie sie in Wahrheit sind, aber, durch den Nebel objektiver und subjektiver

and tended to set back precise theoretical analysis of "the aesthetic" and to promote poetic visionaries, music as the last wordless sound, nonplussed ecstasy.

Schiller altered Kant's conception of aesthetic functioning quite differently in *Über die ästhetische Erziehung des Menschen* (1794–95) where Schiller conceived it as a gritty *Spieltrieb*. Schiller, in a sophisticated neoclassical way, domesticated human aesthetic activity and posited that pure playful delight in sheer semblance is the pivotal fulcrum where human nature turns. *Rein ästhetische Wirkung*, the contemplative state of playful and suspended animation where one is infinitely prone to all manner of possibilities, is the time when humans are most fully human; so aesthetic (not artistic) education shall liberate us for *einem dritten, fröhlichen Reiche des Spiels und des Scheins* wherein society alone will find unity and harmony beguiled from evil by Beauty. In my judgment, hunkered down inside such cruelly benign aestheticism is a vital, conceptual identification of ordinary human aesthetic functioning that was soon lost to theoretical sight.

The significant change Hegel's Berlin reflections brought to the legitimation and praxis of philosophical aesthetics as a theoretical discipline can be conveniently located in two of his basic premises: (1) because human culture is more real than the actual world of nature, it is right to restrict aesthetics, which treats of beauty, to theory of fine art; (2) because art is a less full realization of truth in our day than scientific theory, art is there for the good of aesthetics (*Kunstwissenschaft*), which sanctions art, not aesthetics there for the production of art.[18] With that double blow Hegel accepted the reduction of aesthetics to theory of art and simultaneously guaranteed aesthetics as *Kunstwissenchaft* a place in the family of scientific theories—for which art serves as fodder.

Since the dialectical tradition governs Hegel's aesthetics, one expects its restless, aggressive character, counting as necessary whatever is counter to what is currently dominant in the ongoing, self-consciously absorbing cultural power struggle. Also, process swallows up structures: art theory becomes substantively art history, to be continued. Yet, given the neoclassical Idealistic cultural dynamic that gripped and gave Hegel's aesthetics

Zufälligkeiten hindurch, nicht von Jedem unmittelbar erfasst werden können. Diesen Nebel nimmt die Kunst hinweg." *Die Welt als Wille und Vorstellung*, ed. Julius Frauenstädt (Leipzig: F.A. Brockhaus, 4 A., 1873), 2:464. Also, Samuel Coleridge, *Biographia Literaria*, ed. J. Shawcross (Oxford: Clarendon Press, 1907), 1:202, 2:12, 19, 33–34.

18 Hegel, *Ästhetik*, ed. Fr. Bassenge (Frankfurt am Main: Europäische Verlagsanstalt, 1965), 1:12–14, 20–24.

its élan, mediated especially by Schiller,[19] despite the wealth of his keen, detailed observations on the sensible materials and elements of various art forms in different ages, art history in Hegel still mutates into a monolithic cultural history where art documents the antinomous, self-destructive yet consolidating progress of the Idea through its inexorable—like the rites of passage—idealization. Art is deadly serious in Hegel's scheme, an intrinsically duplicate revelation of the Truth whose concrete works are nevertheless expendable; but art is expected to do cinematic fadeout into the higher reaches of Religion and finally Philosophy.

Hegel gave aesthetics an identifiable "kingdom" of artifacts—Arts Incorporated—to examine, but Hegel took away with the right hand what he gave with the left hand: aesthetics as speculative philosophy of fine art is free to think through metaproblems (metacriticism, metahistory) but must avoid dealing with mundane matters like non-artistic, imaginative (aesthetic) features of ordinary life. This contribution of Hegel was not "progress" for aesthetics[20] in my judgment, but a hermetic closure of theoretical aesthetics that set up the response of Positivist, formalistic sciences of art, as well as the frustrated circles of art-for-art's sake theorists attempting to be corrective and to pry aesthetics open for life (in conceiving matters of lifestyle, taste, fashion, quotidian acts of imagination, play, festivity…).

Reflective comments and proposal

I break off this fragment illustrating a methodology for writing a history of aesthetics to highlight what I think I have been trying to do in the line of McCormick's concluding questions.

(1) Historiographic judgments are necessarily mixed and relative before the norm of inclusive justice because every person's committed contribution, good or bad, to the story of aesthetic theory begun before and continuing after him or her is limited by one's assumed (philosophical) tradition and cultural period matrix. Most thinkers (including Kant and Hegel) take a fruitful or wasteful conceptual step forward, then one or two sideways or backward.

(2) Genetic source studies of philosophical positions or pivotal ideas (especially studies with a preoccupation for pursuit of "causes"), while

19 Hegel, *Ästhetik* 1:70–71. Cf Rudolf Haym, *Hegel und seine Zeit.* Vorlesungen über Entstehung und Entwicklung, Wesen und Wert der Hegelschen Philosophie [1857], 2A, ed. Hans Rosenberg (Leipzig: Wilhelm Heims Fachbuchhandlung für Philosophie, 1927), 439–443.

20 So, Beardsley judges the matter in *Aesthetics from Classical Greece to the Present: A short history* (New York: Macmillan, 1966), 238.

pertinent for contexting texts, still miss the nub of what is historical because the actual reception—what is made out of sources—is what counts for the history of aesthetics.

(3) Theoretical aesthetics is properly concerned with more than the nature of art and literature and the theory of their interpretation, evidenced by much of the reflection in aesthetics before Hegel closed the windows. But cultural leaders like artists and poets and arts policy makers, who are not trained philosophers, can also be formative agents in the thick of aesthetics' history.

If the historiography provides memory for scholarship, then the discipline of aesthetics today needs a sustained historical narrative of aesthetics that is not a one-person, single volume affair, not just a collection of sources that stops at 1700 AD (as do the volumes of Tatarkiewicz). It would seem appropriate for a team of informed thinkers with specialized knowledge in philosophical aesthetics, diverse cultural periods, the varied arts, and non-artistic aesthetic affairs, unified by a historiographic method and a measure of agreement on the priority of representative texts to braid the more significant changing strands into a reliable (standard?) history of aesthetic theory.

A necessary preparatory step would be a concerted, critically comparative assessment of the methodologies of our mostly dated historical narratives of aesthetics on hand (Gilbert and Kuhn, 1939; Wimsatt and Brooks, 1957; Wladyslaw Tatarkiewicz, 1962–67 [English, 1970–74]; Monroe Beardsley, 1966; René Wellek, 1955–86), and a pooling of knowledge from specialized histories of different arts. McCormick's paper is a challenging beginning. There is only one labyrinth, I believe, but we are several beasts. It does seem to me, however, to be a good project for a Society of Aesthetics to sort out its roots together. If our collective memory in aesthetics is at odds, crooked, confused, merely polemical, or blank, then our scholarly examination of present aesthetic realities, as well as of the past, could be primed for trivial pursuit.

The Moment of Truth and Evidence of Sterility within Neoclassical Art and Aesthetic Theory of the Later Enlightenment

Granted that a neoclassical trend existed in art and aesthetic theory c. 1755–1815 in Western civilization, next to other cultural tendencies, can one discern with hindsight what was historically fruitful and what was stillborn in the neoclassical contribution to the development of painting, aesthetics, and the formation of an artworld within society?

One falsifies knowledge of what happened over a period of cultural time if one forces conceptual clarity upon what is not simple. Any historian, however, who would attempt to chronicle the development of an artist's oeuvre, the contribution of a definite aesthetic theory, and make a judgment in relating an artworld *status quo* to before and after, is called upon to decide what constitutes sound *historical leadership* in the given circumstances.

It can be argued that cultural leadership in a given field depends upon the justice done at the time to the realities of canon, tradition, and innovation. When innovation, or its variant of reform or consolidation, effects simultaneously professionally speciated and societally integrated deepening of the limited cultural task in question, then one may say the leadership has been historically sound. When the artistic canon is not renewed artistically but is altered by non-artistic dictation, or when aesthetic theory is attempted either *de novo* or practiced in tradition-bound fashion, or when the modifications wrought in artworks, art theory, or art policy, deny relevant criteria, inescapable roots, or the need for enrichment, then the changes brought about will be historically restrictive and counterproductive.

A figure like Anton Raphael Mengs (1728–1779) epitomizes the

First published in *Transactions of the Sixth International Congress on the Enlightenment* (Oxford: The Voltaire Foundation, 1983), 149–51. Article by permission of the Voltaire Foundation, University of Oxford.

moment of truth and the evidence of sterility within neoclassical art and aesthetic theory of the later Enlightenment. Sir Joshua Reynolds (1723–1792) or Quatremère de Quincy (1755–1849) could serve similarly as significant, formative spokesmen for neoclassical cultural leadership. Their thought and works show how distinct the neoclassical spirit they represent is from the concerns of Cinquecento Mannerist theorists who used the rhetoricians of antiquity to bolster painting's claim to be as honorable as poetry, and how unlike the Seicento thinkers such as Poussin and Bellori, academically intent upon justifying *la grande manière* with an aura of ancient themes and classical detail. The neoclassical trend of the Enlightenment is most exactly understood as a concerted attempt to bring an encyclopedic theory of canonic art into play *practically*, for beginning, intermediate, and professional painters—and thereby set the taste of society, as a propaedeutic for civic morality—doing it in a schoolmasterly spirit of "back-to-the-basics," the "tried-and-true" ideas and methods accumulated throughout the ages, which will bring an enlightened performance and understanding (again) to the art of painting.

Mengs' *Gedanken* (1762) posit the beauty of supernatural simplicity as the canon for painterly art. The artist meliorates the beautiful things in nature by the Zeuxian method, which has him or her extract, like a bee, the sweetest from many flowers to make the honey. The painterly imitation of what is essential in the natural objects perceived—using inventive, compositional design, chiaroscuro, and color—should be ideal, to rouse our "generous passions" and to instruct the human mind, and will be the more valuable as the idea conveyed is "perfect, distinct, and clear."[1]

A dilemma posed by Mengs' aesthetic theory, fraught with attractive difficulties, is this: must a painter reinvest the normative simplicity of geometric uniformities and quieting, primary-color restfulness with "poetic" ideas or not? Since Raphael and Correggio emerge as the touchstones for painterly art and good taste, is "Nature" a covert way of referring to the best of the Western tradition of art?[2]

It can be demonstrated that the fresco *Parnassus* by Mengs in the villa Albani at Rome (1760–1761) was artistically premeditated, a principled, programmatic manifesto professing to redo Greek painting (not by copying actual Roman remains found at Herculaneum, but by following Winckelmann's opinionated specifications deduced from literary sources

1 See his 1776 letter treatise to Ponz, San Fernando Royal Academy.
2 See Reynolds's doctrine of imitating Nature by selective "borrowings" from the best artistic models! *Discourses* VI (1774) and XII (1784).

on what Greek painting must have been).

If Mengs' *Parnassus* is practically a paradigmatic, graphic definition of what "neoclassical" means as an art historical term for capturing the cultural spirit of those kindred artists, writers, and thinkers busy for roughly two generations thereafter, what counts even more than the sculptural fixity, powerful linear clarity, and serious simplicity, as characteristic traits (that struck the viewers of the day surfeited on *composizioni macchinose* as an incredibly uncluttered, pure presentation of truly living figures, paragons of immortal, gracious beauty) is the fact that "Greek" meant the painting was to be a virtual palimpsest, summing up canonic art.

Thanks to Mengs' ontological theory of comparative Beauty, and his openness to pollinate artistic rosebuds wherever ye discriminately may, along with a driving concern to institute art academies and to formulate "Rules for Masters in order to teach well the art of painting, and for pupils to learn it as they ought," Mengs formulated a rough taxonomy of basic art styles for ordering one's art-critical perception throughout the rise and fall of successive ages of painting and sculpture. This systematic art historiography, arguably the first with a rigorous, supportive aesthetic theory, does face another dilemma indicative of a weakness inherent in Mengs' neoclassical position: is there an entelechaic closure to the possible development of painting so that epigonery is inescapable? Or is there an openness to what painting can become so that there is no binding canon?

The neoclassical art academy and the neoclassical vision of tolerant, universal scope to art history were historically sound and fertile acts of cultural leadership both consolidating and unfolding artistic service, redirecting art and aesthetics out of a rococo spirit gone frivolous. The neoclassical tenets that simplification is the norm for artistic innovation and that a palimpsestic conception of tradition is the canon for painting were historically ruinous. Although neoclassical art theory restored the simple strength of drafted line to figurative art, it pressed upon the painterly image an atavistic burden of allegory. And the anti-historical thrust within the idea and praxis of palimpsestic canonic art led to a kind of utopian, cultural suicide for the neoclassical spirit, because both neoclassical art-theoretical concepts and artworks came to suffer the enigmatic antinomy and indignity of a good zoo, where the captured beasts are encouraged to live like wild animals.

Waiting for a train at a beach in Spain en route to Italy to present a
paper at the International Conference of Eighteenth-century Studies
in Pisa, 1979 (photo by passer-by)

IDEALISTIC PHILOSOPHY IN CHECKMATE: NEOCLASSICAL AND ROMANTIC ARTISTIC POLICY

My thesis is that the countering neoclassical and Romantic ideal-ist cultural regimes, as they traded on their Enlightenment inheritance, failed historically.

No one disputes that Winckelmann (and I would add, Anton Ra-phael Mengs) set in motion a concerted program to correct current En-lightenment art, which many believed had gone soft. *Edle Einfalt und stille Größe* indeed identifies the crux of what Winckelmann believed art must be if we are serious about recapturing the invisible, ennobling ideal that ancient Greek sculpture, architecture, and painting embodied. The thrust of Winckelmann's artistic policy is also not at all like the would-be prolongation of classical grandeur envisioned by Louis XIV's Acadé-mie française ruled by Colbert (1661–1683) and Le Brun (1663–1690). Winckelmann's injunction stripped art, you might say, down to the per-fect outline of colorless, background-less figures. The line is everything for Winckelmann, but his favored line is not Hogarth's rococo, serpen-tine line of beauty and grace: it is the profile line, an ellipsis, the centered oval, the tracer of a parabola whose very measured purity elicits quiet, delighted admiration.[1] And if the message overlay to one's artistic image is clear and graceful, says Winckelmann, then the economy of assembled means to delight and to instruct by a simple, chaste contour fulfills the high calling of art to renew humanity.[2]

1 *Geschichte der Kunst des Altertums* [1762], *Werke* (Stuttgart, 1847) 1:133. Cf. Kurt Gerstenberg, *Johann Joachim Winckelmann und Anton Raphael Mengs* (Halle, 1929), 26–28.

2 *Gendanken über die Nachahmung der griechischen Werke in der Malerei und Bildhauer-kunst* [1755], *Werke*, 2:19–20; *Geschichte der Kunst* [1764], *Werke*, 1:515–16; *Versuch einer Allegorie, besonders für die Kunst* [1766], *Werke*, 2:251.

This piece was first published in *Studies on Voltaire and the Eighteenth Century* 263 (1989): 467–472. Article by permission of the Voltaire Foundation, Uni-versity of Oxford.

The same spirit and focus for artistic reform came to a head in the quite different setting of monarchical France after the country's 1756–63 war with England. Comte d'Angiviller (1774–1790) and *premier peintre* J.B.M. Pierre (1770–1789) carried out the wishes of Louis XVI by spending a million francs over ten years on large paintings that used figures from Greco-Roman and French history as *exempla virtutis*.[3] In the summing-up by Quatremère de Quincy in 1791, the régime of Louis XVI aimed to correct the counterfeit *politesse* and miniaturized art of the generation of pygmies around Louis XV, and to reject the stifling flattery in the art of the reign of Louis XIV, whose court painters were really only mediocre followers of the Carracci. The arts of all modern Europe had been paralyzed by the centralizing, methodizing force "de la société [...] des lumières." What was needed, said Quatremère, were *les arts du dessin*, skilled engraving, *écriture* like the ancient Egyptian hieroglyphics that rendered divinity visible, an art of chiseled ideal beauty that would engender rapport with the needs of the people of virtue, instead of letting art be a luxurious vice of the privileged. Therefore, with Plato, art academies must demand the simple, noble, generic imitation of what was good; his advice was to avoid copying live models that always have imperfect detail, and to draw *après la bosse*.[4]

It is striking that this extremely severe, dictated arts policy was adopted by key leaders of the French Revolution (1789–1799). Draft minutes of the *Société populaire et républicaine des arts* and the *Club révolutionnaire des arts*, as well as speeches by Jacques Louis David at the National Convention, setting direction for "the regeneration of the arts" now that the Académie française had been suppressed, testify that the sole purpose of art is to teach civic virtue in public places, to extol heroic traits that will instill patriotic fervor among the *sans-culottes* in this new age for France, year II.[5] So simplified, monumental art conceived to immortalize revolutionary exploits and choices became the order of the day. Artists were directed to aim for the archetype that would clothe current historical events with the moral authority of the ages.

3 Cf. Jean Locquin, *La Peinture d'histoire en France de 1747 à 1785: étude sur l'évolution des idées artistique dans la seconde moitié du XVIIIe siècle* (Paris, 1912), 49–67.

4 Quatremère de Quincy, *Considérations sur les arts du dessin en France* (Paris, 1791), 28–31, 42–44, 55–60, 83–87, 124–25.

5 Jacques Louis David, "Rapport sur la nomination des 50 Membres du Jury qui doit juger le Concours des prix de Peinture, Sculpture & Architecture, au nom du Comité d'Instruction Publique," pamphlet of the Convention nationale (1793), 2–3 [British Museum R.400(35)]. Also, a speech by Hassensfradz at the *Club révolutionnaire des arts*, session 14 Germinal, l'an II.

Napoleon assumed such a ready-made arts policy within the propaganda strategy to celebrate his military conquests for France. "Official" art of the Empire sported rhetorical trappings, however, that offended Quatremère de Quincy, who also had to contest the intrusion of low-voltage Romantic Idealist philosophy lurking, for example, within the splendorous painterly journalism of Gros portraying Napoleonic "triumphs" in foreign lands. But Quatremère de Quincy remains the orthodox ideologue, promoting "the Ideal," that is, the a priori idea of beautiful perfection,[6] as the canon for art, even until 1839.

If Winckelmann, Mengs, and Quatremère de Quincy exemplify the kind of monolithic arts policy at home with the systematized neoclassical Idealist philosophy upheld by figures like Kant and Hegel, artistic policy whose drift flows with the current of *Sturm und Drang*, Herder and the Romantic Idealist thinking of Fichte and Schelling is less organized and societally enmeshed. In fact, Romantic Idealist artistic policy seems to be set more by brilliant scandal or shocking manifesto that catches in their train the imagination of other key artists and writers than by instituting programmatic cultural control. And unlike Winckelmann mania, Werther mania was not an attempt to go behind the Enlightenment to recapture an earlier ideal, but was a movement to push to the limits and beyond the Enlightenment secularizing, light-heartedly questioning, cultural derring-do.

Die Leiden des jungen Werthers, for example, was revolutionary in spirit and in effect for writing narrative fiction, in a way that the French political upheaval that began in 1789 came to be, though almost inadvertently, for statecraft.[7] The Ossianic trend that young Goethe was promoting showed a literature broken free from the conventional travelogue

6 Quatremère de Quincy derives "the Ideal" from Cicero who domesticated Plato's doctrine of extra-cosmic Real ἰδέαι into ideas innate to human nature. Cf. *Essai sur la nature: le but et les moyens de l'imitation dans les beaux-arts* (Paris, 1823), 243–51.

7 Anything "revolutionary" entails a principled, violent rejection and overthrow of the established institutional powers-that-be. Despite the inflated rhetoric and millennial expectations of extremists and the makeshift rationales for trying to control the unplanned consequences of what happened after the execution of Louis XIV, there is nothing particularly revolutionary about the subsequent political repercussion, the brief deist dictatorship of Robespierre, or the anarchy of numerous ruling committees vying for the old hegemony. One might say that the political action in France in 1789–1791 was true to the Enlightenment, and activities after 1792 were basically inspired by a neoclassical idealism. Carlyle's reading of "the French Revolution" as a Romantic burst of terrorism is a fundamental misrepresentation of its genius and evil. Cf. Norman Hampson, *Will and Circumstance: Montesquieu, Rousseau, and the French Revolution* (London 1983), 163–69.

and Enlightenment rationality of Defoe, as well as from the measured neoclassical constraints of Richardson's epistolary novels with their halo of diary and conduct books. Young Goethe was actually practicing the policy that Wordsworth later formulated in the preface to the second edition of his *Lyrical Ballads* (1800): leave the un-dissembling individual utterly alone in the awesome presence of Nature, let that childlike creature but speak its heartfelt perception of "similitude," and you will have the searing truth of poetry.

Such a radical disinvestment of "poetic diction" and standard codes of rhetoric by literary art is comparable to, for example, the enlightened revamping of encrusted iconography that the rococo artists Watteau and Hogarth had introduced for painterly art—which tradition-critical thrust Mengs and others tried to undo.[8] But Romantic Idealist policy for change in any art form is characterized by a disruptive flaunting of the differences enjoined, as if tradition is not only expendable (an Enlightenment tenet) but is a veritable curse, blocking our achievement of the ultimate cultural glory. Someone as reflective and tempered as Delacroix turned traditions upside down and broke new artistic ground with his shocking salon entries that made central to painting splashes of color forming masses, so that the unpolished pigment and agitated brushstrokes relegated *dessin* to being merely a function of implosive color. The whole impressive wildness fascinated and irritated the art world of Delacroix's day in the way Constable's color green disturbed his English public. But that is an advantage over literature, said Delacroix: painting and music *transcend thought.*[9]

By comparison, Enlightenment art seems tame and coy in its sunny pursuit of happiness and refinements. It is a policy, you could say, for Romantic Idealist artists to be pensive and untamed or religiously, uncompromisingly naïve, to be adventurous and exuberant. That driving, revolutionary spirit permeates a large company of diverse artists whose work unsettled generations of people bred on rococo delights. All such Romantic art disseminated a haunting, haunted idealism that would brook no restraint because the artistry had as its life-breath a riveting commitment to the credo that filled both Fichte and Schopenhauer: *Die Welt als meine Wille und Vorstellung!* And the limitless reach of my willful human imagination provided both the pristine, consuming intensity to

8 Cf. Calvin Seerveld, "Telltale statues in Watteau's painting," *Eighteenth-Century Studies* 14:2 (1980–1981), 151–80 {infra pp. 171–195}. Also Paulson in *Emblem and Expression: Meaning in English art of the eighteenth century* (Cambridge, Mass. 1975), 35–78.

9 Delacroix's italics, in *Journal* (26 January 1824), (Paris 1981), 50.

"create" Utopias, and the unending passion that materialized when the questing, undaunted eros remained unconsummated. So there is normally an uncanny black side to the spendthrift thrill of Romantic art— Baudelaire called this Faustian element in Delacroix *molochiste*—because there is something inhuman about expecting brilliant humans to transcend their humanity.

Both neoclassical Idealist philosophy that formed the background to the historically reactionary neoclassical art movement, and Romantic Idealist philosophy that enfranchised the revolutionary art movement short-circuited important openings for art and literature that certain Enlightenment figures had provided. I am not looking for scapegoats and do not intend to assess here how vigorous or blighted the legacy was that the secularizing Enlightenment culture gave its younger generation to work on. I also recognize the truly genial theoretical and artistic efforts put forward by Kant, Herder, Wordsworth, Delacroix, and many others in spite of their cultural milieu. And it is probably so that when leading *ideas* of Idealist philosophy became artistic *ideals*, the inevitable exaggeration that comes with being derived brought along more historical rigidity. But my main point is that the neoclassical and Romantic Idealist régimes as cultural movements by and large mismanaged two items in the Enlightenment inheritance: (1) the beginning in understanding that practicing art as such for the imaginative good it may bring others is its correct raison d'être, and (2) the attempt to incorporate among approved aesthetic and artistic qualities those that were disharmonious, breathtaking, unsettling—the sublime.

Neoclassical art as a whole lacked the presence of mind and nerve to resist institutional control foreign to artistic leadership and so diminished artistic responsibility. Leaders of neoclassical art policy also smoothed out the sublime to be a contemplative view of perfection *sub specie aeternitatis*. The neoclassical art movement reacted against change, and clothed its historical backwardness in the guise of "ancestor worship."

Romantic art, on the other hand, encouraged the artist to become a fugitive from society, beholden to no one, with the consequence that art easily became a marvelous, prodigal parasite in the land, speaking like Cassandra in prophetic riddles. Romantic art policy is really only for the stronger, the truly stout-hearted, because the sublime is unknown and possibly dangerous, but the sublime is all there is for the Romantic artist, no matter what the cost. For the Romantic art movement secondary followers do not count. Delacroix's backhanded compliment for Le Brun is a revealing epitaph for Romantic Idealist art: great masters of art never

form a school.[10]

Historical leadership in art (or in any cultural undertaking) depends upon whether another independent generation can and will establish living connections with the previous status quo of art (or whatever) while it is busy modifying and professionally deepening the limited service of that particular kind of human activity and integrating its newly changed character justly into the societal roster of human endeavors to enact shalom.[11]

While the neoclassical and Romantic Idealist cultural movements spurned or wasted the Enlightenment dowry, philosophical positivism, Courbet, Daumier, and the Impressionists, in their wayward, fact-ridden fashion, did try to pick up the Enlightenment promise to develop art and literature more specifically within a unifying network of cultural tasks. But that is a different chapter in the story of art and literature that we need to tell the up-and-coming generation.

10 Delacroix's *Journal* (26 February 1852), 294.
11 Cf. Edward Shils, *Tradition* (Chicago, 1981), 40–42.

BADT AND DITTMANN:
ART HISTORIOGRAPHIC TESTING OF
HEIDEGGER'S AESTHETICS

The formidable œuvre of art historian Kurt Badt (1890–1973) and the incisive work of Lorenz Dittmann (an editor of *Zeitschrift für Ästhetik und Allgemeine Kunstwissenschaft*) are hardly known in North America. Not translated into English (except for his book on *The Art of Cézanne* [1956, translated 1965]) and sidelined by the 1968 generation of academics in Germany, Kurt Badt remains a lonely, untapped figure, also because of his forced exile to London and the Warburg Institute (1939–50) during the Nazi Hitler anti-Semitic period of power. I should like to demonstrate how Kurt Badt develops his orientation from Heidegger's philosophical reflection on artworks and poetry into several provocative theses for art critical theory and art historiographic praxis, of interest to philosophical aesthetics. I shall also note a few weaknesses in Badt's theses and a couple of insights of Lorenz Dittmann to conclude with a remark that would wish to redirect certain trends in aesthetics.

Place (*Ort*), not space (*Raum*),
as category to elucidate artistic meaning

According to Badt it has been a category mistake to impose the mathematical scientific conception of space—an empty continuum of coordinated contiguity—as a fundamental interpretive criterion for judging paintings. Both Riegl's optic/haptic polarity for plotting where artistry is and Wölfflin's *Sehformen* for diagnosing artworks positivistically assume a Newtonian-Kantian fix on space as a universal invariant that orders sense perception, also within art. This category mistake on space exacerbates

This unpublished paper in abbreviated version was presented at the Learned Societies combined session Canadian Society for Aesthetics/Société canadienne d'esthétique and the Canadian Philosophical Association/Association canadienne de philosophie on 9 June 1994.

another basic misconception: painterly art is to be an *imitatio* with fixed, vanishing-point linear perspective, of a standard three-dimensional reality out there. Because geometric space is an abstraction that is conceivable but not viewable, an ironic consequence of the dominance of the three-dimensional spatial perspective in art has been the movement to objectless art (and an apologetic rhetoric of purity) (*RR* 13–15, 22–23).[1]

Place, placement, locale (*Ort*), not space (*Raum*), is the reality in which art deals, says Badt. The concrete location of bodies, corporealities (*Körper*), chiseled out by the artist's color, line, proportioning relation of masses and forms, to be viewed as a very particular place pregnant with human concerns, is precisely what architecture, sculpture, and painterly art construct (*RR* 94–97). As Heidegger put it: a bridge as artifacted thing (like the Florentine *Ponte Vecchio* [#37] makes riverbanks, a coursing stream, and the surrounding land to be neighbors; bridges turn unde-

[#37] *Ponte Vecchio* (996 AD), Florence, Italy

fined spots, a somewhere, positions (*Plätze, Stelle*) into a definite place, a site (*Stätte*) of earth surface under the sky to be tread by mortals and presided over by divinities (*BWD* 152–55/151–54). A merely instrumental assemblage like a makeshift pontoon crossing of a river for soldiers does not originate place, says Badt. Architecture, however, artwork, brings bodies to rest, converts space into an abode, where viaduct commerce can be carried on all right, but the point of a viaduct is that the life-sustaining being of water and the abiding place of valley concavity between natural rolling ridges of mountains under a glorious sunlit heaven, come fully to the fore, thanks to the *Pont du Gard*. [#38] Artists, artisans, provide

1 Cf. Mark Cheetham, *The Rhetoric of Purity: Essentialist theory and the advent of abstract painting* (Cambridge University Press, 1991).

things their true place, their place of truth, where whatever is at hand like space, water, elevation, stone, comes into its own, its own place in seamless connected relation with every other thing *(RR* 93–94, 98–99). Sculptures, says Badt, deserve a special aloneness, apart from oth-

[#38] *Pont du Gard* (1st century AD), Provence, France

er things, including walls—musea often compromise sculptures with crowded decor—because sculptures do exactly what Heidegger says bridges as artworks do: sculptures fashion place out of space and set its place off against all else, not as cordoned off space, but with the quality of a wholly other kind of terrain transcendent to the space of ordinary sense experience: sculptures clear a unique, settled place of existing (*Ort des Existierens*), the place wherein the realization of the genuinely true being of the creative, constituting imaginings are accomplished (*RR* 114–16).[2]

For example, sculptor Ernst Barlach's (1870–1938) figures, in Badt's reading, present humans pulled into solitary lonely battles against forces stronger than themselves; whether it be *The Avenger* (1944) [#39] or *Monks Reading* (bronze 1932), the thrown-into-it-ness of human existence—Badt quoting Heidegger's *Sein und Zeit*, "Die Geworfenheit . . .

2 "Dadurch enthüllt sich hier eine besondere Qualität des Ortes; er ist nicht Raumbezeichnung, sondern Ort der Existenz, der gelungenen Verwirklichung des Wahrseins der ihn konstituierden und erfüllenden Gebilde" (*RR* 115).

[#39] Ernst Barlach, *The Avenger*, 1914

[#40] Ernst Barlach, *The Magdeburger Ehrenmal*, 1929

gehört zum Dasein"—becomes palpable (*EB* 12,15–16,18,29). Barlach's oak wood *Memorial* in the Magdenburg Cathedral (1929 [#40] shows the surviving "victors" standing "in an **imaginary** space," says Badt [my emphasis], sunken into the killing-fields of the earth like the tombstone cross held centrally and engraved from 1914 lower and lower 1915 1916 1917 1918. This sculpture exposes the stark primordial tragic loneliness of our human mortality where individuals, including would-be heroes, come to have their faces shrouded by the metal helmets meant to protect them. Hölderlin's poetic line sounds—". . . *die Totenklage, sie ruht nicht aus*" [. . . the death knell, the tolling bell, never rests in peace . . .] (*EB* 22–23). Barlach's roughhewn bodies are always clothed, and concentrated on a single incorporeal concern, whether it is the awkwardness of an embarrassing reunion or the ecstasy of song. Barlach's sculptures show the existential grasp of being human taking place.

Badt's focus on place and placement (*Ort*) as the authentic avenues of entry for grasping artistic spatiality has far-reaching critical import for reading painterly art: the nearness and distance (*Nähe und Ferne*) of configured bodies is the key.[3]

Vassals bringing homage to Emperor Otto III in a Trier school piece of c. 985 AD [#41] have a stately monumentality because artisans conceived them to be unreachable, holy, beyond ordinary "real space." Giotto, in the Padua fresco [#42] of Joachim's sacrifice, however, gave holy bodies mass on solid rocky ground, with light and shadows; because the blue with God's hand there is still more heaven than sky, the altar and kneeling Joachim, animals waiting to be sacrificed, angel, sojourner, and land carry "the heaviness of being transcendently present" (*die transzendente Schwere ihrer Gegenwärtigkeit*, *RR* 119). Jan van Eyck's paintings like that of Arnolfini and his wife (1434) show that persons and things occur close together; that is, things happen to be near one another with an intimate familiarity that bespeaks identities that are in their rightful place, whether it be hands, clothing, dog, or wooden shoes. But Italian Renaissance 1500s paintings like those of Leonardo can be characterized, says Badt, by the rise of distance visible on the earth; linear perspective with a vanishing point to infinity promises continuity for *Lebensraum* between what is nearby and far away. Dutch 1600s paintings normally

3 "Die Erde und die Dinge, die sie trägt, in immer veränderter Sicht, in immer veränderter Wertung und Bevorzugung, das es ist, womit die Maler von 1300 bis 1900 sich beschäftigt haben und woraus die fortwährend sich wandelnden Raum*dar*stellungen hervorgegangen sind, welche samt und sonders keine Abbilder des 'realen Raumes' sind noch zu sein sich bestrebten, sondern frei geschaffene künstlerische Darstellungen bestimmter aus dem Zusammenhang von Dingen geschaffener Orte" (*RR* 121).

[#41] Trier School, Homage to Otto III, c. 985 AD

[#42] Giotto, *Scenes from the Life of Joachim:*
No. 4 Joachim's Sacrificial Offering, c. 1304–1306

partition the earth surface into three zones: warm brown foreground, organic green mid-ground, and a blue atmosphere background of brilliant light that lets one experience unreachable things.

And then Caravaggio gave light its own force independent of the firmament so that light and darkness, despite apparent real-life motivation, intensified the superactual (*überwirklichen*) mysterious character of things. Rembrandt's painterly light substantially altered earth and sky into places of wonder and blessing. The Impressionist painters took the appearance of light as a theme and brought the brightness of places and atmospheric air to the fore; space became a playful flow of light particles that coagulated into things with elusive, unsure form (*RR* 118–24,128–30).

That is, Badt reads the history of painting not by the measure of its approximation to the "pictorial spatial reality" achieved under Alberti's prescription, but judges what the quality of placement does to the things imaged in disclosing meaning. Alberti's picture-window "symbolic form" was a mathematicistic worldview imposition that has often misled and handicapped painterly artists, says Badt.[4] Badt would also question, I think, a current fashion of trying to decipher the complex artworks of, say, Velasquez, in terms of problems with perceptional perspectival structure.[5] Left and right, figure with fore- mid- and background, are **objective** spatial realities germane to **artistic** artifacts certainly, I understand Badt to posit, and fundamental to our understanding artworks;[6] but to use calculations on spectator viewpoint outside the painting's frame as the key to unlock the meaning within, for example, Poussin's artworks,[7]

4 Cf. Badt review of John White's book, *The Birth and Rebirth of Pictorial Space* in *Kunstchronik* 11:1 (1958): 11–14.

5 Badt reads the royal images in the mirror of "Las Meninas" not as a conundrum on the spatial position of king and queen and spectator as do Foucault and John Searle (cf. Joel Snyder's careful analysis, "*Las Meninas* and the Mirror of the Prince" in *Critical Inquiry* 11:4 [1985]: 539–72), but reads the mirrored image as a testimony "to the place of pure [true] appearing" (zum Ort des reinen Erscheinens), similar to the way late Rembrandt twists paintings to get to a deeper level of truth (*RR* 126).

6 In his debate with Sedlmayr's theologized reading of Vermeer, Badt lays down as a principle that European paintings are normally constructed to be read from left under toward upper right, if one would correctly elucidate their meaning (*MM* 38–39, 43–45.) Cf. also Badt's correction of Friedländer's reading of Parmigianino, *RR* 125.

7 In *Poussin's Paintings: A study in art-historical methodology* (Pennsylvania State University Press, 1993) David Carrier's confusing use of Bryson tries to turn "internal tableau" and the inability of the actual viewer to perceive what certain depicted figures could be seeing into (1) "destruction of the unity of that [compositional] space" (140–42), and (2) Poussin's "distance from his sources" (217) in order to give "an allegorical reading" (240–43) of Poussin's work: "The point of view in Poussin's paintings

is a mistake, like trying to parse John Donne's poetic line with the grammar of Esperanto.

The only kind of "space" that determines and elucidates **artistic** matters is the **place** of imaged things toward what is upon the earth, under the heavens, in the midst of light and air—veritably the most elemental constituents of anything's being-in-the-world (*RR* 102). And it is precisely this concrete fourfold of place that has been largely lost, says Badt, after the death of Cézanne, in our "new age of art" following the Expressionists, who for fear of losing a hold on things, thanks to the Impressionists' painterly haze, made the life force animating humans to be what regulates meaning (*RR* 130).

How a fourfold "World" characterizes art
with more than aesthetic meaning

The fact that Badt anchors the crucial hermeneutic of place (*Ort*) and the qualities of nearness and distance (*Nähe und Ferne*) in a fourfold (*Geviert*) of world (*Welt*) deserves attention since it poses succinctly Badt's complex interrelation with Heidegger.

Already in 1933 Badt, quoting Dilthey, wrote "The Idea of 'World' and 'Self' as Fundamental Essentials of Imaginative Art" (*Die Idee der Welt und das Selbst als fundamentale Wesenheiten bildender Kunst*), where Badt criticizes Heidegger's 1927 *Sein und Zeit* conception of human "being-**in**-the-**world**" as an inadequate idea of "world," because Heidegger's "world" meant the enveloping actuality humans had to (*vertraute Wirklichkeit*) concern themselves **with** and fearfully grapple **with** (*WS* 33–34). By "world" I mean, however, says Badt, an actual cosmos created with its own ordering lawfulness where**in** external natural reality and the inner-working individuality of a person find seamless unity (*WS* 30).

Human thought deems the synthesis of mental activity and disjunct materiality so necessary there has even been mystical (Pythagorean) speculative numerology to collate the two. Human faith believes it necessary and hopes, says Badt, there is a spirit Creator of actual natural reality, or that forces behind the stars and human spirits somehow bring them as totality together. But human art is the place where the creative microcosmic ego and the macrocosmic natural reality out there come to coalesce. In art, what is actually real is understood to be experienced *as world*, as the

is like that of an observer who looks at an absolute monarchy from outside" (196). Carrier's self-consciously fanciful (169) psycho-socio-political analysis of art—"We do not discover what is there, but create a good interpretation" (46)—does touch on realities "outside the frame," but is a wrong-headed methodology, it seems to me, which skews the human import of Poussin's artistic contribution.

unified **place** where one's own person becomes fully its self *being-in*-the-world and where things are presented, reconstituted also as *being-in*-the-world (*WS* 32–33). "World" for Badt is the splendid, singular, full-orbed presence (*Wesen*) of realities whose being is truly realized (*Verwirklichung*) with a kind of "objectivity" pendent from the special "subjectivity" of the great form-giving, creative artistic personalities (*WS* 34–35).

Badt's 1933 theory may not be wholly clear, especially when he goes on to sort out the typical tradition-bound historical features of artworks from the unique "ahistorical totality of artistic world-configuration" (*ahistorische Totalität künstlerischer Weltgestaltung*) fashioned personally by geniuses (*WS* 36–37); but the thrust of Badt's thesis for pointing to the being of art is clear: an artwork holds a world of its own. And the "world" art embodies is not Panofsky's autonomous realm of ideality nor Riegl's value-free logic of *Kunstwollen* forms (*WS* 29–31), but for Badt "world" is a cosmos of heightened meaning impregnated with a world-view commitment significant for human life in matters that surpass and go deeper than merely aesthetic perception.

Heidegger's meditations on "world" in *Der Ursprung des Kunstwerkes* (1935–36) are relevant to Badt's lead. As Heidegger builds his reflection toward expositing the peculiar truth-working nature of art, Heidegger defines "world" as:

> that ever non-objectifiable to which we humans are subject so long as the paths of birth and death, blessing and curse keep us transported in being. (*UK* 33/44)

"World" for Heidegger in 1936 is the fateful historical opening given to a people (*Volk*) to make the most simple and essential decisions (*UK* 37–39/44–45) to be or not to be. And this given crucial ontic histori-cal ambiance of "world" is always intrinsically and essentially locked in antagonistic (polar) embrace with "earth" (*UK* 44/55), that other inscru-table primordial determinant of human existence, "the never hemmed in forthcoming of what is continually self-secluding, and to that extent, sheltering/concealing" (*UK* 37/48).

It should be mentioned that after the devastating Hitler war, and after Hölderlin's poetry came to fixate Heidegger's program, Heidegger's conception of "world" became less combative, and absorbed "earth" into the fourfold (*Geviert*) of heaven and earth, mortals and divinities.[8] When poetic language names things, letting things bask in the unity of the fourfold, then the "world" is aworlding, said Heidegger, born up by

8 Cf. Michael E. Zimmermann, *Heidegger's Confrontation with Modernity: Technology, politics, art* (Bloomington: Indiana University Press, 1990), 239–40.

the presencing of things and simultaneously granting things their being (S 19–21/199–202).[9] However, the point at hand I want to make to understand Kurt Badt can be focused on Heidegger's *Der Ursprung des Kunstwerkes* "poetic" treatment of the Van Gogh painting of shoes [#43] in getting at the implement quality of equipment (*Zeug*). Heidegger conjures up, almost as in a séance, the weary stubborn "world" of the peasant woman who uses the shoes that ruggedly belong to the "earth"; artist

[#43] Vincent Van Gogh, *A Pair of Shoes*, 1887

Van Gogh's painting discloses concretely, says Heidegger, in the shoes being buffeted by the hard laboring "world" and the sure thrusting of "earth" the worn reliability (*Verlässlichkeit*) of what equipment truly is (*UK* 22–24/32–36).

Badt rejects what he calls the "divinatory practices of Heidegger's philosophical thinking" in such a fanciful eisegesis of one isolated Van Gogh painting to bolster Heidegger's own philosophical theorems (*MM* 14, 23).[10] Yet Badt develops his own 1933 conception of "world," the

9 "Wir nennen das im Dingen der Dinge verweilte einige Geviert vom Himmel und Erde, Sterblichen und Göttlichen: die Welt" (S 19–21/199–202).

10 Suzanne Bloom and Ed Hill whipped up a soufflé on "Borrowed Shoes," which shows, although Samuel Johnson could kick a stone to refute Berkeley's philosophical thesis of *esse est percipi* and be done with it, contemporary scholars can kick around a

self-contained cosmos of realized being-meaning (*Seins-Verständnis*) that defines artworks, by appropriating the existentialistic pressure and elevated, quasi-spiritual aura held in Heidegger's thinking. To be sure, Badt demythologizes Heidegger's fourfold of heaven and earth, mortals and divinities, to an art-specific fourfold of heaven and earth, (atmospheric) air and light; but Badt is convinced that this fourfold is the absolutely indispensable determinant of architecture, sculpture, and painterly art for revealing the essential meaning of humans being amid things being in-the-world.[11] And Badt's conviction that art within its pulsing fourfold frame truly sets out the presence (*Wesen*) of things, the uniqueness and comprehensive place of things in the totality of experience, charges art with an intense, important task that certainly resonates with Heidegger's approach (*RR* 97–100).[12]

So Badt declines to follow both the tack to use art as an iconographic document to index cultural history, with one busy finding "sources" and "quotations," and the formalist choice to analyze art as a hermetically sealed realm of technical compositional problems, spectator sightlines, and possible layers of detectable significance. Naturally one carefully examines all the conditions that date and limit an artwork, says Badt, including the historical factors of commission, tradition, society, morals, training, the norms current (what Badt calls "negative *Determinanten*"), but only in order to free up the once-and-for-all unrepeatable creative achievement an artwork is, to sound its voice and face us viewers with its "world" of truth (*MM* 88–89). Badt also challenges the importation of allegorical and anagogical readings of painterly images as practiced by Hans Sedlmayr on Jan Vermeer (*MM* 23–24/114–27).[13] But the correc-

text forever. *Artforum* 26 (April 1988): 111–17.

11 "Der Ort der bildenden Künste, wie er durch Architektur, Plastik und Malerei als räumliches Bild, Gebilde und Abbild des In-der-Welt-Seins des Menschen inmitten seiner Dinge hervorgebracht wird, unterliegt einer vierfachen Bestimmung. Er wird stets in Hinsicht auf Erde und Himmel, Luft und Licht festgestellt" (*RR* 97).

12 "Indem das künstlerische Gebilde als eine Darstellung von Welt aus dem einen Ort konstituierenden Zusammenhang der Dinge verstanden wird, ergibt sich, dass nicht eine Form der sinnlichen Wahrnehmung das Urthema (und damit der allgemeinste Bezugsbegriff) der Kunst ist, sondern ein Verständnis von Welt und des In-der-Welt-Seins der Dinge, mithin nicht eine geistige Leistung der tieferen Stufe (wie Wahrnehmung der sinnlich Gegebenen als Raum), sondern der höheren, ja der höchsten, welche die Totalität aller Erfahrung als ein Eines und Ganzes zusammenfasst. Denn im Begriff der *Welt* ist künstlerisch die Natur als Ganzheit und gleichzeitig Natur in der Einheit mit dem schaffenden Geiste verstanden" (*RR* 100).

13 Cf. Hans Sedlmayr, "Jan Vermeer: Der Ruhm der Malkunst" (1951), in *Kunst und Wahrheit: Zur Theorie und Methode der Kunstgeschichte* (Itzelsberger: Mäander, 1978),

tive to Sedlmayr's traditionalized over-reading as well as to Heidegger's arbitrary misreading is not a barebones secularized empiricist reading.

Badt's two volume critical art historical exposition of Nicolas Poussin's painterly oeuvre exemplifies the kind of horizons Badt's hermeneutic provides when the fourfold "world" of artwork is taken seriously. Artist Poussin's originality for Badt lies in Poussin's pagan-like bewondering affirmation of all that is natural, since Nature is procreative and numinous for Poussin, the habitat of Olympian gods and Greco-Roman legendary heroes who tread upon the earth not in anecdotal fashion or to teach moral lessons, but as genuine humans, genuine divinities, which Poussin made viewable in a quieting, steady way that discloses their belonging here, present in the grand whole true being of everlasting with-standing (*be-stehende*) Nature (*KNP* 30–33, 73). The statuesque aplomb of Poussin's figures, even while undergoing war and death, show how Poussin as a seer, *vates* in Rome, 1600s AD, understood mortals and god forces in their non-transcendent, says Badt, fated, mythic **reality** (*KNP* 387–88, 455, 465, 478).[14]

Poussin's art may seem to fit Badt's modified Heideggerian slant on "world" too well to be generally applicable, but the carry-over point is this: just as "world" is vaguely theophonous for Heidegger, like a blinding flash of lightning that illuminates what is truly at stake, so "world" for Badt characterizes art and impregnates art with what I will call "the Stonehenge factor." While Heidegger read an uncommon reverence for peasant shoes into Van Gogh's painting and finds bread and wine stigmatized sacramentally in Trakl and Hölderlin's poetry, such that such simple things like bread and wine as "fruits of heaven and earth, gifts from the divinities to mortals" (*S* 25/205) are seen to be practically haloed with holiness, Badt holds that authentic art always wears the aura of mystery, so hard for one-dimensional fact-positivists to see, which the ancient Egyptian pyramids and sphinx, Stonehenge, the Pantheon, and Chartres quietly exude (*RR* 103–108). It is historically so, says Badt, that in Poussin's day during the Reformation and also Counter-Reformation, European culture as a whole did not think religion was an additive to

134–42.

14 "Die höchsten Eigenschaften, die diese Bilder besitzen, sind die vollständige *Aufhebung* des wirklichen *Lebens* mit seiner unsicheren Wandelbarkeit in den immer gültigen Still-stand des Seins, wie in den Handlungen so in den Personen und in den Naturgewächsen—einschließlich der Erde—die völlige Ver- und Ent-bergung ihrer Inhalte in ihrer Figuren und Formen und ihre Stile, Masshaltung und Festigkeit in der *Fugung* des Aufbaus, Distinktion aller einzelnen Erscheinungen als Distinguiertheit" (*KNP* 421–22).

goods but acted as if religion were the deepest root-dimension of all edu-
cative endeavors (*KNP* 80 n.13), so that there was an easy acceptance of
worldly transience **and** an ecstatic openness toward a future of conclusive
world resolution (*End-erlösung*). It is precisely this invisible, prospective
safe and sound "world" (*von . . . ganzer und heiler Welt*) built in the very
cosmos-structure of an artwork, with the power to overwhelm viewers
past, present, and future with a healing orientation that gives shape to
one's life and one's worldview on the mystery of us humans being among
miraculous things, like water and fire, flowers and clouds, breaths of air
and crows on cornfields, that simply compel persons to recognize the
exalted, non-manipulatable specialness of artworks.[15] One should let art-
works be, let artworks work their epiphanies . . . of truth.

Badt's modification of Heidegger's stance on the "Truth" of art
Mention of "truth" primes my last critical point in gauging how art his-
torian Badt relates to Heidegger's pivotal dicta that "Art is truth's setting
itself to work" (*UK* 28/31) and "Humans dwell poetically on this earth"
(*DWM* 180/213).

Heidegger's *via negativa* approach to truth as an occurrence fraught
with conflicting uncertainty, the happening of unconcealing what is fun-
damentally hidden—the inexplicable being of entities—is conceived to
save truth from the limited realm of Cartesian propositional correctness
and science (*UK* 39–43, 50/51–55, 62). Truth takes place only when
there is human creation of an artifact such that momentary disclosure
is made of some thing's unnecessary but nevertheless being. The act of
founding a political state, the questioning of philosophical thinking that
poses the question-worthiness (*Frag-würdiges*) of being, "the ultimate sac-
rifice" (i.e., lay down your life?) of an art**work**, each incarnates, as it were,
in a particularity the uncanny extraordinary precariousness of an entity's
being (*UK* 48–50, 53–54, 57/60–62, 65–66, 69). And so long as the
ancient Greek temple opens up its rocky precincts to be sacred and the
visitants to be suppliants (*UK* 20–32/41–43) rather than tourists, and so
long as a potter's ewer is present as a vessel for gathering the rich fourfold
gifts of water and wine to be the simple one-fold outpouring of libations
for mortals and gods (*D* 169–72/171–174), that is, so long as human

15 ". . . Aus seiner Kosmos-Struktur weist ein Kunstwerk längst vergangener Zeiten
nicht auf seine Umgebung, sondern es zeigt sich gerade in seinem geschichtlichen
Zusammenhang auf und als ein 'zeitlos' gültiges, das heißt dem Zeitlauf enthobenes
Beispiel für die kommende Zeit, nun aber nicht nur im Bereich der sich entwickeln-
den Kunst*praxis*, sondern auch für das Leben, für eine Lebensauffassung und Lebens-
gestaltung" (*KZ* 170).

creations, particular configurations framed with a votive Stonehenge aura, present something that says "I am what I uncannily originally am," then truth is occurring (*UK* 50–52/62–64).

Because art lets the coming of truth happen, as such, says Heidegger, all art is by nature poetry.[16] Heidegger's idea is that poetry, human poetic speech, bestows, grounds, and initiates truth. When human language goes poetically primal rather than remains ordinary discourse, and human crafting of material rises to creative artistic heights, truth makes an historical appearance (*UK* 59–62/72–75). A poetic utterance gives to airy nothingness a name the way a bridge transforms anonymous space into this or that place. Poeting is the veritable *raison d'être* of human existence (*Grund des menschlichen Daseins*), because when the artist says "Let there be. . .," when Pont du Gard takes shape, when Hölderlin writes "*Heimkehr*," when Cézanne paints "*Montagne Sainte-Victoire*," something new originates—that is an historic event! Such poeting humans come to stand in the company of the ("let-there-be" originating) gods and to be involved near the very being of things (*EH* 39–40/282–84). Poets let other things be **other beings,** and get them to appear, give their truth a face (*Sicht*), a voice, that is, inaugurate their entitary being to confront future human caretakers (*UK* 62/75). Art is the proto-originator (*Ur-sprung*) of truth, of truth's becoming historical, of releasing=freeing the very being of things to be (*UK* 63–65/76–78). So the oracular creating/saying of art/poeting is a distinctive way we earthlings authentically claim our very existence (*Dasein*), as wandering human beings who would build a world so we may historically come to **dwell,** knowing ourselves before the unknown God, on the earth (*EH* 42–43/286–89; *DWM* 189–90, 195–202/215–16, 220–27). Poeting is the very nature of history: entrancement of a people (*Volk*) into its appointed task by entering them into their inheritance.[17]

Kurt Badt believes along with Heidegger that art is a distinctive source (*Ursprung*) of truth, whose enactment is the prerogative of special humans.[18] Badt and Heidegger are also kin in judging that the crisis of

16 "Alle Kunst ist als Geschehenlassen der Ankunft der Wahrheit des Seienden als eines solchen im Wesen Dichtung" (*UK* 59/72).

17 "Geschichte ist die Entrückung eines Volkes in sein Aufgegebenes als Einrückung in sein Mitgegebenes" (*UK* 64/77).

18 Heidegger: ". . .weil die Kunst in ihrem Wesen ein Ursprung und nichts anderes ist: eine ausgezeichnete Weise wie Wahrheit seiend und d.h. geschichtlich wird" (*UK* 65/78). Badt: "Die reine Begrenzung einzelner Dinge im Ort der Kunst, in welchem sie selber ihre angemessenen und daher wahren Orte einnehmen und damit zu ihren sie selbst voll aussagenden Formen gelangen, zeigt, dass die Dinge in den Werken

Western culture is marked by substantial loss of any integrative public societal ethos. But Badt differs from Heidegger in not unimportant respects: (1) Rather than German Heidegger's emphasis upon *Volk* with a mandate to resume the people's originary Greek endowment (*UK* 64/77) and as speaking human artist-farmers called to cultivate and thinkingly build on the earth in order to **be** human beings (*BWD* 159–62/159–61), the Jewish thinker Badt notes that nomads are humans too. In fact, says Badt, to be mortals on earth—to be human—entails by nature that humans do **not dwell** here; to be restless and fugitive is the defining characteristic of being human, even when humans do have a dwelling and inhabit the earth.[19] Heidegger fuses "land cultivation" and "home building" in his conception of "dwelling" as the crux of "being" human; however, building protective houses instead of plowing a wound in the earth year by year to renew and restore its fruit bearing nature, permanently ends the earth's bearing fruits where one builds. Building witnesses and establishes the unearthly on the earth, says Badt, the "spiritual" (*das Geistige*); so building can set out the full fulfilling of art, for it is not being and dwelling so much as outfitting oneself to last for a while on the earth that counts, a somewhat forlorn illusionary hope basic to human existence (*RR* 169–70 n.23).[20]

(2) While "truth" in late Heidegger's thinking has a numinous quality—the fourfold "world" is a kind of imperative, and *Gelassenheit* (releasement) signifies almost a Zen Buddhist questioning meditation on "being" that is firmly indeterminate regarding the way humans are to hold the monolithic technocratic mind at bay—Badt's streak of sober loneliness seems to emphasize a more resolute, pro-active response by great creative (artistic) personalities. From the time of the Egyptian pharaohs, from Dio Chrysostomos and Pausanias's judgments on the *entheon* nature of Phidias and company, through the medieval period, the prodigious Renaissance greats like Michelangelo and Raphael, to the Ro-

nicht bloß für sich und vereinzelt vorhanden sind, sondern je ein sinnvoller Ganzes bilden. Dies ist die Welt des sie hervorbringenden Geistes, in welcher jeder Mensch im Vorhinein ist, die aber nur der Künstler, Dichter, Musiker, der Religionsstifter und der Philosoph ausdrücklich zu zeigen vermag" (*RR* 100).

19 "Denn auch die Nomaden, die nicht bauten und nicht wohnten, waren Menschen auf der Erde. Menschsein, als Sterblicher auf der Erde sein, heißt—wesentlich—*nicht* wohnen. Im Gegenteil: Unstet und flüchtig zu sein ist das Charakteristikum des Menschen, auch *wenn* er wohnt und eine Wohnung hat" (*RR* 169 n.23).

20 "Nicht das Sein bindet sie, sondern Dauer und Erde, eine vergebliche, täuschende Hoffnung und eine der ursprünglichen Vorgegebenheiten menschlichen Daseins überhaupt. Überraschenderweise hat Heidegger diese Auffassung im Verlauf seiner Abhandlung bestätigt" (*RR* 169 n.23).

mantics Goethe and Hölderlin, says Badt, original artists have been considered *Göttergleich* (like gods); Schopenhauer and Nietzsche promoted the Artist in the artist's daemonic uniqueness as the only one who can actually take the dead gods' place and save us from our sorrow in these straitened days (*GK* 98–101).

Heidegger might criticize Badt for misappropriating in a modern subjectivist spirit the rapture (*Rausch*) of poetic empowerment that creativity affords, lauding the genial performance of the self-lordly subject (*UK* 63/76; *N* 1:123). But Badt would reply that the historicality of the originality of the art-things (*Kunst-dinge*) created by the originating geniuses lies in their independence from their date of origin; once there, the original artwork exists "in the sphere of the beautiful '*epiphanies*,'" and finds its place "in a permanent present" with "the illumination of benefactoring being" ever recurring and continuing to work even if a generation of subjective viewers become blind to the artwork's beauty.[21] Heidegger is wrong to say the "world" of the artwork deteriorates: the environs of artworks may become decrepit, says Badt, but the "world" of an intact artwork persists, establishing not "being," but founding the substance (*Gehalt*) of something truly integral (*KZ* 169–71). So Badt does not envision humans standing before Being waiting for a mystical oracle to sound, but affirms the highly gifted artist who delineates with éclat the mysterious hidden glory of things.[22]

(3) Heidegger's conception of truth as an inexhaustible happening weights down his philosophical ache for an ontic homecoming with a belabored oppressiveness. Resolution for humans is unthinkable, not only because our times are so poverty-stricken (*dürftige Zeit*), the in-between

21 "So ist in der Tat das Herstellen bestimmter 'Kunst-*dinge*' einmal und 'unwiderruflich geschehen.' Die Werke aber sind nicht nur geblieben, sondern, und das ist das Entscheidende: *von den Bedingungen ihrer Entstehung losgelöst.* Darin liegt gerade das Wesen einer W e r k-Seins. In der Sphäre des schön '*scheinenden*,' das heißt, Erleuchtung spendenden Seins erhalt sich Seiendes dauernd gegenwärtig und immer wiederkehrend, wenn einmal ein Generation oder sogar ein Jahrhundert für seine Art von Schönheit blind geworden ist" (*GZ* 157). "Ist einmal die Entstehungszeit vergangen, so rückt es in eine ständige Gegenwart, das ist der 'Ort,' welchen seine eigene Existenz hervorbringt. . . . Was je Werdendes war, wurde durch die Kunst maß-gebend ins Werk gesetzt" (*GZ* 171).

22 ". . . so scheint es, dass es zwei Arten von Menschen gibt, die in einer besonderen Beziehung zum Göttlichen stehen. Da sind zuerst die großen Frommen, die Heiligen. Der Gott, zu dem sie beten, dem sie sich anzunähern versuchen, steht vor ihnen; er wendet ihnen sein Antlitz zu. Dann gibt es die begnadeten Künstler, von deren Frömmigkeit oder Nichtfrömmigkeit ja hier mit keinem Worte die Rede war noch ist: Ihr Gott steht hinter ihnen. Unsichtbar treibt er sie zu ihrem Werk und überschattet sie mit seinem Geiste" (*GK* 101).

time of the No-more of the gods that fled and the Not-yet of the god still to come (*HWD* 46–48/288–90), and not only because monstrous hydro-electric power plants are damming up the river Rhine, thereby desecrating Hölderlin's hymn to "Der Rhein" (*FT* 23–24/16), but also because thinking truth for Heidegger must remain a "questioning is the piety of thought" (*FT* 44/35). So Heidegger's reflection on art carries a woebegone Orphic character, where the bard charms away evils but is locked disconsolately into a Tao of spring to life and winter to death, as if the recurrent mythic ritual itself of poeting constitutes the very final truth.

Badt, however, surrounds art with a much more festive mood, although Badt is as existentially aware as Heidegger of the impersonality scientism bleeds into human intercourse (*FR* 136), and of the cynical nihilism that has commonly replaced the historical relativism born of modern skepticism (*GS* 224–25, *WW* 6). Yet Badt champions art as an act of celebrative praise that brightens up ordinary life the way communal feasting lifts one above daily drudgery; and a concomitant humane heartiness and unrule-bound concern for joy, sorrow, loneliness, and gratefulness amid music, dance, and remembering, with an excited expectancy, all attend Badt's reflection. Badt believes that celebrating represents a most fundamental attitudinal pattern of living life (*ein Grundverhalten des Lebens*). Art is about rejoicing in discerning unnoticed nuances of actual things that are not only worth attention but demand—it is necessary—for us humans to see whatever it is in its being as being what it is, in its poignant, real verity.[23] Genuine artists put their person in play, says Badt, give their heart to the masterful task of extoling something, including the medium the artists form, to present and gladly make perceptible certain original, unique, deeper illuminated realities. Such metamorphic labors—celebrative encomia that give a shine to things and deeds—is peculiar to art, and is tantamount to doing the truth, for Badt (*FR* 133–40).

Cézanne's *Montagne Sainte Victoire* as epiphany of truth

Despite their differences—nomadic, genius-prone, celebrative Badt and remythologizing, Orphic, would-be dwelling Heidegger—both late Heidegger and Badt find Cézanne to exemplify the truth-giving artist. It is

23 "Kunst ist aber nicht nur Feier im allgemeinen, sondern von der besonderen Struktur des Feierns durch Rühmung. Sie existiert nur je als Werk eines einzelnen, welcher ein Wirkliches rühmt. Dies meint, dass, was immer sie zum Gegenstande nimmt, von Künstler für rühmenswert gehalten werden muss. Jedoch nicht nur des Rühmens *wert*, sondern auch des Rühmens *bedürftig*, insofern es für erforderlich gehalten wird, dass in der menschlich orientierten Welt jedem Seienden eine Notwendigkeit zugedacht ist, zu seinem Sein, in sein Sein, in seine Wahrhaftigkeit zu kommen" (*FR* 139).

my hunch that Badt's 1956 book, *Die Kunst Cézannes*, which Heidegger knew, according to Christoph Jamme (115), along with Rilke's *Briefe über Cézanne*,[24] primed Heidegger to replace Van Gogh and find Cézanne the artistic equivalent of Heidegger's philosophy.[25] Recalling his 1956 and 1957 vacations in Aix-en-Provence, Heidegger is quoted by Hartmut Buchner as saying, "These days in Cézanne's homeland stir up a whole library of philosophical books: if one could only think as unmediatedly (*unmittelbar*) as Cézanne painted—!" (*EH* 47). And as preface to his lecture on "Hegel and the Greeks," at the Université d'Aix in 1958, Heidegger is reported by Jean Beaufret to have said, "I have found here the path Cézanne took [to see and paint Montagne Sainte-Victoire]; my own path of thinking, from beginning to end, in its own way, corresponds to it" (*EH* 11).

Heidegger is hinting that Cézanne's art has been able to penetrate through to the being of visible things and bring such reality to view without painterly academic baggage, without going fantastic, without enclosing things in a constrictive technological form. Such a meta-theo-ontological discernment of things has also been Heidegger's aim as philosopher he means, to bring the being of things to mind, to thinking, without philosophical metaphysical baggage, without going idealistic, without boxing in things with lingual-analytic technical protocol sentences. As Heidegger wrote in the seven stanza birthday poem for René Char in 1971, "Pensivement," in the section subtitled 'Cézanne' (my translation):

In the painter's late work is the twofold
of objects present and objective presence itself
become onefold, simultaneously "realized" and wounded,
transformed into a mysterious identity.
Does a path show itself here which leads
into a bonding of poeting and thinking?[26]

24 Cf. Heinrich Wiegand Petzet, *Auf einen Stern zugehen: Begegnungen und Gespräche mit Martin Heidegger 1929–1976* (Frankfurt am Main: Societäts-Verlag, 1983), 148–52.

25 Maybe other factors prompted the shift in Heidegger's interest too. When Heidegger visited the Van Gogh collection at the Kröller-Müller museum in Otterloo, Netherlands, in the 1950s, he apparently took offense at the Dutch reclamation of arable land from the Zuider Zee, as a technological violation of Nature (cf. Pöggeler 79–80); thereafter Heidegger frequented southern France. Perhaps it is worth mentioning here also my surmise that Badt may have meant more to Heidegger's thinking than has been noted. Heidegger heard with appreciation Badt lecture on the sculptor Barlach (1959), and Badt produced the book on *Raumphantasien und Raumillusionen* with *Wesen der Plastik* in 1963: Heidegger's little known lecture in St. Gallen in 1969, "Die Kunst und der Raum," deals with "spatiality" and sculptural art.

26 "Im Spätwerk des Malers ist die Zwiefalt

As late Heidegger dissolved philosophical phenomenological reflection more and more into an intuitive thinking, a twin peak next to poeting in the mountain range of uncovering being in its fourfold splendor and hidden, undiscoverable truth, Heidegger pursued this will-o'-the-wisp revelation and communion beyond our ken in letting the unspeakable be **and** be thought by gazing into Cézanne's poetic meetings with Montagne Sainte-Victoire.

With less "mystical" overtones Badt too credited the late Cézanne artwork (in the last ten years of Cézanne's painting life) with the status of genius, that is, as painterly art in which its human creator is so deeply rooted in the appearing of being that the very becoming of the world is made apparent and thus the sure, solidly grounded, veritable build of the world as compact, complete, meaningful cohering reality is manifested (*KC* 18/29–30).[27] Actually Badt develops Rilke's admiration for Cézanne's passionate translation of visible into "invisible" presences, Cézanne's fastening upon "the thinghood of appearances":[28] Cézanne's painted apples and oranges are not luscious fruit to be picked up by hand and eaten, but are solidly over there beyond reach, dense globes of color bringing out their substantive individual realities;[29] the roads in Cézanne's landscapes do not invite foot travelers, but are stolidly there, meshed like a tonal third in a strong ninth chord of vegetation, little buildings, immovable rock and distant sky. Cézanne always uses color rather than line

von Anwesendem und Anwesenheit einfältig geworden, 'realisiert' und verwunden zugleich, verwandelt in eine geheimnisvolle Identität.

Zeigt sich hier ein Pfad, der in ein Zusammengehören des Dichtens und des Denkens führt?"

From "Gedachtes," in *Aus der Erfahrung des Denkens 1910–1976, Gesamtausgabe* (Frankfurt am Main: Vittorio Klostermann, 1983), 13:223.

27 Cf. also: ". . . die hier von Cézanne dargestellte Einsamkeit ist eine höhere Geborgenheit, in der das menschliche Wesen in seiner festen Verwurzelung im Schein des Seins, des Werdens der Welt offenbar wird und dadurch den fest gegründeten Bau der Welt manifestiert" (*SC* 38).

28 "Ja, denn unsere Aufgabe ist es, diese vorläufige, hinfällige Erde uns so tief, so leidend und leidenschaftlich einzuprägen, dass ihr Wesen in uns 'unsichtbar' wieder aufersteht." Rainer Maria Rilke letter to Witold Hulewicz, 13 November 1925, in *Briefe* (Wiesbaden: Insel Verlag, 1950), 898. Cf. Jamme 110.

29 "Chardin ist da überhaupt der Vermittler gewesen; schon seine Früchte denken nicht mehr an die Tafel, liegen auf Küchentischen herum und geben nichts darauf, schön gegessen zu sein. Bei Cézanne hört ihre Essbarkeit überhaupt auf, so sehr dinghaft wirklich werden sie, so einfach unvertilgbar in ihrer eigensinnigen Vorhandenheit." Rilke letter to Clara Rilke, 8 October 1907, in *Briefe*, 176.

to define things; so shadows modulate figures and wed them in all their plastic volumnar depth firmly together and . . . to the picture plane! (*KC* 241–42/309) The over-all frontality **and** depth of Cézanne's paintings presents objects intensely present and simultaneously unapproachable. Cézanne was indeed able, says Badt, *vivifier Poussin sur nature*; that is, historically Cézanne carried Poussin's magisterial over-all compositional proportionality **and** the Rubenistes-Delacroix centrality of color fused into the factual world of Courbet, Pissarro and Manet, in order to present things—the world—with existential integrality (*KC* 200, 230, 249–53/271, 295, 318–23; *SC* 14–17,20).

Unlike an Impressionist fascination with the pleasant present moment pulsing with warmth and light, artist Cézanne as seer, says Badt, strove to "realize" the "untemporal, unchanging, existing and holding-itself-in-existence" nature of mountain, land, and vegetation **behind** the perceptible natural surfaces of trees, setting, and view, which are easily understood as becoming and begoing (*KC* 110, 164, 168, 170–73/145, 164, 214, 219, 222–26). For example, Renoir's rendition of Montagne Sainte-Victoire is sunny, wind-blown, lovely, pictorial, awash with wispy, cursive brush strokes as if you were pushing your way through the grasses of countryside on a Sunday afternoon: Cézanne's watercolored mountain is an apparition simply there, dominating the whole area, impassive, forbidding, a structure with underlying stability reaching up to infinity. Cézanne uses daubs of pigment in his oil paintings (and the subtle white luminosity of the paper in watercolors) to construct architectonically a tapestry of colors, a texture, a text, one could almost say, that does not pretend to duplicate a given scene somewhere so much as call up something both vital and massive, and let an elevation emerge in sympathetic vibration, in concert with a wonderful sea of greens, ambivalent violets, fatty ochres, and heavenly blues, which bathe the mountain with a towering immoveable mystery above its earthy subjects. There are green clouds around the mountain, clapping their hands, as it were, in response to the joy of the greenery below.

Badt is willing to read this quality of vivid suspension and unshakableness to the whole brimming constellation of what is imaged as alive but unchanging by Cézanne [#44] *Montagne Sainte Victoire*, 1904–06, Basel]—a flash of transcendent white at the peak of the mountain's thrust upward—all as announcing something hidden and holy. Cézanne "reaffirms that the kernel of deity is the eternal; yet without binding himself to any particular historical religion, Cézanne harks back to Ur-insights. . . . Cézanne reveals the very religious depth of the existence of being

[#44] Paul Cézanne, *Montagne Sainte Victoire* from Les Lauves, 1904–1906

alive."[30] Cézanne's genuine and profoundly integral "conversion" to the Roman catholic christian faith around 1870–72 did not make Cézanne's art specifically christian, says Badt; but Cézanne's deep longing for some kind of faith that goes beyond humanism, romantic pantheism, sensualistic and rationalistic secularity, to salvage values important to humans reunited with a transcendent—what Goethe, Hölderlin, Kierkegaard, Nietzsche, Baudelaire and Van Gogh struggled with too—did mark Cézanne's artistry with the disclosure of truth (*KC* 112–15/147–51).

Cézanne's paintings of "Holy Victory Mountain" for Badt shows it resolute and shimmering like a place where earth and heaven meet, flayed by the encounter of mortals and gods. Heidegger's remark to Buchner— "The wondrously strange mountain with which Cézanne wrestled must have also showed you on occasion its migrating light"—would align the "sacredness" of the mountain more closely with Olympus and Delphi

30 "An der Unverrückbarkeit, dem unveränderlichen Zusammenhalt der Dinge in Cézannes Bildern kündigt sich etwas Heiliges an, das den Inbegriff der Gottheit als des Ewigen wiederholt, ohne sich an eine historische Religion anzuschließen, vielmehr auf ältere Einsichten zurückdeutet. An der Darstellung und Umbildung profaner vergänglichen Dinge ist durch Cézanne die religiöse Tiefe der Existenz des Lebens aufgeschlossen" (*KC* 115/151).

(*EH* 47). A Cézanne letter to Emile Bernard describes Cézanne's own field of wonderment to be the glorious theatre of *Pater Omnipotens, Aeterne Deus.*[31] The truth for Badt, however, of Cézanne's late artworks is their mute revelation of the rock-bottom meaning of what is perishable: how both wild and tamed Nature, despite fascist politics and art historians, is the mortal human's miraculous home. Cézanne's "old age" paintings rise above loneliness for Badt, and uniquely show what Rilke's poetry says: *Gesang ist Dasein* [Song is the meaning of human existence] (*KC* 135, 140, 164, 244–45/175, 181, 214, 312–14).[32]

The cost of Badt's high view of artists

Art for Kurt Badt has its own specific nature. Embedded in worldwide reality, artworks are carefully structured creations by which humans celebrate hidden nuances of things. Artworks present important, subtle knowledge for imaginative reception. Given their defining aesthetic character, artistic objects, texts, and events are not to be taken as peculiarly scientific constructions or as commercial commodities. Because artworks are not simply the aesthetic quality that defines them as art, however, one goes wrong to treat art as only an aesthetic object.

Artworks are to be neither cultured effigies of natural givens out there nor pure expressions of the artist's heightened subjectivity: *tertia datur*. Heidegger's moot ascription of a kind of radioactive oracularity to art/poetry makes art virtually sacred in a nondescript way: art bodes saving power for our deracinated age because, for Heidegger, art occasions truth. Badt demythologizes Heidegger's cultic conception of art, but holds onto the "edifying," if you will, norming, "enlightening," truly human-making power of art. This tenet of art's "ennobling" character gives Badt's aesthetics reflection an old-fashioned Humanist feel, highlights the life-seriousness of art, and protects art from becoming just the butt of another academic game.

The rub to Badt's highly professional treatment of artworks in all their crafted complexity[33] is that Badt with Heidegger affirms that art is a singular conduit of truth, that is, reveals meaning that is somehow ultimate, omnitemporal, certain. Therein lies Badt's motivation for art history-keeping, to revive for the current generation the great "spiritual"

31 ". . . Les lignes parallèles à l'horizon donnent l'étendue, soit une section de la nature ou, si vous aimez mieux, du spectacle que le *Pater Omnipotens Aeterne Deus* étale devant nos yeux." Cézanne letter to Émile Bernard, 15 April 1904, in *Correspondence de Paul Cézanne*, ed. John Rewald (Paris: Beiard Grasset, 1937), 259.

32 Rainer Maria Rilke, *Sonette an Orpheus* 1:3.

33 Cf. two interludes on "Die richtige Reihenfolge der Interpretation," in *MM* 31–78.

(*geistig*) insights artistically embodied once upon a time and needed again now to illuminate and correct modern ignorance and the parochiality of a society whose horizons of meaning generally fearfully exclude anything of final, reliable significance (*WK* 28–30).

It takes original figures of intense artistic genius to mediate truth, Badt believes. But there is a quirk to Badt's idea of "great individuals," which critic O.K. Werckmeister misses when he accuses Badt of artistic elitism and political conservatism (275). In his wartime diary Badt recalls his old school day milieu of middleclass liberalism, the university atmosphere of value-free science where existential questions of death, love, meaning, spirituality, were avoided, and how money and power ruled people's lives in spite of everything else; yet religious questions still percolated underneath this "progressive" modernity, says Badt, and the final answer that great figures like Dostoevsky and Tolstoi tried to give—in spite of Aufklärung and historicist research—"the Christ"—witnessed to what did trouble Europeans behind their complacent veneer. "Great individuals" like Goethe, Nietzsche, Kierkegaard, Schopenhauer, Newman, Baudelaire, Gogol, Verlaine, Claudel, posed the most fundamental question of what does it all mean? took an existential, experiential stand on Christ's presence in everyday life to give meaning to suffering, says Badt, and only that decisiveness gave them the weight of being to bear up in their perilous dissolution of culture (*in einer gefährlichen Verworfenheit*) (*GS* 193–98).

—Badt is writing in the 1940s about "Christ" as an uprooted German Jewish intellectual exiled in bombed London, reflecting on "sacrifice" (for which one word in Hebrew is "holocaust") while reading Nietzsche on "Herren- und Sklavenmoral." I choose the Jew morality, the suffering slave morality, writes Badt, because then you are blessed when you normally fall short of fulfilling your task, because it is made good for you—(*GS* 213–15)

I mention this extraordinary document of Badt's struggle since it formulates his anthropological model for gauging artists:

> . . . a human is tensed like a bow or a lyre that shoots an arrow to the mark or sounds [the secret of life]; otherwise a human is like the Danaïdes doomed to scoop water forever in a sieve. One must not forget, however, that the tensed person is always in danger that his or her strings may rip to pieces; also, while the person is in [desirable] tension one is at the same time also on the rack.[34]

34 ". . . der Mensch ist entweder gespannt wie ein Bogen oder eine Leier—dann sendet er den treffenden Pfeil oder er tönt; oder er ist gleich der Danaide, Wasser in ein bo-

It is precisely such tension—fallen mortal listening for the voice of a hidden God, gods behind the back of Promethean artisans, driving them on[35]—that underlies Badt's fascination with the "great" artist as *vates*, as the seer and bringer of truth. Not philosopher-ruler but artist-priest was Badt's drift in the legacy of Heidegger, yet not restricted to Delphi. Late Rembrandt, Rubens, Poussin, Delacroix, Van Gogh, and Cézanne performed their visionary election in Amsterdam, Antwerpen, Roma, Paris, the Provence. Such embattled, unusually creative artistic geniuses epitomize authentic artistry for Badt, not the very talented virtuosi like Bernini, Velasquez, Frans Hals, and Wagner, who aim to dazzle a public with their performance more than press through to the *tremendum dei*, the very nerve of truth.

The cost of Badt's elevation of great artists to almost demi-god status as gnostic seers is high for aesthetics and art historiographic theory, in my judgment. (1) Badt tends to exaggerate the uniqueness of his selected *vates*—as if Poussin unlike his contemporaries had immediate lived access to the mythic realities they painted (*KNP* 462–63), as if Paul Klee's exquisite mystical-sensuous paintings never had any previous possible comparable likenesses (*BPK* 135). Badt's militance against the positivist parsing of pace-setting artists into 'sources' is sound; but Badt's inordinate commitment to individual originality and the radical dif-ference of each artwork from every other (*eine radikale Ab-ständigkeit voneinander*) *(KZ* 256–57) is inclined to turn art history into a series of monographic epiphanies.[36]

(2) Badt was wary of *avant garde* art movements because of their reductive bent toward aestheticism, the frequent loss of humanist dimensions, or even touches of blatant nihilism (*GA* 189–97, *FN* 72–73). Gauguin was stuck in rejecting tradition, says Badt early on, without

denloses Fass schöpfend. Jedoch der Gespannte, man vergesse das nicht, ist immer in der Gefahr, dass seine Saiten reißen, und, indem er gespannt ist, ist er auch zugleich auf der Folter" (*GS* 198).

35 It is significant, I think, that Badt uses Martin Buber's translation device to indicate the unspeakable JHVH by referring to ER (*GS* 197). Badt hints at his own orientation when he delineates "das Sein der Götter" in Poussin's art (as conceived by Erwin Rohde, Ulricht von Wilamowitz-Moellendorff, Walter F. Otto, Bruno Snell and Karl Kérenyi) (*KNP* 425–35). Dittmann's astute comment relates Badt's God to the divine Being of Schelling (*KKB* 77–78). Cf. also note 22 above.

36 Hans Robert Jauss notes the antinomy between Badt's theory, where great artworks transcend their historicality, and Badt's praxis, which minutely examines the historical settings in which artworks are enmeshed (13–14). Badt's defense: art historians should examine the "negative determinants" of art only to bring to the fore and set free the original power of the singular piece of art (*MM* 88–89). Cf. also *KNP* 438.

showing the creative integrity to initiate new features truly worthy; Gauguin's prototype of artist, however, as temperamental, single-minded purist has had a great following (*G* 127). Manet is a superbly talented *artifex rhetor* for Badt, the first to make a clean break from "the romanticism of [Courbet] realism" with a brilliant display of innovative form, a galvanizing leader in *l'art pour l'art* circles, but void of humane substance (*KC* 192–98/251–57). Picasso uses disturbing images to criticize his age, but Picasso's art is actually a symptom, says Badt, of the cynical devaluation of life where the difference between life and death, sense and insanity, dream and deed, has ceased to hold; so Picasso's striking art does not help against destructive forces (*P* 6). That is, Badt's trenchant judgments on art of the recent past are severe on those figures who close out, jeopardize, or skew what Badt finds to be the crux of **being** art: its reach for a transcendent dimension of truth **within** our natural and human reality.

Dittmann: the protopathic dimension of current art shows its mythic search for truth

On this very point where Badt seems to have run stuck—how can contemporary art that dispenses with wholeness, doubts truth, and calls into question two millennia of great human achievement ever be authentic artistry?—Lorenz Dittmann supplies a thoughtful supplement.[37]

Art in our century, states Dittmann, knows a connection between "creative experience and religious orientation," between discovering new terrain internal to art-making and the vision of a reality that goes beyond visible empirical surroundings. "Religious" does not mean just unquestioning dogmatically posited answers, but refers in a general way to "transcendent spiritual reality" (*RDM* 79–80)—one's own experience of a primal cry without answer (in Barnett Newman's words), before an infinitude (Space for Beckmann), before the purposeless condition of All that is (Malevich), before the cosmos as a marvelously connected Nature constantly becoming (Paul Klee), before the Spirit of creativity blowing where it lists (theosophic Kandinsky). In fact, says Dittmann, it is a central feature of contemporary graphic art to represent unreality and surreality (*die Vergegenwärtigung von Undinglichem und Überdinglichem*) (*AV* 192); and such imagining is not just subjective psychological projection, as Aby Warburg's iconographic art critical method would assume,

37 Professor Lorenz Dittmann (Universität des Saarlandes) is certainly the finest commentator and interpreter of Badt's oeuvre, and was entrusted by Badt with his voluminous manuscript on Veronese for editing and posthumous publication, *Paolo Veronese* (Köln: DuMont, 1981).

but admits to a searching for something more than meets the eye—a real God, gods maybe, something divine or absolute (*KIT* 16–17, 21), like "the transcendent objectivity" (*der transzendenten Sachlichkeit*) beyond mimetic duplication, archaic decorativeness and sentimentality for which Max Beckmann's art strove (*AV* 183).

Then Dittmann takes off from a couple of later Heideggerian texts that claim that, first, truth becomes present only as an ongoing struggle between clearing up and remaining hidden in the opposition of world and earth (*UK* 51/62) and, second, that the zone of "remaining hidden and being unconcealed" is immediately more familiar and accessible to us humans than whatever the term "truth" might mean, which we can neither properly think nor ever see (*P* 19, *LV* 317–18).[38] Dittmann traces how the ancient and medieval metaphysics of light as spiritual good and dark as corporeal evil gradually converts through the mediation of Titian and then Rembrandt's chiaroscuro on through late Cézanne's reversal of the Impressionist dissolution of color into light by making dark colors again the playful hide-and-seek look-through to the white of absented godliness, until artists like Klee, who ascribe "an otherworldly affair" (*eine jenseitige Angelegenheit*) to pure colors, especially in the darkened spectrum where obscurity mirrors age-old divine sounds, and art like "Die Atlanta" by Emil Schumacher posits that earthly **darkness** is the locus of the unavailable hidden Chiffre, the secret of concealed heavenly meaning (*LV* 324–28).

Dittmann's point is that "abstract" painting may be a particularly good vehicle for the apotheosis of "the material" into "the spiritual," since with the loss of mimetic distraction the subliminal knowledge the artist's body provides in generating art comes to the fore (*GH* 70, *KPL* 287, 307–12). Protopathic and epicritic body knowledge occasioned, for example, by grief or deep anxiety (*Schmerz, Angst*), according to Dittmann, pinpoints surely a person's awareness of one's absolutely **own place** historically on earth under heaven before Who-knows-what (*LSK* 321–23,326). Such immediate, existential cutaneous sensitivity has a character and reach similar to mythic knowing, a state in which a person is drawn surely and apprehensively toward something taken to be mana or tabu.

Joseph Beuys' art objects of warmth (with honey, fat, felt, oil oozing

38 Heidegger: "Der Bereich des 'Verborgen-Unverborgen' ist uns sogar, wenn wir uns nichts vormachen, unmittelbar vertrauter und zugänglicher als das, was uns die sonst geläufigen Titel *veritas* und 'Wahrheit' sagen. Streng genommen können wir uns bei diesem Wort 'Wahrheit' nichts denken und noch weniger etwas 'anschaulich' vorstellen" (*P* 19).

from stone) impresses one bodily to a sensed immersion, isolation, implacable envelopment where one's body is an absorbent corporeal island threatened in a sea of closing in material that shall overwhelm you, like a strange ritual of purification (*LSK* 327–29, 332). Beuys' "Environments" do not have a natural science experimental stamp, says Dittmann, but elicit a magical and mysterious feel (*LSK* 330).

Likewise Gerhard Hoehme's art pieces in his volcanic "Etna cycle" achieve an effect similar to that which an archaic Greek *kuros* has, which both attracts and distances an onlooker by its hieratic, prismatic rigid presence. Hoehme's triptych "Bilder aus verschütteten Zeiten" (1983) [Images from teeter-tottering times] shows, right, "Das Feuer des Hephaistos" [The fire of Hephaestus]—burnt red, yellow, and ashen white pouring down like lava from the top right—and center, "unter der Asche offener Wunden" [Under the ashes of open wounds]—a mass of fire-red gullies and flames falling down leftward under a creased scar athwart the top right while loose cords like disheveled hairs hang beyond the canvas—and left, "Aphrodites geronnene Tränen" [Aphrodite's spilled tears]—gently brings the massive volcanic whole steadily to rest in ochre, yellow, and grey tones ending below in crumbly material (*GH* 69–70). Hoehme's "Der Tod des Herakles" (1978) [#45] [Hercules' death] also takes mythical legend to double for current catastrophic events: a haze of grey-green flakes seem to rise and fall helplessly, recalling the waves of burning pain the poisoned shirt of Hercules brought on, while the billowing polyethylene ropes festively celebrate his apotheosis—keeping the viewer off balance as to whether the piece should be seen as something opposite nearby or as a scene far below at a distance (*LSK* 337–38, *GH* 65). Hoehme believes uncertainty is one of the most human qualities, and curiosity is the door to freedom, while we remain living embedded in contradictions (*GH* 60). That hovering troublement captured artistically with almost chthonic body knowledge as unconfined anonymity simultaneously familiar, both controlled

[#45] Gerhard Hoehme,
Der Tod des Herakles, 1978

and accidental, both hidden and unconcealed, gives Hoehme's art, says Dittmann, the mythical ambiguity Heidegger praises, the flickering rooted in the concealing darkness of earth and the light of day (*P* 211), so that Hoehme's images, like Cy Thombly and Barnett Newman art, cast a spell for meditation (*GH* 71–72).

Opening remark: can one recognize the central response to "transcendence" in art without becoming another interventionist lobby in philosophical aesthetics?

Badt and Dittmann do give sturdy art historiographic body to Heidegger's far-reaching philosophical thesis that art works truth and carries a world of committed meaning, giving to things their own certain place. Karl Löwith once wrote that it is this unspoken "religious meaning" in Heidegger's thought, loosed from its christian moorings, that in all its unconfined indeterminate worrying of Being attracts listeners who are no longer believing Christians but would still like to countenance a "religious" dimension.[39] I personally am wary of the siren call of a nondescript transcendence; Badt's artistic *vates* could easily become oracular gurus of self-serving, occult interests. Gerhardus van der Leeuw's supposition that Beauty is penultimate to worship of the Holy[40] shatters on Jauss's remark that beauty can be absorbingly **deceptive** (15–16). Just because the vital primal cry of artistic "creativity" in our deracinated day **can** be an opening to help face what Dittmann calls "perdurant religious truth" (*RDM* 95) does not mean, I think, that every significant artistic cry with no answer heard is en route to the truth—unless one takes Karl Jasper's position, which denies an exclusivity to "religious truth."[41]

Badt and Dittmann's imaginative, corrective outworking of Heidegger's deep-going wrestling with art face North American philosophical aesthetics and art historiography awaking from their positivistic slumber or engagement in pragmatistic busyness with a nice problem: can we

39 "Was aber allem von Heidegger je Gesagten hintergründig zugrunde liegt und viele aufhorchen und hinhorchen lässt, ist ein Ungesagtes: das *religiöse Motiv*, das sich zwar vom christlichen Glauben abgelöst hat, aber gerade in seiner dogmatisch ungebundenen Unbestimmtheit umso mehr diejenigen anspricht, die nicht mehr gläubige Christen sind, aber doch religiös sein möchten." Karl Löwith, 111.

40 Gerhardus van der Leeuw, *Wegen en Grenzen: De verhouding van religie en kunst* [1932] (Amsterdam: H.J. Paris, 1955), translated by David E. Green as *Sacred and Profane Beauty: The holy in art* (Chicago: Holt, Rinehart and Winston, 1963), 294–95, 298–99, 306–17, 329–35, 368–71/266, 270–71, 276–87, 299–303, 333–36.

41 Cf. lecture four on "Philosophie und Religion," especially the section "Gegen den Ausschliesslichkeitsanspruch," in *Der Philosophische Glaube* (Zürich: Artemis, 1948), 79–86.

take seriously late Wittgenstein's remark that

> Religious faith and superstition are utterly different. The one originates from **fear**, and is a species of false science; the other is a trust.[42]

How can we take seriously what Wittgenstein notes as inhering and rooting the human condition, also for artists and philosophers, without joining what Michael Ann Holly calls "interventionist criticism"—analysis and history-keeping that does not serve art, literature, and fruitful thinking, but uses art, poeting, and thinking to further one's ideology (153)? One would forfeit the move Badt and Dittmann make from Heidegger if one just added "spirituality" to the roster of Neo-Marxist, psychoanalytic, militant feminist, visible minority, right-wing political, and other interventionist lobbies in art history and aesthetics—each of whom does have or mean to have a valid thrust to make. There is also no salvation, in my judgment, in pulling back professionally purely to make art or do philosophy as usual, while Rwanda, Timor, starving Somalia, the Los Angeles' ghetto, and North American university education and current "hot spots," as journalists call them, burn. Religiously antiseptic scholarship might just be humanly sterile.

My own chess move is to recognize there is a long-standing tradition of "mystical" art and "mythologizing" philosophy, as Dittmann, Dirk van den Berg, Rosenblum, and others have shown,[43] and let such recognition be my opening gambit before showing how **all** artwork **must** somehow face the truth if it would be taken seriously, and then commend Walter Benjamin's plan for a "redemptive historiography" that will commemorate the marginalized contributors to whom the victors who wrote the history books to date did not do justice.[44] Such reformational activity needs to discern, as it brings even anonymous figures into the

42 "Religiöse Glaube und Aberglaube sind ganz verschieden. Der eine entspringt aus *Furcht* und ist eine falsche Wissenschaft. Der andre ist ein Vertrauen." Ludwig Wittgenstein, *Vermischte Bemerkungen in Werkausgabe*, ed. Georg Henrik von Wright (Frankfurt am Main: Suhrkamp, 1984) 8:551.

43 Cf. Lorenz Dittmann selected bibliography given; Dirk van den Berg, *'n Ondersoek na die Estetiese en Kunshistoriese Probleme verbonde aan die sogenaamde moderne religieuse Skilderkuns* (Bloemfontein: Universiteit van die Oranje-Vrystaat, 1984); Robert Rosenblum, *Modern Painting and the Northern Romantic Tradition: Friedrich to Rothko* (London: Thames & Hudson, 1975). Cf. my "'Mythologizing philosophy' as Historiographic Category," in *Myth and Interdisciplinary Studies*, eds. M. Clasquim, J.D. Ferreira Ross, D. Marais, R. Sodowsky (Pretoria: University of South Africa, 1993), 28–48 {see *CE*: 343–358}.

44 Cf. Walter Benjamin, Thesis IX, "Über den Begriff der Geschichte" [1940] in *Gesammelten Schriften*, Vol. 1:2. eds. Rolf Tiedemann and Germann Schweppenhäuser (Frankfurt am Main: Suhrkamp, 1974), 691–704.

world canon of art and philosophy, what is insightful from what is trivial. That criterion, as developed in this article, would respect art and thinking that gives a sure place to things, bears a world with redemptive horizons, and dares stake out a position in matters of life and death, truth and lie, meaning and vanity. If one could engage such systematic analysis and historiographic narrative to elucidate the human meaning of making, receiving, and reflecting on art and literature, sharing one's insights in scholarly journals, this would become not so much a conflicting one-upmanship argument as making music for one another.

Abbreviations and major works cited

Martin Heidegger

BWD "Bauen, Wohnen, Denken" [1951], in *Vorträge und Aufsätze* (Pfullingen: Günther Neske, 1954), 145–62; translated by Alfred Hofstadter as "Building Dwelling Thinking," in *Poetry, Language, Thought* (San Francisco: Harper Colophon, 1975), 145–61.

D "Das Ding" [1950], in *Vorträge und Aufsätze*, 163–81; translated as "The Thing," in *Poetry, Language, Thought*, 165–82.

DWM "Dichterisch wohnet der Mensch" [1951], in *Vorträge und Aufsätze* 2:187–204; translated in *Poetry, Language, Thought*, 213–29.

EH *Erinnerung an Martin Heidegger*, ed. Günther Neske (Pfullingen: Günther Neske, 1977).

FT "Die Frage nach der Technik" [1955], in *Vorträge und Aufsätze*, 13–44; translated by William Lovitt as "The Question concerning Technology," in *The Question Concerning Technology and Other Essays* (San Francisco: Harper Torchbook, 1977), 3–35.

HWD "Hölderlin und das Wesen der Dichtung" [1936], in *Erläuterungen zu Hölderlins Dichtung*, Gesamtausgabe, ed. Friedrich-Wilhelm von Herrmann (Frankfurt am Main: Vittorio Klostermann, 1981), 4:33–48; translated by Douglas Scott as "Hölderlin and the Essence of Poetry," in *Existence and Being*, ed. Werner Brock (Chicago: Henry Regnery, 1949), 270–91.

KR *Die Kunst und der Raum* (St. Gallen: Erker Verlag, 1969), 5–14; with translation by Jean Beaufret and François Fédier, *L'art et l'espace*, 17–26.

N *Nietzsche, Erster Band, Wille zur Macht als Kunst* (Pfullingen: Günther Neske, 1961); translated by David Farrell as *Nietzsche: The will to power as art* (San Francisco: Harper & Row, 1991), 2 volumes.

P *Parmenides*, Gesamtausgabe, ed. Manfred W. Frings, 54 (1982).

S "Die Sprache" [1950], in *Unterwegs zur Sprache* (Frankfurt am Main: Vittorio Klostermanm, 1976), 9–30; translated as "Language," in *Poetry, Language, Thought*, 189–210.

SZ *Sein und Zeit* [1927] (Tübingen: Max Niemeyer, 1957).

UK "Der Ursprung des Kunstwerkes" [1935–36], in *Holzwege*, 3 A. (Frankfurt

am Main: Vittorio Klostermann, 1957), 7–68; translated as "The Origin of the Work of Art," in *Poetry, Language, Thought*, 17–87.

Kurt Badt

AV "Artifex vates und Artifez rhetor" [1943], in *Kunsttheoretische Versuche*, ed. Lorenz Dittmann (Köln: Verlag M. DuMont Schauberg, 1968), 39–83.

BPK "Zur Bestimmung der Kunst Paul Klees," in *Jahresring* 64–65 [1964]: 123–36.

EB *Ernst Barlach der Bildhauer* [1959] (Neumünster: Karl Wachholtz, 1971).

FN "Die Form des Neuen," *Der Monat* 16 (August 1964): 72–78.

FR "Feiern durch Rahmung" [1960], in *Kunsttheoretische Versuche*, 103–40.

G "Die Gestalt Gauguins," *Zeitschrift für bildende Kunst* 32:5–6 (1921): 120–28.

GA "German Art 1945–50," *German Life and Letters* 4 (1951): 189–97.

GK "Der Gott und der Künstler" [1956], in *Kunsttheoretische Versuche*, 85–101.

GS "Geistige Strömungen meiner Zeit" [1944–47], *Zeitschrift für Ästhetik und Allgemeine Kunstwissenschaft* 35 (1990): 190–225.

KC *Die Kunst Cézannes* (München: Prestel-Verlag, 1956); translated by Sheila Ann Igilvie as *The Art of Cézanne* (London: Faber and Faber, 1965).

KNP *Die Kunst des Nicolas Poussin* (Köln: M. DuMont Schauberg, 1969) 2 volumes.

KZ "Der kunstgeschichtliche Zusammenhang" [1966–67], in *Kunsttheoretische Versuche*, 141–75.

MM *Modell und Maler von Jan Vermeer. Probleme der Interpretation. Eine Streitschrift gegen Hans Sedlmayr* (Köln: M. DuMont Schauberg, 1961).

RR *Raumphantasien und Raumillusionen – Wesen der Plastik* (Köln: Verlag M. DuMont Schauberg, 1963).

SC *Das Spätwerk Cézannes* (Konstanz Universitätsverlag, 1971).

WK *Eine Wissenschaftslehre der Kunstgeschichte* (Köln: M. DuMont Schauberg, 1971).

WS "Die Idee der Welt und das Selbst als fundamentale Wesenheiten bildender Kunst" [1933], in *Kunsttheoretische Versuche*, 29–37.

WW "Picasso, der Maler des Nichts," *Die Weltwoche* (Zürich) 14 (no. 898, 30 August 1945): 6.

Lorenz Dittmann

AV "Auflösung aller Vertrautheit: Kandinsky und Klee," with Walter Falk, in *Jahrhundertwende, Der Aufbruch in die Moderne 1880–1930*, eds. A. Nitschke, G.A. Ritter, D. Peukert, et al. (Reinbek: Rowohlt, 1990), 2:170–94.

BKD "Der Begriff des Kunstwerks in der deutschen Kunstgeschichte," in *Kategorien und Methoden der Deutschen Kunstgeschichte 1900–1930*, ed. Lorenz Dittmann (Stuttgart: Franz Steiner, 1985), 51–88.

GH "Gerhard Hoehmes 'Etna'-Zyklus. Zur Verwandlung der 'Mythischen Form' in der Malerei des zwanzigsten Jahrhunderts," in *Modernität und Tradition*,

Festschrift für Max Imdahl, eds. Gottfried Boehm, K. Stierle, D.G. Winter (München, 1985), 59–74.

KIT "Kunst–Ikonologie–Transzendenz," in *Das Munster* 46:1 [1993]: 15–22.

KPL "Kunstwissenschaft und Phänomenologie des Leibes," *Aachener Kunstblätter des Museumsvereins* 44 [1973]: 287–316.

KKB "Die Kunsttheorie Kurt Badt," *Zeitschrift für Ästhetik und Allgemeine Kunstwissenschaft* 16:1 [1971]: 56–78.

LSK "'Der Leib in Spiegel der Kunst': Joseph Beuys und Gerhard Hoehme," in *Rehabilitierung des Subjektiven, Festschrift für Hermann Schmitz*, eds. Michael Grossheim and Hans -J. Waschkies (Bonn: Bouvier, 1993), 321–38.

LV "Lichtung und Verbergung in Werken der Malerei," in *Kunst und Technik, Gedächtnisschrift zum 100. Geburtstag von Martin Heidegger*, eds. Walter Biemel and Friedrich-Wilhelm v. Herrmann (Frankfurt am Main: Vittorio Klostermann, 1989).

RDM "Religiöse Dimensionen in der modernen Malerei," *Ars et Ecclesia, Festschrift für J. Ronig*, eds. H.-W. Stork, Chr. Gerhardt, and A. Thomas (Trier: Paulinus, 1989), 79–95.

Others

Bartky, S. L. "Heidegger's Philosophy of Art," *British Journal of Aesthetics* 9:4 (1969): 353–71.

Bauch, Kurt. "Die Kunstgeschichte und die heutige Philosophie," in *Martin Heideggers Einfluss auf die Wissenschaften*, eds. Carlos Astrada et al. (Bern: Francke, 1949), 88–93.

Bossart, William H. "Heidegger's Theory of Art," *Journal of Aesthetics and Art Criticism* 27:1 (1968): 57–66.

Holly, Michael Ann. "Vision and Revision in the History of Art," in *Theory between the Disciplines: Authority / vision / politics*, eds. Martin Kreiswirth and Mark A. Cheetham (Ann Arbor: University of Michigan, 1990), 151–68.

Jamme, Christoph. "Der Verlust der Dinge—Cézanne, Rilke, Heidegger," in *Martin Heidegger: Kunst / Politik / Technik*, eds. Christoph Jamme and Karsten Harries (München: Wilhelm Fink, 1992), 105–118.

Jauss, Hans Robert. *Kurt Badts Apologie der Kunst* (Konstanz: Universitätsverlag, 1975), 5–18.

Knudsen, Donald L. "A Crushing Truth for Art: Martin Heidegger's meditation on truth and the world of art, in *Der Ursprung des Kunstwerkes*" (Toronto: Institute for Christian Studies, 1987, M.Phil.F. thesis), x–142 typescript.

Lawry, Edward G. "The Work-being of the Work of Art in Heidegger," *Man and World* 11 (1978): 186–98.

Löwith, Karl. *Heidegger: Denker in dürftiger Zeit*, 2 A. (Göttingen: Vandenhoeck & Ruprecht, 1960).

Perpeet, Wilhelm. "Heideggers Kunstlehre" (1963), in *Heidegger: Perspektiven*

zur Deutung seines Werkes (Berlin: Kiepenheuer & Witsch, 1970), 217–41.

Petzet, Heinrich Wiegand. *Auf einen Stern zugehen, Begegnungen und Gespräche mit Martin Heidegger 1929–1976* (Frankfurt am Main: Societäts-Verlag, 1983).

Pöggeler, Otto. "Heidegger und die Kunst," in *Martin Heidegger: Kunst / Politik / Technik*, 59–84.

Sedlmayr, Hans. "Jan Vermeer: Der Ruhm der Malkunst" (1951), in *Kunst und Wahrheit, zur Theorie und Methode der Kunstgeschichte* (Mittenwald: Mäander, 1978), 134–42.

_____. "Jan Vermeer: 'De Schilderkunst' nach Badt, zugleich Replik," *Hefts des Kunsthistorischen Seminars des Universität München*, 7–8 (1962): 34–65.

Seubold, Günter. "Der Pfad ins Selbe: Zur Cézanne-Interpretation Martin Heideggers," *Philosophisches Jahrbuch* 94 (1987): 62–78.

von Einem, Herbert. "Kurt Badt (März 1890–November 1973), Überlingen." Obituary in *Kunstchronik* 27 (1974): 203–10.

Werckmeister, O.K. Review of Kurt Badt, *Eine Wissenschaftslehre der Kunstgeschichte*, in *Kunstchronik* 26 (1973): 266–75.

Werner, Anne-Marie. *Relativität und Dynamik des Raumes: Kurt Badts pragmatisches Raumkonzept* (Saarbrücken: Universität des Saarlandes, 1988, Diss.), 297pp. typescript.

Zimmerman, Michael E. *Heidegger's Confrontation with Modernity, Technology, Politics, Art* (Bloomington: Indiana University Press, 1990).

TELLTALE STATUES IN
WATTEAU'S PAINTING

The thesis I should like to establish is that the Garden of Love *topos* forms the very syntax of Antoine Watteau's mature paintings, and if one minds the tale told by the statues in his paintings—Watteau's emblematic mutant of classical mythology—one finds a key to the deeper meaning of his oeuvre.[1]

Before 1710 Watteau was a displaced Walloon in Paris working his way up from hackwork into collaboration with one of the best placed decorators of the day, Claude III Audran. For eight years he painted, drew, and designed what was wanted and commissioned by fashionable society: arabesques to fill the panels of salons in hotels and chateaux (e.g., Meudon), chinoiseries (e.g., at La Muette), and gallant figures or scenes from *commedia dell'arte* in demand by engravers.

Typical of his work during this period are the quasi-mythological figures in *Les Enfants de Momus* (c. 1708) [#46]. *Momus* himself has no Olympian pedigree; indeed he is more like a literary personification of faultfinding than a god, a kind of Ur-jester, a fitting patriarch for the marionette-sized harlequin, pierrot, and trio of cupids with shepherd staff, sword, tambourine, and jester accoutrements. They are disposed around a light stage-platform with a heart-shaped pool under a fountain graced by a pair of sculptured dolphins flaunting their tails. Above is an apparition of beautiful Colombine surrounded by a circle of roses. The curtain drapery is suspended above the chaste nymphs half-robed with growing vines, and trails down lightly until it beribbons the serious sileni

1 The reference number for the illustrations of the lesser known works of Watteau correspond to the plates found in E. Deicer and Albert Vallarta, *Jean Julienne et le gravures de Watteau au Vile siècle* (Paris: Maurice Rousseau Libraries, 1921–29).

[#46] Antoine Watteau, *Les Enfants de Momus*, c. 1708

on plinths on each side. Their upright sternness is mocked somewhat by the filigree of trees behind them, which bend gently forward toward the baldaquin like hovering fans.

Dolphins have been messengers of secret love at least since Ovid. Sileni plinths are older satyrs who have lost their he-goat legs; they retain their large horse-ears and knowing smile because in their day they have plumbed the depths of love and life; they know it all. And it was under Claude Gillot's direction that the young Watteau learned to fuse such low-density mythology and minor-league deities—at the most a Bacchus or two—with the love comedy of the *Forains* popular in the Parisian fairs during the expulsion of the Italian *commedia dell'arte* troupes (1697-1716). The "Children of Momus" arabesque has the fanciful feel and look of a marionette theater—which Gillot himself happened to be managing around the very time that Watteau did this piece.[2]

Watteau not only led the eye of his contemporaries a merry chase through traditional pastoral scenes of courtship mixed with the antics of Columbine, Pierrot, and Harlequin,[3] but he also innovated beyond such homogenization. As he became acclimated to the polite society of Paris, Watteau made a significant addition to the vocabulary of artistic

2 Hélène Adhémar, *Watteau, sa vie, son œuvre* (Paris: Pierre Tisane, 1950), 100–101.

3 A striking example of the combination of gallant Arcadian scenes and vernacular comic types can be seen in the little-known folding screen Watteau designed c. 1709, *Six Feuillet d'un paravent* (plates 158–63).

decoration by introducing the swing. Roman daily-life art has no swings. There are no swings in medieval art, probably because "swinging" lacks any orthodox, theocratic parallel. Nor are there any important swings in baroque art, although occasionally we see children on swings in the seventeenth century (a teeter-totter emblem of uncertainty), or an ape may swing to signify laziness.[4] But Watteau made iconographic history in *L'Escarpolette* (c. 1709) by wedding a folk pastime to the gallant world of *fêtes champêtres*.

As Watteau shows it [#47], swinging is a model game for elegant lovers. It simulates the delicate, back-and-forth tug of learning to love, with movements suggestive of coquettishness: the man pushes softly and the woman glides through the air, pausing suspensefully at each up-swing; there is discreet physical contact, but no more. Watteau's arabesque leaves little doubt, however, as to what is in play with the swing. The bagpipes, a folk emblem for male genitalia, dominate the mound between the urns on the far sides, which sport rose trees and the horned ram's head; against the bagpipes are a

[#47] Antoine Watteau, *L 'Escarpolette*, c. 1709

doffed hat, and an abandoned silken shawl, flanked by a tipping basket of flowers. At the very top center is a horned goat with fierce eyes that stare down any observer, and at the very bottom—from top to bottom

4 Hans Wentzel, "Jean-Honoré Fragonards 'Schaukel,' Bemerkungen zur Ikonographie der Schaukel in der Bildenden Kunst," *Wallraf-Richartz Jahrbuch* 26 (1964), 194; A. Pigler, *Barockthemen,* 2 vols. (Budapest: Verlag der Ungarischen Akademie der Wissenschaften, 1956), 2:537–38.

thus—is an ornamental, noncommittal head of Bacchus, closely twined with grapes on the vine. Rising out of the large, grotesque trees, behind them, are four spectral silenus columns topped by urns that support an ethereal canopy of flowers and foliage; the immovable foursome appear like a company of sphinxes, the enigmatic wisdom of the ages, and cast a votive calm upon the scene.

Another early arabesque [#48] demonstrates Watteau's peculiarly rich integration of rustic and idyllic traditions and domesticated mythology, *Le Dénicheur de Moineaux* (c. 1710). The startling curve of the tree trunk (on the right in the engraving) and the wind-flattened bushes on the high and wild bluff (to the left) portend a storm; the mother bird, hanging dead-center, starkly perpendicular over the unsuspecting peasant boy and girl, seems already a victim. The hunting dog keeps a lookout on his ledge, alert for anything

[#48] Antoine Watteau,
Le Dénicheur de Moineaux, c. 1710

moving; but the dog cannot see that the whole secluded world of peaceful retreat is held up by a pair of bona fide satyrs, performing Atlas-service. The girl's hat and ribbons are hung neatly on a rack to the right, and on the left side rest the ubiquitous bagpipes and a cage with a bird in it, the old love-emblem for a girl's virginity (which Jan Steen and countless others hint may take wing and fly away when two young people picnic together in a wooded spot alone). Tucked underneath the fleur-de-lis escutcheon, directly over a young ram lying down, hangs a basket full of eggs, another favorite emblem of the fragility of the maidenhead. The central couple in Watteau's piece, however, are so oblivious to the cosmic storm around them, totally unaware of the emblematic wealth assem-

bled—caged bird, bagpipes, satyrs, ram, and eggs—so utterly innocent that they seem somehow out of reality. But the position of the girl's right arm as she sinks into languor, with her feet on the back of a faun who is gingerly reaching around behind his back with his arm to pluck a rose, bodes ill for the continuing balance and security of this island of peace. No wonder birds of the same family as the dead mother, high up out of harm's way, are shrieking in alarm to the proverbial owl about imminent disaster,

Le Dénicheur de Moineaux epitomizes the kind of iconographic base Watteau built upon and built into his painterly compositions. Early Watteau arabesques are not simple just because they are incredibly delicate. Watteau assembled emblematic detail in carefully suggestive fashion, but it is his juxtaposition of strange elements as if they belong together that creates the wit and arouses a sense of uncertain expectation.[5] Even Watteau's familiar love-emblems have the metaphorical intensity of symbols because they participate in the effortless, built-in juxtaposition of diluted mythical affairs, commedia dell'arte reality, and idyllic Arcadian dreams. The satyr is alive and unreal, but also a statue and real; the satyr does not have "sensuality" as a dogmatic analogue, but as drawn is covertly sensual, next to a real basket of eggs, which is precarious in multiple contexts, and so on. It is this ever-present, subtly critical commentary and mute counterthesis in all Watteau's basic thematic and compositional elements that already in 1710 begins to set off his designing conception and painterly language.

The fact that a note of bumptious impropriety is heard as a constant undertone in the early Watteau is the artistic reason, I think, why his work is often compared to Dutch genre painting. Watteau does stand for commedia dell'arte and the Forains—as his "picturesque," army-camp war scenes show—and not with the official Comédie-Française. But Watteau's contemporaries and disciples, and also most interpreters, have missed the depth and seriousness in Watteau's critique of fashionable society.[6] The penetrating critique within Watteau's rococo painting was missed, I dare say, not so much because his painterly finesse deflects analysis, but

5 Jean-Louis Schefer calls this kind of mysterious, oracular complementariness in Watteau of a central figure or group and the hiding-revealing-contrasting foliage-scape "l'état orphique du monde" ("Visible et thématique chez Watteau," Médiations-Revue des Expressions Contemporaines 5 [Summer 1962]: 40).
6 Michael Levey correctly says that "among the things that the eighteenth century did not understand about Watteau was the extent to which he was a rebel" (Rococo to Revolution: Major trends in eighteenth century painting [London: Thames & Hudson, 1966], 55).

rather because the hidden framework that gives his painting an abiding, semi-epic dimension—the Garden of Love *topos*—has hardly even been recognized.

It is a commonplace of medieval rhetoric, inherited from ancient erotic literature via Horace, that amorous experience follows a definite order of successive steps, stages, or degrees, *gradus amoris: visus* (sighting), *alloquium* (dialogue), *contactus* (touch), *osculum* (kiss), *factum* (the deed).[7] There is also a long literary tradition of *locus amoenus* (love-ly place, pleasance), which has grown up out of Homer, Theocritus, Virgil, Claudian, Isidore of Seville, and others, and describes no place in particular (but not no place either). *Locus amoenus* appears in literature as an enchanted landscape with certain specific charms, grassy meadow, a grove of trees, and spring water, an ideal place that A. B. Giamatti calls "the earthly paradise." *Locus amoenus* is the basic model for Elysium in Virgil's *Aeneid,* for example, and the Garden of Eden in Milton's *Paradise Lost.*[8] What happens in the "earthly paradises" of medieval romance and renaissance epic is what is important, not the *hortus deliciarum* (garden of delights) itself.[9] Those happenings are generally fateful; "earthly paradises" AD are crucibles for sorting out the true from the false, the transient from the enduring[10]—it is no accident that Dante's "earthly paradise" concludes the *Purgatorio* (canto XXVIII).

It is not pertinent in this essay to sort out the many variants of *gradus amoris* and *locus amoenus* from Ovid to Tasso and from Roman classical *carmina* to Ariosto and Spenser, or to show that some are sanctified only by Venus while other pleasant isles hold a Circe. But there are certain basic features that recur in the artistic conjunction of these two literary *topoi*,[11] and they are relevant to Mussia Eisenstadt's thesis that Watteau is to be understood as the innovator in *painterly* expression of what was an age-old *literary* and cultural convention.[12]

Le Roman de la Rose exemplifies the steps of love taken by a lover in a Garden of Love toward the desired prize. Once *Amant* is let inside

7 Lionel J. Friedman, "Gradus Amoris," *Romance Philology* 19 (1965): 167, 171–72.

8 Ernst Robert Curtius, *European Literature and the Latin Middle Ages* [1948], translated by Willard R. Trask (New York: Pantheon, 1953), 183–85, 195–98.

9 John V. Fleming, *The Roman de la Rose: A study in allegory and iconography* (Princeton: Princeton University Press, 1969), 55.

10 A. Bartlett Giamatti, *The Earthly Paradise and the Renaissance Epic* (Princeton: Princeton University Press, 1966), 85.

11 Ibid., 330.

12 Mussia Eisenstadt, *Watteaus Fêtes Galantes und ihre Ursprünge* (Berlin: Bruno Cassirer, 1930), 11.

the walled garden by *Oiseuse* (*luxuria*, Idleness), sees the rose reflected in the fountain-pool of Narcissus, and is smitten by the arrows of *Amors*, he joins the dance of *Deduit* (Mirth), speaks with *Bel Accueil* (the Lady's receptive ear), gets permission to approach and touch, plucks off a close-growing leaf, kisses the rose, and then, in the extended continuation of Jean de Meun with his elaborate analysis of the innumerable, subtle dimensions of *tout l'art d'amours,* ends the *gradus amoris* in the Garden by raping the rose.[13]

The features of *Le Roman de la Rose* important for the interpretation of Watteau's paintings are the aura of visionary illusion conjured up by the longing of the lover for the inaccessible beloved, and the psychomachic architectonics that stamps his pilgrimage: is it loving devotion or lust that drives him on? is the love humanly rational or simply sensual? is the beloved a dream or real? And it is noteworthy that all this restless desire and uncertain movement reach their poignant conclusion at the fountain of Narcissus in the center of the garden, so that the point of this gentle, thirteenth-century "immorality play" seems to be: if you play the chess of *amour* in the earthly paradise, in the Garden of Love, if you pursue the sweet torment of its courtesies and folly, the ironic end of *l'amour carneuse* is self-love, checkmate.[14]

Although Eisenstadt interprets *Le Roman de la Rose* too strictly in terms of pastoral and Arcadian ideals and the troubadour courtly love ethic,[15] she labors successfully to show that *Le Roman* stood behind what Johan Huizinga calls the "languishing tenor" and "resigned melancholy" of fifteenth-century erotic poetry in France,[16] and nourished fictions of

13 See Friedman, 174–75; Fleming, 99–100.

14 Fleming, 79, 95; Giamatti, 289–90. Fleming supports this convincing thesis by pointing out that the Pygmalion myth of Ovid, an exemplum of self-serving, sterile passion, is tossed in as an iconophilic aside near the end of the story, lines 20817–21214 (230–37).

15 Eisenstadt follows the view that Jean de Meun's continuation of the romance counters Guillaume de Lorris's piece (*Watteau Fêtes Galantes*, 123–24; see also Giamatti, 61–65). This traditional view misses the core of irony in the whole poem, which J. V. Fleming has argued. D. W. Robertson, Jr., would also more cautiously tighten up use of the term "courtly love" to keep its referent more exactly the kind of courteous love that assumed a Christian feudal society in medieval Europe and held out the ideal of reasonable love for a woman based on the Ciceronian, classical ideal of friendship; otherwise it is too easy to have "modern" eisegetic readings of the chivalry that had become a somewhat artificial cult by the close of the twelfth century (see *A Preface to Chaucer: Studies in medieval perspective* [Princeton: Princeton University Press, 1962/1973], 448, 452–57, 460).

16 Johan Huizinga, *The Waning of the Middle Ages* [1924], translated by F. Hopman (Garden City, NY: Doubleday Anchor, 1954), 306–16.

l'amour champestre in Honoré d'Urfé's *Astrée*. Eisenstadt shows that these Garden of Love motifs formed all together a natural setting for the exotic costume balls held in the parks, such as Catherine de Medicis attempted, for example, around the theme of *l'isle enchantée*. By the 1660s in France it was the fashion to hold masques using allegories or myths like Daphnis and Chloe to dress up one's festivities, feigning bucolic innocence while celebrating a thoroughgoing sensuality.[17] Such literary traditions and cultural habits were in the air when Watteau came to Paris—not to mention the secret love societies that developed later, like "Aphrodites" near Montmorency, led by the regent, Philippe d'Orléans, whose first by-law, it is reputed, was *"jamais avoir l'ombre d'un scrupule."*[18] (Montmorency is the place where Crozat, who became Watteau's friend and host around 1715, had a country chalet.)

Rubens's *Garden of Love* [#49], which Eisenstadt mentions in passing,[19] established a very definite, iconographic link between the literary *topoi* and the historical, cultural milieu I have just described and Watteau's paintings. If one examines the Rubens painting using the herme-

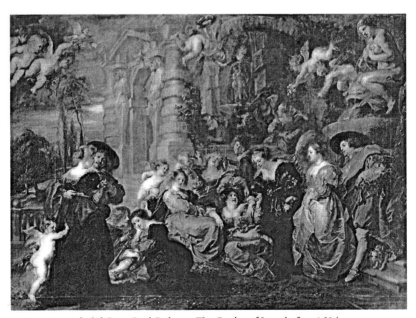

[#49] Peter Paul Rubens, *The Garden of Love*, before 1634

17 Eisenstadt, 130–39.
18 Ibid., 115–16, 146–48.
19 Ibid., 142.

neutical principle formulated by Kurt Badt,[20] as Annegret Glang-Süber-grüb has done in a recent dissertation, it becomes strikingly evident that Rubens depicts by sequential configuration of figures the *gradus amoris,* modified to a focus on schooling in love for marriage.

Rubens' *Garden of Love* is not just a brilliant genre painting deal-ing loosely with fashionable society and vaguely amorous activities. The initial couple (lower left) is not dancing; the hesitant woman, uncertain, is being pushed by a cupid toward some kind of love relationship. The next couple is seated together on the ground, which suggests resistance overcome, and the woman takes a meditative pose, as if almost persuaded by the man. Rubens gives each woman of the center group of three an appropriate cupid. The left one, whose cupid hides his arrow behind his back for later use, is the beautiful, sensitive, as yet unmoved *amor huma-nus;* the ecstatic one, whose cupid points upward, is *amor celestis;* and the matronly woman wearing a hat is *amor vulgaris,* who is encouraging the woman to her right—a twin of the woman in the initial couple—to stroke the hair of the boyish cupid lounging on her lap. The final couple (to the far right) is the initial couple again, wearing more festive clothes, now married and striding forward as assured, equal partners, arms paral-lel and legs in step. Rubens leads the eye on the right up the peacock's tail to the lifelike statue of milk-expressing Juno riding atop a water-fountain dolphin, putting a painterly compositional period to the statement that the painting is about initiation via marriage into motherly love.[21]

Rubens' painting is not descriptive of what happened at Marie de Medici's parties, nor even of what happened at Rubens' happy second marriage feast (which was probably the historical occasion for the paint-ing), and it is not descriptive of what ever happens, like the allegorical, mythological *Love Feast* of Pieter Pourbos a generation earlier. Rubens' *Garden of Love* (or better, *Schooling in Love)* represents concretely the very real stages and typical decisions that love presents to a man and especially to a woman. Rubens is too robust to maintain the hesitancy and irony of the traditional *topoi,* and he has enlarged and channeled their mean-

20 "Read painterly compositions beginning left-under, followed by middleground devel-opment, concluding at the upper right." Badt restricts this *general* principle, which he would base in the normal pattern of our ordinary perceptual experience, to interpre-tation of European painting that is broadly "representational"; he also excepts Man-nerist painting and Cézanne. See *Modell und Maler von Jan Vermeer: Probleme der Interpretation, eine Streitschrift gegen Hans Sedlmayr* (Cologne: DuMont Schauberg, 1961), 30–39.

21 For detailed analysis and argument see Annegret Glang-Sübergrüb, *P. P. Rubens: Der Liebesgarten* (Frankfurt a.M.: Peter Lang, 1975), 15–35.

ing toward the passion of marriage and motherhood—which one almost never finds in Watteau—but the balustrade to the left and the idyllic park behind it is a sure reminder of *locus amoenus:* we are confronted here with the "earthly paradise"[22] in which events crucial for the meaning of human life are faced, won, and lost. The alcove in the painting shows couples in various stages of amorous engagement near a fountain of the three graces, a kind of recessed antiphony to the main "suitor's Progress" scene. This vignette in the background is tied to the whole by the rough joker-musician figure and sileni pillars, which are indeed present, but which serve basically as spectators, outside the elegant proceedings.

The original Rubens painting was not generally accessible after 1666, but Watteau did come to know the version copied probably by Theodor van Thulden before 1640 (the "Waddesdon" version now in Dresden), since it was owned by the comtesse de Verrue who went to Paris around 1700 as mistress to the Duke of Savoy, and was a *dame de volupté* in the libertine "Académie" founded by the comte de Caylus, Watteau's close acquaintance. Watteau could hardly have avoided her salon once he returned from his visit to Valenciennes in 1710 and began to be thrust frequently into the circles of gallant society. In fact, the comtesse de Verrue owned several of Watteau's paintings.[23] Watteau's appreciative knowledge of this particular "Schooling in Love" painting is not in question. Critics have pointed out the similarity of Watteau's pushing cupid in *L'ille de Cythère* to the one at the left in the Rubens painting.[24] But more important than specific borrowing from Rubens and other masters is the fact that Watteau adopted the configurations and the statues, the fountains, and recessed alcoves that suggest both narration and the bittersweet irony peculiar to Gardens of Love unsaved by baroque marriage.

Direct observation of Watteau's paintings is the only way to test the thesis, and irony is never a totally visible phenomenon; but I shall argue the case with an exegesis particularly of certain statues in Watteau's paintings c. 1715-19.[25]

22 F. Saxi 's term for the "earthly paradise" is "a humanist dreamland." See *Lectures,* 2 vols. (London: Warburg Institute, 1957), 1:215–17, 2: plates 143–53.

23 Glang-Sübergrüb, 81, 93–94, 104; Eisenstadt, 147–48.

24 M. Levey, "The Real Theme of Watteau's Embarkation for Cythera," *Burlington Magazine* 103 (1961): 183, note 17.

25 I think the paintings show that Mario Praz, who writes in 1970 that Watteau is "the boudoir reduction of Rubens" (*Mnemosyne: The parallel between literature and the visual arts* [Princeton: Princeton University Press, 1970/1974], 146), grossly misstates, from a Renaissance and seventeenth-century bias, the proper similarities and differences between Rubens and Watteau, and misses the special, deep contribution

There is nothing unusual about the fact that painters use statuary as a visual gloss within a painting, either as a flattering way to fill out the curriculum vitae of their portrait subject or as a marginal *exemplum virtutis* showing knowledge and respect for antiquity (cf. Rubens, *Four Philosophers*).[26] The statues in Watteau's paintings are not on the whole real garden statuary, as they are, for example, in the work of Parisian Lancret, who uses them in paintings for decorative purposes.[27] The fact that Watteau's statues are either oddly juxtaposed, hand-me-down mythic characters like the sileni of the arabesques, or specially invented figures, always appearing (with an exception or two) on the emphatic, right-hand side of the paintings, is supportive evidence of their emblematic function and importance for Watteau. A.-P. de Mirimonde takes Watteau to be very traditional in this matter: "Les statues qu'il place dans ses parcs traduisent les sentiments et les pensées de ses personnages."[28]

Among his paintings prior to *Le Pèlerinage* Watteau has several that utilize the statue of a headstrong goat mounted, teased, and tussled with by two, three, or four children.[29] The goat stands above a large shell of

of Watteau.

26 Iconographic specialists have not normally analyzed the sculptures and paintings within paintings in periods postdating the heyday of *emblemata;* but current studies that give critical weight to the phenomenon—for example, Ronald Paulson on Hogarth and Zoffany in *Emblem and Expression: Meaning in English art of the eighteenth century* (Cambridge: Harvard University Press, 1975), 35–47, 138–58, and Theodore Reff on Degas (in a lecture at the Art Gallery of Ontario, Toronto, 22 January 1976)—demonstrate the expositional power of giving it careful attention. Dora Panofsky also illustrates the method very simply by comparing Watteau's light, satiric pendants on *Sculpture* and *Painting* in "Gilles or Pierrot? Iconographic Notes on Watteau," *Gazette des Beaux-Arts*, 39 (1952) 333–34.

27 A.-P. de Mirimonde, "Les Sujets musicaux chez Antoine Watteau," *Gazette des Beaux-Arts,* 58 (1961): 279; Martin P. Eidelberg, "Watteau, Lancret, and the Fountains of Oppenort," *Burlington Magazine* 110 (1968): 455.

28 A.-P. de Mirimonde, "Statues et emblèmes dans l'œuvre d'Antoine Watteau," *Revue de Louvre* 12:1 (1962): 12; see also Mirimonde, "Les Sujets musicaux chez Watteau," 258.

29 Ettore Camesasca repeats with Adhémar (*Watteau, sa vie, son œuvre,* 105) and others the judgment made by Goncourt that this particular statue of Watteau owes its conception to a sculpture produced by Jacques Sarrazin, *Enfants à la chèvre,* which was owned at that time by Crozat and placed in his garden at Montmorency (*Tout l'œuvre peint de Watteau* [Paris: Flammarion, 1968/1970], 108, 115). One can find the corresponding drawings in K. T. Parker and J. Mathey, *Antoine Watteau: Catalogue complet de son œuvre dessiné* (Paris: DeNobele, 1957), plates 333–34. However, Watteau is so free in his adaptation of the group (three children in *La Cascade,* two in *La Famille,* and four in *Récréation galante),* and he utilized the theme so early in *Pour garder l'honneur d'une belle* (c. 1706) that it is an open question whether the reference

overflowing water in a fountain piece held aloft by the intertwined tails of a school of dolphins [#50]. Fresh water cascades from the goat's mouth (*La Cascade*). A nonchalant gallant stage center with cane and buckled shoes declares his love to a pretty coquette while a friend in back of him

[#50] Antoine Watteau, *La Cascade*, c. 1715

gently plucks a guitar *con amore*, and a pair of confidantes waits and whispers in the shadows. She is in white and holds back, demurely, with averted face, one arm behind her back, the other hand thrust deeply into her cloak pocket. What is at her back hurrying near does not need to be put into words. In a much earlier piece that spoofs Pierrot as a reliable

to Sarrazin's work is artistically relevant.

chaperone of virtue (*Pour garder l'honneur d'une belle*), Watteau placed as a foil behind the engaging, elegant lady and her reclining suitor a huge vase with a suggestive frieze of a boyish cupid about to climb astride a goat held prone. In *La Cascade* the couple is still standing, and while the *factum* of the statue is implicit in the rhetorical stages of their "Progress," what needs decision now, before the pool-fountain so crucial to every *locus amoenus,* is whether to carry on the history or to retreat: that most decisive moment in the world or in the Garden Of Love, where men and women act out their parts. Hence there is in *La Cascade* that indefinable element of hovering poignance that is not present in the ordinary, convivial *fêtes galantes* scene.

"*L'Amour Mal Accompagné*" [#51] proves that Watteau intended the cherub-goat statue to be read, roughly, as fleshly love, for the frieze and statue in it have come alive to be the center action of the piece. The brutish goat is forced by the boys to dance to the lusty tune of bagpipes (played by a brawny ape), but the goat is recalcitrant, tumbling one cupid to the ground. A second naked ape festoons a bust honoring Pan, complete with goat bell around the neck. Madame Adhémar wrote off the disappearance of the painting behind this engraving as no loss, since

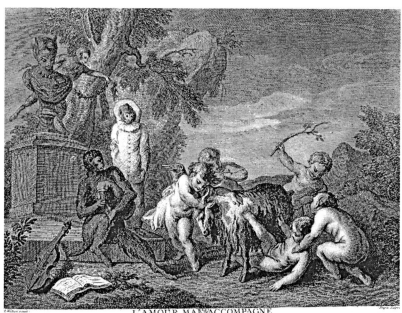

[#51] Antoine Watteau, *L'Amour Mal Accompagné*, c. 1715–16

-183-

it is a pastiche of Rubens and probably was commissioned by a person of vulgar taste.[30] However, it is crucial for understanding Watteau to notice the time-honored emblem in the lower left corner (which would be the right corner of the painting): music and the arts lie neglected in the presence of lascivious love. More significant still is the lone, clothed ape, a dummy of Pierrot, who stands stiffly in an embarrassed pose, tricked-out as an accomplice, but not participating in the vice or in the surrounding festivities. Pierrot's long-standing character as innocent dupe and his morose appearance here as dressed-up ape, though unheeded by the revelers, offer a veiled critique of the festival and hint at the painter's authorial presence as spectator.[31]

In the Berlin *Pilgrimage* cupids frolic over a shapely Venus statue rather than on top of a goat—two cupids are flesh and blood and one is stone. Almost the same Venus statue, without the extra cupids and footnote to Mars, stands in climactic position at the right side of *Plaisirs d'Amour* (Dresden), bathed in golden light [#52]; and the activities of the four couples in the foreground indicate that cupid has indeed done his work well. The couple lounging in the left-center is pausing in their

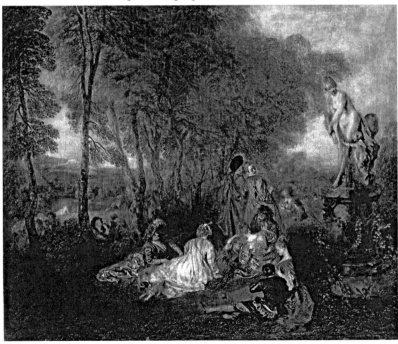

[#52] Antoine Watteau, *Plaisirs d'Amour*, c. 1717

30 Adhémar, 85.
31 See Dora Panofsky, 334.

dialogue; her lap dog looks off startled at the apparent, delicate *contact* imminent in the foremost, right couple; up behind them an attempted *kiss* and embrace is being fended off by the woman. (This very couple comprise a separate painting called *Le Faux Pas* [Louvre], and Watteau's exact use of colors—the woman's pale hand, pressed upward, and the man's reddened, thrust-downward hand—forcefully connote desire coming out in the open.) And the final couple, the top of the human triangle tilted toward the right, are looking back amused at these tentative moves of dalliance; they have passed that stage and are now resolutely walking off to the right, down the line of shortening trees, back behind the statue of Venus to enjoy the delights of love in *deed.* There is nothing melancholic in the painting at all: only a sturdy angle of movement from left to right, and the interconnected, advancing *gradus amoris* toward consummated love under the patronage of Venus, who ironically has to disarm her cupid lest things get totally out of hand.

Both the Berlin and the Louvre *Pilgrimage,* in contrast to the Dresden *Plaisirs d'Amour,* have an undulating S-line of couples rising gently over the foreground promontory that leads the eye from right to left. In both *Pilgrimages* the sense of movement is *away* from the statue at the right; the couples are leaving Venus behind. The fact that the Louvre *Pilgrimage* is more subdued, less explicit, does not reverse that point. That the pilgrims are leaving the delights of the Garden of Love—the island of Cythara is a prototype of *locus amoenus*—is supported in my reading[32] by noticing the pirouette effect Watteau achieves. These turning bodies give a sense of procession, and move from sweet intimacy on the right to a more social conviviality on the left. Watteau does not extend *gradus amoris* to marriage and motherhood as Rubens did in *Schooling in Love;* instead he presents in the *Pilgrimages,* with keen penetration, what could be called the *post amorem* phenomenon. After the rendezvous has become an assignation in the privacy behind the statue of Venus—which is *not* a "seduction" but simply the game of Eros—and union has been enjoyed, there are the *post amorem* steps of whispered tenderness, caresses becoming more polite, professions and expressions of enduring love, and finally a gentle goodbye.

The knowing smile on the face of the Venus term in the Louvre *Pilgrimage,* decked with roses and decorated with the leopard skin of Bac-

32 I follow Michael Levey's conclusive argument in "The Real Theme of Watteau's Embarkation for Cythera," 181–83. See also Edmund Hildebrandt, *Malerei und Plastik des Achtzehnten Jahrhunderts in Frankreich* (Wildpark-Potsdam: Athenaion, 1924), 108–9; Charles de Tolnay, "L'Embarquement pour Cythère de Watteau, au Louvre," *Gazette des Beaux-Arts* 45 (1955): 102.

chus and the sheathed arrows of cupids who are carrying *away* the torch
of love in the distant left, is as enigmatic as any of Watteau's sileni and
yet has the Olympian composure of having triumphed in what has taken
place, will take place, and always takes place in "the earthly paradise"
or "the humanist dreamland" under her sway.[33] Erotic Love teases her
pilgrims with fears of what can be gained and lost, even for the nonce,
before fulfillment, woos them on with intense, short-lived delights, and
lets them down afterwards, inevitably, with a mixed sadness, since love's
consummate pleasures unavoidably end. It is Watteau's genial innovation
here to paint such steps of the *post amorem* story still within the dimen-
sions of the Garden of Love *topos*, Cythara, and its spell.[34]

Watteau increases the thematic density in his Gardens of Love that
follow the *Pilgrimage* by increasing the contrapositive irony of the statues
and by adding an anonymous, black-caped gentleman whose self-assured
mien as spectator challenges the verity if not the reality of amorous in-
trigue. *Les Champs-Elysées* [#53] quotes in its fountain-statue an earlier
painting, *Nymph Surprised by a Satyr* [#54], probably composed by Wat-
teau when he first feasted on the Titian and Van Dyck archives of Crozat
c. 1715.[35] In *Les Champs-Elysées* the beautiful statue nymph, asleep on

33 Mirimonde, "Statues et emblèmes dans l'œuvre d'Antoine Watteau," 17.
34 The "coming or going" debate, which Claude Ferraton tried to renew fourteen years
 later (in "Watteau," *Galerie Jardin des Arts* 149 [July-August 1975], 81–91), could
 become a quibble to save face. Two of the less-noticeable couples in the Louvre *Pil-
 grimage* have poses, it seems to me, that ring truer to withdrawing from attachments
 rather than to making advances. The peasant girl clutches her upper-class gallant who
 leads the central group of figures in the middleground of the Louvre *Pilgrimage* with
 a familiarity that assumes intimacy already enjoyed (*l'amour* wipes out class distinc-
 tions), and is seeking assurances—"Was it all true?" And he, with a cavalier toss of
 his head, is coolly telling her, "Of course." The couple in brown near the boat—one
 notes that the middleclass lovers are the most prompt about return—strike a "farewell
 and be good" air even as he helps her aboard. The Berlin and Louvre versions are so
 similar in composition that once Ferraton agrees the one is a departure from Cythara,
 despite the additional elaboration in the Berlin piece (which is normal when an artist
 does something over again), it is hard to withhold the same judgment from the other.
35 For a long time its title was "Jupiter et Antiope"; however, because it lacks any em-
 blematic sign, e.g., an eagle, to indicate that the lustful voyeur is Zeus, the mytho-
 logical title is really overreading the painting. The vagaries of the title are a paradigm
 of how classical mythology was effaced to lower case and small print in the minds of
 eighteenth-century artists. Severe overpainting has made it difficult to determine the
 extent of Watteau's contribution. Camesasca, in the French edition of *Tout l'œuvre
 peint de Watteau* (1970), lists it as authentic (103); documentation in the English
 translation (no date) leaves its status uncertain (105). Donald Posner lists it among
 the oval paintings of Watteau but does not use it at all in discussing *La Toilette* (see *A
 Lady at her Toilet* [New York: Viking Press, 1973], 23).

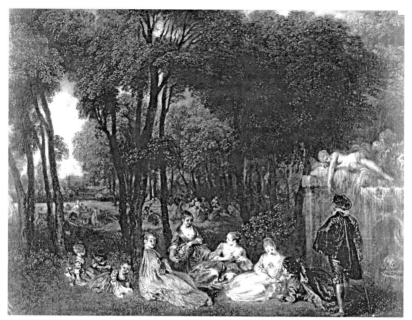

[#53] Antoine Watteau, *Les Champs-Elysées*, c. 1717

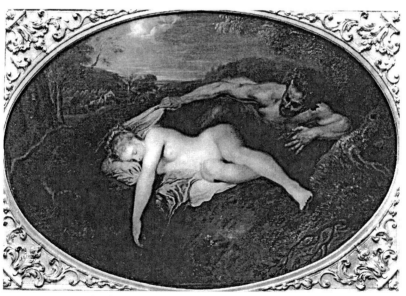

[#54] Antoine Watteau, *Nymphe et Satyr*, c. 1715

a bed of water, and the upright male figure in black cape and red hat underneath her, form the open apex of a triangle on its side that has as vertex the three innocent children, chaperones for the rather prim girls putting roses between their tightly laced breasts; meanwhile a gallant watches on his hands and knees nearby. The background shows a reverse triangle of loving couples in a hazy pastoral setting where sheaves of grain seem to wait to be harvested in the lazy autumnal glow. The girl in the left-center foreground gives the viewer an impertinent stare, avoiding the glance of the gentleman who stands near the fountain, imperiously holding his cane. In the fountain, where a dolphin swims elegantly below and where up above a satyr's head with concave shell as headdress gushes out water, the statuary nymph reinforces his sardonic smile. A quiet afternoon in the park is really a masquerade that hides one's secret desire to be a nymph asleep, waiting for a lover to take her by surprise.

So that there be no mistake about his meaning, as it were, Watteau does the painting again, much as the Berlin version redoes the Louvre *Pilgrimage*, making the point artistically more explicit. The canvas called "*Divertissernents Champêtres*" (c. 1718) [#55] uses the motifs of *Les Champs-Elysées* with much sharper sophistication. The saucy girl in the left-center foreground has become a gallant who plainly mocks the fastidious affectation of the women. The innocent children have detached themselves into a triangular emblem of tethering animal passion, pulling it back toward sociability. The couples in the back middleground have become a song-and-dance party, with music provided by fairly elderly

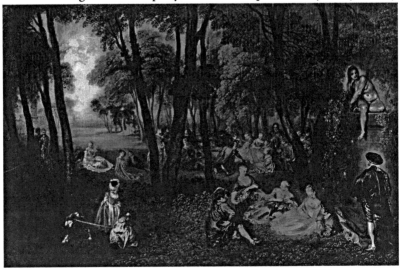

[#55] Antoine Watteau, *Divertissements chainpêtres*, c. 1718

gentlemen, and a few of the ladies, perhaps bored, peer out to the foreground for something new. The sardonic smile of the gentleman in black is the same, but the statue has shed any pretense of sleep and has become a voluptuous woman about to inject a little *commedia dell'arte* into the niceties of Garden of Love proceedings.

Watteau has also used this figure—which I call "Nude descending a plinth"—as a central statue in *Le Bosquet de Bacchus* and in the favored right-hand position of *Le Leçon d'Amour* where its core meaning has germinated (c. 1718) [#56; presents the engraving, which inverts the painting's right and left]. All oblique lines—the guitar, the arms of the maid plucking roses for her mistress's lap, the shoulders of the one being serenaded, and the arms of both the singer and her soldier gallant—all point to the statue for resolution. In contrast to the idyllic setting (castle and church in the wooded background, mill and water wheel and arched bridge) and the refined propriety of the serenade and the delicate hint of its efficacy (a few roses have already fallen at the feet of the lover), the statue exudes a chubby, fleshly vitality that lives by other rules. Her hair is loose and still wet from the swift ride on the dolphin at her side; one of her arms reaches around to scratch impatiently the sole of her foot, and

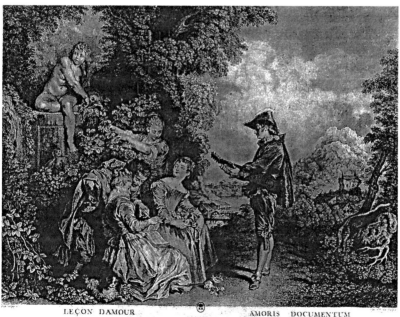

[#56] Antoine Watteau, *La Leçon d'Amour*, c. 1718

one bare leg is already over the edge. Why is this statue interrupting the *"Schooling in Love"*? The answer is tucked into the face of the plinth: a woman with flowing hair cups her ear to hear the music. It is the nymph Echo, who had that unhappy affair with Narcissus.

Watteau's "Nude descending a plinth" in *La Leçon d'Amour* and in *"Divertissements Champêtres,"* along with the mysterious black-caped stranger, suggests that the formalized lovemaking of Watteau's day is a charade, essentially narcissistic, of disguised and suppressed sensuality. It is not clear that Watteau means that the forthright, naked presence of the statuary woman might decisively alter affairs; but one may remember that the candle-holder ape dressed as Pierrot in *L'Amour Mal Accompagné* [#51] was critical of wanton love. And in several paintings of these years Watteau pursues the motif of the world-wise gentleman who strides around as spectator and outsider. In *Réunion en Plein Air* the black-caped spectator quite coarsely inspects a reclining nude statue from the rear position of the satyr. In the complex painting called, not inappropriately, *"Fêtes Vénitiennes"* c. 1718-19 [#57]—if one keeps in mind the interminable length of Venetian festivals, so that wearing a mask in eighteenth-century Venice became almost a way of life—Watteau probes the bitter truth that not all masks worn by men and women in public together are narrow bands of velvet across the eyes.

The painting is a brilliant kaleidoscope of pied colors and outrageous hues, all vying for attention but still melted together into a luxurious masterpiece and centering on the white prima donna. Her slight, doll's body is tensed for the opening step of the dance, and her eyes betray some apprehension as to what might happen to her, opposite this imposing, paunchy fellow got up in a costume of oriental pomposity. Already at her right elbow, on the side lines, a "faux pas" attack is being disdainfully repulsed. On her left is a peasant in short pants playing his genital bagpipes, as if in collusion with her partner. Directly over the woman in white, high up on a vase in the shadows, as in the early arabesques, is a horned ram's head. And behind her is our critic, fitted with a blue cloak for the occasion, explaining the scene to a rather shocked companion. His left-handed gesture toward the statue, if not intentionally obscene, is at least heavily sarcastic: "Here, my good woman, you have an honest mirror of what you see before you. The primping, strutting pair stage-center are really a couple of gamecocks in an arousal scene before mating. The truth of the matter, behind the facade of sweetness and light, ravishing modesty, endless fantasy and schooled elegance, is our full-breasted, reclining beauty here, odalisque-hipped, arm raised above her head in an

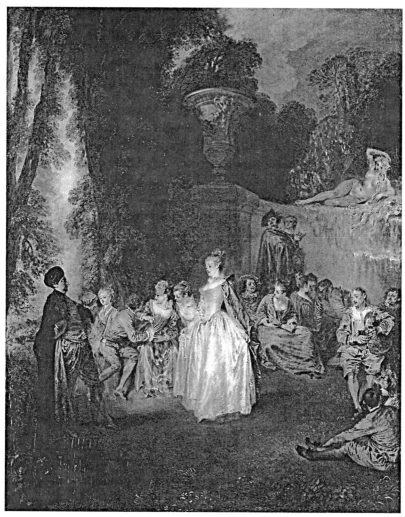

[#57] Antoine Watteau, *Fêtes Vénitiennes*, c. 1718

age-old artistic sign of seduction, about to sink out of sight on the back of a dolphin. That is the true reality, which, in our society, of course, is only statuary."

Watteau's statues have been considered "ambiguous" because they have never been taken seriously enough as integral to the meaning of the paintings. Somewhat in line with André Chastel's argument that painters from the fifteenth to the twentieth century have often used "*le tableau dans le tableau*" as a thetical anagram of their deepest held esthetic,[36] I

36 André Chastel, "Le tableau dans le tableau," in *Stil und Überlieferung in der Kunst*

believe I have shown that especially from c. 1715-19 Watteau's statues are indispensable for the correct reading of his paintings and highlight what sets him off from all the others who have made *"fêtes galantes"* a household word in eighteenth-century scholarship. Watteau's unsettling *tristesse* is due to the thematic-narrative structure and irony of the Garden of Love *topos* he makes his painterly own, and to the covert but deeply committed critique of the style of life and love around him, which is phenomenologically present in the telltale statues.[37]

I do not mean that Watteau moralizes, or that he is anecdotal.[38] But if one takes the garden concerts and reunion-of-musicians scenes prevalent in seventeenth-century Lowland paintings as the horizon of Watteau's iconography or takes the unconsummated love suspense in Watteau's paintings as the troubadour ideal updated, one cannot explain the statues or the genuine hurt expressed in the art of Watteau, except psychologically (e.g., Watteau was an irritable, caustic fellow, according to his rakish friends).[39] Watteau is *for* passionately consummated love, the

des Abendlandes: Akten des 21. *Internationalen Kongresses für Kunstgeschichte in Bonn* [1964], 3 vols. (Berlin: Mann, 1967), 1:16, 28–29.

37 Watteau's irony ends (beyond the scope of this article) in Gilles, the poor man's Pierrot, who coalesces the emblematic statue function and the role of the mysterious, critical stranger into one moving symbol of a tragic clown who is the foil, mirror, and butt of humankind, a displaced creature who cries for acceptance and warm human love, which society cruelly denies, even by the faint praise of applause. For hints of this interpretation see Erwin Panofsky, "Et in Arcadia Ego: On the conception of transience in Poussin and Watteau," in *Philosophy and History: The Ernst Cassirer festschrift,* ed. R. Klibansky and H. J. Paton (1936; New York: Harper & Row Torchbook, 1963), 247–52; Dora Panofsky, 325, 330–34, 335–40; Madelein Ochs, "Antoine Watteau: L'Instant qui s'éternise," *Jardin des Arts* 210 (May 1972): 34–39; Ronald Paulson, 103–4.

38 See Michael Levey in *Art and Architecture of the Eighteenth Century in France,* with Wend Graf Kalnein (Baltimore: Pelican History of Art, 1972), 19; Posner, 90.

39 René Huyghe and Hélène Adhémar tend to adopt the idyllic concert as frame of reference for Watteau. See Huyghe in a footnote of the original French edition of his incisive interpretation, "The Universe of Watteau," in Adhémar, 53, note 12. As a consequence, perhaps, Adhémar has a blind spot; she feels uncomfortable with the mature Watteau who "seems to be obsessed" by the beautiful figure of Antiope and was "seduced for a certain period, 1715—1721 by the nude" (Adhémar, 104, cf. 116–17). But that period covers the major part of Watteau's oeuvre and his best paintings! In the course of Mussia Eisenstadt's impressive detection of the traditions backgrounding Watteau's *topos,* she sometimes blurs the strands, which are indeed very interwoven (see *Watteaus Fêtes Galantes und ihre Ursprünge,* 129–32). Claude Ferraton proposes that the Venus term in the Louvre *Pilgrimage* represents "Platonic love" ("Watteau," 87). The psychologizing of Watteau's humor is widespread (e.g., Levey and Kalnein, 18); while true, it is not as such *artistically* illuminating. In fact, it may be used as a hermeneutical escape hatch.

factum as well as *visus* step toward the Rose. It is just that Watteau sees, from a fundamentally *commedia dell'arte* perspective, that every earthly paradise has its snake in the grass. Watteau paints as if every man and woman is willy-nilly implicated. He paints both the earthly paradise and the enigmatic, soft bite of the snake.

Watteau's knowing critique of what ruled and plagued polite society acquires historical strength and artistic subtlety from the fact that the painting no longer has pictorial referents that need to be or can be checked out in Cesare Ripa. Watteau illustrates particularly well one of the ways painting came to be of modern, secular age, where both the classical pagan frame of reference and the world picture of heaven and hell and God are lost to view. Many lesser painters in different European countries during the eighteenth century contributed to the loss of Renaissance and Baroque, metaphysically thick emblematics simply by the attrition of ignorance or by hollowing out older iconic rhetoric to stereotyped formulas, which made such dimensions less attractive and viable for serious young artists.[40] But Watteau effected iconographic change without revolution in France and with genuine promise.

Like many of his contemporaries, Watteau learned how the simplification demanded by decorative art freed a painter from the literary encrustations of the Academy. One could say it is a positive contribution of the rococo style in general that it encouraged painting to be just painting, and that the delicate hedonism that attended various rococo cultural manifestations relaxed the painterly task and laicized its universe of sight.[41] The superficiality that followed such secularization is well known. Watteau, however, unlike many of his contemporaries, did two things with his depoliticized, demythologizing, popularly accessible paintings: (1) he embedded what he painted in the matrix of *commedia dell'arte* crossed with the grand Garden of Love traditions; and (2) he used similar figures drawn from life, in similar pictorial contexts with subtle differences that evoked a kind of Proustian, half-remembered, imagined cohe-

40 See A.-P. de Mirimonde, "Plagiats et bévues en particulier dans l'iconographie musicale," *Bulletin de la Société de l'Histoire de l'Art Français* 1969 (1971): 184, for a particularly good example of how Jacques de Lojoue miscopied Veronese.

41 See Patrick Brady's careful exploration of Watteau's particularly "delicate neo-mannerist (or proto-rococo) hedonism," in "Rococo Painting: Some points of contention," *Studi Francesi* 16:47/48 (1972): 271–80. Brady also attempts a careful characterization of "rococo" so that the concept is applicable to both plastic art and literature, in "The Present State of Studies on the Rococo," *Comparative Literature* 27:1 (1975): 26–27.

sion.[42] That combination, spirited by a rococo lightheartedness, resulted in a reform of standard iconic practice, much like that which Paulson notes in Gainsborough.[43]

Watteau set in motion a reform of iconic practice that proffered a hitherto untried web of graphic reference. The "rose" in Watteau's paintings never stands for "the Beloved One," like a Petrarchan Laura. Watteau's "rose" is always a rose growing wild, cultivated, or picked to nestle between a young woman's breasts or to lie fallen at a lover's feet, *vaguely* emblematic, as A.-P. de Mirimonde has shown at length, of the promise, beauty, fragility, and brevity of voluptuous love. "Nude descending a plinth" does not have *concupiscentia naturalis* as dogmatic *analogon*; it is not just part of the landscape as decor: the living nude statue charges epiphorically the painted ladies, gallants, and stranger present with undertones of passion held back and latent, whose outcome is unsure. That is, while there is no lexicon of fixed equivalents for Watteau's amalgamation of traditional emblems and arabesques, chinoiserie and *commedia dell'arte,* because his art no longer uses classical Humanist or scholastic Christian horizons, his images and pictorial language do cohere intelligibly within a new, large cohering perspective on life, even if it cannot yet be delineated in categorical terms. The symbolic feature of Watteau's art is not "self-reflexive" in a nineteenth-century romantic, private-subjective sense and not in a twentieth-century idiosyncratic sense: his pristine, Enlightenment style works in ways comparable to the *commedia dell'arte,* which presents perennial types (amateur, rake, gracious lady, shyster, melancholic voyeur) but can absorb current issues, concrete hopes, and foibles.[44]

42 Denys Sutton, *Antoine Watteau "Les Charmes de la Vie"* (London: Percy Lund Humphries, 1950), 8–11.

43 Paulson, 224–31.

44 Cf. Benedetto Croce's analysis in "Pulcinella e le relazioni della commedia dell'arte con la commedia popolare romana" (1898), *Saggi sulla letteratura italiana del Seicento* (Ban: Gius. Laterza, 1962), 244–47. Jan Bialostocki has signaled the need in *Stil und Ikonographie: Studien zur Kunstwissenschaft* (Dresden: VEB Verlag der Kunst, 1966), for a history of iconography, as a doorway to "eine Kunstgeschichte als Geschichte der menschlichen Vorstellungswelt," which would let us finally ask the right kind of questions on "whether changes in the Way-of presentation, which fashions one's images, corresponds with the changes that take place in the area of media and technique" (156). Paulson's 1975 study, *Emblem and Expression: Meaning in English art of the eighteenth century,* tackles that very problem most perceptively. Theorists will need to take care, however, not to accept the newer and later iconographic system of any given age as more "empirical" and "visual" next to the older as a more "literate" and "conventional" style. The "return to Nature" of each age, Robert de la Sizeranne has pointed out, is the call to break out of iconic canons formulated by previous generations that

It is this kind of iconographic change Watteau initiated in French painting to move it on to modern secular art. His *Oeuvre gravée*—a genuine emblem book of the Enlightenment, often fitted out with verses and even Latin titles—came to be familiar to all kinds of artists and connoisseurs, who more often than not adopted his manner rather than his meaning; and this only accelerated the process of emblematic change and reduction. Ironically, that fact may be an important reason why viewers and interpreters today have largely missed the key to the critical meaning of Watteau's paintings given us by the telltale statues.

have become scholastic (*French Art from Watteau to Prudhon,* ed. J. J. Foster [London: Dickinsons, 1905], 7). But Watteau, Hogarth, and Gainsborough's demythologizing reforms also became "conventional" formulas that needed to be posited afresh. The (modern) attempt to excise the iconic dimension from painting altogether suffers from the historical thinness that sticks to anarchic tendencies (see Hans R. Rookmaaker, "The Changing Relation between Theme, Motive, and Style" (1964/68), in *Western Art and the Meanderings of a Culture: The complete works of Hans R. Rookmaaker* (Carlisle: Piquant, 2002), 148–49. A "natural" iconography in painting *semper reformanda est,* under the enduring order experienced by each generation of artists.

GOD'S ORDINANCE FOR ARTISTRY
AND HOGARTH'S "WANTON CHACE"

Although William Hogarth (1697–1764) is not a stellar artist in the pantheon of western art, Hogarth's artwork and theoretical aesthetic reflection and artist stance in society is more important in the history of artistry than most textbooks on art think.[1]

In bringing attention to Hogarth in this celebrative volume for John Vander Stelt who moves on now after thirty years of faithfully teaching philosophy and theology at Dordt College, I want to make that very point.[2] I respect the performance of tasks that deepen a sector of cultivating God's world, and I believe such deeds are worth noting and remembering. My wife and I are very thankful to John Vander Stelt for teaching a generation of college students, including our three children, that creatural life is a seamless whole of meaning and is a gift entrusted to us by the LORD which we are joyfully to give away enhanced to our neighbors in the name of Christ. Of such faithful service is built, under the Holy Spirit's guidance, the winsome Rule of Christ's body in history, also in the cornfields of Iowa.

Maybe Sietze Buning[3] will not be anthologized in the next Norton

1 For a general critical review of the main texts that have been used this generation in college "History of Art" courses—viz., Helen Gardner, *Art Through the Ages* (1926, 1986), H. W. Janson, *History of Art* (1962, 1969), E. H. Gombrich, *The Story of Art* (1963, 1995), and Frederick Hartt, *Art: A history of painting, sculpture, architecture* (1976), 2 vols—see Patricia Hills in *Artforum* 14:10 (1976): 58–61, and Bradford Collins in *Art Journal* 48:1 (1989): 90–94 and 48:2 (1989): 190–94.

2 Special thanks go to colleagues Adrienne Dengerink-Chaplin and Bob Sweetman for reading my writing and critically commenting on this study, to help protect me from misstatements.

3 Sietze Buning is the pen name of Stanley Wiersma, with whom I was a classmate at Calvin College, 1948–52. Wiersma loved to teach at Dordt College (1980–81), and around that time he wrote *Purpaleanie* (1978) and *Style and Class* (1982), which, not unlike Hogarth's penchant for English city lowlife, but with more love, celebrates

First published in *Marginal Resistance: Essays dedicated to John C. Vander Stelt*, ed. John H. Kok (Sioux Center: Dordt College Press, 2001), 311–336.

Anthology of Literature, but the angels in heaven probably read Sietze's verses in their off-hours with relish. And John Vander Stelt may not have been feted in a Philosophers Hall of Fame, but that is not important when the roll is called up yonder. The truth is: "the little ones" he served as professor and pastor were, through good times and hard times, presented with wisdom. Such a professional life is worthy of commemoration.

The thesis of this article is that Hogarth insightfully pointed to the ordinance God has laid down for artistry. William Hogarth's vision is not a particularly Christian one, although he was raised in a Dissenter family (Paulson 1971: I, 7–12, also 1989:1); but Hogarth endears himself to me because he poked in a popular artistic way at the injustice, ignorance, and authoritarian cruelty rampant in polite society around him in 1700s England, and also pried open the reductionistic conception of Beauty which for centuries had ruled western thought about artistry. That is, Hogarth's theoretical reflection and satirical engravings, though not of the artistic caliber, let's say, of painter Jacob van Ruisdael or Renaissance great Michelangelo, significantly deepened subsequent awareness of the reach of aesthetic activity and demonstrated how to connect the service of art as art to ordinary, nonaristocratic life.

The western legacy of ennobling Beauty

Ancient time: To situate ourselves in western civilization's story of being in love with Beauty, one could do worse than say Plato (427–347 BC) set the pattern. Philosopher Plato's writings say BEAUTY is a timeless paradigm of proportionality (*symmetria*). BEAUTY is a perfect, objective mental reality like triangularity or circularity, a pure form itself. For anything like a tree, boy, or girl to be beautiful, it needs to reflect the integrated unity and measure of BEAUTY. Harmonic music, dramatic poesy, crafted sculpture, said Plato, also are good only if they lead members of the ancient Greek polis to become a lover of beauty (*philokalos*), whose civic life then is structured by this rational Eros to be a subordinate part of a perfected, proportionate whole (*Philébos*, 64d9–65a6; *Symposium*, 201d1–212a7; *Res publica* 606d1–608b3).

Macedonian biologist-philosopher Aristotle (384–322 BC), in what we call the more cosmopolitan period of Hellenistic empires, analyzed the workings of Greek tragedy more than he reflected on beauty. But Aristotle's single comment on the quality of beauty emphasized Plato's

rural shenanigans with a reformed slant and a Dutch hangover in midwestern North American life.

mathematical slant and put beauty into a handy formula. "The beautiful consists of a certain sized order . . . whose unity and wholeness can be overseen" (*Poetica* 1450b34–1451a6). The plot unity in dramatic poetry, for example, Sophocles' *Oedipus Rex*, is what concerned Aristotle. Since then tragedy would build to its cathartic climax and ennoble the audience of spectators, giving them a god's-eye point-of-view to accept one's fated life (*Poetica* 1449b24–28 and 1451a36–38, 1451b5–11; and *Nichomachaean Ethica* 1177b16–1178a8).

Both Plato and Aristotle's reflections on beauty sifted into the philosophical theology of Thomas Aquinas (1225–74 AD). Aquinas defined Beauty as a formal splendor that pleases when seen. Aquinas believed Beauty to be as real and divine as an attribute of the Son of God, possessing a trinity of properties: integrality (*integritas*), consonance (*proportia sive consonantia*), and a shining glory (*claritas*) (*Summa theologica* I q.5 a.4 resp. ad 1, q. 39, a.8 resp.). And Aquinas's complex idea of simple Beauty became the dominant doctrine of Beauty in the western tradition, even though intellectuals and pace-setting artists of the Italian Renaissance were secularizing their philosophy and art-making for Florentine princes and the Vatican.

Modern time: Raffaello Sanzio (1483–1520) epitomizes perhaps the beauty coveted in painting by leading Humanists and the Roman Catholic Church in Italy during the 1500s. Raphael's portrayals of Madonna or the Holy Family, so long as Julius II was pope (1503–1513), are always perfectly balanced, calm compositions of red, gold, and blue, which quietly beautify the saintly figures with a beatic harmony. And Raphael's fresco, *School of Athens* (c.1511) for the pope's apartment rooms, where the figure of Plato points up to the sky while Aristotle's arm is stretched toward the earth, amid the illustrious gathering of ancient thinkers given features of Raphael's contemporaries, catches the allegorical adoration of antiquity which vied at the time with Renaissance secularity to extol Nature. Raphael's consummate beautiful artwork humanizes divinity and covers pagan learning with a sheen of grace.

French painter Nicolas Poussin (1594–1665), lionized in both Paris and Rome during his lifetime, deliberately canonized the kind of decorum and dignified beauty that resulted from smelting ancient Roman republican virtues with Jesuit Christian learning of the day. Whether Poussin painted a series of *Bacchanals* (commissioned by Cardinal Richelieu, 1631) or huge canvasses depicting the *Seven Sacraments* (for patron Chantelou, 1644–48), Poussin's style breathed the monumental seriousness of taking classical grandeur religiously. The beauty Poussin's paint-

erly artistry assumes ensconces whatever the topic be in an elevated realm of mythic reality (Badt 1969: I, 465–472). For Poussin the beautiful certifies that the truth of what is presented is noble and sure, everlasting, worthy of supernal felicity we mortals should aspire to join.

Jean Baptiste Colbert and later Charles LeBrun adopted Poussin's approach to painterly beauty as the teachable rule for the French *Académie royale de peinture et sculpture*. Since the French Academy had a monopolistic control *des beaux arts* in culturally powerful France, this doctrine of decorous Beauty Poussin's painting embodied, along with the philosophical underlay noted above—Beauty is a certain harmony of configuration that lifts one up to a position of honorable meaning, world without end—this theory and praxis of Beauty became the received artistic tradition on the continent in court circles, and was exported everywhere.

Hogarth's critical practice of picaresque artistry

As often happens when a certain norm is taken in absolute fashion, its moment of truth is perverted, and "Beauty" became a constrictive manacle around "fine art."

Cultural milieu: At least William Hogarth believed the English artistic establishment was courting subservience to a degenerate Franco-Italianate style of Beauty in the portraiture of his day. English aristocrats and the monied nobles who hung around with Sir Robert Walpole at the court of George II wanted their three-quarters or full-length "picture taken" by a visiting continental painter who would dress them up as a Muse or give them the fashionable trappings derived from the manner of Louis Rigaud (1669–1743, who portrayed Louis XIV in his ceremonial robes) or Nicolas de Largiliere (a most sought-after French court portraitist, 1656–1746, who painted James II at his coronation).

Joshua Reynolds later domesticated, anglicized this "elevated" *grande manière* of French style, for example, with *Lady Sarah Bunbury Sacrificing to the Graces* (1765) [#58]. Reynolds portrays the duke's daughter as a stately priestess offering incense on a rich urn outfitted with the gargoyle of a bronze serpent and a cascading floral arrangement before a marble statue of the three (nude) graces. It is a pose of adoring humanist culture and Greco-Roman classical learning that the landed gentry affected in order to accredit themselves as educated connoisseurs with breeding.

Such fabrication is pompous bunk, said Hogarth, in his *Self-portrait with Pug* (1745) [#59]. I choose my mongrel watch-dog as emblem of who I am, rather than pretend to French court foppery and the folderol

[#58] Joshua Reynolds, *Lady Sarah Sacrificing to the Graces*, 1763–1765

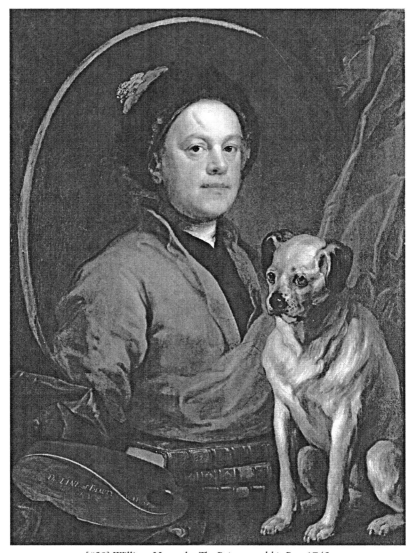

[#59] William Hogarth, *The Painter and his Pug*, 1745

of sacrifices at Delphi. The artist smiles out warily from an oval that acts both as a gentle mocking halo and a mirror, which rests on three books next to the tools of his trade, engraver's burin and palette. The books are volumes by Shakespeare (known for being true to nature), Milton (the grandeur of heaven and hell), and Swift (bitter satire)—Hogarth's favorite authors. English painters should not try to ape dead white Italians and Frenchmen but be true to our own no-nonsense "classical" English

sources, is Hogarth's painterly point.

Hogarth had tried to obtain commissions from the lords and ladies who went to Bath to have their portraits painted, but he could never quite crash the charmed circle. Hogarth did land assignments from the *nouveaux riches*, for example, Daniel Graham, appointed to be apothecary at the Chelsea Royal Hospital. Hogarth's group portrait of *The Graham Children* (1742) carries it off with a cheery flair; but the down-to-earth informality shown—the family cat peeking over the velvet chair at a bird in a cage behind the backs of the children—betrays Hogarth's roots from the other side of the tracks, a fact that could never be completely trusted with portrait intimacy by would-be noblemen and ladies.

Also, Hogarth firmly rejected the spirit of genuflecting before antiquity. The whole protocol of "history painting" set up as the highest form of painterly art in the French Royal Academy roster, a category in which a significant moment of mythical or humanist past would be commemorated, enshrined, struck Hogarth as sheer vanity. Art is not good because it memorializes what is dead and gone: living humans are important, and a good English beer, a scrappy effort to get ahead and better your lot in society. . . .

On this count Hogarth breathes the sunny-side-up enlightenment dynamic of a practical, populist, rising middle-class in England, filled with humanitarian industry and pugnacious ambition. Hogarth, like John Locke, trusted primarily our senses as a base for knowledge, not bookish learning. Hogarth had to live by his wits; so he really was more at home in engravings that dealt with current events than in paintings that aimed at glorifying sitters. As Addison and Steele's *Spectator* papers tried to raise the cultural level of people who could read, Hogarth's engravings used images to reach a merchant public that knew the underside of society, and he tried, tongue-in-cheek, to educate them.

The satire that filled Hogarth's engravings has a playful rationality to its moral bite, evenhandedly exposing both poor knaves and rich imposters as corrupt. In fact, there is a kind of street-wise rococo lightheartedness in the humor that encompasses his artwork. Like John Gay's *The Beggar's Opera* (1728) (of which Hogarth painted 6 versions, for the theatre building and for fashionable members of the audience) and like Henry Fielding's early burlesque comedies and 1740s novels (*Tom Jones*, 1748), Hogarth's artistic consciousness (until 1750) breathed a serious comic pursuit of life, liberty, and happiness.

Crafty approach: Hogarth's twist to John Bunyan's renowned *Pilgrim's Progress* (I, 1678) was to construct a number of paintings in se-

quence to be engraved as a series to tell the story of *A Harlot's Progress* (6 scenes, 1732) and also *A Rake's Progress* (8 scenes, 1735). Like Defoe's *Moll Flanders*, Hogarth's "progresses" implicate respectable society in the dissolution of "fallen women" and a middle-class youth who receives enough money to imitate an aristocrat's way of life. But Hogarth never uses the picaresque tradition to heroicize his rogues or to moralize their regress to a pauper's death and Bedlam. Hogarth's keenly observed details jar the viewer with an almost documentary, kilroy journalistic veracity.

The harlot's tantrum before her rich Jewish "keeper" (who has Italian-looking masterpieces on the walls of his rooms) spears both the "affairs" of high-class women as well as the violence of low life with exaggerated gestures, quirky jostling lines that hint at a frenetic unsettled life of constant agitation. A plethora of restless intersecting shapes and interesting goings on fill each stage of the rake's gradual descent and entrapment in his excess. Hogarth's artistic composition works like a puzzle where you have to enter into the rough-and-tumble scramble of the visual melee in order to grab bits of meanings which are more than amusement.

In the twelve-piece series on *Industry and Idleness* (1747) Hogarth makes explicit, as it were, the age-old tradition he was renewing, which made him eccentric to the reigning doctrine of decorous Beauty in the then art world of England. Hogarth's *Industry and Idleness* engravings tell the parallel stories of an industrious apprentice, Francis Goodchild, and a lazy apprentice, Tom Idle, who step by step progress to their appointed end. Francis manages a textile sweatshop well, marries the boss's daughter, becomes a judge, and finally the lord mayor of London. Tom carouses with ruffians, falls in with robbers and gamblers, and ends up being hanged at Tyburn gallows. Each print along the way has a Bible text below the scene as summing-up commentary on the vivid, multiple images in the separate scenes. That is precisely what emblem books from the 1500–1600s were all about: a visual representation of something worth knowing, plus a motto or written verse explaining its significance. The Dutch Jakob Cats (1577–1660) adopted emblems as a form of illustrated catechism to impress younger people or illiterates with certain truths. Also at that time Jan and Kasper Luyken used the same format to dignify the ordinary trades people plied, for example, the butcher, the baker, and fisherman as God-honoring activities.

Hogarth adopts the emblematic tradition from the picaresque vantage point, and therefore one must beware of taking everything at face value. Hogarth ironically deconstructs the stereotypical "morality play" conclusion readers of pious tracts might expect from the series. Tom Idle

is learning to read on the way to the gallows [#60] as a Methodist minister points dramatically to the judgment coming from the open heavens. But the unruly crowd has not learned from the Proverbs 1:27–28 text, that godlessness reaps the whirlwind: the hanging is a holiday! the woman offside in the foreground is hawking a probably fabricated "The

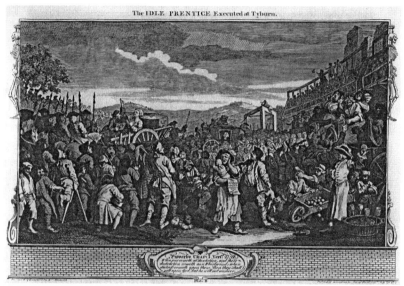

[#60] William Hogarth, *Idle Apprentice Executed at Tyburn*,
plate 11 in *Industry and Idleness*, 1747

last dying speech and confession of Tom Idle" to make a few pennies on the deal; a boy in the front far-right corner is pickpocketing his master, starting the cycle of Idleness all over again; and Francis Goodchild who as judge condemned Tom without mercy to death is helplessly stymied all by himself inside the box of his carriage in the mid-ground sea of humanity, ignored by everyone—he also is not a free man!

But Hogarth's outdoor crowd carries on with Rabelaisian gusto. The mob itself is a spectacle of gross, indulgent humanity, indifferent to the misery in which it is mired—this! is a "history painting," hints Hogarth, and not the *Rape of the Sabines* (Poussin, c. 1635) or a staged, fake dying scene of some English general killed by Indians (cf. Benjamin West later, *The Death of Wolfe*, 1771). I show the genuine history, says Hogarth, where the fabric of society is a bumptious, rough-and-tumble clobbering tussle to fill your belly and get ahead, and may the devil take the hindmost. That's real life. Yet Hogarth pictures this picaresque worldview with a graphic excess that holds one fascinated, prone to laugh at our

unwitting stupidities, to smile at the energy gratuitously expended, and to take it all with a grain of salt in good humor. Hogarth aims to show us life is an ups-and-downs struggle for survival, but presents it teasingly, like a jester telling the truth.[4]

Historical contribution to art-making: As eccentric, picaresque enlightenment artist Hogarth took several firm steps that were historically significant for artistry.

(1) Hogarth's engravings made art fun for a large public of uneducated people. Hogarth showed up the stuffiness of continental "history paintings" and traditional Beauty beloved by an affected connoisseur elite. Hogarth's "regresses" practiced a secular version of the medieval *biblia pauporum* (Bible for the poor), and were popular comic strip art with the hardy grit of a shop sign character for the local pub mixed with a Grub Street editorial cartoon. Robert Walpole, Lord Burlington, and the patron establishment would not deign to consider Hogarth's artistry worth their pricey attention, the way certain critics today might dismiss it as "anecdotal." But Hogarth was connecting art to ordinary people in their places of work, much as the Dutch artists of the 1600s had marketed their artworks to middle-class people.

(2) Hogarth helped graphic artists become professionals in England, to earn their livelihood by their artistry. To protect his art engravings from being pirated by unscrupulous print-sellers who sold unauthorized (often poorly executed) copies for a fraction of the just price, Hogarth petitioned the English parliament to extend the literary copyright act of 1709 to cover the graphic design invented by artists. "Hogarth's law" became law and received royal assent in 1735 and protected graphic print property for fourteen years. After 1735 Hogarth even advertised! his artworks in the press.

> In 1735 Hogarth also re-started a (private) drawing academy his father-in-law Sir James Thornhill had once led, in St. Martin's Lane, to which inexperienced and seasoned artists were welcome to come draw without fees. This free Academy was more like an informal guild where one could upgrade one's training in a community of artists and make connections for placing artwork in hospitals and public buildings, as Hogarth did; that is, the Academy at St. Martin's Lane was an opening for artists to become independent of aristocratic patronage stuck in its solemn Beauty. The Academy in St. Martin's Lane was run ostensibly along democratic

4 Cf. a good art historical remark by Frédéric Ogée in "'And Universal Darkness buries All,' Hogarth et l'excès," in *Image et Société dans l'oeuvre graphique de William Hogarth*: "Et c'est peut-être dans ces scènes de foule désordonnée que l'esthétique de Hogarth se rapproche le plus de ce que l'on appelle aussi le rococo" (67).

lines, and was Hogarth's alternative to the hierarchical French Academy model. Later on, however, through dissension, political maneuverings, and Sir Joshua Reynolds' authority, a more centralized Royal Academy came into existence (1769), after Hogarth died.

But Hogarth was not too proud to credit his and others' artistry as work, a trade, an honorable task in society that deserves to be paid for so an artist can put bread and wine on the table. Art for Hogarth is not a frill on the garment of life.

(3) Hogarth challenged the received tradition of literate, well-proportioned, harmonious Beauty as the norm for art. Hogarth's most characteristic art never has a centered focus and lovely balance, but is rambunctious with physio-organic energy, as if moving vitality is the norm for genuine artistry. Hogarth's vivid observational ability and surplus of detail in the engraved artwork has the edge of reporting empirical reality intensified rather than prettified. Hogarth's art asks the viewer to squint at the artwork rather than stare, to look for nuances hid in the margins of the piece, as if art is meant to be oblique, playful, ambiguous, puzzling, witty, celebrative, rather than merely contemplatively beautiful.

Hogarth's rococo *Analysis of Beauty* (1753)

Hogarth preached theoretically what he practiced artistically. His *Analysis of Beauty* (1753) I consider to be a major (and largely neglected) text in the history of aesthetic theory, which formulates succinctly the rococo aesthetics straining for expression among English thinkers like Shaftesbury, Hutcheson, and Hume, who were still theorizing under the ancient sway of traditional beauty theory.

Theoretical setting: In 1700s England Beauty as supermundane reality or objective quality has become thoroughly subjectivized. Beauty is now a human activity: your "inward eye distinguishes the fair and shapely" (Shaftesbury 1709: II, 137); educated humans with good taste have an "internal sense" which "is a passive power of receiving ideas [*cs:* =sensations] of beauty from all objects in which there is uniformity amidst variety" (Hutcheson 1725: 34–9, 80). Hume is very clear: ". . . the beauty, properly speaking, lies not in the poem, but in the sentiment or taste of the reader" (Hume 1742: 125).[5]

That is, beauty is a sentiment of decorous refinement that is natural to those who have been bred to live a polite, leisurely existence. The beautiful is not just an artistic affair, but is a moral matter too; the beautiful and the decent go together. "I call beauty a social quality" where you have

5 Stanley Fish was not so original with his article, "Is there a text in this class?"

tenderness and affection for company (Edmund Burke 1757: 42–3). Their concern for beauty became a general interest in humane behavior and the capability to appreciate the beautiful in Nature. The old doctrine of Beauty as a reasoned harmonious proportionality has metamorphosed mostly into the creed of good-beautiful propriety.

The German Alexander Gottlieb Baumgarten (1711–1762), a contemporary of Hogarth, is still scholastically busy parsing together the centuries old theology of Beauty with an empiricist stance on sensation in trying to approximate, with important results, what it could mean to "think beautifully" (*ars pulchre cogitandi*) (Baumgarten 1750:1). Hogarth's English contemporaries aim their philosophical "essays" and "enquiries" toward the very same Baumgarten point of defining "sensitive knowing," but do it with a more genteel urbanity. The very bantering way Shaftesbury and Hume do their philosophy, its manner, as well as the conceptual results, breathe what I call the ludic rationalism of what has come to be called a "rococo" culture. Usually "rococo" is historically confined to the French gallant fashion at the time of Louis XV (1715–1774), but the lighthearted spirit of theoretical reflection in England at this time has the same rococo feel of meandering discursivity.

Subversive text: This means that Hogarth's *Analysis of Beauty* did not just drop out of heaven unexpectedly, but fits his times extremely well. The chapters of *Analysis of Beauty*, after the preface and introduction, are not organized for a rigorous, systematic deductive argument, but stroll along with varied observations the way one would follow an informal English garden developed by William Kent or "Capability Brown" in those days. Instead of any French geometric patterns, in an English landscaped garden you moved from one picturesque scene to the next vista, past an hermitage, through a grotto, in a rolling serpentine line that denied your eye or mind logical closure. Such an ongoing "progress" of surprises embodies a rococo dynamic.

Yet Hogarth's rococo treatise[6] consistently rejects the Whiggish gentleman and Toryish lady idea of beauty as decorum with emphasis on measured uniformity held by the polite Shaftesbury, Hutcheson, and Hume. From Hogarth's picaresque corner the beautiful is not going to be a decent symmetry, but rather something indecent, whatever "leads the eye a wanton chace" (25).[7] And Hogarth develops his thesis on a norma-

6 Cf. Joseph Burke's remark in *William Hogarth: The Analysis of Beauty, with the rejected passages from the manuscript drafts and autobiographical notes*: "...the Analysis is, in part, a sustained and at times brilliant rationalization of observed rococo principles" (1943: xlvi–xlvii).

7 References to Hogarth's *Analysis of Beauty* will be mentioned in the text by referring to

tive, elegant taste for beauty and grace with puckish, subversive agility and tenacity. Beauty is a weasel-word, and Hogarth subtly redescribes the matter to make it quite unlike the traditional concept gone stale.

Hogarth bases his apologetic for "INFINITE VARIETY" first on Shakespeare who "speaking of Cleopatra's power over Anthony . . . says, 'Not custom stale / Her infinite variety'" (*Anthony and Cleopatra*, II, 2,141–42) (xvii), and then Hogarth uses Milton on the frontispiece of *Analysis of Beauty* [#61], where Milton in *Paradise Lost* portrays the Satan serpent:

So varied he, and of his tortuous train
Curl'd many a wanton wreath, in sight of Eve,
To lure her eye. (IX, 516–518)

THE

ANALYSIS

O F

B E A U T Y.

Written with a view of fixing the fluctuating I D E A S of
T A S T E.

BY *W I L L I A M H O G A R T H.*

So vary'd he, and of his tortuous train
Curl'd many a wanton wreath, in fight of Eve,
To lure her eye.------- Milton.

L O N D O N:
Printed by *J. R E E V E S* for the *A U T H O R,*
And Sold by him at his Houfe in LEICESTER-FIELDS.

MDCCLIII.

[#61] William Hogarth, frontispiece to *The Analysis of Beauty*, 1753

the page number in the facsimile edition of London's Scolar Press (1969/1974, edited by Richard Woodfield).

Hogarth mischievously uses the most "classic" English authorities to give notes of sensuous allurement and indiscreet entanglement to his idea of graceful beauty.

Hogarth is also not above foraging in "antiquity"—challenging connoisseurs with their own pedantic tactics—for evidence that his proposal for "the serpentine line" is sound. Post-renaissance theorist Giovanni Paolo Lomazzo (1538–1600), says Hogarth, reports Michelangelo said that painters "should alwaies make a figure Pyramidall, Serpentlike. . . . For the greatest grace and life that a picture can have is, that it express Motion" (v–vi). (Notice that Hogarth puts the pyramid with an inscribed serpent shape on the title page of *The Analysis of Beauty*.) Hogarth quotes this authority tongue-in-cheek, because later he easily corrects Lomazzo (and Albrecht Dürer) for wanting graphic art to obey the mathematical laws of musical harmony (76). Hogarth selects and slants the evidence he wants to cite, as he affects a show of learning in expositing "the first [ancient Greek] fundamental law in nature with regard to beauty" (xii), namely FITNESS.

From the start Hogarth always insinuates his own twist into the usual terminology he employs: not artists who visit Rome to study only art, but ordinary people who "*see* with our own *eyes*" and "learn to *see* [*cs*: natural] objects *truly*" (2–5) [my emphasis] can freshly determine which fluctuating taste is well grounded. Hogarth trusts homely observation to set the standard for what is beautiful, he seems to say, not time-honored, dogmatic precepts.

But then he lists and exposits six principles, which most theorists of the day would also accredit: fitness, variety, uniformity, simplicity, intricacy and quantity—"all which co-operate" (12). Hogarth keeps hidden that certain of these principles are more equal than others. VARIETY is quietly positioned as the base for the pyramid and serpent-line on the frontispiece [#61]. When he exposits uniformity, regularity, or SYMMETRY, Hogarth slips in the note that uniformity is not "the chief cause of beauty" (as Hutcheson's dictum posits); although symmetrical regularity serves the idea of fitness, "the eye is always better pleased on the account of variety" (18–20).

The basic principle of "Simplicity, or Distinctness" is also downgraded to being a complementary factor to variety, to prevent perplexity. "Nature in all her works of fancy . . . most frequently employs the odd" rather than the simple (21–23), comments Hogarth. The oval (of egg and pineapple) is so much more elegant than a simple circle, as a triangle has more grace than a square, and a pyramid more than a cube (25).

"Fitness, or propriety," as Hogarth phrases it, traditionally has meant

decorum, what is appropriate, a socio-ethical *"bienséance* or a congruent disposition of ideas" [*cs*: impressions] which are right for the mores or a moral context (34). But Hogarth actually conceives fitness as a quasi-technical matter of being well "adapted . . . to the uses they are designed for" (14), and holds up Nature as the paragon model of such fitness (72). The "apparent *disproportions"* of the ancient (Glicon's) *Hercules* statue (fig. 3 in #62), where the lower parts are less in size than the huge torso, are in Hogarth's eyes, *fitting* (15–16), because the serpentine lines are organic. The beauty of the human body, of shells and flowers, depends on *il poco piu*, the graduated little bit more (and less) that is eminently natural, and not subject to rules or mathematical measurements (46, 62, 67, 75–76, 79).

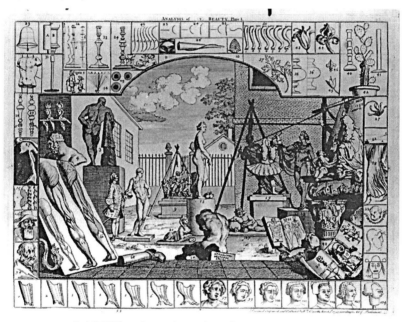

[#62] William Hogarth, *Analysis of Beauty*, plate 1, 1753

Hogarth actually converts the standard fitness of precise proportions into a sliding scale of "composed variety" (17) "designed" by Nature, and whose beauty is best seen by "a good eye . . . the familiar path of common observation . . . our usual feeling, or joint-sensation, of figure and motion" (78–79). Hogarth also calls this "joint-sensation" which appraises such a moving figure "imagination" (84), and then focuses his position for readers by dwelling on "the waving serpentine lines" together with the principle of intricacy.

Intricacy in form, therefore, I shall define to be that peculiarity in the lines, which compose it, that *leads the eye a wanton kind of chace*, and from the pleasure that gives the mind, intitles it to the name of beautiful: and it may be justly said, that the cause of the idea of grace more immediately resides in this principle, than in the other five, except variety; which indeed includes this, and all the others. [Hogarth's italics] (25)

So intricacy and variety are the most determinative principles of beauty and grace for Hogarth, because "pursuing is the business of our lives" (24), and the elegant serpentine line around a cone (cf. fig. 26 in #62) which is constantly changing in its gentle twisting and pleasing turns, like a flowing wave, hiding and revealing itself, epitomizes for Hogarth, "within the bounds of fitness," what is gracious and tasteful, natural (39–43, 50, 58, 64). For example, the lovely curve of Antinous's body (20, 81) shows how comically rigid is the current-day dancing master's posed body of vertical, artificial stiffness (fig. 6 and 7 in #62).

It is important to note that Hogarth sees a line in 3-D as the rib of a solid and not just as an outline scratched on paper (9), because then he has the wherewithal to read natural lines as an index of attitudes and character and see them as purely ornamental (125–30, 135, 141). This is Hogarth's way of grounding his "infinite variety" of beauty by claiming that the intricate line of beauty is both a myriad natural form (fitting) and ornamental (merely entertaining the eye with pleasure) (16, 45). Hogarth's beauty is both rococo and picaresque: elegant but not precious, pleasant but full of unexpected (if not rude) surprises.

His discussion of the principle of QUANTITY abounds with examples, from elephants and whales, the facade of the Louvre in Paris, centaurs and monsters, to bones and asparagus going to seed, which show, he says, that the incongruity of impressions given off by things which make us viewers laugh (29–33, 55) also have a mix of dancing and plain lines worth seeing and appreciating. Chase down the lines and colors and shadows of matters (128–130) indiscriminately, from the sublime to the ridiculous, because

This love of pursuit, merely as pursuit, is implanted in our natures, and designed, no doubt, for necessary and useful purposes. . . . Every arising difficulty, that for a while attends and interrupts the pursuit, gives a sort of spring to the mind, enhances the pleasure, and makes what would else be toil and labor, become sport and recreation. (24)

Systematic contribution in recognizing an order of intricate variety: Hogarth's conception of the beautiful, graceful serpentine line has a large, free-wheeling, cosmic comprehensiveness to it and is not at all restricted

to "fine art" matters. His penchant for the "wanton chace" of obliquity (101) demonstrates a wide-open taste that gave the lie to the tradition that beauty must be a regular harmony, conservative, proper, staid. Hogarth's theses allow him to have his beautiful cake and to eat it too. That is why, in my judgment, Hogarth's *Analysis of Beauty* is historically significant in its whimsical analysis toward developing aesthetic theory along more normative lines.

(1) Hogarth's *Analysis of Beauty* breaks open the constrictive hold of Beauty as a Raffaelan (mathematical) harmony with a *je ne sais quoi* perk, which emphasized the unity in the variety, the balanced wholeness to the different parts, so that beauty became an academic doctrine of reasonable proportion and composure that uplifted affluent people. Hogarth erases the moral tone to beauty but affirms its natural normative spell and, without saying it in so many words, accepts playful, comic, fantastic, ironic, and strange matters into the conceptual neighborhood of the beautiful and graceful. When the inelegant is given relevance for analysis of beauty, the field of investigation for tasteful life and making fine art has been greatly opened up. The picturesque, the odd, the sublime, the humorous then are not trivial deviations from the beautiful but can be understood as deepening analogues of such imaginative reality. Hogarth in his rococo spirited picaresque approach saw this, and to the dismay of most establishedment artists in England propagated the ideas.

(2) Without yet naming this realm of (fluctuating) taste as an "aesthetic" zone of life, Hogarth was fingering precisely this imaginative realm of reality, which I would characterize as the irreducible facet of objectifiable world and subjective human life whose nature is characterized by playful nuancefulness and allusivity. With his "principles" Hogarth recognizes that intricate variety with flexible fitting bounds constitutes what is tasteful, beautiful, graceful, elegant. Whether it be human deportment, handwriting, a figure of dancing, the shape of a seashell, or an Arabian warhorse (55, 72–73, 139–141, 176–177), a composed intricate variety of (serpentine) lines is the natural order things follow in so far as they meet the norm-without-logical-rules for what is tasteful.

As subjectivist thinker Hogarth does not recognize that such a discoverable order is a specific gracious ordinance set by the redemptive creator God. Hogarth believed "the natural persuasion of the [human] eye . . . begets these principles" (45). But Hogarth was pointing to an aesthetic ordinance holding for nonhuman creatures, for human life, and for making art, that was closer to the crux of its nature than the received tradition of harmonious "beauty."

The philosophical reflection that followed Hogarth's lead footnoted his work as they explored other dimensions of beauty and taste. Edmund Burke (1729–97) approved of "the very ingenious Mr. Hogarth," in the second edition of his *A Philosophical Enquiry into the Origin of Our Ideas of the Sublime and Beautiful* (1759), "whose idea of the line of beauty I take in general to be extremely just" (115). Burke went on to praise the "judicious obscurity of Milton" and to champion the sublime as legitimate, even though "the sublime is contrary to the beautiful" (59, 157).

And when Kant (1724–1804), who mentions Hogarth's engravings in Kant's 1764 rococo lectures on *Beobachtungen über das Gefühl des Schönen and Erhabenen*, carefully incorporates an "Analytic of the sublime" into his systematic 1790 *Kritik der Urtheilskraft* (*Critique of* [taste and teleological] *Judgment-power*), and makes playfulness (*Zweckmässigkeit ohne Zweck*) the critical third moment in aesthetic judgment,[8] the old restrictive cast of untroubled "beautiful harmony" for designating the crux of differentiated aesthetic reality was finally broken in western theory.

Many backwater philosophers naturally ignored the break-through and kept repeating variations on the theme of theological Beauty. And romantic idealist philosophers like F. W. J. von Schelling idolized "Beauty," but Beauty became a wild and dangerous, different concept that knew no bounds (Seerveld, 1989). Hegel (1770–1831) went on to hamper exploration of aesthetic reality in normal life by reducing natural Beauty to an also-ran in the field of aesthetics; for Hegel artistic beauty is what truly counts.[9] Hegel's move substantially shunted the field of theoretical aesthetics away from "Beauty" into theory and critique of art, where it has largely stayed focused until recently.[10]

8 Cf. especially *Kritik der Urteilskraft*, par. 12, 14, 16. Kant comments on Edmund Burke's ideas in the General Remark following par. 29. Also, see Seerveld 1987:166.

9 Despite a brief chapter on *das Naturschöne,* Hegel's prejudice spoken at the beginning of the introduction determines what follows for two volumes: "Diese Vorlesungen sind der *Ästhetik* gewidmet; ihr Gegenstand ist das weite *Reich des Schönen,* und näher ist die *Kunst,* und zwar die *schöne Kunst* ihr Gebiet" (from the Heinrich Gustav Hothos 1842 edition, indexed by Friedrich Bassenge, published in Frankfurt am Main, Europäische Verlagsanstalt, 1965) 1:13. Translated by Bernard Bosanquet: "The present course of lectures deals with aesthetics. Their subject is the wide *realm of the beautiful,* and, more particularly, their province is *art*—we may restrict it, indeed, to *fine art*" (in G. W. F. Hegel, *On Art, Religion, Philosophy,* ed. J. Glenn Gray [New York: Harper Torchbook, 1970], 22).

10 Cf. Guy Sircello, "Monroe Beardsley and American Aesthetics," in *Text, Literature, and Aesthetics,* in honor of Monroe C. Beardsley, eds. L. Aagaard-Mogensen and L. De Vos (Amsterdam: Rodopi), 116–117. See Sircello's earlier, curious, and incon-

Concluding thoughts on
"historical development" in aesthetics and in artistry

Because William Hogarth was probing theoretically the lode of what God ordained for imaginative reality, and because Hogarth intently offered his artistry to a largely disenfranchised public in society, my judgment is that Hogarth's thinking and art-making should be commemorated historiographically for its modest significance in the historical development of philosophical aesthetics and the production of art in western civilization.

(1) *more or less normative:* By "historical development" I do not mean "betterment" on the model of evolutionary improvement. Hogarth's secularized limiting concept of "wanton chace" gets closer to the nub of the facet of subtlety God gave creatural reality and to human imaginative response to such nuances, in my judgment, than did the Christianized Greco-Roman speculative idea of "Beauty." Even though subjectivist thinker Hogarth had less sense of God-ordained reality providing norms than Plato, Thomas Aquinas, or Raphael did, Hogarth zeroes in on the crux of obliquity that gives artistry its specific glory and particular nature, and which is resident as an irreducible quality in all creatures (nonhuman creatures too).

Thinker Hogarth, perhaps because he was a bona fide artisan reflecting, brought together the bookish idea of transcendent Beauty and the intractable sensible reality of perceptive sensation an artist needs. That conjunction helped Hogarth approximate what he, like innovator Baumgarten, called a "joint-sensation," "imagination,"[11] an apperceptive faculty of the mind (79, 84, 107) that goes beyond the ordinary five senses recognized by John Locke to get external impressions and internal sensations into our black box ("dark room") of a mind.[12] This "joint-sensation" ferments a specific way of acting, being tasteful, getting at "the utmost beauty

clusive book *A New Theory of Beauty*, (Princeton University Press, 1975) as well as Mary Mothersill, *Beauty Restored*, Oxford, Clarendon Press, 1984. There have been attempts since 1979 by Allen Carlson and others to delineate some kind of "environmental aesthetics"; cf. "Nature, Aesthetic Appreciation, and Knowledge," *The Journal of Aesthetics and Art Criticism* 53:4 (1995): 393–400. See also Arnold Berleant, *The Aesthetics of Environment* (Philadelphia: Temple University Press, 1992).

11 Heinz Paetzold (1983:42–54) credits Baumgarten's struggle to find a metaphysical, ontological home for brute aesthetic sensation with bringing a *facultas fingendi* (an imagining faculty) to the fore, although it took Kant to give "aesthetic" judgment its own peculiar place in the roster of human ways of knowing.

12 Cf. John Locke, 1690, *An Essay Concerning Human Understanding*, Book II, chapt. 11, par. 17. Also see Hamish Robertson's 1997 linkage of this metaphor of Locke's empiricist rationalism with the rise of photography as an art, in *Photography, Science, Art* (Toronto: Institute for Christian Studies, M.Phil.F. thesis), 80–85.

of proportion" (81) and attended Hogarth's affirming "wanton chace," an on-going pleasing disorder as a (desacralized) natural order!

I make the judgment that Hogarth's thesis of "wanton chace" is more normative as a leading idea of God's ordinance for aesthetic quality and aesthetic activity than the standard "beautiful harmony" is, because I have, over the years, gradually firmed up an embattled position on the nature of an irreducible, intra-related mode of aesthetic reality in God's world whose ordering is not of a logical but of an imaginative order. I do not just float along and judge "historical development" on simple succession, bigger "influence," or novelty. The criterion for historical development in theory, for example, is whether the theoretical contribution made is more or less normative; and the change can be substantially good (Hogarth) or positively bad (to pick a figure, Winckelmann) for theoretical aesthetics.

My basic (Christian) philosophical orientation could be correct and my historiographic judgment could be mistaken, but at least I am self-critically aware and open about my criterion for historical judgment. There is no inexorable entelechaic historical fulfillment at work in history, nor a fixed Spenglerian cultural decline to an apocalyptic disaster. Historical development is an irrupted sequence of sound and wayward steps along the way of our concerted, fallible human attempts to respond, generation after generation, to the varied calls of the LORD with obedient or disobedient, interrelating or isolating, informed or uninformed cultivation of God's world (Seerveld, 1991). One's responsibility is to be fruitful rather than wasteful with the legacy one receives.

The thoughts of one generation become more normative than an earlier generation's conceptual results if the innovative theoretical work is more exact, more integrative, and promotes more redemptive fall-out[13] than what they inherited. For example, D. H. Th. Vollenhoven and Herman Dooyeweerd's theory of modal law-spheres seems to me to be a sound historical development of Abraham Kuyper's principle of institutional sphere sovereignty in society, because reformational philosophy (*Wijsbegeerte der Wetsidee*) excises Kuyper's mystical idealist hangover,[14] and extends Kuyper's guidance for societal interaction toward a professional, phenomenological philosophical theory that promotes the encyclopedic, interrelation of different speciated scientific discourses in an

13 "The guideline for historically normative decision and cultural action I should like to posit, which follows the contours of Dooyeweerd's 'differentiate, integrate, individualize,' is this: regenerate, speciate, diaconate" (Seerveld 1996:56). {See *CE*: 228.}
14 Vander Stelt (1973) signaled this matter. Cf. also Seerveld 1980, 121–5.

educational college or university (Seerveld 1985: 49–52).

As for my own historical development on the problem of "Beauty" in aesthetics: ever since I spoke out on "the curse of Beauty" (1962: 28–31), and proposed "allusivity" for the meaning nucleus of aesthetic reality,[15] I have tried and finally come to understand "beautiful" as a mathematical, the most elemental analogue within the aesthetic zone of God's creation. That explains why Beauty was conceived as mental and divine (numerical, spatial, and kinetic modes of existence are without entitary representatives), and why Beauty in time became so constrictive (because other more complex imaginative features had to be strained through its quantitative sieve or be found wanting).

But if "allusivity"/"nuancefulness"/"ludicity" is designated as the nuclear moment of God's fiat for the aesthetic side of creatures, one can account for the mysterious *nescio quid* usually thought to accompany beauty (because beautiful is a harmonic within ambiguity, and not a strict mathematical proportion with an unknown, pleasant surplus). At the same time one can credit all manner of imaginative features that rationalistic intellectual theorists have had trouble rhyming with an aesthetic order, such as the sublime, tragic, ugly, grotesque, comic, strange and playful matters (because they are all refined complications of ludicity). To grasp God's aesthetic hold on creatures as one of "allusive" meaning (rather than at core, "beautiful harmony") identifies, I think, more precisely, with greater aperture and a deeper enriched appreciation, the intricate aesthetic marvel God has gifted us. Critical study of Hogarth's oeuvre supports this systematic aesthetic thesis.

(2) *neighbor-friendly or not:* By "historical development" I do not mean "success" in dominating the ensuing cultural scene for better or worse. Hogarth's journalistic turn to the unwashed populace as viewing audience for his engraving artwork was a significant step in doing art for one's neighbor, even though Samuel Johnson and Joshua Reynolds with the neoclassical ruling Royal Academy carried the day artistically in England, tending to the educated well-to-do. Rococo art, although mostly confined to gentry and courtly circles, did have the practicalist Enlightenment bent for art to be flush with one's environs, integrated

15 Cf. Seerveld 1980:131–5 and 1984:44–9. There is an important note in *Rainbows for the Fallen World* (1980:132n12), where I signal the change in terminology made during the early 1970s—thanks to critique by A. Th. Kruijff, and after my 1972 inaugural, *A Turnabout in Aesthetics to Understanding* (Toronto, Institute for Christian Studies, 10–12)—on referring to the law holding for aesthetic reality as the "law of allusiveness" rather than the earlier formulation, "a law of coherence." Also, see Seerveld 1985:64–68.

into the societal decor of polite life. Hogarth's picaresque art tradition (Pieter Brueghel the Elder, Cervantes, Jan Steen, later Daumier, Charles Dickens, Jean-Francois Millet, Diego Rivera)[16] slanted his work probably toward the broader anti-establishment populace and aimed to communicate and build a community among them, excluding "the beautiful people." But Hogarth's art was popular, like Shakespeare, Rembrandt, Giotto;[17] that is, Hogarth's engravings had the layers of meaning which could attract the artistically uninitiated, serve those who knew a little about art, and could hold the attention of the art historically literate.

It is a mark of sound historical leadership, I think, in any field of endeavor, to regenerate one's neighbors with what one specially or professionally does. That is an act of love (cf. Romans 13:8–10). It is poor historical leadership to foster a clutch of disciples who are so enamored with what their leader has given, told, or trained them in, they remain immature dependent recipients. It is also anti-normative historical leadership to muzzle your neighbor, block them off from understanding areas of God's world, or mislead, for example, into a (Matthew Arnold) humanist idolatry those who trust your leadership. L'art pour l'art and much avant garde art, even when the artistry was powerfully crafted, has often given hateful aesthetic leadership, in my judgment, by forming fashionable cliques and trying to dumbfound the ignorant.

For me art at its best deserves to be popular, that is, beckoning one and all to deeper nuanced knowledge and imaginative enrichment—just the opposite of certain commercialized "pop art" busy dumbing down its multitude of listeners, programming their reactions with formulae, or fostering coteries of those hip to its clichés. The "academic" art of the little poetry magazines, publically correct art galleries in Soho, and obscurantic po-mo experiments, can be just as perverse. Sound artistic leadership will stretch the educated, feed them imaginative food with the songs, paintings, sermons, films, or radio programs produced, but always have an artistic hand ready to help the imaginatively handicapped walk, if not dance, and help those who are visually blind, give them the eyes to read images that disclose reality. Hogarth's offerings of "wanton chace," despite his faults and sour grapes, performed in his day, I think, such diaconal service.

Very important too was the fact that Hogarth's artistry and aesthetic

16 Cf. Suzanne Human (1999) for a detailed examination and exploration of this artistic typiconic format shaping artistry through the centuries.

17 We need to re-conceive "popular" art so it is not a pejorative term, but can be a mark of historical distinction, meaning art opened up to social concourse. Cf. chapter 4 in Romanowski (1996).

theory were thoroughly embedded in and fostered consciousness of actual nonartistic life matters that were peculiarly "beautiful" and "graceful." Hogarth's sharp eye for comparing the staple of wigs to the lion's mane, the attractive plainness of Quaker clothes, the ubiquitous serpentine line in human muscles! the curl of a lily, iris, or cactus, and observations like "How soon does a face that wants expression, grow insipid, tho' it be ever so pretty?" (31, 35–36, 44, 54): Hogarth breathed the push and pull of daily life in his theory as well as in his art. That's a solid reason why his artistry and theory were neighbor-friendly. No matter the underclass could not read his book, and that the literati and connoisseurs ignored his artistry and reflections. Hogarth's prints and *Analysis of Beauty* text provide an inoculation against esoteric aestheticism, and can remind artists, critics, and theorists even today of the full creatural watershed of daily life in which we all draw our cultural drinking water. That is a sound historical contribution.

William Hogarth's aesthetics and artistry were at the keyhole of aesthetic knowledge, even if he apparently lacked the key to open the aesthetic door wide as an offering to our Lord. Christians do not need to avoid probing disbelieving culture, which unwittingly often helps us unlock the doors of meaning God is waiting for Christ's body to discover in history.

We must beware of taking in Trojan horses, but we also must not run around with the skeleton key of Jesus Christ shouting "I've found it!" and not know where the key holes of creation are that need opening, entering, and cultivating for God and neighbor's sake. All human culture is grist for the redemptive mill. Unbelieving and disbelieving scholarship and artistry can challenge and confirm the communion of saints' humble attempts to giveaway the peace of God in history while knowing sin is a present surd reality we must contend with until the Lord returns. Being faithful in such an arduous historical task is what I understand was an abiding concern of John Vander Stelt in teaching philosophy and theology at Dordt College.

I once had an articulate unchristian student in my Philosophy 101 class at Trinity Christian College. At the end of the course, having done readings he never knew existed before, he said quite perceptively: "I see, Calvin was reforming Augustine; Kuyper was reforming John Calvin; Vollenhoven and Dooyeweerd were reforming Kuyper, and now you are trying to reform Dooyeweerd."

It's true, even the Derridean extravaganza on intertextuality that claims there are no virgin forests in philosophy. John Vander Stelt, as well

as myself and many other Christian professorial colleagues, I believe, will be grateful if our students of the coming generation reform our cultural work too and bring its conceptual offerings closer to the norm of our Lord's will, so that miscues will be refined into blessings. Laus Deo!

Works Cited

Antal, Frederick. *Hogarth and his Place in European Art* (London: Routledge and Kegan Paul, 1962).

Badt, Kurt. *Die Kunst des Nicolas Poussin* (Köln: M. DuMont Schauberg, 1969).

Baumgarten, Alexander G. *Aesthetica* [1750] (New York: Georg Olms, 1961).

Burke, Edmund. *A Philosophical Enquiry into the Origin of Our Ideas of the Sublime and Beautiful* [1757], ed. J. T. Bolton (London: University of Notre Dame Press, 1986).

Burke, Joseph. *Hogarth and Reynolds: A contrast in English art theory* (Oxford University Press, 1943).

Cats, Jacob. *Spiegel van den Ouden en Nieuwen Tyt, bestaande uyt Spreekwoorden, ontleent van de voorige en jegenwoordige Eeuwe, verlustiget door meenigte van Sinnebeelden, met Gedichten en Prenten daer op passende* [1618, 1632] (Amsterdam: Jacobus Konynenberg, 1722).

De Villiers-Human, E. Suzanne, 1991, "Hogarth's Vitality," *South African Journal for Art and Architectural History* 2:2 (1991): 42–49.

———. *The Picaresque Tradition: Feminism and ideology critique*, (Bloemfontein: University of the Free Orange State, Ph.D. Diss., 1999).

Hogarth, William *The Analysis of Beauty* [1753], ed. Richard Woodfield (London: Scolar Press, 1969).

———. *The Analysis of Beauty, with the rejected passages from the manuscript drafts and autobiographical notes*, ed. Joseph Burke (Oxford: Clarendon Press, 1955).

Hume, David. "The Sceptic" in *Of the Standard of Taste and other Essays* [1742], ed. John W. Lenz (New York: Bobbs-Merrill, 1965).

Hutcheson, Francis. *An Inquiry Concerning Beauty, Order, Harmony, Design* [1725], ed. Peter Kivy (The Hague: Martinus Nijhoff, 1973).

Kant, Immanuel. *"Beobachtungen über das Gefühl des Schönen und Erhabenen"* [1764], in *Gesammelte Schriften* (Berlin: Preussischen Akademie der Wissenschaften, 1900–1955), 2:214–215.

Lamb, Charles. "On the Genius and Character of Hogarth," in *The Works of Charles Lamb* (London: Edward Moxon, 1859), 540–549.

Luyken, Jan and Kasper. *Spiegel van het Menselyk Bedryf, vertoonende Honderd verscheiden Ambachten, konstig afgebeeld, en met Godlyke spreuken en Stichtelyke verzen verrykt* (Amsterdam: Jacobus van der Burgh, 1790).

Ogée, Frédéric, ed. *Image et Société dans l'oeuvre graphique de William Hogarth*, Actes du Colloque tenu à l'Université de Paris, X (Nanterre: Universite Paris, 1992).

———, ed. *The Dumb Show: Image and society in the works of William Hogarth*

(Oxford: Voltaire Foundation, 1997).

Paulson, Ronald. *Hogarth: His life, art, and times*, 2 vols. (Yale University Press, 1971).

——. *Emblem and Expression: Meaning in English art of the eighteenth century* (Harvard University Press, 1975).

——. *Popular and Polite Art in the Age of Hogarth and Fielding* (University of Notre Dame Press, 1979).

——. *Breaking and Remaking: Aesthetic practice in England, 1700–1820* (London: Rutgers University Press, 1989).

Paetzold, Heinz. *Ästhetik des deutschen Idealismus. Zur Idee ästhetischer Rationalität bei Baumgarten, Kant, Schelling, Hegel und Schopenhauer* (Wiesbaden: Franz Steiner Verlag, 1983).

Romanowski, William D. *Culture Wars: Religion and the role of entertainment in American life* (Downers Grove: InterVarsity Press, 1996).

Seerveld, Calvin. *A Christian Critique of Art and Literature* [1962–64], rev. ed. (Sioux Center: Dordt College Press, 1995).

——. "Early Kant and a Rococo Spirit: Setting for the *Critique of Judgment*," in *Philosophia Reformata* 43 (1978): 145–167. {See *CE*: 317–342.}

——. *Rainbows for the Fallen World* (Toronto: Toronto Tuppence Press, 1980/2005).

——. "A Way to go in the Problem of Defining 'aesthetic,'" in *Die Ästhetik, das tägliche Leben und die Künste*, Ausgewählte Vorträge, 8, Internationaler Kongress für Ästhetik, eds., Rudolf Lüthe, Stephan Nachtsheim, Gerd Wolandt (Bonn: Bouvier Verlag Herbert Grundmann, 1984).

——. "Dooyeweerd's Legacy for Aesthetics: Modal law theory" in *The Legacy of Herman Dooyeweerd: Reflections on critical philosophy in the Christian tradition*, ed. C.T. McIntire (New York: University Press of America, 1985). {See *NA*: 45–80}

——. "Idealistic Philosophy in Checkmate: Neoclassical and romantic artistic policy," in *Studies in Voltaire and Eighteenth Century* 263 (1989): 467–472 {supra pp. 131–136}.

——. "Footprints in the Snow," *Philosophia Reformata* 56:1 (1991): 1–34. {See *CE*: 235–276.}

——. "Dooyeweerd's idea of 'historical development,'" *Westminster Theological Journal* 58:1 (1996): 41–61. {See *CE*: 211–234.}

Shaftesbury, Anthony, Earl of. *The Moralists: A philosophical rhapsody* [1709], in *Characteristics of Men, Manners, Opinions, Times* [1711], ed. John M. Robertson (New York: Bobbs-Merrill, 1964).

Shesgreen, Sean. *Engravings by Hogarth* (New York: Dover, 1973).

Solkin, David H. *Painting for Money: The visual arts and the public sphere in eighteenth-century England* (New Haven: Yale University Press, 1993).

Vander Stelt, John. "Kuyper's Semi-mystical Conception," *Philosophia Reformata* 38 (1973): 178–190.

Uglow, Jenny. *Hogarth: A life and a world* (London: Faber and Faber, 1997).

Lambert Zuidervaart, Adrienne Dengerink-Chaplin, Calvin Seerveld,
speaking at a meeting of the Canadian Society for Aesthetics/Société
canadienne d'esthétique, at the Learned Societies of Canada,
University of Toronto, 2002 (photo by Hamish Robertson)

CANONIC ART: PREGNANT DILEMMAS IN THE THEORY AND PRACTICE OF ANTON RAPHAEL MENGS

The problem of canonic art recurs in history. Whenever artists and aesthetes assume leadership because they are dissatisfied with the state of artistry, are intent upon significantly changing a reigning style, or feel called upon to defend the status quo, such leaders in the artworld exercise certain preferences, lending their authority to their choices. The choices made by leading artists, theorists, critics, and even art patrons, have a way of assuring that the ensuing art is normative, a canon for subsequent art. The dilemmas concealed in the establishment of canonic art surface with special clarity and historical importance in the work of Anton Raphael Mengs (1728–79).

Mengs was a published art theorist to whom the renowned Winck-elmann dedicated *Geschichte der Kunst des Altertums* in 1764. Mengs was also a celebrated artist. In 1751 he was named principal painter at the Dresden court of Augustus III, King of Poland. In 1759 he was com-missioned in Rome by Cardinal Albani to do the crowning fresco of the *galleria nobile* of the whole villa complex that served as salon for papal entourages and for illustrious visitors from foreign lands. In 1763 Mengs was stated as Director of San Fernando to establish a Spanish national Academy of Art. He became the principal painter at the Madrid court of Charles III in 1766. Pupils tutored by Mengs and younger kindred spirits became directors of art academies and their curricula in Turin, Stuttgart, Dresden, Karlsruhe, Copenhagen, and Vienna.[1] Mengs was also a profes-sional art historian who both assisted and corrected Winckelmann, per-

1 See Nikolaus Pevsner. *Academies of Art Past and Present* (Cambridge: Cambridge University Press, 1940), 150–151.

First published in *Man and Nature / L'Homme et la Nature*, volume III of the Proceedings of the Canadian Society for Eighteenth Century Studies / La Société canadienne d'Étude du dix-huitième siécle, ed. Robert J. Merrett (Edmonton, 1984), 113–30.

haps even spoofed him, in the analysis of Greco-Roman art discoveries.[2] Mengs' method of art criticism supplied Goethe and Heinrich Meyer with what they needed to give their classicist Weimar *Kunstfreunde* direction.[3]

That is, Mengs practiced an uncommon range of artistic tasks, and had the freedom of position—especially as a gifted outsider asked to come into a cultural situation—to formulate his ideas about artistic excellence. Mengs was able to define a coherent praxis and policy for art. His tenets are worth analysis, especially if we recognize that the problem of giving leadership in painting is a matter of vital importance for the art-world of any day. Are there ways to posit artistic norms, canons for art, that will be neither dogmatic nor *laissez-faire*? Can the conception of canonic art be fruitful rather than abortive?

The six theses of Mengs' art theory

Gedanken über die Schönheit und über den Geschmack in der Malerei took shape during conversations with Winckelmann in Rome and was finally published in 1762 in Zürich by the father of Henry Füssli. The core

2 J. N. de Azara's generous comment "que todo lo que hay técnico en la Historia del Arte de Vinkelman es de su amigo Mengs," ("Noticias de la vida y obras de Don Antonio Rafael Mengs," in *Obras de D. Antonio Rafael Mengs*, Joseph Nicholas de Azara, ed. [Madrid: Imprenta Real de la Gazeta, 1790], xxxv) is based on Mengs' undisputable connoisseurship. See Mengs' letter to Fabroni (in *Opere*, Carlo Fea, ed. [Roma: Stamperia Paglarini, 1787], 357–68); Otto Harnack, "Raffael Mengs' Schriften und ihr Einfluss auf Lessing und Goethe" (1892) in *Essais und Studien zur Literaturgeschichte* (Braunschweig: Verlag von Friedrich Vieweg und Sohn, 1899), 200–201; and Herbert von Einem introduction to *Mengs, Briefe an Raimondo Ghelli und Anton Maron* (Göttingen: Vandenhoeck & Ruprecht, 1973), 20–21. Thomas Pelzel (in "Winckelmann, Mengs, and Casanova: A reappraisal of a famous eighteenth century forgery," *Art Bulletin* 34 [1972]: 300–13) might find support for his judgment on the apocryphal nature of Mengs' role in the incident of fooling Winckelmann in the fact that the original Spanish memoir by de Azara *lacks* the account of the incident that is given in the 1793 Italian Bassano edition on pages lxxxiv–lxxxix.

3 See Goethe's letter of March 1788 as he was reading the new 1878 Fea edition of Mengs' works: "Es ist in allem Sinne ein trefflich Buch . . . Auch seinen Fragmenten über die Schönheit, welche manchem so dunkel scheinen, habe ich glückliche Erleuchtungen zu danken" (in *Italienische Reise 1786–1788* [München: Hirmer Verlag, 1960], 507–08). Also, Goethe's letter of 17 September 1799 to Knebel: "Außerdem habe ich jetzt mit Meyern die Kunstgeschichte des gegenwärtigen Jahrhunderts vor. Erst bis auf Mengs und Winckelmann, dann die Epoche die sie machten, und welche Wendung nach ihnen die Sachen genommen habe" (*Briefe*, Mandelkow, ed. [Hamburg: Christian Wegner Verlag, 1964], 397. See Herbert von Einem, "Goethe und die bildende Kunst" [1949] in *Goethe-Studien* (München: Wilhelm Fink Verlag, 1972), 122–30.

doctrines of Mengs' theory are clear: (1) There is an invisible, absolute, divine Perfection in which each form of Nature participates, according to its specific, graduated destiny.[4] (2) Anything that visibly conforms to our idea of its telos is considered beautiful, because Beauty is visible Perfection (1:7–8, 10–12, 17, 21). (3) Since some things are more beautiful than other things, good taste is the rational selection of the most beautiful forms of Nature (1:26–30). (4) The art of painting, like poetry and music, can surpass Nature in Beauty, "meliorate the things in Nature," because the artist, like the bee extracting sweetness from many flowers to make its honey, can freely choose to imitate the most beautiful parts found here and there in Nature for composing the artwork (1:18–19, 30, 51).

In the important treatise of 1776 addressed to Don Antonio Ponz, secretary of the Royal Academy, San Fernando, Mengs takes a stand on matters then current that gives his theory of canonic art its cachet: (5) This painterly imitation of what is essential in the natural objects perceived—using design, chiaroscuro, and color—should be ideal, and will be "the more valuable as the idea conveyed will be perfect, distinct, and clear."[5] (6) Grecian artists have excelled in perfecting the over-all rendition of Beauty; but even the Greeks would be astonished at the admirable precision of expression in Raphael's design (*P* 52, 106), and although Correggio is not so great as Raphael in painting mental states, Correggio painted bodies in chiaroscuro so enchantingly he "completed" the art of painting, and "was the meridian of the art: from that point it always went declining" (3:53); and Titian is the master of true coloring. These three artists in their respective strengths are the touchstones for painterly art and the best taste (1:20, 37–38, 40, 78; *P* 44–45). By way of digression, it should be mentioned that Mengs elaborates in theory what he preaches for artistic praxis; it is unfair to brand his amalgam of ideas eclectic or muddled.[6]

4 (1:9, 13, 15). For convenience sake the complete English translation of *The Works of Anthony Raphael Mengs*, ed. J. N. de Azara, translator unknown (London: Faulder, 1976), is cited in the text by volume: pages.

5 This lengthy letter treatise to Ponz "sobre el merito de los Quadros mas singulares que se conservan en el Palacio Real de Madrid" (1776) will be cited in the text from the John Talbot Dillon English translation from the Spanish and published as *Sketches on the Art of Painting* (London: Baldwin, 1787) as (*P*, pages): (*P* 10–13).

6 Pelzel depreciates Mengs' "gospel of eclecticism" (*Anton Raphael Mengs and Neoclassicism: His art, his influence and his reputation* [Princeton University Ph.D. diss. Under R. Rosenblum, 1968], 117–19) out of a bias that shows itself later: ". . . in the final analysis, Mengs can only be considered, in both theory and practice, as having been eclectic and conservative rather than imaginative and revolutionary" (ibid. 348–49).

Certainly, Mengs' description of the five principal parts of painting in which "invention" and the "composition" subservient to it form the principles constituted by design, chiaroscuro, and coloring (*P* 36–43, 98–103; 3:96–97) repeats what had become a commonplace among European artists and thinkers since the writings of Vasari and Dolce, Lomazzo and Zuccaro.[7] Mengs' metaphysic of Beauty, trailing thin Meso-Platonic clouds of deity in Nature that our rational soul inspects to find what comports there with our human idea of the more and most beautiful (1:22–23, 30), articulates precisely the major thesis of Batteux's *Les beaux arts réduits à un même principe* (1746), namely, "l'imitation de la belle nature."

The fact that Batteux's thought was in vogue among Germans after Schlegel's 1751 translation,[8] the fact that the writing of Mengs constantly echoes Bellori and the Italian art theorists of cinquecento,[9] and the fact that Lomazzo was Mengs' favorite reading[10] are all evidence that Mengs was steeped in tradition. His theory of beauty, taste, and art, far from being a pastiche of odd thoughts, is intellectually coherent. His theory even conforms to the age-old epigram of Zeuxis, updated: cross expression from Raphael's design, harmony from Correggio's chiaroscuro, and true representation from Titian's color, and moderate your inventive composition with the Greek spirit of reserved perfection, and you have the *summum bonum* of Beauty, taste, and painterly art (1:37–41 and 1:part III *passim*).

Whether Mengs appropriated the Zeuxis fable from Bellori or (more probably) from Lomazzo, Alberti, and Pliny, or first heard of it in

The fact that one man's boon is another man's bane and depends much upon the reader's own subjective perspective is documented by the opposite judgments of Mengs' younger contemporaries Carl Ludwig Fernow (see *Neuen Teutschen Merkur* of 1795, quoted in Dieter Honisch, *Anton Raphael Mengs und die Bildform des Früh-Klassizismus* [Recklinghausen: Verlag Aurel Bourges, 1965], 15) and Goethe (see supra n. 3).

7 The original source of this listing of elements for painting is probably found in book II of Leon Battista Alberti, *De pictura* (1435), par. 30–31, 35, 46: "Picturam igitur circumscriptio, compositio et luminum receptio perficiunt."

8 See Ulrich Cristoffel, *Der Schriftliche Nachlass des Anton Raphael Mengs: Ein Beitrag zur Erklärung des Kunstempfindens im späteren 18. Jahrhundert* (Ph.D. diss. Under H. Wölfflin [Basel: Benno Schwabe, 1918]), 139 n.18.

9 An example: Lodovico Dolce, *Dialogo della Pittura intitolato l'Arentino*, cited in W. Tatarkiewicz, *History of Aesthetics* (Hague: Mouton, 1974) 3:214: "Deve il pittore procacciar non solo di imitar ma di superar la natura." Mengs: ". . . si vedrà, che l'Arte può molto ben superar la Natura" (*Opere* [Baseano 1783 edition], 1:19).

10 Note (a) "Stimava più di tutti il Lomazzo. FEA" in *Opere*, Fea, ed. (1787), xxxv.

conversation with Winckelmann[11] neither matters nor detracts from his genius in having turned it into a theory of art tied to a practical norm of visible Beauty and taste with a canon for painting that could be known, taught, and was believed to be important for the state of what Pico della Mirandola earlier called *Des hominis dignitate* (1:33). And Mengs put these "Thoughts" down in writing that was accessible to non-specialists, in short chapters that should have warmed any popularizing encyclopedist's heart. His *Gedanken* antedated Schiller's short series of letters, *Über die Ästhetische Erziehung des Menschen* (1794–95) by a generation. Nothing systematic like Mengs' *Gedanken* had appeared in German before 1762. No wonder it was acclaimed and went through five editions before his death.[12]

A close scrutiny of the texts corrects the unfavorable Romantic reading given them and might end superficial characterization of his theses about canonic art.

Despite the Meso-Platonic flourishes of his doctrine, Mengs' basic approach is not speculative, but is Aristotelian.[13] His theory of imitation takes its cue from Aristotle's conception of *mimesis*, according to which the artist seeks to represent "the motive of its model." Mengs explicitly contrasts such "imitation" with Plato's concept of the journeyman-like copy (1:35, 44; 2:105; *P* 10–12, 112–116). The artist-theorist Mengs also very matter-of-factly gives precedence to training of the eye and hand over learning rules for art. Extrapolating from his own history, Mengs unequivocally posits that practice and execution should precede theory and scientific rules in the education of an artist (1:3). Such are not the dicta of a scholastic, arm-chair theorist.

While Mengs shared with Winckelmann a connoisseur's veneration for the art of antiquity, Füssli was wrong to lump them both together

11 G. Paolo Lomazzo, *Idea del tempio della pittura* (1590), chapter 17: "Mà dirò bene che à mio parere chi volesse formare due quadri di somma profetione come sarebbe d'uno Adamo, & d'un Eua, che sono corpi nobilissimi al mondo; bisognerebbe che l'Adamo si dasse à Michel Angelo de disegnare, à Titiano da colorare, togliendo la proportione, & conuenienza da Rafaello, & l'Eua si disegnasse da Rafaello, & si colorisse da Antonio da Correggio: che questi due sarebbero i miglior quadri che fossero mai fatti al mondo" (photographic reproduction, Hildesheim: Georg Olms Verlagsbuchhandlung, 1965, p. 60). See Rensselaer W. Lee, *Ut Pictura Poesis: The humanistic theory of painting* (New York: Norton, 1967), 9–16.

12 1762, 1765, 1771, 1774, 1778. See Winfried Lüdecke, "Mengs-Bibliographie," *Repertorium für Kunstwissenschaft* 40 (1917): 255–60.

13 See Tatarkiewicz on Lomasso, *History of Aesthetics*, 3.208; and Erwin Panofsky on Bellori in *Idea: A concept in art theory* [1924], translated by J.J.S. Peake (Columbia: University of South Carolina Press, 1968), 106.

as *antiquomanes*. Mengs was a conservationist in theory, but he valued the Greeks not because they were the faultless paradigms Winckelmann somewhat indiscriminately believed them to be, but because the Grecian painters, by moderating their artistic attempts to cover equally well all the necessary parts of imitating "the whole of Nature," had fashioned the best examples of complete Beauty (1:38–39, 75–77). For Mengs the paragons of painting are Raphael, Correggio, and Titian. That fact helps distinguish what Mengs is doing in 1762 from the antiquarian concerns of Winckelmann but also from the habit of latching onto "Greek connections" prevalent with a Mannerist thinker like Junius (1512–75) or with Bellori (1615–96).

The distinctions are nice, but such fine distinctions are important if art historians are to assess accurately what is historically particular in Mengs' "neoclassical" thinking. Cinquecento theorists used the rhetoricians of antiquity to bolster painting's claim to be as honorable as poetry, and did it often rather pedantically. Seicento thinkers on painting were not concerned with an apology for painting so much as justifying *la grande manière* with an aura of ancient themes and classical detail (cf. Poussin) and reinterpreting Greco-Roman theories with an academic accent. Mengs, however, simply includes, and thereby relativizes, the Greco-Roman statuary, the tales of Greek painting (and the findings at Herculaneum after 1738), as Exhibits A, so to speak, in his pantheon of canonic art, which is filled with *other* exhibits.

Although he would whistle the allegro of a Corelli sonata while painting an "Annunciation" and switch to a melody of Dorian mode for "Deposition from the cross,"[14] and although he continually drops phrases, for example, in describing "invention" as "the essence and poetry of a picture" (*P* 99–100), Mengs is not at all concerned with arguing about *ut pictura poesis* or the "correspondences" between painting and music. That vocabulary is simply the idiom in which Mengs focuses all his attention upon bringing an encyclopedic theory of canonic art ("*all* those parts" of painting, "*all* the rules of the art" [my italics], 1:3) into play *practically*, for beginning, intermediate, and professional painters (1:4). Mengs' theory is "neoclassical" only in the sense that it reveals a belief in ancient fundamentals (2:145–46), the "tried-and-true" ideas and methods accumulated throughout the ages that he trusts will reintroduce an enlightened understanding and performance to the art of painting.

There are two dilemmas posed by Mengs' theory of canonic art that need particular attention, one stemming from the systematic structure

14 See J.N. de Azara, "Noticias," in *Obras* (1780), xxvi–xxviii.

of his aesthetic theory (theses 1–4), and a second from his neoclassical temper (theses 5–6).

Firstly, if the best Beauty the art of painting achieves is one of super natural simplicity[15]—both by concentrating natural beauties and by neglecting encumbering minutiae (2:113, 116; *P* 11)—will the best painterly art tend to leave actual "Nature" behind and use objects only to reflect Beauty?[16] And if the most noble part of painting is to rouse (but not ruffle!) our "generous passions" and to instruct the human mind (295; *P* 9–11, 90), must painters reinvest the normative geometric uniformities and perfect primary colors—upon whose infinite variety painterly beauty depends (1:10–13)— with "poetic" ideas, or not?[17]

Secondly, if the art of painting attains the most sublime degree of beauty and perfection the ancient Greeks gave it (1:20–21), is the only possible historical change one of decline (2:117)? Or, if painting is always more or less perfect (see "gradations of Beauty," 1:15), what makes the "rise, progress, and decay" of canonic art possible as a pattern? And if any human act, which is imperfect, can be "carried to a higher degree" of perfection (1:24, 80), why is it doubtful that another Athens might appear in Italy (1:21)?—can Athens not repeat itself?

That is, surrounded by the legitimation of decorative, easy-going art ("adapted to the discernment of those who employ us," writes Mengs in a wry note), and aware of the ongoing loss of a literary tradition in the art of painting, Mengs unfolds a theory that combines a secularized theology

15 ". . . those pieces which are forced or overcharged destroy the taste of the art, but the simply beautiful works accustom the eye to a more delicate sense. . . . The best Taste which Nature can give, is that of the Medium, since it pleases mankind in general" (1:26). Winckelmann articulates the thought two years later in 1764 with choice images: "Durch die Einheit und Einfalt wird alle Schönheit erhaben . . . Diejenige Harmonie welche unsern Geist entzückt, besteht nicht in unendlich gebrochenen, geketteten und geschleifen Tönen, sondern in einfachen lang anhaltenden Zügen. . . . Nach diesem Begriff soll die Schönheit sein, wie das vollkommenste Wasser aus dem Schooße der Quelle geschöpft, welches, je weniger Geschmack es hat, desto gesunder geachtet wird, weil es von allen fremden Theilen geläutert ist" (*Geschichte der Kunst des Altertums* par. I, iv. 2.1 [Leipzig: Verlag der Dürr'schen Buchhandlung, 1882], 110–11).

16 See Otto Harnack, 199; Wilhelm Waetzoldt, "Mengs als Kunsthistoriker," *Zeitschrift für Bildende Kunst* 30 (1919): 122.

17 Winckelmann had discussed and enjoined this option already in his own *Gedanken über die Nachahmung der Griechischen Werke in der Mahlerey und Bildhauer-Kunst* (1755): "Scheint die Vorstellung möglich, so ist sie es nur allein durch den Weg der Allegorie, durch Bilder, die allgemeine Begriffe bedeuten" (in *Kleine Schriften, Vorreden, Entwürfe*, Walther Rehm, ed. [Berlin: De Gruyter, 1968], 55–56). Winkkelmann developed the theme again in *Versuch einer Allegorie, besonders für die Kunst* (1776).

of Beauty with a humanist philosophy of history. He proposes as canonic art the kind of painting that imitates "Nature"—half-understood to be "the best of the Western tradition of art." Although Mengs slips into this position more by way of practical, pedagogical concerns than of carefully argued, philosophical reasons (1:40, 78), the problematic import for theory of art is still serious: canonic art becomes essentially a kind of palimpsest.

Evidence for this reading of Mengs' theory and its dilemmas is at hand in the *Parnassus* fresco he painted in the villa Albani (1760–61) [#63]. The exhaustive detective work by Steffi Röttgen on *Parnassus* with its flanking *tondi* and an earlier drawing that shows compositional

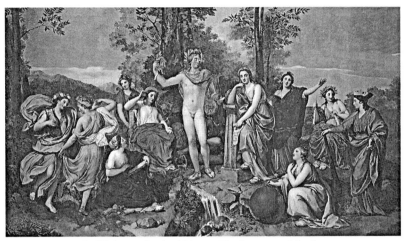

[#63] Anton Raphael Mengs, *The Parnassus of Apollo,
Mnemosyne, and the Nine Muses*, 1760–1761

change in the final painting, which she has put in context by examining all relevant treatments of the *topos*,[18] has iconographically unpacked every graphic hint in the piece. Most important is this: the god Apollo surrounded by the nine Muses prepares for the coronation of Albani as the reigning seigneur of the new Mount Olympus found at "eternal" Rome, and gestures in presentation toward the most favored position of Calliope, muse of painting, who leans pensively on a Doric column, signifying ancient art, and holds a scroll inscribed with the name of Mengs. Mnemosyne, mother of the Muses, seated on Apollo's right, hand to ear as

18 Steffi Röttgen, "Mengs, Alessandro Albani und Winckelmann: Idee und Gestalt des Parnass in der Villa Albani," *Storia dell'arte* 30/31 (May-December 1977): 87–156 +60 plates.

prescribed by Ripa, and pointing to the spring of fresh water at Apollo's feet, emblematizes mnemonics, the *art* of remembering, which, in a tradition running from Cicero to Lomazzo and onward, was an art assigned especially to painting. Painting makes abstract ideas concretely vivid and memorable; painting functions *par excellence* commemoratively, making the past present.[19] So, like a mirror mirroring a mirror, Mengs paints the meaning of painting, that is, the best art for making present idea-filled Greek art in all its excellence.

The whole conception of Cardinal Albani, counseled by Winckelmann, was to effect a genuine restoration of Greek art in a natural setting that would give the lie to everything artificial. Every piece of authentic ancient art the Cardinal owned would be housed so as not to seem antique. Albani did not want his villa to be a museum, a showcase of replicas,[20] but to recapture the glory of a real ancient Roman villa alive with Greek art. Every artwork must not seem but *be* Greek. Because there was no genuinely Greek painting among the Cardinal's fabulous cache of sculptures, marble columns, bronzes, mosaics, dishware, reliefs, and valuables, Mengs was commissioned in 1759 to produce a Greek painting that would both celebrate this new center of Greek art and *be* its climax.

Mengs fulfilled the commission according to the specifications of Winckelmann, who had formed strong opinions from his literary sources about what Greek painting must have been like. Two criteria are evident: one, the painting be a repository of images replete with poetically fashioned, universal ideas (*algemeine Begriffe*) ranging from mythology to the secret wisdom of many peoples, the more exquisite the allegorical dress the better;[21] two, Greek sculpture should be the paradigm for the paint-

19 S. Röttgen, 114–121.

20 See Carl Justi, "Der Cardinal Alexander Albani," *Preußische Jahrbücher* 28 (1871): 338–43.

21 "Der Künstler hat ein Werck von Nöthen, welches aus der gantzen Mythologie, aus den besten Dichtern alter und neuerer Zeiten, aus der geheimen Weltweissheit vieler Völker, aus den Denckmählern des Altertums auf Steinen, Müntzen und Geräthen diejenige sinnliche Figuren und Bilder enthält, wodurch allgemeine Begriffe dichterisch gebildet werden" (Winckelmann, "Gendanken" [1755], in *Kleine Schriften*, 57). "Der Pinsel, den der Künstler führet, soll im Verstand getunckt seyn, wie jemand von dem Schreibe-Griffel des Aristoteles gesaget hat: Er soll mehr zu dencken hinterlassen, als was er dem Auge gezeiget, und dieses wird der Künstler erhalten, wenn er seine Gedancken in Allegorien nicht zu verstecken, sondern einzukleiden gelernet hat" (ibid., 59). "Eine jede Idee wird stärker, wenn sie von einer oder mehr Ideen begleitet ist, wie im Vergleichungen, und um so viel stärker, je entfernter das Verhältniss von diesen auf jene ist. . . . Je mehr unerwartetes man in einem Gemälde entdecket, desto rührender wird es; und beydes erhält es durch die Allegorie" ("Erläuterung der Gedanken von der Nachahmung" [1756], in *Kleine Schriften*, 120).

erly composition.[22]

This last criterion, which complements Winckelmann's remytholo-gizing literary concern, is of historical importance because it explains the feature that startled contemporaries of *Parnassus* into admiration and made them believe a new artistic era was dawning. There was precedent enough for the vertical perspective and non-illusionary space in *quadri riportati* done by Annibale Carracci, even Pietro da Cortona, Guido Reni, and others who had decorated ceilings in *gallerie* of Roman *palazzi*.[23] Mengs certainly needed to follow that local taste and could not allow the figures above the spectators to soar off into a baroque heaven when the whole point of the commission was that the Muses have taken residence here on earth! But the sculptural feel in the painterly line provoked eyes to see something new. The contour of each figure poised like a solitary silhou-ette, separated from the others, and tastefully arranged in an oval tableau struck the viewer surfeited on *composizioni macchinose*, as singularly dif-ferent, an incredibly uncluttered, pure, restful presentation of truly living figures, statuary paragons of immortal, gracious beauty.

Parnassus is not the work of a neophyte who mimicked the Raphael piece in the Vatican, ended up with an artificial collection of mannered individuals who lack organic unity, and was praised excessively by his fa-mous friend Winckelmann. This is the Romantic misreading that has be-come largely the official one.[24] Mengs knew precisely what he was doing and did it masterfully: painting a *Greek* painting! This entailed following Winckelmann's sculptural prescription (which certainly took precedence over "copying" any *Roman* remains found at Herculaneum).[25] Mengs as-sumed that the Greeks bestowed great assiduity on single objects and that their most celebrated paintings and statues "did not form one grand

22 See S. Röttgen, 140–43.

23 Ibid., 128.

24 Cf. ". . . an insipid and artificial style, as may be appreciated from Mengs' own *Parnas-sus* (Villa Albani, Rome, 1761)" in *The Oxford Companion to Art*, ed. Harold Osborne (Oxford Clarendon Press, 1970), 768. Hugh Honour's insightful and magisterial summary of "Classicism and Neoclassicism" does, however, fail on this point too: "Belonging to the early, negative anti-Rococo phase of Neo-classicism, it [Mengs' *Parnassus*] seeks to do more than recreate a dream of classical perfection by a synthesis of antique sculpture and Raphael's paintings" (*Neo-classicism* [Harmondsworth: Penguin, 1968], 32).

25 Röttgen (140) is correct too in distinguishing the "borrowing" of a motif or two, which Gerstenberg detects (*Johann Joachim Winckelmann und Anton Raphael Mengs* [Halle: Max Niemeyer, 1929], 14), from the "completely other, over-all cast of de-termining style" of what Mengs produced in contrast to the discovered pieces Mengs came to see.

unity, but only an assemblage of figures, which had their particular excellence" (*P* 45). Further, Mengs believed Raphael, whose genius penetrated the truly beautiful style of the ancients, was held back by the ignorance of his own times about Greek customs and ideals; Raphael's own genius "could not entirely abandon humanity, with the happy success of the ancient Greek painters" who ranged freely "between the heavens and the earth" (1:49, 62; 2:101).

Mengs' *Parnassus* was artistically premeditated: it is a principled manifesto for the remaking of Greek painting, which yet is, palimpsestically, thoroughly pro-Raphaelite. Unlike Raphael, Mengs had seen the Apollo Belvedere; so Mengs' Apollo stands naked. Mengs' improved knowledge of Greek ideals, he believed, permitted him to perfect Raphael, that is, return Raphael's genial art to a more unearthly, Greek divine Beauty.

A brief remark en passant can tie the analysis so far into a larger problem. One could do worse than remember Mengs' fresco *Parnassus* as touchstone for a graphic definition of what "neoclassical" can mean as an art historical term for capturing precisely the cultural spirit of a time that formed by radiation, as it were, a kindred number of artists and writers who constitute a fairly definite and roughly datable period or "movement" in Western cultural history. Whether certain traits—sculptural fixity, powerful linear clarity, serious simplicity—can serve as neoclassical differentia in other arts than painting, and in other painterly artists, for identifying this homogeneous drive to redo Greek (or Roman) art and be "neoclassical," will depend upon comparative examination. But there is a method of art historiography that allows for a kind of flexible precision in determining such categories. It can be illustrated in outlining a way to understand Mengs' own painterly development (even though painting by painting analysis cannot be done in this brief article).

Most commentators agree that the *Parnassus* is quite unlike the rest of Mengs' *oeuvre*.[26] Another major problem for interpretation is to sort out the effects of Mengs' double-minded appreciation of Raphael and Correggio, and of his changes in locale, e.g., his moving from Dresden

26 Röttgen (137–39) grounds and motivates historically the rigorous exceptionality of the *Parnassus* fresco and attributes its uniqueness to Winckelmann's dictations on this particular commission. Dieter Honisch downplays its *Sonderstellung* most, perhaps, in his form-critical problematics that stresses the continuity of Mengs' shift from ornamental motifs to use of the painting field for ordering the composition (see *Mengs und die Bildform,* 34–37). Pelzel debunks Mengs' whole contribution to "the reformatory classicism" as only an "episodic," "incidental factor" in Mengs' artistic corpus (*Mengs and Neoclassicism,* 127, 367).

(dominated by Ismael Mengs) to Rome (friend of Winckelmann, rival of Batoni) to Madrid (fierce competition with Tiepolo and Giaquinto), back to Rome, then to Madrid, and again back to Rome.

Although everyone's professional development is a labyrinth of influences, and although every historian mints his own coin of terms, one way to order and understand the stylistic changes in Mengs' painterly art is this (see the schematic note): From 1744–58 Mengs was "a promising young painter in the Raphael-Maratta tradition," as Ellis Waterhouse puts it,[27] who was steeped in a Germanic-courtly rococo spirit.[28] Around 1759–61 with *Parnassus*[29] Mengs' love for Raphael's balanced order and measured use of color became reinforced by a commitment to neoclassical sobriety, which breathed simplification and a new idealism into Raphael's artistic features. Then, from 1762–79, in Mengs' art a submerged predilection for Correggio rose to the surface. A preference for scumbled color and a warmer grace moderated but perpetuated the neoclassical temper.[30]

27 "The British Contribution to the Neo-classical Style in Painting," *Proceedings of the British Academy* 40 (1954): 58–59.

28 See Honisch, 22, 26, although Honisch calls Mengs' Dresden altarpiece on "Christ's Ascension" (1755–66) and the San Eusebio fresco (1757–58) loosely "noch in barocker Tradition," 27.

29 Another painting of these years reinforces the judgment; see Pelzel on "Augustus and Cleopatra," 99–108.

30 Honisch notes how Mengs appropriated Correggio's themes and even formal properties to his "Passion scenes" of 1765–68 (31–32). Pelzel sees the Correggian hegemony in later Mengs as evidence for denying Mengs any serious role in the spread of neoclassical art (145–52, 348–52). But Pelzel finds the *Parnassus* in fact already retrogressive toward a Rococo formal *Empfindung* (126, 140) and reads the late Mengs loosely back into "the Baroque tradition" (165). Herbert von Einem shows how Mengs struggled to modify neoclassically, as best he could, the heroicizing project of decorating the Spanish King's palace, e.g., the heroes in "Hercules' Apotheosis" (c. 1762–75) sit, stand, and walk around, separate from the clouds, and weightless Doric columns replace the heavens in the "Apotheosis of Emperor Trajan" (c. 1774–76) (*Mengs, Briefe an Raimondo & Maron*, 17–18). Every art historian stumbles to find accurate terms: Gerstenberg uses "baroque classicism" (27), and S. Röttgen "Neo-seicentismus" (145).

Schematic note on shifts in Mengs' style

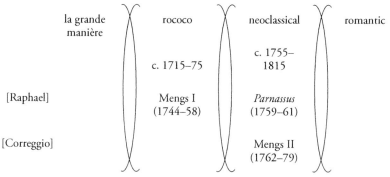

la grande manière	rococo	neoclassical	romantic
		c. 1755–1815	
	c. 1715–75		
[Raphael]	Mengs I (1744–58)	*Parnassus* (1759–61)	
[Correggio]		Mengs II (1762–79)	

An advantage to this kind of analysis for tracking trends and shifts—if it stands verification—is the recognition that neoclassical art, epitomized perhaps by the spirit of Mengs' *Parnassus*, does not need to follow Raphael's paradigm. The neoclassical allegiance—to *be* the classical ideal *anew*—can follow Correggio too. There are various types of neoclassical painting.[31]

The pregnant dilemma posed by Mengs' *Parnassus* for painting is this: how can there be an avant-garde palimpsest, a reconstruction meant to be schematic new, painterly reform by return? If one discounts the caterwauling of "pseudo-classicism" indulged in by critics who have an ideological axe to grind, the dilemma still remains: is repristination of art possible without committing the historical error of becoming anachronistic? How can what is historically past be made the norm for the future without becoming utopian, historically unreal? Can reiteration of a perfect canon be made the norm for art without spawning work that will be, at inception, stale? What is the legacy of the spirit of *Parnassus*?

Mengs' framework for writing art history
The dilemma in Mengs' *theory* of canonic art, which confronts an artist with the task to simplify inventive composition if he wishes to reach a

31 Rosenblum opens the door to this insight by identifying the "Neoclassic Horrific," "the Neoclassic Erotic," and "the Neoclassic Stoic"—all modes of Neoclassicism; but he skews this insight when he understands at least "the Neoclassic Horrific" to have a *Romantic* view of antiquity (see *Transformations in Late Eighteenth Century Art* [Princeton: Princeton University Press, 1967], 11, 20, 28). "Neoclassic" and "Romantic" were contemporary trends or "periods," in my judgment, and both looked back in time; but their driving forces excluded each other, and were as at odds as Sir Joshua Reynolds and William Blake. See C. Seerveld, "Towards a Cartographic Methodology for Art Historiography," *Journal of Aesthetics and Art Criticism* 39:2 (1980): 148–49 {supra pp. 75–77}.

higher degree of Beauty, produces a curious tolerance for both artistry and taste, together with a hierarchy of Beauty. The dilemma in Mengs' *praxis* of canonic art, *Parnassus*, which purports to redo perfections of the past, prompts the emulation of the Masters of perfect Beauty, especially if divine Beauty is a teachable ideal in the Academy and can be learned through practice.

The results of Mengs' dilemmas are (1) an ontological breadth to the canon of artistic Beauty that supports Enlightenment tolerance, and (2) a Zeuxian openness to pollinate rosebuds wherever ye discriminately may. When one joins the results of these dilemmas to the artist-theorist Mengs' strong conviction that the artistic elements—design, chiaroscuro, and coloring—are central to the purpose and meaning of a painting, then the upshot is an innovative, systematic methodology for "modern" art historiography, arguably the first.

Every painter in the polite arts, writes Mengs, has imitated Nature; the only difference is that they have done it in different ways (1:75). The styles in which painters execute the "picturesque appearance" of their ideas "are infinite, but the principal ones from which the others should flow, may be confined to a small number" (*P* 14–15), five good ones, to be exact, and two unworthy "manners."

(1) *Sublime* style transcends in form any possible perfection found in nature; an abstracted, austere simplicity is its clue (*P* 17–19). (2) *Beautiful* style is distinguished by imaging every perfection possible, neither slighting nor exceeding any essential quality proper to what is imitated, in its totality (*P* 19–23). (3) *Graceful* style highlights the gentleness of a modulated chiaroscuro, whose excellent agreeableness is not to be belabored (*P* 23–27). (4) *Expressive* style gives precedence to design, which exhibits by its conforming line the exact, corresponding character of what is represented (*P* 27–29, 106–7). (5) *Natural* style is particularly attached to what is casual and amusing; its *forte* is the coloring of aerial perspective so requisite for being true to everyday life (*P* 29–32).

Some painters, writes Mengs, have made a habit of merely affecting the virtues of other styles, thereby corrupting them. This mannered approach could be called the (A) *Vitiated* style (*P* 33–35).[32] And painters

32 Pelzel translated *estilo viziosos* as "Vicious Style" (144). This slanted translation exemplifies the tendentious way Pelzel twists so many facts about Mengs' thought, making Mengs seem mean-tempered or simple-minded. Mengs is not, as Pelzel claims, "most contemptible of all" on the "Easy-Style" either. Mengs' serious effort to give good painterly advice and tips on taste is very undoctrinaire and generous. On the "vitiated style" Mengs writes: ". . . I do not condemn the authors, since great defects are often annexed to great accomplishment. . ." (*P* 15).

who potboil artworks for the easy return of popularity may be called exponents of the (B) *Facile* style (*P* 35–36).

Mengs has constituted, therefore, without much prejudice, a rough taxonomy of basic styles that provides systematic ordering for art-critical perception. Compared to Diderot's salon reports (begun in 1759) where, with an antipathy for rule-book judgments, Diderot gives voice to the sentiments welling up in him while his connoisseur's eye roves over the painting, Mengs' approach seems as detached and object-oriented as a professional. Compared to Vasari's *Vite* (1550) where, says Mengs' first editor Joseph Nicolas de Azara with a touch of spleen, the anecdotes often "treat of everything except what is essential in the Arts,"[33] Mengs focuses attention rigorously on artistic phenomena. Because Mengs' typology of styles is based upon categories that deal in the hegemony of certain artistic features, he can credit each style with equal artistic canonicity, even though each is more equal than the others as far as its own peculiar patterning and contribution to Beauty goes.[34]

A strength of Mengs' categorical framework for analysis of paintings and sculpture is that it has a comparative scope: the framework can't help but relate and group, weight and contrast, for example. Titian, Velasquez and Rembrandt, who manifest a Natural style, next to Annibale Carracci's male figures, Guido Reni's female portraits, the Venus del Medici and the torso of Apollo, whose lines, says Mengs, have the Beautiful style. A person determines the style of art by examining which artistic element gives the distinctive feature to a piece. This kind of taxonomy in grappling with the art of painting in the 1760s–70s is a genial, not to say original, step on Mengs' part, toward formation of a *bona fide* art historical method that had been lacking.[35]

Further, Mengs carried his systematic sense of pattern and concern

33 J. N. de Azara, "Noticias," xxxix.

34 Herbert von Einem seems to interpret the types of style as a psychological index of artistic dispositions: "zwar in psychologischer Hinsicht als Unterscheidung von Begabungstypen" (*Mengs, Briefe an Raimondo & Maron*, p. 18). While Mengs gives cause for such a reading occasionally ("I advise therefore all painters not to study Correggio if they have not sensibility like him." 1:67), Waetzoldt sees the issue more sharply when he refers to the delineated Urstile as "Anschauungs- und Gestaltungweise" (*Deutsche Kunsthistoriker* [Leipzig: E.A. Seemann, 1921], 1:91–92). There may be the ready-made anthropology of *facultates* and the still earlier "humors" psychology of Hippocrates, which was so popular in the Renaissance, behind Mengs' typology; but Mengs' schema is intent upon *artistic* matters more than on a roster of personality-archetypes.

35 Reynolds' *Discourses* come later (from 1769 on) and are a comparable, if less systematic, attempt to give structure to "learning" critique and the history of art.

for canonic art over into the problem of temporal succession—the "History of taste" (1:32–39), the "Rise, progress, and decay of the art of designing" (2:110–153), and had the uncommon temerity to say:

> Painting has partaken of the same vicissitudes and revolutions as all other sublunary things. It has had its bright period, and its fall, has risen again to a certain degree, and now declines once more. It has not only experienced these alternatives, but has varied even in its fundamental principles; for what was considered at one time as an essential attribute, has been coldly looked upon in a successive age, as of no consequence; besides, there has been a contrariety and difference of opinions in various times, relating to those points which constitute the very art itself. (*P* 43–44)

So alongside his principled commitment to canonic art Mengs had a sure sense of the relativity of times: "every age has its particular character, which by means of a general ferment, enlivens the imaginations of men" (2:137). But the relative and the normative intersect, according to Mengs, or at least cannot gainsay the fact that the Greeks were the acme of art. The Romans ruined art through opulence, and a barbarous taste arose when Christianity was embraced (2:17–19). The arts revived with Giotto and the study of perspective; the quattrocento artistic geniuses in Italy became models of perfection. After "a pause," writes Mengs, the Carracci, especially Annibale, reintroduced "the justness of the Greek statues" to painting (*P* 54); Poussin too "came nearest to the classic style of the Greeks" (*P* 57). But Pietro da Cortona, three generations ago, and scholastic disciples of the great painters became superficial, extravagant, and led to the recent ruin of painting (2:130–46; *P* 55–56).

That this ground plan became standard a generation later need not concern us here.[36] That Mengs shared Winckelmann's belief that climate brooked large in encouraging or limiting artistic performance and that "political liberty" and the "customs" of a land served either as a base for a flourishing artistic community or impaired it (2:3–5, 20–21, 138–39, 144, 147) can be documented. But important for understanding the fruitfulness and the latent sterility of Mengs' neoclassical paradigm about the recurrence of canonic art is to ask pointedly with respect to the writing of art history: does the conception that Greek sculpture and painting was the pinnacle of artistic excellence, followed by a fall, and that the quattrocento showed perfection, pause, flurry . . . and then a fall, mean that this is an inevitable, recurrent pattern?

36 See Alexander Potts, *Winckelmann's Interpretation of the History of Ancient Art in its Eighteenth Century Context* (Warburg Institute, University of London, Ph.D. diss. under E.H. Gombrich, 1978), 2:476–78.

Mengs' categorical framework of style-types holds steady, it seems, during changes in painting.[37] Mengs does not convert his rubric of styles into schematic phases of a lockstep sequence as Winckelmann does when the latter traces the changes in ancient art from the Archaic (*ältere*) style rising to the Lofty (*hohe*) style, slipping to the Lovely (*schöne*) style and down to the discredited Copyist style (*der Nachahmer*).[38] And Mengs does seem to allow for historical openings and resurgences that have a chance nature—"accidental causes" and "good fortune" (2:140). But he maintains as axiomatic an underlying art historical principle that sets up a final dilemma: since all human thought and action tend toward progression, once perfect art has been reached by a Master artist every attempt to "superadd" to what has been achieved—whether out of the competitive desire to surpass, or a genuine attempt to improve—the "too much excellence" introduces what is unessential, novel, superfluous, and therefore renders the ensuing art faulty (2:117, 122, 130–31, 136–67, 146, 152; *P* 49, 115–16).

The dilemma is this: If canonic art is attainable at large in history more than once, decline will be periodic. If the rise and fall of painting is a permanent recurrence (also palimpsestic?), artistic leadership that asks one to learn the Beauty of Nature by imitating the Master artist leads one into a bind (2:106–7). If there is a canon for painting, then there is an entelechial closure to its possible development and epigones are ontologically inescapable. If there is an open-endedness to what painting can become, is there then a binding canon?

Mengs' art historiographic account remains troubled by this dilemma. He is unsure about whether Raphael, who was the "most divine," entails that Correggio was lesser, or whether Correggio's "adding" charm to Raphael's work, which never reached for the grace beyond Expressive art, means Correggio was not still more superlative (1:54–55; 3:52–53, 149; *P* 53). Mengs' fundamental commitment in theory to canonic art, however, and his attempt at a millennial artwork in *Parnassus* attest to his desire to make the palimpsestic dilemma fertile. Mengs meant to restore

37 In fact, Mengs uses the abiding *Hauptgattungen des Stils* to detail the change, in a given painters style: Velasquez shifts from painting in the Natural style to Graceful style, to the Expressive and finally to the Beautiful style (2:82–83; *P.* 62–63); Murillo turned from the Natural style to one of sweet Loveliness (2:84; *P* 64–65); Raphael went through three styles, the last and best was developed out of Raphael's appreciation for Michelangelo's Sistine chapel painting (2:133); in Correggio too Mengs carefully discerned three changes of style (3:26, 38).

38 *Geschichte der Kunst des Altertums* par. I, iv, 3. 1–4, 152–73. See Carl Justi, *Winckelmann und seine Zeitgenossen* (Leipzig : F.C.W. Vogel, 1923) 3: 154–58.

to patrons and the up-and-coming generation of artists the accumulated treasure of art knowledge "hidden in forgetfulness" (2:19). He accepted this Sisyphean task without demur as a good neoclassical Idealist should, until at age fifty-one he died from overwork.

The dilemmas in Mengs' thought and work bore the fruit of an art historiographic method because he dared attribute relational categories to art that was regarded as normative during cultural change. That Mengs identified a certain tradition (the fictional "Greek" one represented by Raphael and Correggio) (2:91–92, 101–3) to be *the canon* and misjudged innovation by a norm of *simplification* were neoclassical errors that impeded his insights. That he did face the dilemma of giving leadership in theoretical aesthetics, artistic style, and art historiography at a time of considerable cultural stress at least makes us aware today that there are such problems.

No Endangered Species:
An Introduction to the
Wood Engraving Artistry of
Peter S. Smith

Box wood is hard to come by these days. The very hard, fine-grained wood of the box tree (*Buxus sempervirens*) is the best for wood engraving. The engraver cuts into the stubborn end grain of a small piece of carefully dried, polished box wood slowly, patiently, with a burin, so that when inked the cut-away block can be pressed to print a relief image on quality paper.

What is the sense of making wood engravings in our day of fast-paced cultural excitement replete with utensils industrially planned for obsolescence?

A Roundabout Introduction

Once upon a time women were important (c.1250–1550) in commissioning and in receiving what has come to be called Book of Hours (*Horae*) in the Western world.

The Book of Hours were hand-written texts of biblical Psalms and prayers in Latin, especially prayers to the Virgin Mary, inscribed on parchment. The manuscript pages were bound together as a book, which monks and priests used, but also literate, aristocratic women of piety could request or receive as a bridal gift. So these textual prompts for daily prayer at different hours of the day and night extended a regimen of faith exercises to a lay readership. A Book of Hours was like having in reserve a little "church activity" at home in your personal quarters, or a kind of "Gideon Bible" for devotions while undergoing the rigors of travel.

These standardized prayers on precious parchment were "illuminat-

This "Introduction" was first published in the book listed below and is made available by special permission, and is meant to be an encouragement for readers to purchase the book of wood engravings by Peter S. Smith entitled *The Way I See It* (Carlisle: Piquant, 2006) filled with 45 excellent reproductions. It is available from ptrss@me.com or visit www.peterssmith.weebly.com.

ed" by teams of well-paid artisans. The fine calligraphic text was complemented by miniature, once-off paintings of the Annunciation to Mary, for example, or a scene from the biblical story of David and Bathsheba, the Crucifixion of Christ, with a tiny portrait of the patron, or Saint Jerome flagellating himself in penance. Other master craftsmen and their workshops were engaged to decorate the page with borders of fantastical animals, fruits, plant tendrils, or colorful, purely geometric designs. The final sumptuous product was usually magnificent.

By the 1400s handmade Books of Hours were prized treasures, often passed down in noble families as heirlooms. The Horae were a tribute to the penitential piety of a wealthy aristocratic laity during times which were a-changing from a medieval, Church-driven culture to a Humanist and Renaissance mix of worldly splendor that seemed to sideline devotion to God and park a person's faith privately, kept for ceremonial occasions only.

The historic Reformation, which happened north of the Alps in the 1500s, was multifaceted, affecting the power position of the institutional Church in society and the role that governing princes came to play in the professed faith of a nation (*cuius regio ejus religio*). The general movement for Reformation also stimulated the democratizing of artistic culture.

Clergy had earlier affirmed the painted images in Book of Hours as a good aid for women in schooling their piety. Iconoclasm in the Roman catholic Church had largely been laid to rest by Gregory the Great (Pope, 590–604). The concern of Reformational leaders lest sculptural images become idols for the ignorant had the surprising effect of promoting graphic art, because art on paper lost the stigma of being a painting or a three-dimensional image that could itself be adored in devotional prayer.

What was achieved by painted fresco murals of Bible stories and mementos of venerated saints on the walls of Roman catholic Italian churches, and by icons in Greek and Russian Orthodox churches crafted to focus the devout attention of believers into meeting God, now in Protestant Reformation countries was achieved through block books of woodcuts, the *biblia pauperum* for "poorly" educated preachers.

Albrecht Dürer from Nürenberg (1471–1528), who later in life became deeply convicted by Luther, fashioned already early on (1498) a powerful, dramatic series of fourteen woodcut plates to tell not royalty but German burghers, almost like a lay preacher, the fascinating episodes of the Newer Testament Apocalypse of John. Lucas Cranach (1472–1553), Wittenberg court painter for Frederick the Wise, not only painted his Mannerist nudes of demure lasciviousness with names like "Eve" and

"Venus," but did many portraits of Luther replicated and multiplied in copper engravings and in woodcuts and distributed like broadsheets so that his profile became well recognized.

The invention of movable type had led to the folio-printed Bible of Johann Gutenberg (c. 1394–1465) in 1456—Cranach has twenty-one illustrations in Luther's *Neues Testament Deutzsch* (1522). And artist Hans Holbein the Younger (originally from Augsburg, 1498–1543, died in London) drew forty-one scenes on wood blocks (1523–26) that taught that death is no respecter of professions but comes calling on pope and farmer, children as well as the aged. Holbein's drawings were meticulously cut into the wood by Hans Lützelburger, an expert craftsman specialist trained to reproduce exactly what the artist wanted; and the lot was finally published as a kind of biblical catechism, an Emblem book, *La Danse des Morts*, in Lyons, 1538 [#64].

"Emblems" were an instructional composite of (1) visual representation of an idea, with (2) a motto or Bible text, normally in Latin, and (3) a short verse explaining the point in the vernacular language. These well-crafted devotional aids, dating from the Reformation, were printed booklets duplicated on paper rather than one-for-one illuminated manuscripts on parchment. So Emblem books served a wider, more commoner public and facilitated literacy.

[#64] Hans Holbein the Younger, *Gebeyn aller Menschen*, in *La Danse des Morts*, 1538

Touching down in English wood engraving history

Painter William Hogarth (1697–1764) was never fully accepted by the English gentry of his day, and so he took to the streets, one could say, with his engraved etchings that told stories in pictures with a moral point.

Hogarth's graphic art followed up John Bunyan's *Pilgrim's Progress* (1678) with his *Harlot's Progress* (1732) and *Rake's Progress* (1735), and a later series on the *Industry and Idleness* (1747) of apprentices. These combined the Emblem book tradition and picaresque story line to report in empirical detail and to caricature the sometimes hypocritical middle-class commercial ambition. Hogarth's heavily subscribed early engraved etchings on copper were so popular they were pirated, copied, and sold cheaply without giving him credit or any recompense. So Hogarth initiated in Parliament "the Hogarth Act" in 1735, which protected engravers' rights to their designs and products for fourteen years.

Another gifted English artist, the poet-drawing engraver William Blake (1757–1827), challenged the smug Enlightenment mentality, which was busy supplanting the christian faith, and the "religious wars" (Seven Years War, 1756–63) with a tolerant Deist Rationalism: "*Mock on, mock on, Voltaire! Rousseau! / Mock on, mock on, 'tis all in vain! / You throw the sand against the wind, / And the wind blows it back again.*" Blake's "illuminated printing," as he called it, married compelling linear, hand-colored drawings and poetic texts. Words and flamboyant image were engraved and printed on the same page and looked almost like pictorial hieroglyphics. Blake's visionary Swedenborgian imagination and driving restless Romantic spirit, however, kept his brilliant eccentric artwork, and even his few late wood engravings, prized by the few, beyond the pale of most proper folk.

Thomas Bewick (1753–1828), who set the standard for wood engraving in England (using the end grain of box wood) as distinct from woodcut (using the plank side grain of softer woods), fits snug into the sunny-side-up Rationalistic sensibility of the day and the appetite for encyclopedic knowledge of "natural history." Bewick's *History of Quadrupeds* (1785–90), followed by *History of British Birds* (1797–1804), depicted animals he had spent time observing (whenever possible) and drawing in their habitats [#65]. He was not reproducing anything, but

THE CROSS-BILL

[#65] Thomas Bewick, "The Cross-Bill," 1847

was "life drawing" animals, with respect for their several natures, engraving with precise exactness the overconfident strut of the starling and the wary, alert early bird robin in a snow-covered field near a still frozen pond of water. Thomas Bewick was rigorously rural, an industrious denizen of Newcastle, whose tail-piece vignettes (to fill out a page of print) have the gentle, puckish humor and wisdom of a sharp-sighted, shrewd country sage, like this Saturday night reveler staggering home with his cane from the pub seeing two moons in the night sky [#66].

[#66] Thomas Bewick, untitled wood engraving, 1818

Periodicals like *Punch* (founded 1841) and *Illustrated London News* (began publication 1842), which served the rapidly increasing literate public, hired teams of wood engravers to illustrate their journals. The *Christian Herald*, as well as the cheap "penny dreadful" chapbooks hawked on the street, the elaborate catalogues of the Coalbrookdale Ironfoundry and Edward Lear's (1812–88) *Nonsense Books* all needed illustrations to catch the reader's eye and sell the traders' wares. Wood engravers could earn a living with their engraving craft! even if it sometimes became pressured commercial routine and they with their apprentices were nicknamed "woodpeckers."

The literary Pre-Raphaelite painterly artists Millais, Holman Hunt, and Dante Gabriel Rossetti designed narrative illustrations, for example, for an edition of Tennyson's poems (Moxon edition, 1855–57), and left the actual engraving to the expert Dalziel brothers who were expected to reproduce the prescribed design without deviation. Instead of considering such a partnership co-operative artistry, the Royal Academy of Art

(Painters and Sculptors) considered the lowly wood engravers ineligible to be artists. Even someone like Timothy Cole (1852–1931), who made fantastically accurate facsimiles of famous paintings for the American Scribners publisher, was discounted as merely a "craftsman."

Those were fighting words for William Morris (1834–96) who, with John Ruskin (1819–1900), faced the quandary that photo-mechanical processes and the Capitalistic assembly line in force were indeed both downgrading wood engraver apprentices into hacks of slavish detail and making them expendable. With Utopian Socialist fervor Morris instigated Walter Crane (1845–1915), architect William Richard Lethaby (1857–1931), and others in "the Arts and Crafts movement" to raise the status, quality, and pay of manual artisans. Unfortunately Morris's visionary "medieval" and "Icelandic" norms suffered from a domesticated Neo-Idealist spirit sometimes called "Victorian." The Kelmscott Press that Morris set up in Hammersmith (1891) to fuse typography, text, and wood-engraved image into a hand-printed and bound illustrated Book Beautiful (*Gesamtkunstwerk*) constricted wood engraving more toward decorative borders. An item too luxurious for Industrial day laborers to own, it had an immediate out-of-date feel and look.

The significant historical upshot, however, of William Morris's cultural effort was: (1) the differentiation of wood engraving from being an ancillary complement to art into becoming recognized as artistry itself—the gallery of Dutch E. J. van Wisselinge & Co showed seventy-one wood engravings framed on gallery walls in a London exhibit on 1 December 1898. And (2) other private (non-commercial) presses like Morris's Kelmscott Press struggled into existence to publish fine limited editions of books featuring prints of wood engravings as artworks.

At the Central School of Arts and Crafts in Southampton Row, London, built by Lethaby, a calligrapher Edward Johnstone (1872–1944) taught in 1899 both Noel Rooke (1881–1953) and Eric Gill (1882–1940). Rooke later taught wood engraving at the same school (beginning 1912) to Robert Gibbings (1889–1953), John Farleigh (1900–65), and others, emphasizing that a wood engraving is only a bona fide, original work of art if the engraver has self-designed and incised the block, using the graver tools to make marks in the distorting end grain proper to the graver's instruments.

And it was this nucleus group who in 1920 organized the Society of Wood Engravers, along with Lucien Pissarro (1863–1944), Gwendolyn Raverat (1885–1957), John Nash (1893–1977), Philip Hagreen (1890–1988), Sidney Lee (1866–1940), Edward Dickey (1894–1977),

and Edward Gordon Craig (1872–1966). The Society of Wood Engravers was formed to hold an annual exhibit in order to give wood engraving its own niche as an independent graphic art.

Stone engraver and letter cutter Eric Gill was one of the more flamboyant members. Son of a Nonconformist minister he became Roman Catholic in 1913 and formed a sort of Catholic Guild of wood engravers in Ditchling to expose economic evils in society. Eric Gill also illustrated many books for the private Golden Cockerel Press run by Robert Gibbings (from c. 1924–33). Gill's wood engraving style has a strong, flawless black line, and is often flagrantly in-your-face erotic, with a brazen coldness similar to the black-and-white art nouveau drawings of Audrey Beardsley.

John Farleigh's truly interactive development with George Bernard Shaw to illustrate Shaw's fable of *The Adventures of the Black Girl in her Search for God* (1932) [#67] demonstrates how illustrations in a book can be striking artistry and not just an explanatory device or decorative

[#67] John Farleigh, wood engraving, 1932

sideshow: Shaw even agreed to write twenty extra lines of text to accommodate the page placement of one of Farleigh's prints! Farleigh's wood engravings visually enhance Shaw's verbal meaning. The finely engraved images allusively clarify and epitomize what Shaw narrates. Just as a good literary translation almost imperceptibly highlights only certain connotative features compressed within the original text of a different language, so Farleigh's taut drawings full of vitality subtly translate Shaw's English text into captivating figures. The unaffected naked virginity of the black girl amid the clothed vulgarity and self-deceit of her disputants reverberates with and reinforces Shaw's risqué irony.

Sculptor Gertrude Hermes's (1901–83) wood engravings breathe a planned experimental spirit. Whether it be the undulating curves of *Waterlilies* (1930), a panoramic gaze upon impassive *Stonehenge* (1963) or the penetrating exploration of human relationships, there is an intense fixity to the artwork. The object depicted is brought frontally close to the picture frame excluding any landscape background. The nervous Cubist style exploration of *Two People* (1933) has a troubled, unfinished struggle to its form. There are usually murky undercurrents of gravity and mystery in Hermes's engraved prints that bespeak unsettled life in our current world society.

The vicissitudes of the Society of Engravers as generations passed since its inception in 1920, the hard times and failure of many private presses in the financial depression of the 1930s, the disruption in the British artworld brought on by World War II (1939–45) and the threat of extinction to xylography by postwar linocut artistry, not to speak of the rise of commercial ready photographic art, all seem to place wood engraving as a species of artwork in jeopardy today.

However, John Farleigh wrote *Graven Image* (1940) and led to setting up the Craft Centre of Great Britain in 1946, which united the Society of Wood Engravers with four other independent arts and crafts societies. The Victoria and Albert Museum held "The Craftsman's Art" exhibition in 1973, and after Albert Garret (1915–83), who had been president of the Society of Wood Engravers for sixteen years, died, Hilary Paynter (b. 1943), Kenneth Lindley (b. 1928), and George Tute (b. 1933) revitalized the Society of Wood Engravers in the 1980s.

These are the circumstances in which the young painter and design instructor Peter S. Smith has gradually found his own way. After having his wood engraving work accepted for three years in the annual open exhibit, a requirement for admission, Peter was nominated for member-

ship in the Society by Edwina Ellis in 1986. His most current artwork has been the finishing of a commission by Kingston College, Surrey, for six large paintings showing the neighboring environs of the college (1995–2005). But wood engraving is not an endangered species in the oeuvre of Peter Smith: this special, difficult artistry in wood fits the man to a T.

Peter S. Smith: a portrait of a young man becoming an engraver
To grave the end grain surface of an expensive piece of hard box wood with the cut of a line is as final a judgment as taking a chisel to stone or marble. Copper etchings can be corrected, but carved-away stone or wood is less forgiving of mistakes. Disciplined precision is requisite for wood engraving: steady hands, deliberate marks, a love to be in touch with intractable woody material. And it takes patience to engrave wood. Once one has acquired the enormous skill needed to do a good water-color sketch on paper, it can be done relatively fast. But putting burin to wood can never be done quickly, no matter how accomplished one be in the craft; it is slow, time-consuming work. And a good engraver has to be big enough to be pleased with small results.

Peter Stanley Smith was destined, you could almost say, to develop the gifts needed for xylography. Born in 1946 of Non-conformist Methodist parents and raised abstemiously in the North West of England, his maternal grandfather, a carder at Hollins Mill in Marple, Cheshire, drew trains for the young boy Peter on the large blackboard in his office, and gave him in 1952 as a five-year-old boy the responsibility to paint their house number "7" on the trash bin all by himself—no help or interference—because Peter wanted to be a draughtsman when he grew up. This serious event marked him for life. "Peter, remember, you can't paint without paint on your brush."

At age 11 Peter qualified for admission to the Hyde Grammar School for Boys. Because he was not being programmed for university, he was free to enjoy English and Art, and particularly Woodworking, at the school. The headmaster thought Peter's idea of going on afterwards to art school was "romantic." But for seven years the strict, friendly woodwork teacher at the school, a Mr. Cousins, disciplined his young students in the craft and taught Peter a profound love for materials and for the tools to fashion the materials.

Mr. Cousins died of cancer before the successful results of Peter's final exams were announced. Peter, who at age 15 had made profession of the christian faith during a Billy Graham Crusade in Manchester (1961), and who knew Mr. Cousins had a Methodist background, went to visit

him before he died. "We will meet again, Peter," Mr. Cousins said. That remark was a sure signal of recognition, since you didn't wear your christian faith on your sleeve in an English Grammar School for Boys in those days. You just lived out the Non-conformist Methodist rigor and plodding gravity of life by requiring structured woodwork from rambunctious boys and by instilling in them somehow a deep sense of cherishing the comforting solid feel of good wood.

In 1965 Peter Smith left home to attend Birmingham Art School to become a graphic designer. After the required first year of training in diagnostic art and design during which he took an English course still needed—he was tutored weekends at home in Hyde by his fiancée, Carol Longden, who was studying Advanced Level English Literature at Astley Grammar School for Girls in Dukinfield—Peter's Birmingham tutor declared the received wisdom of Fine Art tutors of the day: "If you do graphics, that is all you will be able to do. But if you do Fine Art, then, if you want to, you can still be a graphic designer."

So from 1966 to 1969 Peter completed his BA degree in Fine Art (Painting) at Birmingham Art School. He met a large circle of young artists who became friends there—John Shakespeare, Ann Gall, Martin Rose, Jerry and Jackie Coleman, Paul Martin, and Philip Miles, amongst others. They became a sounding board for Peter's encounter with convictions about life and work and death that greatly amplified the rather pietistic version of Methodism he had known.

John Shakespeare had discovered the writings of the historical Reformers, Luther and John Calvin, the English Puritans, and a new Dutch brand of Reformation philosophical thinking that had no truck with world flight christianity but wanted to gird men and women for redemptive service in the regular world of labor, politics, academics and art. So John Shakespeare arranged through the patronage of David Hanson, who was beginning his medical practice in London, to have this art history professor at the Free University of Amsterdam, Hans Rookmaaker (1922–77), a specialist in Gauguin's art, come give a lecture at the Birmingham Art School.

Rookmaaker was a stump lecturer, popular in manner but thoroughly at home in art-historical detail and method a la Panofsky, with a disarming bluntness about his christian faith, whose hobby was Afro-American jazz, blues, spirituals, pop art, and pop music. The Birmingham academic art historians present at the lecture were nonplussed: how can a matter-of-fact open Christian be an "objective" scholarly authority

on Gauguin and Gauguin's circle? And some of the "Christian Fellowship" students present were disappointed that Rookmaaker didn't try to evangelize anyone or "preach Christ" to the gathering. He just talked about powerful artworks, Utopianism, and the breakdown of Rationalism in modern art.

But for Peter Smith, John Shakespeare, and friends, Rookmaaker's unabashed witness to how a sober, biblically christian faith can bring insight to art-historical matters—and ground art making as a responsible calling for those who are serious Christians and have the imaginative talent and determination to dedicate their work in love to God and neighbor—was most exciting. You don't have to design tracts for missionaries or confine yourself to constructing art for churches to be a "christian" artist! You just need to love what you paint, sculpt, engrave, dance, or write stories about in God's world, do it well and let your love breathe through the materials you form.

Rookmaaker was wont to prod and tease both unthinking Pilgrims on the narrow road and the cocksure Positivists fellow-travelling the broad road—so pointing to a 1600s painting in the Rijksmuseum of Amsterdam by Pieter Claeszoon, a "still life" that captures the glory of pewter, broken glass, luscious fruit, a crust of bread, and shining goblet of wine with the memento mori of a dead bug, he said, "Now there's a Christian painting!"

After graduating with his B.A. in Fine Art (Painting), Peter Smith married Carol Longden in August 1969 and headed to Manchester College of Art to do a one-year Postgraduate Certificate in Education. That year Peter arranged for Rookmaaker to come lecture at Manchester College of Art. Peter was now stimulated to read the Dutch Henk van Riessen's translated *Society of the Future* (1952), Schaeffer's *Pollution and the Death of Man: a Christian View of Ecology* (1970), and Rookmaaker's writings, especially "Modern Art and Gnosticism" (1973).

There were so many ideas, trends, artistic styles, and contemporary controversies to sort out! If you took Kandinski's paintings and book *Concerning the Spiritual in Art* (1912), which cribbed from Madame Blavatsky—Peter Smith made a study of this—what does it mean for doing art? Should the English landscape tradition updated by Ivon Hitchens (1893–1979), John Piper (1903–92), and Graham Sutherland (1903–86), which appealed to painter Peter Smith, be considered passé backwater because Abstract Expressionism and Greenberg-induced Minimal Art of New York made-in-USA was the 1960s rage also in British art

colleges? The visual language of nineteenth-century Courbet "realism" or the diversionary tactics of the Pre-Raphaelite painters is not the way for forward-looking Christians busy with art to go if they want to be taken seriously in the postwar era of the Beatles, is it?

When Carol and Peter returned to the Midlands in 1970 for a tough job teaching Art at the large Frank F. Harrison Comprehensive School in Walsall, where John Shakespeare was also teaching, "the Birmingham Group" of artist friends continued regular interaction with Rookmaaker when he lectured in England. Rookmaaker's message for young artists was not prescriptive. His Reformational wisdom, however, had a definite thrust: (1) Renounce the Romantic notion (Shelley) that artists by definition are prophets who will herald, if not legislate, a brave new world; (2) deal imaginatively with the ordinary creatures around you—they have hidden glories; (3) make art that speaks to anybody rather than art enclosed within the jargon of a christian ghetto.

While the small group of Birmingham friends wrestled with the Calvinian/Kuyperian directives popularized by Rookmaaker, Peter Smith had become Corresponding Deacon for Midlands Road Strict (and Particular) Baptist Church. He also had his first two-man art show with Jerry Coleman at the E. M. Flint Gallery in Walsall. Peter taught Art full-time for two years at Frank F. Harrison (1970–72), and then halftime for two years (1972–74).

The following position Peter Smith received (1974) was in nearby Dudley at Park Boys Secondary Modern School of 200 plus boys and ten teachers. At the same time he began his Night paintings.

Rookmaaker always said, "Paint what you know and love." Peter became fascinated when driving the motorway around Birmingham at night: the dark attractive curve of the road, mysterious dots of light in the distance, temporary road signs covered prior to use, the dangerous comfort of being alone while driving. The paintings became glimpses of reality with which people could identify. Peter's Night paintings were popular in the 1975 exhibition "From Birmingham," which he organized at the Free University of Amsterdam, on suggestion of Rookmaaker, for himself and painters Paul Martin, Martin and Kate Rose, and Jerry Coleman, ceramist Jackie Coleman, and jeweler David Secrett. Philip Miles designed the poster to advertise the event.

In 1977 Peter Smith was awarded the first Fine Art Fellowship provided by the Arts Council of Great Britain in the West Midlands area. The Fellowship was linked to the Dudley Education Services: two-thirds time in one's studio, one-third time spent working in schools. The Fel-

lowship worked so well it was extended a second year, in which Peter had time to do etching and printmaking with Kim Kempshall, then Head of Printmaking at Birmingham Polytechnic. And it was in 1979 that Peter's interest in wood engraving was sparked, just about the time he accepted the post at Brooklands Technical College in Weybridge, Surrey, to set up a printmaking department for them. At this time also, Carol and Peter's family was beginning to come into the world: Zillah (1977), Alec James (1980), and Jacob (1983).

The quiet voice of Peter Smith in wood

Like many other wood engravers, Peter Smith is self-taught. Wood engraving has been largely neglected at Art Colleges in England for at least two generations.

Browsing in a bookshop in 1979 Peter came across Walter Chamberlain's *The Thames and Hudson Manual of Wood Engraving* (1978). He bought the book, sent off for four pieces of box wood and three tools, and made a start. His boyhood training in wood working stood him in good stead. The first engravings he did were hand burnished and later on printed on an 1846 Albion Press run by hand. His wood engraving *Leaving* (1984) [#68] was accepted for the open exhibit of the Society of Wood Engraving that year. So began his tourney in this exacting, unpopular but modest, people-friendly artistry.

[#68] Peter Smith, *Leaving*, 1984

Coming to wood engraving as a painter, Peter Smith gives three-dimensional depth to his wood-engraved prints. There are frequently gentle curves in the composition that lead the viewer's eye back into the underground tunnel or past the foregrounded figure. The angle of the cut logs, the reflection of the teddy bear, the two rounded corners of the "baptism" print itself, ensure that there is never just a silhouette but always an object in a background setting too. Such a compositional "landscape" format is a trait found generically in the art of Bewick, Gwendolyn Raverat (1885–1957), and others, but quite unlike the bold frontal presence with which Blair Hughes-Stanton (1902–1981) typically faces the viewer.

Peter Smith's centered objects are placed in confining spaces—a tub, a room, an underpass, a patch of ground. Human figures are seen from the back or in profile, and are entering, exiting, or waiting soberly, patiently, for whatever is to come next. There is vivacity but no commotion. The bent figure in *Baptism* (1984) is deliberate, and the body under water is not struggling. The commuters leaving the underground [#68] have rounded shoulders from the day's long work, too tired to jostle, just plodding forward. Even the etchings of the 1990s—*Winter Labels, Kew*, or

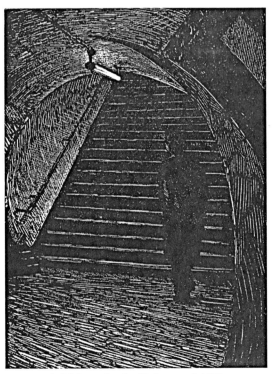

[#69] Peter Smith, *Underground*, 1985

the nature morte named *Broken* (1992)—have a fixed, stationery stolid character that is nevertheless expectant.

Peter Smith's earlier Night paintings (1974–80) probably underlie the darkness to his engravings of persons walking, waiting, or working late, in dimly lit surroundings. The solitary dark figure in *Underground* (1985) [#69] is neither ominous nor forlorn, just minding his business in the shadowy cavernous walkway of stairs. *Underpass* (1985) has three figures and an off-perpendicular black frame. The uncharacteristic engraving marks fleck the scene with soft friendly lighting, but the scene is dark enough for a person to be not too comfortable among strangers who are walking in step behind you. *Waiting* (1984) has the same ambiguity: there are no cross-hatching marks, but the grays gentle the environs, so the figure is not threatened but is poised, somewhat hesitant to move.

Doorway (1985) [#70] captures best, perhaps, the ambiguity of these darkling enigmas: the figure is not a stalker but is more of a flâneur in this rather uncertain architectural assemblage, facing the outdoors where there are trees, a light in the sky, and other distant doorways to enter. In *Doorway* there are not the sharper, rather jagged and forbidding Existen-

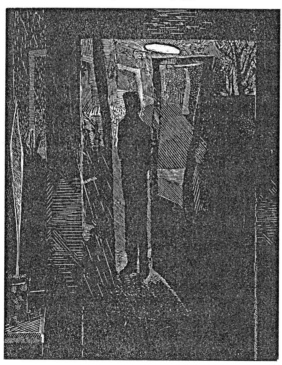

[#70] Peter Smith, *Doorway*, 1985

tialist shapes of Paul Nash (1889–1941). Peter Smith's darkness is not of crisis but is close here not to a brooding dilemma but to an enveloping suspense of mystery—maybe if the fellow steps out he will meet a doppelganger as in a story by Charles Williams.

Mr. Punch (1987) has a grin, a fancy collar, and a pleasant landscape behind his appearance, but most of Peter Smith's engravings are fairly sober. The dried out, cut-off plant stalks in *Winter at Kew* (1987) are not exactly headline news for the *Daily Mail*. But their group portrait is alive with wisps of light grasses, almost like earthy fireworks, showing the stalks they are not forgotten but in relief are being celebrated! The wood engraving *Seedling* (1992) and soft ground etching *Shoot* (1992) echo the same point: there can be light out of darkness, new life miraculously out of a dead stump of wood, a sprightly weak sprig in a flower pot next to large shards of discarded earthenware. It is a recurring leitmotif in Peter Smith's oeuvre: *Demolition* (1987) and *Remains* (1992) testify that what is left for refuse, the remnants of destructive human activity, have their own story to tell. Even Peter's "abstract" etchings, which remind one roughly of Monica Poole's (1921–2003) fossil forms, are titled *Broken* (1992), *Discarded* (1992), and *Fragments* (1992). Leftovers are valuable too in his eyes; broken pieces reflect glints of light and reward attention that is not sentimental or morbid but simply inquisitive. Like those *Chapel Flowers* (1992) and etchings of ungainly clumped re-arrangements of spindly stems and blooms, they call to mind British poet Alice Meynell's lines in "To a Daisy": *"O daisy mine, what will it be to look /From God's side even on such a simple thing?"*

Working Late (1986) [#71] is my favorite print and sums up for me the rich quality and humanly warm outreach of Peter Smith's wood engravings. His *schlicht* style, as you would say in German, his "unpretentious" low-key style has a strict and particular austerity to its horizontal-vertical boxed regularity of a frame, yet there is gentleness in the markings of so many different sorts. The barred window through which we look into the room where the seated figure is bent earnestly over his work at the large desk is not a barrier, but is softly inviting us to take a closer look. Artist Peter Smith uses the intimacy of the wood engraving medium to tell us without words that we are entering a retreat, a simple place of studied quiet. Working late is not waiting for Godot but is being faithful in one's assigned service.

I would describe the spirit that breathes through all of Peter Smith's wood engravings, etchings, and drawings, as a spirit of chaste, quiet wonderment. There is no place in his artwork for the provocative or

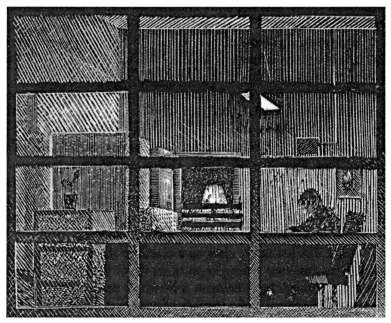

[#71] Peter Smith, *Working Late*, 1986

querulous, the sensational or sophisticatedly parodic. There is a sense of traditional order that is not old-fashioned but that is reliable. There is modesty in Peter Smith's artistry, a winsome homeliness that half-knows you are really courageous when you are fearful but carry on doing what is needed. He has the copious imaginativity to see not "sermons in stones" nor "a World in a Grain of Sand" but a well-tempered sound of steady, arresting hopefulness in whatever transpires around us. I find intimations of quieting peace in the artwork: no jubilation, no laments, but a strong trusting expectation that all our troubles and uncertainties will not end in melancholy but may anticipate *Light in the Garden* (1994) we tend.

In 1983 Peter Smith became Head of Art at Kingston College in Surrey. Under the new Principal, Arthur Cotterell (in charge, 1984–2005), Peter was encouraged to expand the Art program so that when the College moved certain courses to new quarters in 1995, the fine old Edwardian building was free to become the new base for Art and Design, which has become Kingston College's School of Art, now with some forty staff and over 500 students. Peter Smith's managerial talents and time are taxed to the limit. He was still able to achieve a post-graduate M.A. diploma in printmaking (1989–92) at Wimbledon Art School working

with Brian Perrin, and also stone lithographer Simon Burder, with Jane Joseph as personal tutor. And wood engraving?

After the great storm of 16 October 1987 Peter went to draw the mayhem of uprooted trees and destroyed vegetation in Richmond Park. A large charcoal drawing he did of the destruction was shown in his one-man show at Alba Fine Art Gallery in Kew, 1988. Seasoned wood engraver Edwina Ellis (b. 1946) saw the drawing, bought it, and talked with Peter who said he was engraving the piece too. Edwina had been commissioned by the Society of Wood Engravers, with four others— George Tute, Peter Reddick, Claire Dolby, and Monica Poole—to do a folio edition of prints as a memorial for the devastation of England's trees. In an act of pure-hearted generosity Edwina Ellis was able to give her commissioned spot to Peter Smith. Making good on Edwina's great gift Peter's stunning *Fallen Tree* (1989) [#72] is the result.

Fallen Tree lets us see close up a chunk of the massive trunk of a magnificent tree, now resting in peace gently on the impacted ground, cleanly cut through by a chainsaw. A bit of sky and a brush of trees fill the upper background, and a few twisted twigs in the narrow foreground dance at the death of this huge, heavy, wonderful creature. The age-old bark is honored with various intricate engraved patterns, shining almost like the ribbons on chests of war veterans. And the two mighty sections of trunk kiss discretely across a hairs-breadth chasm of air backlit by wondrous light. We see the stillness after the storm. *Fallen Tree* is a requiem. A tree as impressive as the cedars of Lebanon, the Psalmist would say, has been broken by the sevenfold voice of the LORD God (Psalm 29:5). And it is terrible. So be quiet and awed, little man and woman. Even mighty trees, which usually live longer than we humans, can become fallen. And then we who survive are bereft, as Gerald Manley Hopkins phrased it: "*What would the world be, once bereft / Of wet and of wildness? Let there be left, / O let there be left, wildness and wet; / Long live the weeds and the wildness yet.*" In a very orderly way Peter Smith's *Fallen Tree* echoes the deep-seated wish of many for the great trees of England and the wildness to be left yet.

In 2004 Peter received a commission from Tate Britain to engrave a 4"x 4" wood block of a flower that could accompany a small side-gallery exhibit of Victorian illustrations engraved by the Dalziel brothers. In line with their educational policy, curator Heather Birchall of Tate Britain and Sarah Hyde, Head of Interpretation, wanted a set of proofs and the actual wood block for people to touch, handle and examine, to get a

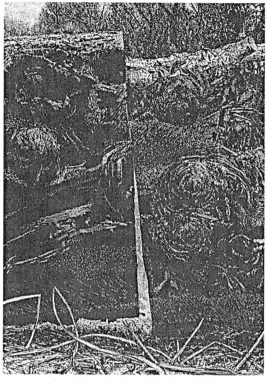

[#72] Peter Smith, *Fallen Tree*, 1989

sense of the incredible skill needed in the wood engraving process. Peter's lovely animated *Peperomia* (2004) met the public block-in-hand at the Tate for a whole year. It was a wonderful way for him to carry on concretely the vision of Pieter Claeszoon bespoken earlier by Rookmaaker.

The artistry of wood engraving is not an endangered species so long as a community of painstaking, skilled, imaginative artists like Peter Stanley Smith take the time—can find time!—much time, to engrave wood for neighbors to give them eyes to see and ears to hear with quiet wonderment the marvels hidden and waiting to be discovered in ordinary things and daily occurrences.

The sense of wood engraving in our day is to give those who are inundated by noise and pushed silly by routine and deadlines, weary of the pell-mell speed and incessant din hemming us in, a respite, a pause for reflecting thankfully on our being dated and located human creatures.

Selected background sources

Ainslie, Patricia and Paul Ritscher. Introductory essays. In *Endgrain: Contemporary wood engravings in North America* (Mission, British Columbia: Barbarian Press, 1994/1995).

Barstow, Kurt. *The Gualenghi-d'Este Hours: Art and devotion in Renaissance Ferrara* (Los Angeles: J. Paul Getty Museum, 2000).

Brett, Simon. *An Engraver's Globe: Wood engraving world-wide in the twenty-first century* (London: Primrose Hill Press, 2002).

———. *Engravers: A handbook for the nineties.* Compiled for the Society of Wood Engravers, with an introduction (Swavesey, Cambridge: Silent Books, 1987).

———. *Engravers Two.* A handbook compiled for the Society of Wood Engravers (Swavesey, Cambridge: Silent Books, 1992).

———. "Wood Engraving." In Archie Miles, *Silva: The tree in Britain* (London: Ebury Press, 1999), 316–25.

Chamberlain, Walter. *The Thames and Hudson Manual of Wood Engraving* (London: Thames and Hudson, 1978).

Farleigh, John. *Graven Image: An autobiographical textbook* (London: Macmillan, 1940).

Garrett, Albert. *A History of Wood Engraving* (London: Bloomsbury Books, 1978).

Hamilton, James. *Wood Engraving and the Woodcut in Britain c. 1890–1990* (London: Barrie and Jenkins, 1994).

Harbison, Craig. "Introduction to the Exhibition," printed with an earlier lecture delivered by Erwin Panofsky, "Comments on Art and Reformation" [1960]. In *Symbols in Transformation. Iconographic Themes at the Time of the Reformation: An exhibition of prints in memory of Erwin Panofsky* (Princeton: The Art Museum, Princeton University, 1969).

Jaffe, Patricia. "Taken by Storm." *The National Trust Magazine* 69 (Spring 1990): 37–38.

Lindley, Kenneth. *The Woodblock Engravers* (Newton Abbot: David and Charles, 1970).

Moxey, Keith. *Peasants, Warriors, and Wives: Popular imagery in the Reformation* (London: University of Chicago Press, 1989).

Rookmaaker, Hans R. *The Complete Works of Hans R. Rookmaaker*, 6 volumes, edited by Marleen-Hengelaar-Rookmaaker (Carlisle: Piquant, 2002–03).

Seerveld, Calvin. "God's Ordinance for Artistry and Hogarth's 'wanton chace.'" In *Marginal Resistance: Essays dedicated to John C. VanderStelt*, ed. John Kok (Sioux Center: Dordt College Press, 2001), 311–36 {supra pp. 197–222}.

———. "Telltale Statues in Watteau's Paintings." *Eighteenth-Century Studies* 14:2 (Winter 1980–81): 151–80 {supra pp. 171–195}.

Selborne, Joanna. *British Wood-Engraved Book Illustration 1904–1940: A break with tradition* (Oxford: Clarendon Press, 1998).

Wieck, Roger S. *Painted Prayers: The Book of Hours in medieval and renaissance art* (New York: George Braziller, with the Pierpont Morgan Library, 1997).

Many conversations and lengthy correspondence with artist Peter S. Smith.

REDEMPTIVE GRIT:
THE ORDINARY ARTISTRY OF
GERALD FOLKERTS

Dutch-Canadian, of Midwestern Winnipeg, an ordinary follower of Jesus Christ: this is perhaps the most succinct way to situate the artist Gerald Folkerts. Readers may ask, "Can any artistic good come out of Winnipeg?"

Come closer. Take a look.

Winnipeg, Manitoba, is not like Bible-belt Alberta, but is hard-working Mennonite farming country. Under God-blue skies, its utterly flat, expansive plains of ripening grain are as overwhelming as the "America the beautiful" of the Dakotas, Montana, and Wyoming. Nothing fences you in except myopia.

The Canadian prairies are the original stomping ground of Metis Indians, immigrant Ukrainian Catholics, and the ubiquitous followers of Menno Simons, who fled persecution in Russia via Canada to South America. The cultural lay of the land is not Wild West, but Midwest. People come here to settle, raise families, do honest labor, and take their Sabbath rest, all far from the madding crowd. Also far from the established art center of Toronto, the avant garde beat of Quebec, and the theater-cinema-youth circles of Vancouver, not to mention the sophisticated "artworld" of New York City. Winnipeg today, a city of 640 thousand at the center of Canada, still has a rural feel and mentality. Here is an open-hearted small-town environment where hospitality is a native virtue.

A frank, homespun, and no-nonsense attitude toward art is rather unusual in the western museum world today, but Winnipeg is an exception. The well-respected Winnipeg Art Gallery was homegrown, not instituted from the top down as a provincial branch of the Royal Canadian Academy of Art. It began with the Manitoba Society of Artists, which grew to include an art gallery and school in 1912 and was incorporated by the legislature in 1923. The school's curriculum was rigorous and rath-

This work originally appeared in *Image* 63 (Summer 2009): 51–60. Reprinted with permission.

er Victorian in the early days, but it enrolled amateurs as well as art-career students, offered night classes, and undertook community outreach projects. This inclusive approach became a defining feature of Winnipeg's official attitude toward artistry: "involving people in the visual arts" to enrich the populace at large.

After graduating in 1980 from Dordt, a Christian liberal arts college in Sioux Center, Iowa, with a degree in fine arts and education, Vancouver-born Gerald Folkerts went to Winnipeg to settle down, raise a family, and make a living. There he taught art and Bible courses to middle and high-school youth in schools allied with the Christian Reformed Church of North America. You need to be a husky, six-foot, four-inch tall fellow with a ponytail and survival skills to keep your imagination firing and discipline that age group as they draw and paint week after week, year after year. But teaching studio art to a younger generation is probably more allied with art-making, if that is your calling in life, than waiting tables in a restaurant. In the old days in Holland, Vermeer brokered paintings to earn part of his keep and let his mother-in-law pay the rest of the bills, while Jan Steen ran a tavern. It was not until 1988, when Folkerts' wife Arlis, after bearing four children, found a consulting job troubleshooting for the Manitoba Department of Education, that Folkerts could start doing art full time.

During these early years Folkerts made many drawings. These meticulous, time-consuming one-off pieces offer carefully composed graphic narratives. As when you tell Bible-stories to children, when you draw in pencil, you highlight details that fascinate and make the main points memorable.

A Double Portion (1987) [#73] shows Elijah being tornado-funneled up to glory in a fiery chariot with flaming horses, finishing his earthy stay tumultuously, the way he lived it. The planets and stars through which he passes twinkle like little Christmas tree ornaments, and the big black ravens God once used to feed the discouraged prophet fly ominously below, like huge bombers over the curved face of the earth. Scrawny Elisha stands there, before a Hokusai wave through which he must pass, seeking a blessing, ready to catch Elijah's fallen mantle. The whole complex scene is rendered in a straightforward fashion. The extraordinary incident is pictured with simple wonder but without mystical intimations. Heaven and earth are of a piece to the eyes and consciousness of a believing child.

Good Friday (1989), [#74] another graphite piece from this early period, is storytelling for grownups. In imitation of the famous (staged)

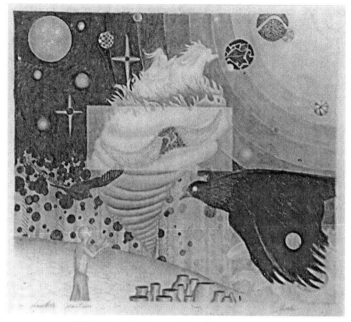

[#73] Gerald Folkerts, *A Double Portion*, 1987

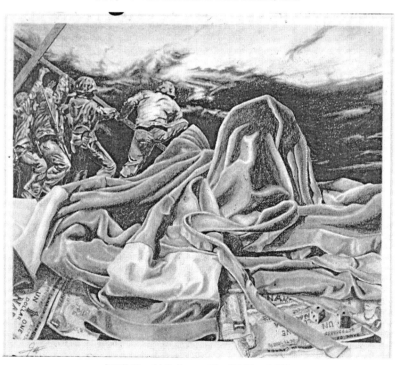

[#74] Gerald Folkerts, *Good Friday*, 1989

raising of the American flag on Iwo Jima during World War II, Folkerts' drawing shows the iconic soldiers raising instead of the flag, a cross. Dark, rocky soil occupies the background, while the foreground is filled with a close-up of the disheveled, seamless tunic Jesus is said to have worn. Dollar bills lie beneath the huge garment, and a pair of thrown dice rest upon it, showing snake-eyes. It doesn't take too much pondering to sense the banality of evil here. Soldiers may die in worthy wars or do the dirty work of unjust governments, but the professional military life is mostly boring and sordid. While the soldiers are American, the dollar bills are Canadian. Like a morality play, the piece quietly implicates everyone who condones violence, any country that exports weapons, as complicit in the crucifixion of Jesus Christ.

The early drawings are a tour de force in pencil. The fact that they tell stories does not make them illustrations. A good illustration is worth its salt, too, but there, artistry is willingly subordinated to the literate communication it accompanies, enhancing and complementing a text, like a poster. But in my book only a drawing that tells a story by itself, like a song without words, that keeps the graphic note uppermost so the tale stays ambiguous, musters the imaginative cachet to qualify as art. You don't need an allegorical overlay to convert a heap of linen cloth into art. In portrait, Christ's soiled tunic, its twists and turns, modulated fuzzy grays, shadows and whites, sits at center stage like a *memento mori,* whispering of death.

At the time Folkerts made these drawings, narrative graphic art was out of fashion. In the fifties, New York critic Clement Greenberg had been influential among mainstream Toronto artists, and in Canada the New York School was promoted as a progressive trend one could be part of in order to avoid parochialism. In the late seventies while visiting Toronto, Greenberg still intoned ex cathedra that any serious artist had to go to New York, where the real action was. Folkerts missed all this overly serious art-school fervor. He came out of a good Christian liberal arts college milieu and was content to tell stories with a pencil. He did not have to come to terms with a lot of fashionable art-school baggage and could simply make drawings about what seemed important to him. It's a bit like not needing to decide whether to write poems like T. S. Eliot's footnoted "Wasteland" or "Howl" with Allen Ginsberg: you just compose soft-spoken verse like Emily Dickinson.

Another drawing, *Mama, Waar Bent. . . ? (Mother, Where Are You?)* (1990) spotlights a little child entering a huge, dark barn looking for his caregiver, who has hanged herself from the broad wooden beam which

holds the barn walls together. The carefully drawn horizontals and verticals and vanishing-point perspective tone the melodrama down to a gripping rural tragedy. Like Robert Frost's "The Death of the Hired Man," *Mama, Waar Bent. . . ?* is unmistakably regional, but it reaches out and touches humanely whoever has known hardship and loneliness. Art that is locally rooted but universal in its awareness of life's troubles has been a hallmark of Winnipeg's tradition over the last century. Folkerts' painstaking early work found a cultural home in this regional setting.

The Fred Reinders Consultant firm, when it remodeled a high-rise apartment building in Edmonton, Alberta, into the King's College campus, believed that artwork was part and parcel of educational construction. So for the building's interior they generously commissioned a series of Folkerts' paintings dealing with the creation of the world. Folkerts called it the *Alpha* series, eight oil paintings on mahogany panel, each four by four feet, one for each day of the biblical Genesis account (and one before the creation began). Quite naturally the topic led to nonrepresentational work, since the primordial chaos does not have much of a contour, even after it is illuminated by God's command. And it takes ingenuity to picture the mess of waters separating into manageable clouds, seas, and rivers, while the earth brings forth vegetation, colorful flowers, ganglia of cells, spermata, bacteria, and creeping creatures. Only with the creation of humans—Folkerts inscribes his own naked form on the face of one of a scramble of toy blocks in *Alpha 6*—do we approach perceptible formed objects. *Alpha 7* portrays someone resting in a stuffed green armchair, reading a book entitled *Wonders of the World*, celebrating the Sabbath and the feat of God's alpha Word in action.

This commission was important in Folkerts' development. First of all, it was a vote of confidence that he could provide professional quality art and be paid a fair price for his labors. Second, the idea of a series honored his bent for narration, while giving him time to depict the meaning of different connected events. Third, it led to his trademark brushstroke of oil-paint dabs, chips, and jumbled slabs (done with a brush, not a palette knife) somewhere in between German Expressionism and Seurat's pointillism.

As *Study for Alpha 3* (1992) [#75] shows, the painting is composed of deliberate strokes loosely juxtaposed. The colors seem at first to be placed randomly, but you soon sense that the strokes are intuitively ordered. A couple of plant shapes materialize. We see leaves, sunlight. Definite planes, panels of color, and segments guide the viewer's eyes. The

[#75] Gerald Folkerts, *A Study for Alpha 3*, 1992

whole is pleasantly geometric, but with an organic feel. There is little buildup or layering of applied paint. The spots of yellow and green are like raindrops, petals, and reflections, while the darker orange and brown are earthy. The unreworked, splattered character of the dabbed paint provides excitement and brightness to the whole, so you tend to overlook the minute attention each piece of brushed paint demanded.

What strikes me about Folkerts' pieces is the workmanship in evidence, but also the playful qualities of surprise and elliptical reference. I take art to be a well-crafted artifact or act distinguished by an imaginative quality whose nature is to allude to more meaning than what is visible, audible, written, or sensed. For me, the first requirement of artistry is skilled formation in a medium (paint, voice, words), and the last requirement is a subtle quality that permeates the whole object or event with an engaging metaphorical coagulation of nuances. The first requirement keeps fine art related to artisanship. The second asks that the defining imaginative nuancefulness be embodied, ingrained in the object, that it inhere the enactment itself, rather than be merely attributed to it by a reacting subject. Folkerts is a master of this ordinary artistry. His nononsense approach to his materials is deeply engrained in the artifacts he creates, with their plurisuggestive meanings. Here is no metaphysical gasconade with a pretentious title, no hint of a literary analogue: it is

simply *A Study for Alpha 3*, a laughing, early burst of colored paint that breathes organic life.

After Folkerts was able to devote himself to painting full time, he produced a series of good-sized oil paintings, *Restless Slumber* (1999-2002). These works delve into a deeply human phenomenon that is also shared with animals and even plants. Shakespeare's Macbeth calls sleep "the death of each day's life, sore labor's bath / balm of hurt minds, great nature's second course / chief nourisher in life's feast." Folkerts' own analysis of the series is this:

> *Restless Slumber* is a body of work in which sleep is used as a metaphor to probe the uneasy tension between providence and what humanity experiences on a daily basis: life's vulnerability. Personal experience would suggest that each of us is one death, one sickness, one lost job, one encounter with brokenness away from living in a wilderness of despair where all that once suggested stability seems shallow and insecure. *Restless Slumber* is an attempt to explore and contemplate the brokenness that exists within each of our own realities. . . . Through the portrayal of sleeping figures, the *Restless Slumber* paintings probe the tension between our longings (to be safe and secure) and what we know (that brokenness is inescapably part of life).

An early painting in the series draws on the nuclear disaster that took place it the Ukraine in 1986—*Chernobyl Nightmare* (1999) [#76]. Working with a model, Folkerts portrays an unclothed woman asleep

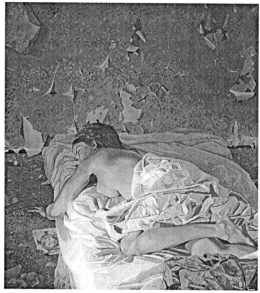

[#76] Gerald Folkerts, *Chernobyl Nightmare*, 1999

on a cot under rumpled sheets. The paint on the shabby walls is blister-
ing because of past nuclear heat. The purple shadows on the woman's
exposed back, arm, face, and legs do not look healthy. Her hand seems to
grasp the gravel floor for support—or is she reaching for the little bottle
of pills? An Orthodox icon of John the Baptist lies on the floor, half
under the mattress, perhaps for nightly prayers—a rather wan token of
protection. The air is deathly still. The sense of the woman's vulnerability
is overwhelming. She is asleep alone, "dead to the world," unsuspecting
of lethal invisible particles in the air. The painting's balanced design, the
lack of any climactic focus, the overall dull purplish and gray coloring,
the collapse of background into foreground—all contribute to an aura
of stillness, of being forsaken, forgotten by everyone—except the artist,
who caresses the supine figure with care, remembering the disaster by
quietly noticing the aftermath, well after the media have gone on to look
for more headlines.

Folkerts writes:

> I believe it's exactly in the kind of world in which we live today that God
> calls God's people to artistic faithfulness with a renewed sense of urgency,
> because our art may be (certainly not by itself!) one significant ingredient
> in a soothing ointment that God would use to heal the aching wounds
> which fester deep in the very heartbeat of a world that more often looks to
> economics, science, and technology for some kind of salvation as it teeters
> on the edge of despair.

The *Restless Slumber* series ranges far and wide as resolutely figurative
art. Just as rhyme and rhythm give a level of density to formal poetry that
is not available in blank verse, human figures in paintings allow view-
ers—if they take the time to look imaginatively—to reach for deeper
resident meanings, it seems to me, than can be offered in, for example,
color-field painting or optical art. Good figurative art is people-friendly
and draws a viewer into what Pascal called "the glory and misery of hu-
mans" in God's world.

Anniversary #31 (2000) is an amazing tribute to faithful marriage
[#77]. A diptych of two four-by-four-foot canvases shows in close-up
the sleeping heads of a husband and wife, each in a separate panel, he
wearing a grotesque sleep-apnea apparatus, and she curled, fist to her
cheek, also in deep sleep. The air cable from his machine, like a convo-
luted green snake, joins the diptych in the background and coils around
her neck. A ghastly purple hue delicately saturates the scene. Indeed,
thirty-one years of sleeping together is a commitment made for better
and for worse. The utterly unromanticized, true-to-life exposure of hu-

[#77] Gerald Folkerts, *Anniversary #31*, 2000

man intimacy touches, astounds, causes a double-take. This is nothing like Francis Bacon's angry, slashing disfigurement of the human form. Instead, like the wise man of Ecclesiastes, the painter gently picks up the pieces of human travail.

Weariness brings on sleep too, as an impressive four-by-five-foot

[#78] Gerald Folkerts, *Unfinished Business*, 2000

canvas titled *Unfinished Business* (2000) shows [#78]. This is an art painting about the manual labor of paint-roller painting—in fact, of painting over an old wall. The tall, tired worker in this self-portrait sleeps somewhat precariously on a board supported by two ladders. The job is not done. Under one of the ladders lies an overturned bucket of yellow paint, making a mess. But the painting is carefully ordered, every angle of the shadows calculated. Folkerts' style is too forthright to be ironic; the overturned bucket emblem is more epigrammatic than ironic. *Don't cry over spilled paint,* it seems to say. *Clean it up, and keep working.* The image of the sturdy lone worker in his fatigue seems close to the spirit of Matthew's Gospel: "Well done, good and faithful servant; enter into the joy of your lord."

Two of the *Restless Slumber* series deal with dreaming, that private fold of consciousness in which we wrestle with fears, desires, and memories unresolved in waking life. The smoking, flaming fires in *The Watcher* (2001) immediately catch the eye [#79]. Then you see the dark, silhouetted figure of a man. His back to us, he leans on a shovel, watching the many backfires he has set to control the burning of the acres of farmland he faces. In the darkened foreground you notice a reclining, naked, full-breasted young woman. She is not quite a pin-up girl, also not quite real;

[#79] Gerald Folkerts, *The Watcher*, 2001

she is, however, an erotic presence behind the back of the man watching the field of fires; he does not look at the largest fire closest to the vulnerable woman. It is an intriguing painting, both accepting and critical of the way erotic desires can run wild in men. The placement of the shovel handle in relation to the woman's body is not accidental. The vivid jumble of nervous brush strokes—full palette—energizing the furrowed fields, burning embers and flash fires, seem to engulf the stolid, grim, silhouetted man in a graphic ancient proverb:

> Can a man take fire in his belly and his clothes not be burned? Can a man walk on burning coals and not have his feet roasted?

Folkerts was elected president of the Manitoba Society of Artists in 1999, and began to win first prize in their annual open juried exhibitions with embarrassing regularity (in 1999, 2002, 2004, and 2006). You become a professional artist, I think, not so much when you have an M.F.A. in hand as when you can play with the fundamentals of your task and consistently produce something worthwhile. A good amateur can upon occasion throw a strike, while a professional comes through with solid results even on bad days. The *Restless Slumber* series testifies to Folkerts' hard-won credentials.

Waiting for Eternity (2002), [#80] the last painting in that series, is

[#80] Gerald Folkerts, *Waiting for Eternity*, 2002

an exceptionally strong, painterly piece in which vigorous underpainting seems to work toward a practically monochromic amber color. An almost life-sized figure is caught diagonally, as if running a race, suddenly entangled in a web or resinous netting. The inert person is enmeshed—embalmed, you could almost say—in the fabric, a kind of friendly winding sheet, since the painting does not have an ominous cast. It is not as if prey has been trapped, more as if a treasure has been saved, protected, and reverently stored. A fitting comment would be the Apostle Paul's remark to those who were confronted with the upsetting tact that believers in Jesus Christ's resurrection power apparently still died: "Don't worry," he wrote to the Thessalonians. "They are just sleeping." And that aura of security and peace does emanate from the work.

A companion piece to *Waiting for Eternity* is a little nonrepresentational construction entitled *Half-moon Dance with Ball and Chain* (2002) [#81]. Each of the ten large paintings in the *Restless Slumber* series

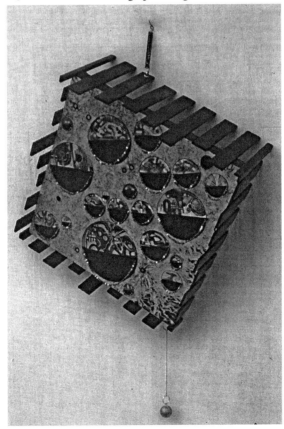

[#81] Gerald Folkerts, *Half-moon Dance with Ball and Chain*, 2002

has a small, complementary, nonfigurative painting next to it, composed of the palette pigments left over from the main painting. What started out, in good thrifty Dutch fashion, as a way not to waste good paint became a way for Folkerts to fool around imaginatively and loosen up the tightness of his usual style. Folkerts thinks these abstract offerings are where his personality shows up most clearly. I myself see them as wholesome attempts to exhale, to come up for a breath of fresh air, to laugh out loud a minute before continuing to grapple with what is at stake in God's troubled world: life, or death.

Half-moon Dance with Ball and Chain is a delightful contraption that looks like a tilted dance floor on which half-circles, outfitted with necklaces of beads, are crowded together like bumper cars at an amusement park, ready to dance and fling off their inhibitions. But the ball and chain are present as restraints. Viewers are encouraged to pull down gently on the ball, because the chain above is actually a spring. When one pulls, the whole dance floor is animated, and the necklaces pleasantly shimmy. The piece is a lovely *memento vitae* for anyone who feels shackled by killjoy customs of a faith tradition.

Folkerts' last major undertaking was a series of large works called *Head over Heels*—as God is head-over-heels in love with us human creatures. Only heads and feet are painted, sometimes in diptych or triptych, at other times as a single canvas, in vivid, sometimes even lurid dashes of brushed color. The faces and bare feet (or in some cases, shoes) deftly set up in-depth character studies: a worn face and battered shoes tell a story. Folkerts' portraits give voice to those who have trouble speaking, or to whom nobody else is listening.

Young *Brendan* (2003) holds a fistful of rocks in an alley; tangle-haired *Timothy* (2004) broods, drinking pop on a park bench, holes in the soles of his shoes; wrinkled *Monty* (2004) with bulbous nose, paint-splattered sneakers, and malformed feet waits to he hustled away; bedridden *Toni* (2006) suffers quietly, confined indoors; imperious garbage-picker *Daryl* (2006) stamps confidently through refuse in an ashen dump; pain-stricken *Carol* (2007) stares ahead unseeing; farmer *David* (2007) has been untimely pulled clean out of his work boots and is gone with the wind; wizened *Richard* (2008) presides in his wheelchair on a street corner. It is not a rogues' gallery, but a generous tribute to a raft of outsiders, persons who for one reason or another do not fit into regular society. Each has been ostracized by antisocial behavior, sickness, poverty, a disreputable occupation, or a crippling handicap, segregated by who knows what fault or unfortunate event.

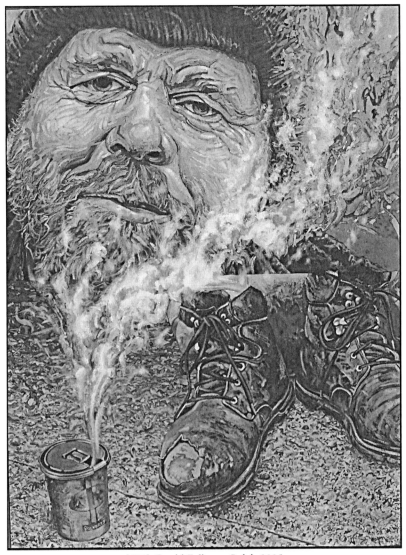

[#82] Gerald Folkerts, *Ralph*, 2005

My favorite portrait is *Ralph* (2005) [#82]. His sorrowful eyes ask for commiseration and pity, and his scruffy shoes witness to his plight. But Folkerts' artistry ennobles this homeless man, giving him the benefit of the doubt after hearing his story that his wife kicked him out of the house a half year ago: a glorious rainbow of lavish paint brightens the sad face, and the steam from the lowdown Tim Horton's cup of coffee at his feet rises, hinting that perhaps Ralph, too, will undergo an as-

sumption out of his miseries. Whether the poor fellow is culpable for his situation or a victim of complicated circumstances, Folkerts does not judge. Instead, he dispenses imaginative attention as a friendly benediction. Maybe this is what a professional artist whose wife brings home the bacon feels need of too.

In *Head over Heels,* it is as if the lone, fitful sleepers of *Restless Slumber* are now awake in the vicissitudes of daily life. The *Head over Heels* paintings offer their own graphic beatitude: *Blessed are the derelicts and left out persons, for such characters are all unforgettable to God,* they seem to say. And we respectable ones should not forget the excluded either; the outsiders, the leftovers of humanity, are not negligible. Folkerts visited and talked with each of these misplaced people on location. They are people with names, who deserve to be taken seriously as neighbors. These buffeted people can teach us that the Lord of the universe does indeed provide for his creatures through thick and thin, prosperity and poverty, wellbeing and woe. And as Paul writes to the Galatians, when you love your neighbor as yourself and shoulder your neighbor's burdens—even simply by listening—you are fulfilling the law of Christ.

I find the vision of the world underpinning the work of Gerald Folkerts to be as large and inclusive, as sharp-sighted and relevant as the cosmos of the biblical psalms. There are fascinating sights, enigmatic histories, subtle temptations, untold possibilities, exuberant and sorrowful incidents to be noted—and these things can be taken by the faithful with a measure of equanimity. God's providing care absorbs both tragedy and comedy. In Folkerts' art, life is ruled not by struggle against failure, but acceptance of one's lot. The very compositional design, the placement of configuring lines, the expressly chosen rainbow of colors all bespeak not resignation but a basic openness and trust that all things shall work for the good of those who please God. Backgrounds seem to coalesce with foregrounds. Figures appear close up, hiding nothing. All this gives a paradigmatic, quieting settledness to the stories being told, including the failures. Faith in God's gracious sovereignty is simply normal in Folkerts' artistic purview, unselfconsciously assumed as basic, not something to be worn like a badge or medal. That rooted confidence in God's guiding hand gives a fundamentally reserved peace to all Folkerts' work.

A loving, diaconal spirit permeates the drawings and paintings, an unobtrusive gratitude for the ordinary gifts of being human. There is no straining to elevate art into a vehicle for transcendence, to make it sacramental or give it liturgical overtones. The work's aura is not narrowly

devotional or meditational, but its spirit is one of reformation, deeply aware of both creaturely glories and societal shortcomings. But Folkerts' work doesn't preach. It remains oblique and allusive, though intelligible. This art does not reach for heavenly ecstasies or mountaintop experiences of the numinous holy, but is content to mitigate earthly sorrows with a painterly embrace, to spread grace upon earth through paint. Folkerts had the wisdom to let his Christian faith subtly percolate in his painting by showing compassion for his problematic subjects. In his work there is a quiet beguilement with the wonders of our world, plagued by troubles. As we look at these images, contemplating the restless sleep or anxious indigence of our neighbors, we ourselves may begin to take on the serious, gentle, non-judgmental, and perceptive approach of the artist.

A special mark of the oil paintings of Gerald Folkerts is their ordinary workaday grit, quite different from most current market-oriented fine art. Folkerts is not caught in any "modernist avant garde" versus "postmodernist potpourri" dialectic. Instead he lived and made art directly out of the vibrant folk continuum of Canadian Midwestern daily life, somewhat as old Netherlandish Vermeer and Breughel did in Europe long ago. Folkerts' art is not about art, but about neighbors, about the marvels and predicaments of our fellow creatures—thank God. Art is not important. It is what an artist does that counts: put paint on canvas to show that he sees and cares for what needs tending in God's world. Folkerts' ordinary, well-crafted paintings spill hope upon whoever looks at them attentively. They document the human burden in a way that is thoroughly unsentimental. From beginning to end, Folkerts' drawings and paintings listen to those neighbors, giving voice to those who are unable or have given up trying to tell their hurts. It's enough to make the angels around Winnipeg break into a canon of rejoicing.

Gerald Folkerts was diagnosed with an inoperable brain tumor in September of 2008. He became progressively more incapacitated and entered palliative care. Over the winter, Canadian songwriter and friend Steve Bell and Anglican priest Jamie Howison, along with Mennonite and Reformed community members, prepared an impromptu retrospective exhibition of Folkerts' work at the Outworks Gallery in Winnipeg, and also produced a full-color catalogue. His friends expected this to be a posthumous honor, but Folkerts rallied and even attended the opening and closing of the exhibit in a wheelchair with his wife and extended family. Throngs of people visited the four-day exhibition—youth, the elderly, believers, disbelievers—and it was promoted by *Christian Week*,

CBC television, and even the professed atheist art critic Morley Walker of the *Winnipeg Free Press,* who spoke up to ask for a miracle of healing. All this testifies to the power of Folkerts' ordinary, neighbor-loving artistry, not confined to the sophisticated artworld. The event had the jubilant, crowded feel of a barn-raising picnic on the prairies. Those in attendance marveled at this foretaste of how, on the new earth, art will not be a precious commodity for gnostic contemplation, but an ordinary shared gift of joy that builds communion.

Gerald Folkerts died on 30 May 2009 at the age of 51.

Advertisement put on kiosks around Winnipeg, Manitoba, 2000

A REVIEW: THE NEW ART HISTORY

The NEW Art History, eds. A.L. Rees, and F. Borzello. London: Camden Press, 1986, 174 pages, £5.95.

This is a handy paperback collection of more than a dozen brief pieces which illustrate where the action is today in the field of art history. There is an edge to the Neo-Marxist, Feminist, Structuralist, and Deconstructivist positions advanced here because most of the writers are on the outside looking in as it were, united in their opposition to the established status quo which runs both British academia and the museum, gallery, and art auction circuit. Every contributor believes that the principles and methods of traditional art history have remained largely unexamined (10). "Art history as a discipline has long been in need of a more rigorous theoretical base" (Pointon, 152). That is what "the NEW art history" (term coined by Jon Bird for a conference at Middlesex Polytechnic in England, 1982) is about: a challenge to the traditional, positivist "notion of the history of art as a value-free discipline" (Gormally and Nunn, 61). "New" art historians are self-conscious of the point of view one has adopted and disbelieve scholarship can be pontifically "objective" (Rees and Borzello, 4).

Art history came of age as a science with Riegl (1893) and Wölfflin's (1915) methodical analysis of artforms. Panofsky and Edgar Wind soon gave evidence that artforms are not hermetic but are signs of historical context and cultural undergrowth (Rees and Borzello, 7). And it is the sociological history of art by Antal, Hauser, and Klingender that serves as precedent for the concerns of "new" art historians (Bird, 33, Overy, 136). The current generation of societally conscious art historians, however, sees art not as a benevolent product critics need to ground historically, but view art itself as a problematic carrier of ideological baggage (Iversen, 84). You do not do art history as if it were untouched by actual political power, entrenched positions on man-woman relations, and the reality

First published in *Journal of Aesthetics and Art Criticism* 45:3 (1987): 313–314.

of which piper pays the tune, if you are doing art *history* (Bann, 28-29). That is why E. H. Gombrich is a problem today: his practice shows a staggering, culturally conversant knowledge of the past, but he preaches the disembodied eye (Burgin, 47; Pointon, 154). Does Gombrich's psychology of art not undercut the doing of genuine history of *artworks*?

This book bristles with good, informed questions that are actual, real-life questions. (1) If Levi-Strauss is right that all histories are selective, and if "isms" are token categorizations ("Surrealism"), labels (like "Dada"), which distort and misidentify quite a diverse phenomena as homogenous wholes (Mes, 15, 17), are all the "stories of art" and histories of art used in teaching art to undergraduate students not falsifying schemata? Is that professionally responsible? (2) If the tidal wave of French structuralism, anglocized in Norman Bryson's recent, penetrating art-historical studies, is underwritten by Saussure's linguistics that has a fatal flaw as far as painterly images go (Iversen promotes Peirce's theory of signs, 85), *après le déluge sémiologique* what of bona fide *art* history will remain? Does art-historical terrain face expropriation "by the Great Powers of literary and linguistic studies" (Bann, 23)? (3) If Clement Greenberg god-fathered the "new" art history, and T. J. Clark's 1974 manifesto in TLS led the troops over the barricade (Overy, 133, 141), now that we are officially in year V of the revolution, has the new art history changed the status quo? Answer: no, the radicals have been co-opted by the establishment; there are individual *courses* ("A feminist approach to . . .") at certain universities, but the basic categories of writing art history remain reactionary (Rifkin, 161–62). Answer: wait! no unified methodological solution was ever promised—once we realize art history is a cultural practice concerned with *power*, we may need to move to "collective organization, and institutional resistance" (Tagg, 165–70, visiting professor at University of California, Los Angeles).

The normal academic response to this British anthology would be silence, since some of the contributors are shouting a bit. But silence would be a mistake, I think. Art history does need to define its specific boundaries, also in North America, demonstrate methodical rigor, and articulate principles that honor the nature of artworks as a kind of cultural product (Harrison, 76–77; Pointon, 127–28), if it means to survive as a discipline. Such foundation-laying thought, in my judgment, is a task of aesthetics. If art historians avoid aesthetic theory, they are ripe for colonizations by the social sciences (Harrison, 80–81). "Art history without aesthetics seems as blind as aesthetics without history would be empty" (O'Pray, 132). So aestheticians need to think through with prac-

ticing art historians, now that the empire of positivism is failing, on the way to go in *constructing* a philosophically responsible, nonpartisan art historical program that will allow the specifically aesthetic contribution of art speak from out of its embedded historical milieu.

I am sounding a note voiced earlier by Ackerman, Kleinbauer, Alpers, McCorkel, and others. The trouble with the Derridada deconstructive cocktail is that it acts like a Philistine hemlock, since it seems perversely set against ever leading to anything reconstructed. Now that right-brains are in the news, and "everyone is recognizing the importance of visual [images] in relation to verbal experience" (Pointon, 153), it is a good time for aestheticians not to write a prolegomena that will end all future metaphysics, but to help focus on categories that could give a theoretical, systematic framework of sorts, which will resonate with and deepen the best art historical praxis.

List of illustrations▪

© – copyright granted or purchased
AP – reproduced with the artist's permission
CS – photograph by Calvin Seerveld
CSU – © status unknown
PD – in the public domain

1 Thomas Gainsborough, *Mary Countess Howe* (c.1760), oil on canvas, 244 x 152.4 cm, Kenwood House, U.K. PD

2 Fake bridge to view from Kenwood House, United Kingdom. CC

3 François Boucher, *Madame Pompadour* (1756), 212 x 164 cm. PD

4 Hyacinthe Rigaud, *Louis XIV* (1701), oil on canvas, 277 x 194 cm, Louvre Museum, Paris. PD

5 Philippe de Champaigne, *Cardinal de Richelieu* (c. 1640), oil on canvas. PD

6 El Greco, *The Virgin with Saint Inés and Saint Tecla* (1597–1599), oil on canvas, 193.5 x 103 cm, National Gallery of Art, Washington, D.C. PD

7 Michelangelo Buonarroti, *Day* (1526–1531), sculpture in marble for tomb of Lorenzo dei Medici, Florence, 155 x 150 cm. CS

8 Pieter Bruegel the Elder, *Bauerntanz* (c. 1568), oil on panel, 114 x 164 cm, Kunsthistorisches Museum, Austria. PD

9 Canaletto, *Venice: The Basin of San Marco on Ascension Day* (1754), oil on canvas, 59 × 54 in. PD

10 Leonardo da Vinci, *Mona Lisa* (1503–1505), oil on canvas, 76.8 x 53 cm, Louvre Museum, Paris. PD

11 Raphael, *St. Catharine of Alexandria* (c.1507), oil on poplar wood, 72.2 x 55.7 cm, National Gallery, U.K. PD

12 Correggio, *Jupiter and Antiope* (c.1528), oil on canvas, 190 x 124 cm, Louvre Museum, Paris. PD

13 Rembrandt van Rijn, *Self-portrait* (1659), oil on canvas, 84 x 66 cm, The National Gallery of Art, Washington, DC, PD

14 Antoine Watteau, panel 1 (1709). Phot. Bibl. Nat. Paris

15 Antoine Watteau, panel 2 (1709). Phot. Bibl. Nat. Paris

16 Antoine Watteau, panel 3 (1709). Phot. Bibl. Nat. Paris

▪ Links to many of these illustrations in full color can be easily accessed at www.dordt.edu/DCPimagesSeerveld

17 Antoine Watteau, panel 4 (1709). Phot. Bibl. Nat. Paris

18 Antoine Watteau, panel 5 (1709). Phot. Bibl. Nat. Paris

19 Antoine Watteau, panel 6 (1709). Phot. Bibl. Nat. Paris

20 Antoine Watteau, *Les Bergers* (1717), 31 x 44 cm, Musée Condé, La Tribune, Chantilly. PD

21 Giorgione Barbarelli da Castelfranco, *Le concert champêtre* (c.1509), oil on canvas, 1.10m x 1.38m, Louvre, Paris. PD

22 Dennis Burton, *Niagara Honeymoon No. 4–AUM–The Sound of the Falls*, 1968, oil on canvas. CS (1977)

23 Nicolas Poussin, *The Triumph of Pan* (1636), oil on canvas, 135.9 x 146 cm, The National Gallery, U.K. PD

24 Nicolas Poussin, *The Adoration of the Golden Calf* (1633–1634), oil on canvas, 154 x 214 cm, The National Gallery, U.K. PD

25 Nicolas Poussin, *Et in Arcadia Ego* (c.1639), oil on canvas, 101 x 82 cm, Devonshire Collection, England. PD

26 Nicolas Poussin, *Et in Arcadia Ego* (c.1650–1655), oil on canvas, 87 x 120 cm, Louvre Museum, Paris. PD

27 Nicolas Poussin, *The Exposition of Moses* (1654), oil on canvas, 150x204 cm, Ashmolean Museum, Oxford. PD

28 Johannes Vermeer, *De Schilderconst* (c. 1666), oil on canvas, 120 x 100 cm, Kunsthistorisches Museum, Austria. PD

29 Johannes Vermeer, *Melkmeisje* (c. 1658–1661), oil on canvas, 45.5 x 41 cm, Rijksmuseum, Netherlands. PD

30 Johannes Vermeer, *Delft* (c. 1661–1663), oil on canvas, 96.5 x 117.5 cm, Mauritshuis, The Hague, Netherlands. PD

31 Johannes Vermeer, *Woman in Blue Reading a Letter* (c.1662–1663), oil on canvas, 46.5 x 39 cm, Rijksmuseum, Netherlands. PD

32 Johannes Vermeer, *Woman with a Pearl Necklace* (c.1664), oil on canvas, 55 x 45 cm, Gemaldegalerie, Berlin, Germany. PD

33 Johannes Vermeer, *Allegory of the Catholic Faith* (c.1671–1674), oil on canvas, 114.3 x 88.9 cm, Metropolitan Museum of Art, New York City. PD

34 Johannes Vermeer, *Woman Holding a Balance* (c. 1665), oil on canvas, 42 x 35.5 cm, National Gallery of Art, Washington, DC. PD

35 Anselm Kiefer, *Midgard* (1980–1985), oil and mixed media on canvas, 279.4 x 378.46 cm, Carnegie Mellon Art Museum, Pittsburgh, PA. © Anselm Kiefer

36 Anselm Kiefer, *Wayland's Song (with Wing)* (1982), oil, emulsion, straw, photograph, on canvas, 110 x 150 in. © Anselm Kiefer

37 *Ponte Vecchio* (996 AD), Florence, Italy. CS

38 *Pont du Gard* (1ˢᵗ century AD), Provence, France. CS

39 Ernst Barlach, *The Avenger* (1914), bronze sculpture, 438 x 578 x 203 mm, Tate Collection, UK. CS

40 Ernst Barlach, *The Magdeburger Ehrenmal* (1929), oak sculpture, 2.5 x 1.5 x .75 m, Magdeburg Cathedral, Germany. CC

41 Trier School, Homage to Otto III (c. 985 AD). PD

42 Giotto, *Scenes from the Life of Joachim: No. 4 Joachim's Sacrificial Offering* (c.1304–1306), fresco, 200 x 185 cm, Cappella Scrovegni, Padua, Italy. PD

43 Vincent van Gogh, *A Pair of Shoes* (1887), oil on canvas, 33 x 41 cm, Van Gogh Museum, Netherlands. PD

44 Paul Cézanne, *Montagne Sainte Victoire* from Les Lauves (1904–1906), Basel Kunstmuseum. PD

45 Gerhard Hoehme, *Der Tod des Herakles* (1978), mixed media, canvas, 300 x 240 cm, Saarbrücken Kunstmuseum. CS

46 Antoine Watteau, *Les Enfants de Momus* (c.1708). D-V 120. Phot. Bibi. Nat. Paris

47 Antoine Watteau, *L'Escarpolette* (c.1709). D-V 67. Phot. Bibi. Nat. Paris

48 Antoine Watteau, *Le Dénicheur de Moineaux* (c.1710). D-V 5. Phot. Bibi. Nat. Paris

49 Peter Paul Rubens, *The Garden of Love* (before 1634), oil on canvas, 198 x 283 cm, Madrid, Prado, Phot. of the Museum

50 Antoine Watteau, *La Cascade* (c.1715), D-V 28. Phot. Bibi. Nat. Paris

51 Antoine Watteau, *L'Amour Mal Accompagné* (c.1715–16). D-V 272. Phot. Bibl. Nat. Paris

52 Antoine Watteau, *Plaisirs d'Amour* (c.1717), Dresden, Staatliche Kunstsammlungen. Phot. of the Museum

53 Antoine Watteau, *Les Champs-Elysées* (c.1717), oil on panel, 31 x 42 cm, London, Wallace Collection. PD

54 Antoine Watteau, *Nymphe et Satyr* (c. 1715), Paris, Louvre. Phot. Clichés des Musées Nationaux, Paris

55 Antoine Watteau, *Divertissements chainpêtres* (c.1718), London, Wallace Collection. Reproduced by permission of the Trustees.

56 Antoine Watteau, *La Leçon d'Amour* (c.1718), D-V 263. Phot. Bibl. Nat. Paris.

57 Antoine Watteau, *Fêtes Vénitiennes* (c.1718–19), Edinburgh, National Gallery of Scotland. PD

58 Sir Joshua Reynolds, *Lady Sarah Sacrificing to the Graces* (1763–1765), oil on canvas, 242.6 x 151.5 cm, The Art Institute of Chicago, Illinois. PD

59 William Hogarth, *The Painter and his Pug* (1745), oil on canvas, 90 x 70 cm, Tate Britain, UK. PD

60 William Hogarth, *Idle Apprentice Executed at Tyburn,* plate 11 in *Industry and Idleness* (1747). PD

61 William Hogarth, frontispiece to *The Analysis of Beauty,* printed by J. Reeves for the author, 1753. PD

62 William Hogarth, *Analysis of Beauty,* plate 1, 1753. PD

63 Anton Raphael Mengs, *The Parnassus of Apollo, Mnemosyne, and the Nine Muses* (1760–1761), oil on canvas, 313 x 580 cm, Villa Albani (now Torlonia), Rome. PD

64 Hans Holbein the Younger, *Gebeyn aller Menschen,* in *La Danse des Morts,* 1538. PD

65 Thomas Bewick, "The Cross-Bill," Loxia curvirostra, wood engraving, *A History of British Birds* (1847), 1:233. PD

66 From Thomas Bewick, *The Fables of Æsop, and others, with designs on wood* (London: Longman, 1818), 242. PD

67 John Farleigh, wood engraving in George Bernard Shaw's *The Adventures of the Black Girl in her Search for God* (1932), Private Collection. CSU

68 Peter S. Smith, *Leaving* (1984), wood engraving, 103 x 127 mm. Collection of Inès and Calvin Seerveld. AP

69 Peter S. Smith, *Underground* (1985), wood engraving, 102 x 77mm. AP

70 Peter S. Smith, *Doorway* (1985), wood engraving, 127 x 102mm. AP

71 Peter S. Smith, *Working Late* (1986), wood engraving, 76 x 102mm. AP

72 Peter S. Smith, *Fallen Tree* (1989), wood engraving, 174 x 126mm. AP

73 Gerald Folkerts, *A Double Portion* (1987), oil on canvas. The collection of Inès and Calvin Seerveld. AP

74 Gerald Folkerts, *Good Friday* (1989), oil on canvas. Collection of Inès and Calvin Seerveld. AP

75 Gerald Folkerts, *A Study for Alpha 3* (1992), oil on canvas. AP

76 Gerald Folkerts, *Chernobyl Nightmare* (1999), oil on canvas, 60 x 54.5 in. AP

Index

Wölfflin, H. 23, 137, 279
Wolters, A. 1, 7-10, 47, 80
worldview(s) 47, 64, 69, 75-6, 90, 107,
 143, 145, 149, 205

Zeitgeist(er) 5-8, 10, 19, 62, 72, 118

Brief Biography

Besides philosophical aesthetics at the graduate Institute for Christian Studies in Toronto, Dr. Seerveld also explored problems in the historiography and critical theory of art. His cartographic methodology works out of Vollenhoven's "problem-historical" conception of the history of philosophy, modified to deal with artworks. For several years Seerveld focused his research and professional writing on artistry buoyed by the European Enlightenment. His "Telltale Statues in Watteau's Paintings" won the Clifford Prize for best article in 1980–1981, awarded by the American Society for Eighteenth-Century Studies. His partiality for picaresque William Hogarth, as serious aesthetician as well as artist, and for Anton Raphael Mengs, signals Seerveld's eye for the idiosyncratic figures in art history. His study of the neglected art historian Kurt Badt with Lorenz Dittmann at the Universität des Saarlandes in Saarbrücken, Germany, and giving serious narrative exposition to young christian voices like British Peter S. Smith and Canadian Gerald Folkerts are attempts to give examples of what deserves attention to round out what constitutes the art historical world. www.seerveld. com/tuppence.html